PACIFIC BASIN BOOKS

Editor: Kaori O'Connor

OTHER BOOKS IN THIS SERIES

8/28/92

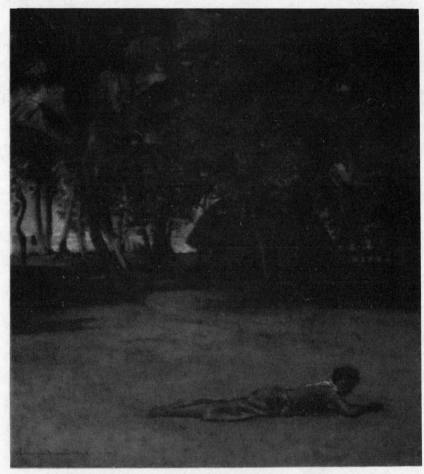

GIRL WEEDING IN FRONT OF OUR HOUSE. VAIALA, SAMOA

AN AMERICAN ARTIST IN THE SOUTH SEAS

BY JOHN LA FARGE

Introduction by Kaori O'Connor

KPI

LONDON AND NEW YORK

First published in 1914

This edition published in 1987 by KPI Limited
11 New Fetter Lane, London EC4P 4EE

Distributed by
Routledge & Kegan Paul, Associated Book Publishers (UK) Ltd.
11 New Fetter Lane, London EC4P 4EE

Methuen Inc., Routledge & Kegan Paul
29 West 35th Street
New York, NY 10001, USA

and
J M Dent Pty Limited
112 Lewis Road, Knoxfield 3180, Victoria, Australia

Printed in Great Britain by
T. J. Press (Padstow) Ltd., Padstow, Cornwall

ISBN 0 7103 0256-8

INTRODUCTION

The spectacular beauty of the Pacific islands seems made for the artist's palette and the painter's eye, but it is a strange fact that few artists of note have lived and worked there since the days when masters like John Webber and Louis Choris travelled with the great explorers. Today we think of Paul Gauguin as *the* modern Pacific painter, but there was another – a man who preceeded the Frenchman to the South Seas, and whose reputation far overshadowed that of Gauguin in their time – John La Farge, aesthete, philosopher and doyen of American artists. On August 23, 1890, La Farge sailed from San Francisco on the first stage of a year-long odyssey that would take him to Hawaii, Samoa, Tahiti and Fiji. He visited with Robert Louis Stevenson, became versed in traditional Polynesian culture, met the controversial Shirley Baker of Tonga, was adopted into an aristocratic Tahitian family and journeyed to see the wild hill tribes of Fiji with Sir John Thurston, painting and sketching the while. This account of his experiences, illustrated with his own work, is a unique and significant contribution to the artistic, literary and historical heritage of the Pacific, and a revealing insight into the life and character of a complex and fascinating man.

John La Farge was a striking and singular figure – tall, pale and slender, he dressed habitually in black and everything in his appearance suggested 'refinement in its very essence.'[1] Fastidious by nature, he had 'his own kind of pen, his own kind of paper, his own distinctive way of doing everything; every gesture of his body seemed to relate to the ultimate ends of his

life and work.'[2] He had the tact of a diplomat, the manners of an old world courtier and the breeding and bearing of a gentleman. As his friend Henry Adams, the distinguished historian, put it:

> he prided himself on faithfulness to tradition and convention; he was never abrupt and abhorred dispute. His manners and attitude to the universe were the same, whether tossing in the middle of the Pacific Ocean sketching the trade-wind from a whale-boat in the blast of sea-sickness or drinking the *cha-no-yu* in the formal rites of Japan, or sipping his coconut cup of *kava* in the ceremonial of Samoan chiefs, or reflecting under the sacred *bo*-tree at Anaradjpura.[3]

Quiet and reserved in manner, he seemed the very embodiment of sophisticated poise and cool detachment, yet his outward calm masked a restless and inquiring mind, and a relentless individuality lurked behind his scrupulous propriety.

Born in New York city in 1835 to a wealthy and artistic family of French descent, La Farge had a classical education and was intended for a career in the law, but found himself drawn to science, philosophy and poetry. Advised by his father to study painting under a master as an accomplishment before becoming a lawyer, he went to Paris at the age of 21 and worked for a time in the studio of Thomas Couture but quickly became dissatisfied with the salon style of painting which, as he saw it, made no attempt at a 'synthesis of light and air'[4] and used color in an arbitrary way 'merely as a manner of decorating systems of painted drawings.'[5] Breaking away from the studio, he studied paintings and old master drawings in the Louvre and in museums and galleries in Germany, Holland, Belgium, France and England, concentrating on the problems of color, light and shadow. On returning to America he entered a lawyer's office,

but left in 1859 to study painting at Newport, Rhode Island, under William Hunt, the earliest interpreter of the modern French school in America.

His interests now included architecture, history, Oriental philosophy and Japanese art, and he found it impossible to confine his attentions to a single discipline. He read widely in many fields, experimented with light and optics, studied Japanese brush painting and mastered Mandarin Chinese. He would speak of Titian and Tintoretto in one breath, Tao and Nirvana in the next, then turn to a discussion of mathematics. As Adams put it:

> La Farge alone owned a mind complex enough to contrast against the commonplaces of American uniformity, and in the process perplexed most Americans who came in contact with it. . . . One was never sure of his whole meaning until too late to respond, for he had no difficulty in carrying different shades of contradiction in his mind . . . his thought ran as a stream runs through grass, hidden perhaps, but always there.[6]

He struck everyone who met him as an eternal seeker and questioner, among them the eminent French critic Paul Bourget who remarked on 'the impression of a nervous activity unappeased by any effort, unsatisfied through any experience, and seeking, and seeking again.'[7] For La Farge, knowledge was not an end in itself, but a means of discovering the transcendental truths that he believed could be found in all cultures, all times and all disciplines. As his son John remembered,

> his questioning was based on the conviction that he had reached certain truths and that there *were* answers to the questions. Innumerable queries tormented him to the end,

and yet there was always somewhere an answer, he seems to have realized, which led to a greater answer.[8]

Later in life, La Farge recalled how these concerns made it difficult for him to settle to his chosen career:

No one has struggled more against his destiny then I; nor did I for many years fully acquiesce in being a painter, though I learned the methods and studied the problems of my art. I had hoped to find some other mode of life, some other way of satisfying the desire for a contemplation of truth, unbiassed, free and detached.[9]

As he saw it, it was not enough for art to be decorative – it also had to have a spiritual dimension that could express truths in an artistic form, and the truths had to be drawn from the many fields of his inquiries. The final painting style that he developed was a complex and sophisticated blend of innovation and tradition, modern techniques and ancient principles, and combined elements of Western art with those of the East. It anticipated the pre-Raphaelite commitment to rendering the phenomena of nature literally and faithfully, without falling into the trap of mere representation. It presaged the Impressionists' desire to render the imaginative essence of a scene, without slipping into abstraction. It involved clear and subtle colorings that were in the spirit of the modernist movement but entirely distinctive and original, based on his work with prisms. But the foundation of his work was the classical tradition, based on the Greek ideals of beauty which he believed represented all that was best in Western art and culture, and also embodied harmonies and fine sensitivities to nature that he had found in the art of China and Japan.

La Farge's restless spirit of inquiry was paralleled in his artistic

career, where he made rapid progress from one medium to another. He painted in oils and watercolors, illustrated books, and designed elaborate ceilings, bas-relief panels, wood inlays and embroideries. He moved on to the problems of marrying color and art to architectural form through the use of large-scale mural decorations. His decoration of Trinity Church, Boston, was the first real mural painting in America and marks the beginning of an epoch in American art, his finest surviving work in the genre being the wall above the altar in New York's Church of the Ascension. His interest in color and optics led him to take up working in stained glass, one of his most important commissions being the Battle Window in Harvard University's Memorial Hall. He experimented with methods of joining glass without lead, and invented the method of glass overlays and the use of opaline glass now generally known as 'American stained glass.'[10] Typically, he did not think to patent the process, which was subsequently taken up and used by the lamp-maker Louis Tiffany, but a large La Farge stained-glass window exhibited at the French Exhibition of 1889 won him the Legion of Honour and this accolade:

> He is the great innovator, the inventor of opaline glass. He has created in all its details an art unknown before, an entirely new industry, and in a country without traditions he will begin one, followed by thousands of pupils filled with the same respect for him that we have ourselves for our own masters.[11]

At a time when Europeans ridiculed the very idea of American artists or American art, La Farge's achievements had earned him a unique and commanding position in the international art world. Already established as his country's leading artist, he was now hailed in the salons of Europe as a Renaissance man of

genius.

But success had taken its toll on La Farge. Since the 1870s he had suffered recurrent periods of debility as an after effect of lead-poisoning contracted through his use of lead-based paints and later exacerbated by his work with glass. He also suffered from what his wife called 'diplomatic illnesses,' brought on by his tendency to 'become lost in the world of his own creativeness.'[12] He found it difficult to meet deadlines on time, and was temperamentally incapable of dealing efficiently with the details of everyday life. It was characteristic of La Farge that, on the night before he was to leave for the South Seas, he was 'struggling with the Whole Inferno'[13] with three pictures to paint, two windows to lead and his packing to do before he could go away. Family life had been another casualty. In 1860 La Farge married Margaret Perry, a great-great granddaughter of the American President Benjamin Franklin, but within a few years he had begun to withdraw into his work, leaving his wife to raise their seven children in the country while he lived and worked in New York. La Farge's son John, who became a Jesuit priest, saw his father's absence as a 'total forgetfulness of life's ordinary obligations'[14] rather than a case of willful neglect, but another member of the family, the writer Oliver La Farge, took a less charitable view: 'Grandfather was far from being always an admirable man. . . when he painted, he painted, and to hell with everything.'[15] For La Farge, the only way to relieve the pressures of work and family was literally to escape them, and in 1890 he and the widowed Henry Adams set off for the Pacific 'like two schoolboys on a lark.'

To La Farge, the initial attraction of the Pacific was its remoteness. He had read Herman Melville's *Typee* and *Omoo* and Pierre Loti's *Marriage of Loti*, but apart from a desire to visit the Typee valley, he set out with no artistic preconceptions or

expectations. In Hawaii, the first port of call, he was intoxicated by the islands' beauty and became an 'animated prism,'[16] sketching and painting from morning to night in an effort to capture the elusive shades of blue, green and violet that turned to silver at the slightest change of light. La Farge was enchanted by the scenery but the culture made little impression on him, and although he found his sojourn in Hawaii immensely stimulating, it was superficial indeed compared to the experiences that awaited him in Samoa.

His first Samoan landfall was on the island of Tutuila 60 miles from Apia, where the astonished La Farge came ashore to find himself apparently transported to the world of ancient Greece. The splendid physiques of the young men rivalled those of Greek statues, their *tappa* sarongs reminded him of classical drapery, their wreaths and flowers were like those worn by the sylvans and fauns of Attica, and the girls who performed the seated *siva* dance seemed to him the bronze figures of antiquity brought to life by some strange magic. La Farge was stirred to the depths of his complex soul. As Adams put it, 'La Farge's spectacles quivered with emotion and gasped for sheer inability to note everything at once.'[17] Why, he wondered, had no one ever told him that 'a rustic Greece was still alive somewhere, and still to be looked at?'[18] In a place where he had least expected it, La Farge had found confirmation for many of the theories and questions that had preoccupied him all his life. To him, the Samoans were the very embodiment of the poetry of form and color that had been Greece – an example of 'an old beauty, always known.'[19] Although their culture was a simple one in material terms, he found that the Samoans had 'a feeling for completeness and relation'[20] that marked the pure spirit of the love of art. In Samoa and the Samoans he saw:

living proof that Greek art is not the mere invention of the poet – the refuge of the artist in his disdain of the ugly in life.[21]

He began to study Samoan customs, and found an inherent nobility in their love of ceremonial, adherence to time-honored etiquette, reverence for tradition and sophisticated concepts of aristocracy and chieftainship. *Had I only known years ago,'* he wrote with feeling.

La Farge and Adams settled at Apia, where they were entertained with great hospitality:

> We are the first great Americans who ever came to these islands as great chiefs travelling for pleasure and the natives regard Americans as their saviors and dearest friends. Nothing is too good for them. From Malietoa and Mataafa downwards, we are received with open arms.[22]

Robert Louis Stevenson was living in the hills 5 miles from Apia and La Farge and Adams, who shared with Stevenson such mutual friends as Sidney Colvin and Henry James, rode out to pay him a visit. Vailima had not yet been built and they found Stevenson and his wife Fanny camped in a half-cleared field. Stevenson wore very dirty cotton pyjamas and mismatched socks, Fanny was barefooted and dressed in a grubby, long 'missionary' shift, and Adams took an instant dislike to the pair, writing to friends at home that Fanny was 'a wild apache'[23] while Louis 'looked like an insane stork, very warm and restless.'[24] La Farge drew a discreet veil over his personal feelings, but was known to share something of Adams's views. Many years later, when one of Stevenson's biographers criticized what he considered a snobbish attitude on the part of the American visitors, La Farge's son replied in this way;

I can't answer for Adams; he was an Adams, after all. With regard to Father a snobbish attitude does not seem to make sense. I would say rather that he disliked Stevenson's appearance simple because he disliked non-convention for non-convention's sake. He believed in old traditions; he reverenced the past in small things and great things, and had inherited from his parents a strong feeling of *noblesse oblige*: when you are out of the normal current of affairs and traveling around the Pacific Ocean, you should observe extra care to preserve your self-respect. You *might* neglect dressing for dinner at home in Newport – though I don't think he would – but still it would not be so important. But if you were in Tutuila or Tahiti you would most undoubtedly dress for dinner, because otherwise it would be an insult to the hospitality of your hosts. The Samoans were an ancient and cultured race with great traditions of their own and coming from so many thousands of miles away to make one's home among them demanded an attitude of reverence and delicacy in their presence, with regard to what we felt as conventions in our life.[25]

La Farge's reservations about Stevenson went far beyond the writer's sartorial shortcomings. He felt that Stevenson did not understand the nature of Polynesian chieftainship on which traditional Samoan society was based, a failure that meant that Stevenson could not grasp the complexities of the socio-political situation in Samoa, would see things inaccurately from what was essentially a European point of view, and would embark on actions that, although undertaken for the highest of motives, would ultimately do more harm than good. Whatever the merits of La Farge's view, the analysis of the Samoan situation that he gives here makes a fascinating contrast to that given by

Stevenson in his *Footnotes to Samoan History*.

For his part, Stevenson was greatly taken by La Farge, if not by Adams, and many visits were exchanged before the travellers left Samoa. Their original destination had been the Marquesas Islands but Stevenson had convinced them to go to Tahiti, which at the outset proved something of a disappointment. Although the beauty of the landscape reminded La Farge of the paintings of Claude Lorraine, Papeete struck him as overcivilized after his Samoan idyll, and he saw little to admire in the nominal ruler King Pomare V. The Pomares, who were maintained on the throne by the French, were a perfect example of Pacific kingship on a European model that La Farge had come to deplore. As he put it:

> Nor is the line of the Pomares, anymore than that of the Hawaiian rulers, so connected with all antiquity as to be typical of what a Polynesian great chief might be to the people whom he rules. The Pomares only date from the time of Cook. They were slowly wresting the powers from the great family of the Tevas, by war and by that still more powerful means – marriage. . . . Polynesian descent is the only real aristocracy; there is no ruling except through blood. Hence the absurdity of the kingships that we have fostered or established, which in our minds seemed quite legitimate because they embodied the European ideas which belong to our ancestry. Hence the general discomfort and trouble that we have helped to foster. Hence also – and far worse – the breaking down, in reality, of all the basis upon which the old societies rested.[26]

Disheartened, La Farge left Papeete and went to Tautira to stay with Ori a Ori, a member of the junior branch of the chiefly Teva family. Ori was a friend of Stevenson and had adopted him

into his family, a gesture that had touched Stevenson so deeply that he had dedicated his *Ballad of Rahero* to Ori. Ori now adopted La Farge and Adams in the same way, and shortly afterwards they were adopted into the senior branch of the Teva family – a great honour that was not bestowed on Stevenson and was given to only one other foreigner, Prince Oscar of Sweden. In Polynesia, the adoptive relationship is neither lightly given nor taken. By his adoption into the senior Teva line, La Farge literally became Teraaitua, a chief of the highest lineage. For the remainder of his stay in Tahiti he varied his painting with collecting and studying the ancient and secret family myths and legends to which he was now heir, ultimately arriving at a deeply mystical understanding of Tahitian culture.

La Farge left Tahiti with great regret some two weeks before Paul Gauguin arrived in Papeete on his first visit to the South Seas and, following an adventurous visit to Fiji, returned to New York after an absence of fourteen months. Critics and public in Europe and America were enchanted with La Farge's Pacific paintings, praising the nobility, grandeur and elegance of his studies and the beauty of his colorings. Every detail of costume, context and grouping was accurately observed and scrupulously rendered, but the ultimate appeal of La Farge's work lay not in his undeniable technical mastery or ethnological accuracy, but in his ability to capture and convey the very essence and spirit of the island cultures and people. As one admirer put it:

For many a 'travel note' in modern art a photograph might easily be substituted. La Farge on his travels made his lightest sketch a thing of enchanting originality. As through some curious wave of inner illumination you are made aware among his pictures not simply of mountain and

valley, of sea and sky, but of the very genius of a far scene. When he painted 'The Hereditary Assassins of King Malietoa' he made manifest all that was uncanny about those personages.[27]

In La Farge's Pacific paintings, there is nothing crude, primitive, violent, ugly nor even strange. It is the noble and not the savage that predominates. They are, in every way, the very opposite of Gauguin's Pacific works, about which La Farge had this to say in later years when, in reply to a letter from Adams, he wrote:

I say 'wild Frenchman'. I should say 'stupid Frenchman'. I mean Gauguin. No, I think that he went there just as we arrived in Paris in 1891. His pictures were on show with Whistler's portrait of his mother. . . . I was then told that our Frenchman was going to our islands. . . . After that accidentally I came across some letters of his, later published in some review, written from Tahiti. They were meant to be expressive of a returning of the over-civilized to Nature. They were very foolish and probably very much affected but also naive and, I think, truthful. I never remembered to get the whole of them – I mean the letters. He described his meeting with some of our ladies, the Queen included, and some of his quotations were parlous. . . . And he didn't like the French of course, and he had no money or little, or made believe to have little, and he went into the wilderness and lived the simple life – the coconut and breadfruit life – with some relative companion to charm the simplicity of food etc. All that seemed natural enough; stupid enough; and yet there was something of the man who had found something.

Then somebody sent me a catalogue of an exhibition of

his. I have no doubt that your description of the Frenchman's paintings, which I understand you have not seen, must be quite accurate about the peculiar shows which some of these good people indulge in; I mean that they are driven to do something to attract attention. Even their own attention.[28]

It is easy to understand why La Farge would see in Gauguin's work a hideous distortion of all he had found to be beautiful and good in the Pacific, and an artistic slander that gave the lie to the truths he had worked so hard to convey in his own art. As the poet Rupert Brooke put it in a letter written from Tahiti:

> Gauguin grossly maligned the ladies. Oh, I know all about expressing their primitive souls by making their bodies square and flat. But it's blasphemy. They're goddesses. He'd have done a Venus De Milo thus.[29]

Scholars of Gauguin's work concede that his knowledge of Tahitian culture was not as comprehensive as that of La Farge, being little more than 'local color'[30] in which he cloaked a very personal *rève* or vision, but argue that the true value of Gauguin's Pacific painting lies in their 'deeper layers of reality.'[31] But as these reminiscences, which were not published until after his death reveal, La Farge's works were also conceived and executed on many different levels. While further comparisons would be invidious, it is clear that Gauguin should not be considered the *only* modern Pacific painter of note. And it should be recognized, as a study of the illustrations to this book will demonstrate, that of all the artists who have worked in the Pacific, John La Farge is the only one who was able to capture the elusive elegance of the dance, arguably the greatest Polynesian art form.

La Farge never returned to the Pacific, but continued to pursue his multi-faceted career in New York where he received many awards and distinctions. When he died on November 14, 1910, he was recognized as the man who had done more than any other to establish American art and artists on an international level, and his passing was mourned in fulsome remembrances of which the following is representative:

One of the greatest artists this country has produced, a universal genius who belongs to all time, has released his hold upon the brush which limned the beauties of earth. He translated medieval moods: he vied with the pre-Raphaelites and the Japanese; he revived the lost art of artifices in stained glass and placed his work with theirs in the venerable cathedrals in France; he drank deep of the romance of the isles of the Southern Seas, yet through protean changes he retained his own individuality and enriched and glorified the land of his activity.[32]

These reminiscences of his days in the Pacific have as many aspects as La Farge had talents, but one enigma links the artistic, ethnological, historical and literary threads in the book. La Farge, Stevenson and Gauguin were in the Pacific at the same time and La Farge knew, separately, many of the same people that Stevenson and Gauguin knew. All three loved the island people deeply – but all three saw things in a very different way. One reflects that the Pacific, for outsiders, has always been a strange and magical mirror in which one sees only what one wants to see. Or, as John La Farge speaking in another context, put it:

The perpetual Maia, the illusion and enchantment of appearances, sings for each of us a new personal song, as if

she returned our admiration, as if she cared – indeed, as if she existed – in the way that we say we know her; for she takes form in us and fits our shapes.[33]

Kaori O'Connor

NOTES

[1] Cortissoz, Royal, *John La Farge: A Memoir and a Study*, Houghton Mifflin Company, Boston and New York, 1911, p.11.

[2] La Farge, (Father) John, S.J., *The Manner is Ordinary*, Harcourt, Brace & Company, New York, 1954, p.7.

[3] Adams, Henry, *The Education of Henry Adams*, Houghton Mifflin Company, Boston and New York, 1918, p.369-70.

[4] La Farge, John, in Waern, Cecilia, *John La Farge: Artist and Writer*, Portfolio Artistic Monographs, Seeley & Co., London, 1896, p.11.

[5] Ibid., p.12.

[6] Adams, op.cit., p.369-70.

[7] Waern, op.cit., p.81.

[8] La Farge, Father John, op.cit., p.6.

[9] Waern, op.cit., p.14.

[10] *American Art Annual*, vol.9, 1911, p.315.

[11] Waern, op.cit., p.52.

[12] La Farge, Father John, op.cit., p.29.

[13] Adams, Henry, *The Letters of Henry Adams, vol.3 (1886-1892)*, ed. J.C. Levenson, Ernest Samuels, Charles Vandersee and Viola Hopkins Winner, The Belknap Press of Harvard University Press, Cambridge, Massuchusetts, 1982, p.259.

[14] La Farge, Father John, op.cit., p.29.

[15] La Farge, Oliver, *Raw Material*, Houghton Mifflin Company, Boston, 1945, p.22.

[16] Adams, op.cit., 1982, p.280.

[17] Ibid., p.291.

[18] La Farge, John, *An American Artist in the South Seas*, KPI, London, 1987, p.86.

[19] Ibid., p.93.

[20] Ibid., p.94.

[21] Waern, op.cit., p.90.

[22] Adams, op.cit., 1982, p.301.

[23] Ibid., p.304.

[24] Ibid., p.351.

[25] La Farge, Father John, op.cit., p.11.

[26] La Farge, John, op.cit., p.310-11.

[27] Cortissoz, op.cit., p.147.

[28] Ibid., p.241.

[29] In Snow, Philip & Waine, Stephanie, *The People from the Horizon*, Phaidon, Oxford, 1979; p.215.

[30] Rookmaaker, H.R., *Gauguin and 19th Century Art Theory*, Swets & Zeitlinger, Amsterdam, 1972, p.226.

[31] Ibid., p.234.

[32] La Farge, Father John, op.cit., p.8.

[33] Waern, op.cit., p.25.

PREFATORY NOTE

THIS record of travel in the South Seas was designed by Mr. La Farge as a continuous narrative, but some of his most valuable impressions were embodied in letters written from the Islands to his son, Mr. Bancel La Farge, or jotted down at the moment in his journal. Since it was his intention to introduce this material into the book, it has with scrupulous care been drawn upon for that purpose.

<div align="right">G. E. B.</div>

CONTENTS

REMINISCENCES OF THE SOUTH SEAS

EN ROUTE

On Board, 26th August, 1890.

San Francisco was the same place, with the same curious feeling of its being cold while one felt the heat; but there was neither place, time nor anything for me; there were things to buy and replace — all sorts of things had been forgotten, and now more than ever I realize that it is well to be overloaded — even if I believe that later I should feel it. What I want I want badly, and San Francisco is not a place to get it in.

And then there was a pleasant club, with the usual hideous decoration, but very comfortable and with such a good table, and such a *real* one — meats that were *meats*, and fish that was *fish*, and fruits in quantity, and fruits are not fruits for pleasure unless they be in quantity; and good wine and champagne of a kind that is not ours; and a Mr. Cutler who took us there and talked of things he had done or would do, that were interesting, and the contrast between the smoothness of life there, and the apparent difficulties outside. I say apparent because many of them are based upon a feeling of indifference or "look out for yourself" in any event outside. Yes, the Union Club was a good waster of time. And then I am not yet well recovered at

all from the strain of the beginning of the month; and I felt as if I had sea-legs and gait from the motion of the car. So that I shall say nothing of the great bay, nor its mountainsides, that look at this time as if they were nothing but those we have seen all along, but with the sea rolling in.

We got off on Saturday, not at noon as stated, but waiting for a couple of hours in dock, the little steamer filled with people and with very pretty girls, who, alas! were not to accompany us. But we have a circus troupe "à la Buffalo Bill"; an impresario with the nose and figure head of the "boy," and his wife, or lady, the usual "variety blonde" to match, joining, like the telegraph, (through the seas and continent of America), furthest Australia and the Singing Hall of London. Long-haired cowboys see them off, one of them fair-haired and boyish and "sixty-two." There are Indians, one long-haired, saturnine, and yet smiling, with the usual length of jaw and hair (so that his back runs up from his waist to his hat), who sits with some female, perhaps a dancer, and talks sentiment evidently, in his way, to my great delight — and hers, too, whatever she might say. They sit with one blanket around them, and he points gracefully, and puts things in her hair — and draws presents out of his pockets, wrapped up in paper, and puts them back to pull them out again. She sits against him, and smiles at him ironically.

and laughs, and generally looks like a pretty cat lapping cream.

The cowboys meander about and go to the bar-room too frequently, especially one, a fair-haired one, who feels the first attack of sea-sickness, and sits with his head on his hand — and resents his comrades' begging him to come below, telling them that they have mistaken the man he is, that he is a Pawnee medicine man, he is, and that he will wipe the floor with them; and then he subsides again — so that my expected row does not occur.

Then everybody subsides, even the cheerful young Englishmen and old Englishmen, and the middle-aged Englishmen, who pervade a good part of the ship and utter all their small stock of remarks with slowness and power. There are others — the teacher going back for her vacation, to the seminary at Hawaii — the young German I suspect of being an R.C. priest, and the Scotchman who has carefully talked for the last hour on the advantage of our system of "checking" baggage, which as he says allows you to go on without getting off at any station to see if the "guard" has the things all right. But as he remarks, for the hand luggage, a "mon" can take care of that himself, otherwise he would not be fit to take care of MONEY!!

But the weather is disappointing, very cold (so that ulsters

are convenient), dark and grey, and there is a heavy coast sea, which I didn't like until yesterday, since when it has been warm, and we have had blue sky in large patches through rents in the violet silveriness of the clouds. It is the exquisite clearness of the blue of the Pacific, a butterfly blue, *laid* on as it were between the clouds, and shading down to white faintness in the far distance, where the haze of ocean covers up the turquoise. The sea has the blue for a long time, but dark and reflecting the grey sky. This morning (Thursday) it has been blue like a sapphire, dark to look at except near by, but when you look down to it, and see it framed in the openings of the windows or the gangways, blue light pours out of it, and I realize that my blue sketches of four years ago are no exaggeration. When the clouds open somewhat, the blue light pours down and makes the shadows of the clouds violet, except when this fog against the warm sky looks red and rosy. Even the shadows of the blue sea look at moments reddish, when they reflect the opposite grey cloud. But we are not yet quite in the *sun* seas — this is not the season yet nor the place. There is all the time a veil of cloud, a veil so heavy as to make great cumulus clouds bunch out in extreme modelling. But when it is grey, all in silver — there is a light — a lilac grey, a silver, not known to the other side; and it is only when the distant smoke of the steamer goes over the

grey clouds that I realize that they become like those of the north Atlantic.

This is Thursday afternoon. On Saturday at dawn, or before it, we shall sight at first the island of Molokai, the leper's island, where Father Damien lived, then Oahu and its capes and Honolulu.

Friday, 29th August.

Last night the sun set in those silver tones that I associate with the Pacific and with Japan. The horizon was enclosed everywhere, but through it every here and there the pink and rose of sunset came out and in the east lit up the highest of the clouds in every variety of pink and lilac and purple and rose, shut in with grey. But the moon, "O Tsuki San," had her turn—then I realized where we were. All was so dark that the horizon was quite veiled, but the light of the moon, in its full, and high up, poured down on what seemed a wall-embroidery of molten silver slanting to the horizon. Itself was partly wrapped in clouds or veils or wraps like those that protect some big jewel, and when unveiled or partly covered, it had the roundness — the nearness of some great crystal "with white fire laden." The clearness was so great at places open through the clouds, that I thought I could see Jupiter's satellites, and decided it was he by this additional glitter. There

is no way of telling you all that the moon did, for she seemed to arrange the clouds, to place them about her or drive them away, to veil herself with one hand of cloud. It was like a great heavenly play — and played in such lovely air! If I could write on for pages I could only say that I had no idea of what the moon could be, nor of the persistence of colour that she could hold in all the silveriness.

When I went to bed, blue light poured in by reflection from the waves that had looked dark and colourless from the deck. It was the same contrast as by daylight, when the dark sea, isolated from the sky, takes a blue like Oriental satin, and is fired with light.

To-night again the moon gave a play — no longer in the great pomp of a simple spread of silver forms of cloud, but like an opera of colour and shadow, far in front of it, hung at times, a cloud so dense as to seem as dark as our bulwarks or "roofing" — but usually a cloud of blue, perhaps by contrast with the warmth of the clouds behind, all lit up and modelled and graded tier on tier. No Rembrandt could have more *indication* of grading and of dark than these clouds had in *reality*. No possible palette could approximate the degrees of dark and of light, for the moon, when she uncovered entirely, was the same transparent silver vase out of which poured light. It seemed impossible — the electric light alongside of us was no

brighter apparently than the bright markings of the light on
the deck, on the edges of the bulwarks, and on the brass of the
railings. Imagine the electric light, in say our Fifth Avenue,
really turned on everything around you. It is a stupid simile,
but I wish you to believe in what I am saying. I took a
coloured print into the moonlight to try, and could make out
the colours — fairly of course — moonily, but there they were
all, all but the violet. We could read, poorly, but we could
read. But this is not the point, it is that we could see far
away to the moon, and that it made a centre of light for every
dark, for every half-tint, curtain upon curtain hung in front of
it — all the foregrounds of sky you could wish for in that pos-
sibility of fog cloud.

Never shall I think again of the moon as a pale imitation.
Of course its representation began when the sun was gone.
Why it was like a sun one could look at without winc-
ing, and canopied itself with colours that did not imitate, but
were merely the iridescent spectrum that belongs to the great
sun. These colours, by their arrangement in the prismatic
sequence seemed to make more light, to arrange it and dispose
it, as if art was recalling nature. All this must seem unintel-
ligible. It would to me if I dared reread it. But this is at
least what we came for — the moon and the Pacific.

To-morrow morning, Honolulu.

There was the profile of Oahu at seven this morning. Earlier, Molokai was a long cloud on our port. Now Oahu becomes clearer, and is distinctly violet or plum colour. The sea in front of it is blue, and dashed with white foam. Above, the clouds are in the more delicate greys and violets, and far up is a little rift of blue. To the right a large white triangular patch — an extinct volcano cone. Near the base of the mountains all is mist.

It is now 7:30. Birds, swallows, and sea-mews meet us; the swallows came early this morning. But until yesterday, for two days, there was no life except the flying fish.

We are very close, so close that I cannot draw except in panorama. All looks like cinders as we go on. Lovely cloud effects on the hills — rainbows — and the furthest edge of everything in this promontory daring all.

Then, as we round this, *with our first turn perhaps since we left*, we can see more mountains and hills — for the first time, right on the blue sea, a fringe of green (not yellowish) — the first time I have seen a fringe of green to deep blue sea.

Later we see beneath the great hills or mountains, that look like cinders, green bushes of trees, and houses looking pretty enough and cool — but we are still far off — and then behind this grey mountain with fringe of green we begin to feel Honolulu.

Big mountains, green valleys and slopes far back, a fringe of trees, some large buildings, a steamer's smoke from some place, here and there masts — all this spread for miles, like an edging. As the space unfolds we see an immensely long beach (Waikiki) running at the base of the hills around a bay, and far off in the haze many masts. "White water" edges the sea everywhere, even before the line of ships. The water has calmed on which we now slip. There is no motion to it; no more, apparently, than would make a fringe of foam to a lake. A narrow channel in the surf, and we see the shipping and the port: steamships and sailing vessels, an English and an American warship, and we are in, and I am interrupted for the keys of the trunks.

HONOLULU

Sunday morning, Nuuanu,

 Nuuanu Valley, Honolulu.

Last night, after having tried the Hawaiian Hotel, we came up here and took possession of Judge Hartwell's house, which we had seen in the afternoon.

We sat in the verandah, looking out toward the sea, I should say about two miles from us, with the same brilliant moonlight we had had the night before. The two palm trees in front of the house were gradually illuminated as if the whole air had been a stage scene, through the smoothly shining trunks glistening like silver, where the lower green stem of the bole leaf or branch of the tree beneath the branches separates from the lower cylinder. Behind them spread sky and ocean, for we are just on the summit of a hill, the sea-line spreading distinctly and the air being clear enough, (even when a slight drift of rain came down across the picture), to see the surf far out, and the lines of a great bar (to the right), which made a long hooked bend into the sea. Lights shone red on board of two English and American war vessels. Far off a few azure clouds on the horizon; and occasionally a white patch of cloud floated

12

TREES IN MOONLIGHT. HONOLULU, HAWAII

like gauze over the palms, then sank away into the space shining far off — a little darker now than the sky, and warm and rather red in colour.

Meanwhile, the palm branches tossed up and down in the intermittent gale which blew from behind us in the great hills. The landscape was all below us, lying at the very foot of the palms which edge the hill upon which we are. Across the grass the moonlight came sometimes, as if a lamp had suddenly been brought in — and the colour of the half-yellow grass, which was not lost in the moonlight, urged on this delusion. Even the violet of the two pillars of palm and its silveriness were strong enough to make greener the colour of the sky.

When I walked out behind the house the hills were covered with cloud — I say covered, but rather the cloud rested upon them, and poured up into the sky, in large masses of white; the moon shining through most of the time, out of an opening more blue than the blue sky, itself an opaline circle of greenish blue light, with variant iridescent redness in the cloud edges. Against it the heavy trees looked as dark as green can be, and now and again the branches of other palms were like waves of grass against this dark, or against the sky all shining and brilliant. Occasionally it rained, as it did in the afternoon; the edges of the great cloud blew upon us like a little sprinkle of

wet dust, and later, as it came thicker, the rustle of the palms was increased by the rustle of the rain. The grass of the hills shone as with moisture, but the grass outside, near us, was so dry that the hand put down to it felt no wet.

And I went off to bed under mosquito nettings, in a room that smelt of sandalwood, to sleep late and feel the gusts of wind blow through the open windows, and to think that it rained because I heard the palms.

Yesterday it rained very often. As we landed, the rain had begun, and the air was difficult to breathe with the quantity of moisture. All was wet, underfoot, though the wet, by the afternoon, had dried in this volcanic soil. We had been taken up to the home of Mr. Smith, Judge Hartwell's brother-in-law, and decided at once upon going to housekeeping, for which we had to drive into town quite late; and we made out of our business a form of skylarking, I think to the astonishment of our guide and friend, who may have thought that persons who had been able to discuss seriously in the afternoon with himself and a member of the former cabinet, Mr. Thurston, the question of the sugar tariff, and its relation to the Force bill and the position of Mr. Blaine and of the Pennsylvania senators, should not be people to waste their minds on the dress of Hawaiian girls and the fashion of wearing flowers about the neck.

But the ride was full of enjoyment and novelty. Honolulu streets are amusing. The blocks of houses are tropical, with most reasonable lowness, and are of cement in facings; and the great number of Chinese shops and of Chinese, with some pretty Chinese girl faces and children's faces, enliven the streets. And there are so many horses, small, with much mustang blood and good action and good heads, and ridden freely — too freely, for we saw a labourer ridden down by some cowboyish fellow. Hawaiian women rode about in their divided skirts; they had, as well as many of the men, flowers around their waists and their necks, and among their delights, peacock-feather bands around their hats. Many of them were pretty, I thought, with animated faces, talking to mild and fierce men of similar adornments. And as I said, there was much Chinese, and dresses of much colour — for men and women — and trees with flowers, like the Bougainvillia purplish rose coloured; grey palm trunks, and many plants of big leaves like the banana; yellow limes, and fiercely green acacias.

At any rate it was fun; we stopped and bought mangoes and oranges from natives who smiled or grinned at us. The air grew delicious with the wind that took away the oppression of the dampness, (we have about 80 to 83 degrees), so that if this be tropical, it is easy to bear, and the vast feeling of air and space gives a charm even to the heat.

I walked about this morning toward the hills, of which the near ones are covered with grass of a velvet grey in the light, and dun colour in the shade; but behind, the higher hills are purple and lost in the base of the cloud that has never ceased to turret them. After a while the sense of blue air became intense.

Tuesday.

We sat up again and waited for the moon to rise, and watched her light drown the brilliancy of the stars and of the milky way. Jupiter shone like diamonds, and Venus was like a glittering moon herself; and beneath her in the ocean a wide tremulousness of light broke the great belt of water with a shine that anywhere else might have done for the reflection of the moon. The great palms threw up their arms into a coloured sky not quite violet nor quite green; the gale blew again from the mountains with the same intensity; the great cloud hung again up to the same point in the heaven until the moon began to beat its edges down, and break them and send them in blots of white and dark into the western sky. Then, at length, she came out again to sink behind the advancing cloud, which again broke, over and over again, and through the trees behind us and over the hills hung in a mass of violet grey. The wind blew more and more violently, but never any colder;

always as if at the beginning of a storm, not as if any more than a long gust. And when the moon was free in the upper sky, and the cloud rested in its accustomed place, above the hills, we walked out into the open spaces to see the clouds lie in white masses of snow piled up, and above them to the north, the sky of an indefinite purple, terrible in its depth of uncertainty of colour, with no break, no cloud whatever.

Wednesday night we had rain, though only above us. Occasionally the clouds gained over in the southwest before us, but not entirely, and for a time the horizon of the sea was dusty and a little uncertain, but never at any moment did we fail to see the stars before us and the clear light of the sky. But we had to say good-bye to the moon. She will rise now so late that for us who are getting tired with a little more movement, there is impatience at having to watch; and, besides, the mosquitoes pour about us in swarms, unless we remain outdoors in the continual gusty surge of wind that makes us more and more sleepy.

Now the sky in the night becomes more purple and more violet as we look toward the south, instead of holding delicate blue-green, that promised the moon; and around Venus, until her setting, there is an area of light in this violet; and below her the sea is bright as if with a moon, and all the stars toward the south are brilliant and fiery.

Friday.

Yesterday we drove up the valley. We ourselves are on a bank or projection into it, though the rocks rise to our left as we look northeast, which is the trend of the valley. Honolulu is below us, spread by the sea, and the valley goes up from it as do others; to the north and east there is a wide fringe or space by the sea, which is as a big slope, and into it these valleys open, so that, as we look back on our drive, that narrows more, we see the scene opening more and more and further and further below us, Honolulu and its plain or lower slope shining in light, with the sea beyond it, the surf breaking away out from its shore, and the sea spreading over the sand in a faint wash of greener colour; further out a purple line of reef below the water, and then the waveless blue of distance. All is light; even the converging hills — hills coming together in the perspective, like stage wings, but opening out in reality — even the hills seem transparent with light. The valley side rises generally, but our view is occasionally interrupted by divisions of higher land, slopes from the mountainsides that run across. And so we go for five miles. The hills and mountains, for they are high, are steep and pointed and covered with green. Here and there black marks indicate the volcanic rock; a cascade comes down the apparently perpendicular side of the rock, like a snake twisting; making a movement

like a throbbing, for there is no leap, it merely glides down
the wall. Then suddenly the road rises still more, and we
come to a bank before us where the road turns; and over the
bank we see distance, and green hills like a plain under us,
and red roads through the multitudinous green, and far
away a promontory out to sea, silver and grey, for the vege-
tation has suddenly stopped there, and there is nothing but
the nameless aridity of mountains standing out to sea, in a
fairyland of blue and white surf, and sand between white and
yellow, and a warm emerald of shallow waves near the shore.
We are on the famous Pali, thirteen hundred feet above the
hills below us. Pack mules grope down the path, and a car-
riage held back by two riders on horseback goes down the
precipitous winding road. There is shouting and clicking of
stirrups and spurs and bridles, the plunges of the horses and
sudden throwing back of the men, all in a gale of heavy wind,
make me feel in this smallness even in animals the size and
space before me. As we go down the road a little, we see,
looking up, the great cliffs of the Pali to which we have driven.
It makes a great cliff of walls opposite to the sea, (over which
we have broken), and to the west it stretches in shadow, and in
the west we see the marking lost in shade of unnamable tones,
as the green precipice casts its shade across the foothills and
slopes for a vast space, (it is two thousand feet high), looking

as if it had been some great sea-cliff once, and the sea had once formed the spaces now green, and undulating with hill and valley. But the great Pali has probably been one side of the stupendous wall of a great crater, now partly under the sea, and the grey mountain far off to sea has been the central cone of this ancient circle.

September 6th.

We had to-day a very Hawaiian afternoon; we tasted of the delights — perhaps it would be better to say the comforts — of *poi;* eaten with relishes, squid and salt fish, and fish baked in *ti* leaves, and also of some introduced things, such as the guava, which is spooned out from its rind. But all this is known to you. And this was two-fingered *poi.* When fully stiff it is one-fingered, the three-fingered being effeminate, and coming to-day more in use with general degeneracy. And we see later old *poi*-dishes with an edge running in, upon which to wipe the finger or fingers. And as the talk went on, turning always more or less to ancient habits and traditions, we heard much more than I can remember. As a shuttle through the web of the conversation ran the personality of the King; interesting, in many ways, because of his race, and of its exact relation to the *pure* race, and of his caring for the old traditions and probably superstitions. He collects, or has collected;

but is little addicted to the civilized habits of curators of museums, and is fond of arranging his remains and fragments, placing them and setting them occasionally in gold, and remaking old idols which are fragmentary, not without surmises of his taking more than an outside scientific or artistic interest in them. And no wonder! there must remain every reason of inheritance in mind. The christianizing of the native mind can be represented by the supposition of an acceptance of a Jehovah who ruled in great matters, and over the soul, but whose attention was not directed to little things; so that there might be essences that controlled ordinary life, good to invoke in time of danger, and for usual help, at any rate of good omen, or to be propitiated for fear of harm. And so often the native in great distress, as when death threatens, resorts to old forms, as invalids all over the world look to remedies out of the regular way — the good woman's doctorings and the help of the quack, who may not perhaps be *all* out in some matters. And so it is possible to hear that this personage has rebuilt a *heiau* or temple — a fishing temple of propitiation near his summer residence, upon the old lines of the former one; — and to listen to the singular anecdote, which gives him as consulting an old crone when age is on her in the full of a hundred, and who remembered the erection of the old temple now destroyed. When consulted by us she was still able to work, though so

very old, and was found seated under some hut or shelter, scraping twigs for mats, with a sharp-edged shell, as she had done when a child of ten. Much could not be obtained from her, as she had no consecutive thread of talk, but she was able to show where the cornerstone of the old temple lay, and beneath it the bones of the human being sacrificed as a propitiatory and necessary part of the foundation — a habit and tradition common to all races, as we know. The King could not, of course, sacrifice a human being to-day, so that a pig was the propitiation, and the new *heiau* is built. The first offering from fishing is thrown there and success established.

Another pig comes in a more curious and fantastic way, and forms part of a possible picture, conjured up in the story. For some old priest or *kahuna* assured the King, anxious to discover the remains of the great Kamehameha, that they could be traced by divination. The pig, filled with the spirit (*ahu*), was let loose, and an old priest and less old but heavy chieftain careered after him, until the animal passed, and began to circle about in convulsions. Then they dug and lo! a skull, which the King now keeps as the remains of the great head of the sovereignty, from whom his predecessors were descended, as was, for example, the wife of our Mr. Bishop the banker — for the present King is not of that lofty strain.

This difficulty of finding what was left of the great tyrant and hero was owing to the Hawaiian (and Polynesian), habit of hiding the remains of the great; sometimes even they were eaten; the people were not cannibals — they did not kill to eat, but it was necessary to protect the remains from insult. No one would wish to have his chief's bones serve for fish-hooks, nor to make arrowheads to shoot mice with, nor I suppose even to make ornamental circles in the sticks of the *kahili*, the beautiful plumed stick of honour, originally a fly-brush, I suppose (like the old Egyptian fan), which was the attribute of power, and which is still carried about royalty, or stands at their coffin or place of burial. Consequently every precaution was taken to hide the bones, which were tied together and put in some inaccessible secret place.

Another *kahuna* or priest told the King how to have access to the terrible hiding-place where were deposited the remains of some chief that Kalakaua wished to have, to give them finally some resting-place of honour. The only way to get at this cavern was by *diving* and when he did so he came up into a cavern, where he found them, and also large statues of idols and other remains. But the place was haunted, and not for the whole of the Islands would the King again undertake such a journey. Nor should I, even if I swam well enough. Can you imagine making a hit-or-miss entrance through the surf

into some narrow hole, from which one would emerge into hollow and drier darkness; and then to have to make light and grope about for things in themselves of a spooky and doubtful influence — and things that should *resent* the *hand of the intruder!*

For it is even hinted that many of the present tombs in the royal mausoleum are empty or not authentically filled; for instance, King Lunalilo is certainly not there. In old days some devoted friend of the chief's would have hunted about and found some man looking like him, and then would have incontinently massacred the more vulgar Dromio, would have left his body in the place of the chief's, and hidden the honoured remains from all but most sacred knowledge, that around the priest, the depository of holy mysteries, all power might cling. Power of priests: power to designate who should die — killing the chief's friend or supporters if it were advisable to weaken him.

With their privilege of designating victims the power of the priests must have reached into the province of politics, for a king's or chief's men, precious to him but dangerous to enemies, might be chosen at any moment so as to weaken him. The *men* of the *priest* could be saved from such a terror. The man to die might be put an end to as he entered the temple by a blow from behind with a club or stone, or his back might be

broken, in a dexterous way known of old, or his neck might be twisted so as to break the spine. The death at least was made as painless as possible.

The real *kahunas* are extinct, but have many pretended successors. The King himself claims to be *kahuna* more or less. He claims to have a cure for leprosy. I hear too that a leper is kept at the palace, and another at the *boat house*, for experiments, but of course of that I know nothing — *no more than of anything else*. The boat house is the place where the King gives *luuaus*, Hawaiian dinner parties, and when the *hula* is danced there are well-known dancers who come or are retained or sent for. They are in the photographs much dressed and rather ugly, and some have very thick legs, monstrous to the European eye, but I suppose that talent is not always found in the pretty shapes. Some good people (from Minnesota), lately expressed a wish to see these dances, and the King, who is apparently a very courteous person, kindly consented to help them, and invited them then and there to dinner. They came to an excellent dinner, and saw the *hula* danced. They were informed by the King that the custom was to give some gratuity to the artist; so that money was thrown into a dish, the King giving two dollars, and the others the same. When the collection at the end was taken up after each dance (my informants giving some seven dollars apiece)

and presented as by etiquette to his majesty, he retained the mass, giving one dollar and a half to each dancer as their proper proportion. This reminds me of Oriental tradition, and is probably quite consistent with a certain liberality, the Hawaiian instinct, especially with the chiefs, being toward generous giving; so much so that many have become impoverished from this and other forms of improvidence, in the days of the change to civilization, when they owned a good deal that gradually passed into the hands of those who held the mortgages.

Mrs. Dominis, the heir apparent (now the Queen), keeps also some tenderness for superstitions and beliefs of the past, and I am told (but not by so sure a person), that she sacrificed some time ago to Pele, the goddess of the volcano, some pigs and hens, which were thrown into the fire of lava. At present the account is vague and mixed to me, but I think of it as connected with some illness of one of the late princesses, for whom also came a portent of certain fish appearing in quantity, a presage of death to great chiefs. Naturally one listens to any gossip referring to the reversion of the race to any former habits, and this I give you only for this reason.

One little touch, however, with the common people, is pretty, just what happens anywhere, and that is the fondness for lying low, if I may so put it; the using of the underneath of their houses (which is one way), the cellar, or rather open space

under houses, becoming, low as it is, the residence, and the house itself being kept with its furniture and carpets, only as a sort of show; matting being laid down on the earth below, and the whole affair made comfortable in savage fashion. Here all live together. Somebody was telling us how, in a trip somewhere, they had found a family who were living under their house, and who gave them their own unused room with a big four-post bedstead. And in the morning a strange rustle aroused them. It was the native couple struggling to escape unnoticed from *beneath* the bed, under which they had passed the night.

And also there is a peculiar use of objects which we hide, and which are placed usually at the doorstep. I have seen them carried with great care through the streets, and at my first purchases in a Chinese shop I noticed the discussion of some natives upon the adornment of these utensils which they had come to buy.

The old-fashioned house has passed away; hardly any one has now the knowledge of how to build it. It was well suited to its use and made with great care. It had a thatched roof which was made of bundles tied with hibiscus bark and carefully disposed, and this whole house had to be built according to rite, or it could not be lived in. The main archway, or one made by say the pillars and lintel and crossbeam, had to be

of one wood, and so forth. The floor was made of stones, laid together in different layers, growing smaller and smaller, upon which mats were placed, one over the other; which also could be made very fine, and which are excellent to sleep on, being very cool.

I was much struck by the shape of some skulls of natives showing a peculiar *tent* or *roof shape* of head, and extreme squareness of jaw. The heads are fine, very often, and the type massive. Man and woman tend to fat apparently, if one may judge of the average types one sees, but then they are seen in the street or in houses and perhaps well fed. Some of the young women or girls have great delicacy of expression, and the line of the jaw and chin separating from the throat is graceful and refined. There is a pretty tendency, owing to thickness of lip, apparently, to a shortness of the curve above, that gives a little disdainful look quite imposing in some of the older and uglier women, when they are not too fat. The men look like gentle bandits. But there is a certain *sullen* look in a great many that is unsatisfactory, and has grown, I suppose. They probably need firm hands to govern them; and are certainly *not* satisfied now; whether stirred on by agitators or by any real grievance, I of course can't know. In old times they sent away to faraway islands for chiefs and rulers. From Samoa and Tahiti rulers came, some whose names are known, for

over this vast space the war canoes went, two thousand miles and more, and the places of their departure and arrival bore names indicating their distant relationship. But some places or islands are missing to-day, which apparently once rose above the surface, and now are shoals perhaps. One of their rulers, a sort of demigod, who sailed away one day promising to return in coming years, they took Cook to be when he appeared, and they called him Lono. And years before him some Spaniards were left behind, in the hit-or-miss sailing of early days, and have left certain signs, it is said, in languages and other things.

For their great voyages the Hawaiians had a knowledge of the winds and of many stars, six hundred of which bore names.

Wednesday night, September 11th.

To-night it blows again from over the Pali and mountains, the first time since Sunday. We have had a south wind, which has slowly come round with rain, back to its old station. We have painted at the Pali, during the south wind, for it did not then blow against us, and I was able to sketch without the extreme difficulty that I had feared. We drove up Monday afternoon in the great heat, clouds hanging over the valley rather low, so that I feared that we should be covered.

Their shadows hung along the walls of the hills, and made dark circles around the great spots of sunlight. All varieties of green were around us, in the foliage and the plants, and the green of the slopes and mountains. We came up, as before, to the edge of the Pali, suddenly, all before us a blaze of green, and looked over. No more astounding spread of colour could be thought of. The blue was intense enough when we saw it against the green bank before us, imprisoned between that and the warm low cloud, but it was still more astounding, opening to the furthest horizon, gradually through every shade to a faint green edge, blotted in with white clouds, bluish, with bluish shadows, and far away a long, interminable line of cloud in a violet band (because in shadow, broken above and below with silvery projections). The sea bluer yet than the sky, spotted with green in the shoals, and with white in the surf, the headland of Mokapu stretched out in brilliant grey unnamable; the sand also of no possible colour; the last range of hills tawny grey, like a panther-skin, warmed here and there with yellow and with green; a brilliant oasis of green in centre, like the green of a peacock. Then near us the intense feathery green of great hills and the billowy valley, all of one tone, one unbroken green, as if covered with a drapery, and the same green reflecting the blue above. Now and then red lines of road, red as vermilion, not only because of red earth,

but because the green vegetation is so deep by contrast; and all this in partial shadow, except the great distance and the silvery promontory. And later, far off, half the ocean in absolute calm, repeating the high clouds of the distance, and their shadows and lights. It was violent as a whole, but delicate and refined almost to coldness.

Here I had the misfortune to find that the usual trick of bad work and poor paper in my blocks would prevent my making any adequate record. (I say adequate — what I mean is plausible.) But we both sat and worked until sunset and after hours, each not daring to look at anything but in one direction, there was so much to prevent one's *doing* anything. And at the last moment I went down part of the road toward the base, to see the entire distance lost as in a dream, great long streamers of mist apparently blowing away from the face of the Pali. And we returned in the afterglow, which now that the moon has left us, keeps the whole sky and landscape in tones like those of some old picture clear and apparently distinct, but intensely coloured, however colourless it may seem, for we have no names for tones — so coloured that the lamplight, inside the room where I am, seems no warmer than the twilight without, as if they were painted together, as in one picture the sky is merely a beautiful background.

Then comes, alas! the great hum of the mosquito, if we are

in the wind, and we have to resort to burning powders if we do not sit in the draught that blows them away.

Day after to-morrow we shall go to Hawaii in the steamer *Hall*, land on the south coast, go to the volcano Kilauea and down from there to Hilo. This afternoon we have heard talk of the situation politically, of the wrongdoing of demagogues; and also we have seen one of the extraordinary yellow and red capes that the chiefs wore, made of small rare feathers, and each little tuft sewed on to plaited fibres and also a *lei* or neck-wreath of the same bird feathers, with the addition of some soft green ones, in divisions all very rare and valuable; and a beautiful wooden polished spittoon with handle of some exquisite wood light and dark, which has served to preserve the exuviæ of some chief from the great danger of capture for incantation or working harm through sorcery.

HAWAII

Off Island of Hawaii, 13th September, 8 A. M

We are lying off a little place, Keauhou, while people are landing in boats from the small steamer that carries us. The shore is broken with black lava rock, in beds that do not seem high, so flat are they on top. It is about eight o'clock, and the impression is of full sunlight on the green of everything. Behind the fringe of shore rises the big slope of the mountain seen in profile, so gigantic that one only sees a slice of it at a time; there are, of course, ravines up the hills, and trees and grass, but from my focus of the square, between the pillars of the roof of the upper deck, and seated by the guards I see rather shade broken with sunlight. The sea, of course, at the shore is glittering blue, but everything else that can cast a shade throws its edges upon the next; so that I see a black seaside broken up by lava rocks, and near them cocoa and palm, and some small wharves, or jetties, built out to protect the smaller beaches, that run back between the rocks. Each break of projection or recess has its trees, that make the fringe of shade with patches of sun, which the eye takes in along the water.

There are a few houses strung along, half in light, half in shadow; three of them are tall grass huts, hay-coloured in the half-shade of the cocoanuts beside them. Above them are patches of sun on the green slope where the upper bank or slope behind first flattens into the strong light. In the shadow, faint whites and pinks and blacks on the dresses of people waiting for their friends, or watching the steamer. Their horses and mules and donkeys stand in rows along the houses —or walls—occasionally they pass into the sunshine. One girl in red runs (why, heaven only knows—time seems of no possible use), and as she rises over a rock in the sand, the sun catches her brown feet and legs and the folds of her floating gown.

These people, I am told, have many of them ridden some miles from our last landing, at dawn, to meet us again. But there are special deliveries of people and freight at each place — so many and so much on board that one can hardly realize where they are stowed. Three full boatloads at the last place, and one here, of people jammed — dark Spanish faces, peacock feathers, and red veils on hats; coloured neckerchiefs, and head and shoulders covered with flowers or leaves that hang to the waist. There is loud objurgation and chattering, and keeping the children together, and holding up odds and ends of things not sent ashore by the other boats that carry goods and household furniture.

BEGINNING OF DESERT, ISLAND OF HAWAII

Last night we were pretty full. Children and women lay in files on our deck by the guards, the children ill with the rolling, for we pass several channels between islands, each one a pretext for the wind to give us a dance. And in the steerage people lay like herrings. It was picturesque; a few Chinese, the rest Hawaiian, with much colour and abundance of flowers and leaves that they like, and all eating on the spot, apparently without moving — guitars playing — we had two guitars aboard, and part of the night and morning somebody strummed; sometimes a man appearing from a cabin, posing guitarero-way, touching a few chords and going away again. Once, some fellow playing, squatted on the deck, apparently for the baby, and the other babies, who inspected the guitar inquiringly and approvingly — sometimes some of the women. In the late afternoon, as the sun struck this mass of colour against a blue sea of unnamable blue, at least two dozen of the people all in colours were eating watermelon all red down to the rind. The appearance of a palette well littered was only a symbol to it. And there was one beauty with long nose and the rounded end suggesting the aquiline, the black eyebrows *under* the frontal bone, the pouting lip, and heavy chin and long slope of jaw, and what they all have, even the ugly (like the Jap girls), a pretty setting of ears and neck and black-hair's growth. But the children were prettier. We had a

neighbour who had many and who looked so plaintive, and another, though sick, was jolly and smiling. And another was like a chieftain (or "chiefess") with three great furrows down her forehead above her nose. But they all smiled with great sweetness, and I wish our women could do as much. All sullenness or sternness or disdain disappeared from the face. They talked in English, partly for convenience, but a little, I thought, for the gallery, the children mixing their languages, and their mothers gliding back occasionally to it. But the talk was just what it is everywhere — schools, and how dear, and what ideas are put into the children's heads and whether there is a distinction between those who pay more or less, or have

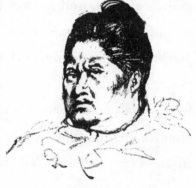

"The Chiefess"

scholarships and something about prices in general. One is reading "Sabina Zembra" and we talk a little while the ship rolls, rendered sympathetic by suffering, and I am sure that two of my good ladies do not consider themselves *kanaka*, at least if I am to judge by their reference to *kanaka* and such like; but they are brown like berries, one light, the other sallow.

Later in the afternoon I go forward in the dance of our pas-

sage to the next island of Maui; the island lies before us across the sea, so sky-like that it is difficult to realize that the vast slopes are of earth; that the greenish hue, now and then, under the violet of the bank of heavy clouds, all brilliant and shining like satin, is not thicker air — just such tones make the island as with us make winter skies. Far off to the southeast stretches under clouds another line, that of the further Maui which ends above in Haleakala, the extinct volcano. As we draw near, the sun is setting, the jib and mainsail curving before us in shadow and light, as we drop a little to the south, repeat near to us the colours of the island and of the clouds. These hang far forward toward us, while the slope of green and peachy grey runs up behind it; and we glide soon into more quiet waters, and stop off the town of Lahaina. Then long hours are spent in unloading and loading, so that when we sail again, we only faintly see the mass of Haleakala. But in the morning, with the dawn which has no colour, but in which, to the east, stand up, in some sort of richer violet shade, the outlines of Hawaii, we see further the great slopes of Mauna Loa, so gentle that it is difficult to tell where the flat top is reached, and where the slopes begin again on the other side; and then we stop in the early sunlight. A fisherman comes up with fish; other boats (outriggers all) with fruit, and we see what I was telling you when I began to write. And later we have come to a great

bank of black rock running out to sea, and precipices of black spotted with a green all of one colour, which is where Cook was killed, and where they have put up a little monument to him. This is Kaawaloa. We try the land, for the roll of the ship is disagreeable, as it waits, and we run in over the transparent water. It is too deep just by the landing for anchorage. The sea jumps from light aquamarine to the colour of a peacock's breast in the shadow. We go up the black lava that looks as if it had been run out on the road, not under it, and sit in the shade a moment, and exchange a few words with our fellow passengers now on land — a little flock of tired children and mother, and our "chiefess." And it is hot — the heights have shut off the wind, and all is baking. Horses and donkeys, saddled, stand about near the shadow of fences, left to themselves, while the cargo is landed. Higher up on the heights some planters tell us it is cool. They wear enormous hats, and have a planter-like appearance that suggests our being different.

As I look around on this green and black, and the few cocoa-nuts, and the dark blue-green olive water, I think that it is not an unlikely place for a man to have been killed in. The place has for Hawaiians another interest: it was once a great place, and the high cliffs have many holes where chiefs are buried, inaccessible and hidden. And a little way beyond was

a city of refuge—that is to say, a sacred city—where none who took refuge could be injured. Even though the enemy came rushing up to the last outlying landmark, the moment that it had been passed, the pursued was safe, and after having sojourned according to due rite, could depart in peace and safety.

After this, and the same story of like places below the edge of the green table that slopes up to the sky and further on to the clouds, we stop, and the white boat takes our last passengers in the blue water; its white keel looking as if washed with blue. The people wait on the shore under less and less shadow, and on the other side we have now the enormous ocean opposed to this big slope, not as last evening, when always we had an island, now before, now behind, now to our side, as if we were in some inland sea. That is to say that now the sea occupies more than half of the whole circle that we can sweep, though we are only a few rods from shore. Do you realize the difference?

At last we are on the outlying edge of the group, and will soon this afternoon round the island, and stop at the place where we take the road to the volcano of Kilauea.

Sunday night.

At the volcano of Kilauea.

As I wrote I had no notion of the importance and eventful-

ness of a landing at night. As we came around the hard black
cape marked with lava flow it was already dark, so we could not
distinctly see the shore, though above were great slopes and
some buttresses and heavy hills standing out from the mass.
We could see lights at the place called Punaluu, where we
were to land. The steamer shrieked and stopped as we pre-
pared to leave it and come down the companion ladder to the
heavy boat dancing below it. Women were first dropped in,
and one by one gradually we men jumped into the hollow, half
packed with trunks and boxes and men balancing themselves
in the rolling. Perhaps had I been more accustomed to these
forms of landing I might have seen less of a picture; but when
I had got down, and watched the next passengers from below,
and danced high up to them, and heard them told "Now!" or
"Not yet!" as we came too high or too low or struck the bot-
tom of the ladder, (so as to make one wonder whether we should
not capsize in a rougher sea), when I could look at their fore-
shortening, and saw the heavy lower forms of the *kanaka*
ladies, under their flowing drapery, and then saw them tuck
their one long outer garment between those legs in a great
bunch, to be untied at the next step and heard their discus-
sions, I enjoyed the play, even if I was part of it.

The talk was in *kanaka*, but its meaning was plain: the two
ladies objected to jumping just then or before or after, and it

was now too high, now too low, and in general they expressed all possible doubts regarding the process. One of them especially, whom I had seen much of during the day, a massive archaic person, with the manners and features that might have belonged to an Eve of some other, more cannibalistic tradition than ours, poured all this out with a voice heavier than the roar of the water or the grinding of the boat's gunwale against the companionway and her declamation was answered by a chorus from the boatmen, with the accompaniment of shifting lights, so that my simile of a play was but natural.

At length we were all stowed in and departed, one sailor still standing as he had from the beginning, balanced with a child in his arms. At the little wharf the scene was repeated on a small scale, while above us the one lantern lit the legs of an expectant multitude; and at length we were singled out by the host who was to take care of us, and who had the one single hotel or house, to which we were sent up with a lantern.

Then we rested. Adams had suffered very much from the tossing, so much so as to make me anxious, and I too was much the worse for the wear of the last two hours of resting in harbour while waiting for boats to go out and return. We had some food and rooms given us by the Chinaman factotum, major-domo, cook, servant, etc.; and later our host appeared

in his shirt-sleeves, and asked our intentions and whether we were to go right off in the morning to the volcano. Having ascertained these facts, he selected one of the party — we were four, we three and some one else — and to this some one he poured out some information, mainly about the bad sides of the other way to the volcano — the Hilo way; its raininess, and in general all the wrongfulness of Hilo people. With that he also poured forth his bottom thoughts about the whole business that he had charge of, the idiotic way in which people travelled to see the volcano without sufficient practice on other volcanoes beforehand, so that invalids (he called them invalids) found it difficult to ride on horseback, and some were sometimes thrown from mules, and in general he showed the folly of trusting to the advertisements of his own enterprise. For he is, I understand, a great man, who has this road and runs it. All this I absorbed before going to bed, so as to prepare for the next day, which began early with the Chinaman, and making for the train.

The train is a little engine with two platforms on wheels, that runs to a plantation some few miles off. One platform had a roof for the gentry; the other was loaded with the common people, consisting of some Swedish women and children, some Hawaiians, and one or two young people who belonged to our side, but preferred riding thus, thereby escaping the

smoke that we got. We had a watchman and a Chinaman on the engine. At the start we were requested to trim our weights. The Hawaiian lady who had been a tragedy the evening before, was on our side, and whatever side she had taken, that would have been the heavy one. But still we risked it, and ran along the little road which occasionally passed over trestling and did have something of a reason for trimming.

The ride was lovely except for the smoke. We had left the shore at which we had landed the night before, for the car ran to the little jetty, where the sand was as black as ink — volcano dust, with a fringe of white like teeth. Then we slowly gained some heights, and saw behind us the great blue sea and white headlands; black lava looking grey in the sunshine, and to our left the great hills and slopes. And we ran by the sugar-cane and through a country with few or no trees, a great surface of up and down of moors, until we came to the plantation, where we stopped. Everybody had reached home except ourselves, and our accidental companion. We found a covered wagon with two mules and two horses, into which we were packed with difficulty, as our luggage was bulkier than is customary, owing to my not having been able to persuade our host to allow me to reship some that we did not want. He could not "fuss with such matters." In fact he

was right. The whole affair is merely for the convenience of travellers; on the part of the people who undertake it, there is no need of it and one feels indebted to them for the courtesy they show in allowing one to pass through their place, even though they charge for the same.

So we rolled slowly over the great downs, upon some sort of a trail, occasionally perturbed by some stones, or perhaps banked up with no incident. The great mountain was being covered with clouds, but the sea spread far below us, the capes at the corner, and the east of the shore glistening as if silvered, and white upon their local blackness. It was as Newport beaches might look upon a gigantic scale. Here and there a few trees (the *ohia*), stood up, orange-brown butterflies, Parnassians, flew continually across our path, spotting the entire landscape all busy with their loves. A few birds, plovers, I believe, rose at a distance, or flew across, or with a cry, peewits waved to and fro on the slopes below us.

By and by, at noon, we came to more trees; the landscape became more shut in, the sea disappeared behind the slopes we were leaving, and we took lunch at a convenient shanty where we were well treated, and tasted the native *ohia* berries. Then we entered a rockier soil, much broken up, with much black dust, and with many trees, all small and as if lost, something like little back country lanes — anywhere.

And this went on and on, and we walked sometimes, in despair of our mules and horses, driven by a driver who urged them with word and whip, and occasionally with stones, without being able to get them much out of a walk, broken by an occasional trot. Then things were colder, and on a landscape of no shape, with blocks of lava thrown over the soil as if by the spade of journeyman or maker of worlds; with ever so many queerly conventional trees, — the *ohia* before mentioned, which has yellow trumpet flowers — and many others; and at last many ferns, and more ferns, and the tree ferns. We saw on our right some cloudy forms of smoke rising toward the clouds of only a little warmer tint than they, and that was the smoke and steam of Kilauea — which was really below us, hidden under the edge of the desolate plateau we were driving on.

Then we came to more vegetation and many ferns, and we suddenly saw the glance of a sulphur bank, yellow, green, and white, like the surface of certain beans; and we drove up toward the house that stands by the volcano. It was not yet dark, but dark enough to see confusedly the crater just below us, only a few yards away, a mass of black, and high walls around it, and three cones apparently in the distance, with steam about them, and steam issuing near them in many places, so that the further wall was dim. And steam near us

came out of crevices at our feet, and on our road, and a little everywhere, where ferns grew richer — and we had arrived.

We went in to make our host's acquaintance, and got our simple rooms in a sort of rough farmhouse, with doors opening on the verandah, and in front of the crater of the volcano. And we sat later at dinner, and after dinner by the fire (for a fire was pleasant in the damp, cold air), and heard him talk, and spoke to him about Mr. Dana's book, and the changes in the crater, and all the volcano talk that can come out of the absorption of much reading and much hearing. Maby (our host) talks of danger to his children from the steam fissures just mentioned.

Kilauea — The Volcano.

Maby, the keeper of the hotel, is not the old gentleman of Dana's book, but a person whom I should describe if I had the time. He is a New Yorker, and has been away since the early war, and has sailed about much in this part of the world. The type is a well known one to us, and amusing enough. He is married to a Hawaiian woman, also shrewd-looking, good-looking, reminding one of many people with us, with a high forehead and thick lips; and has many children who play about, and make the place seem less showlike.

As we gather around the fireplace, Maby tells us stories of

himself, and sailor yarns that interest us as regarding places we are looking to. One about Nukahiva has a flavour of Melville about it. It shows Maby landed there, and being told that he must (unless he wishes to behave suspiciously), report to the governor. This official receives the visit graciously, but requires a poll-tax of two dollars, not asking directly, but by the proper channel. Maby states that two dollars he has not, but offers to work it out; whereat he is taken at his word, and helps toward the completion, carpentering and painting, of the governor's house; and after some long stay, at fair wages, offers to deduct his two dollars. But no, says the governor, he is now in government employ, and not liable to taxation.

In connection with this story, in my sleepy memory, is one of some expedition, with the governor and his army of *one* gendarme ("jenny dee arms," Maby calls it), into the interior, or, rather, along the shore, for the purpose of levying the tax. Money there is none at the first place they come to, so that the gendarme is ordered to take a pig or so in payment. But the country has been aroused. Men come flocking down with old flint-guns, a retreat along the beach to the boat is ordered, and the pigs are abandoned on the way. All this was capital, as was Maby's delight at the absurdity of some savage who knew not of gold, and to whom an Englishman gave a piece of gold instead of silver. As he complained, Maby relieved

him of his anxiety by taking it and giving him the desired shilling.

With many stories we sat up and went late to bed, looking out on a darkish night, wherein two slight illuminations at a distance meant the light of the volcano. But nothing looked propitious. Dana Lake was quiet; there was only a little fire on the edges of the lake. Maby spoke as if something must happen elsewhere from the quiet of the volcano here.

In the morning Adams woke me out of sound sleep; the air was cold, damp, and the room decidedly so during the night. As I came out the sun was rising. Before us was the volcano, still in shadow, but the walls of the crater lit up pink in the sun, and farther out the long line of Mauna Loa appearing to come right down to these cliffs, all clear and lit up except for the shadow of one enormous cloud that stretched half across the sky. The floor of the crater, of black lava, was almost all in shadow, so that as it stretched to its sunlit walls it seemed as if all below was shadow. In the centre of the space smoked the cones that rise from the bed of the crater. Through this vapour we saw the further walls, and on the other side of the flow, as it sloped away from us, more steam marked the lava openings at Dana Lake, invisible to us.

We sketched that day and lounged in the afternoon, the rain coming down and shutting out things; but in the noon I

CENTRAL CONE OF VOLCANO OF KILAUEA, HAWAII

was able to make a sketch in the faint sunlight; and that was
of no value, but as I looked and tried to match tints, I realized
more and more the unearthly look that the black masses take
under the light. A slight radiance from these surfaces of
molten black glass gives a curious sheen, that far off in tones
of mirage does anything that light reflected can do, and fills
the eye with imaginary suggestions. Hence the delightful
silver; hence the rosy coldness, that had made fairylands for
us of the desert aridity. But nearer, the glitter is like that
of the moon on a hard cold night, and the volcano crater I
shall always think of as a piece of dead world, and far away in
the prismatic tones of the mountain sides, I shall see a revela-
tion of the landscapes of the moon.

Late in the afternoon the young Australian, or whatever he
was, who had been with us, went down with a guide into the
crater, and returned toward ten o'clock with a story that
Dana Lake had broken. He had seen the grey surfaces move
and tumble over like ice pack into the fire, and we were pro-
portionately curious to see and unwilling to go. For I must
own that it has been rather out of duty than otherwise that
we have been here. Neither of us cares for climbing, and
certainly the pleasure of seeing fire near by must be very
exciting to amount to pleasure. Yet we went next day and
toiled down to the surface of the crater, which is accessible

from our side by a zigzag path. By and by one gets to the
surface of the crater, which rises to the centre and (when one
is on it) shows nothing but a desolate labyrinth of rocks. We
walk over this tiresome surface that destroys the sole of the
boot, following more or less in single file, because of crevasses
that are deep, and at the end of a walk of some three miles,
we approach the cones that rise high above us, perhaps seventy
feet. Maby says that they are higher than they were, for
this whole surface of lava is movable, and parts of it like the
cones float over a molten surface underneath. Think of it as
glass and you will just get the simile that it makes mentally. To
the eyes it is rock; around the cones there are loose disorderly
rocks piled up like loose stones in a fence — absolutely like
it, which loose formation is called *a-a* in Hawaiian, as the
flowing, smooth lava, on which we have mainly walked, is called
pa-hoe-hoe. Some of it is in crusts that are hollow to the
tread, and that give way suddenly, to one's annoyance, for it
is hard to realize that it is still solid underneath. Especially
as here our guide points out a small cone about a mile off,
sticking out of a confusion or heap of broken rocks, or above
the broken rocks that are before us and below us, for we are
now walking on a colossal loose stone fence — far off, I say,
in this confusion is a single cone, with a red glow in it. And
now we cross a little more fence; the smooth and crusty sur-

face is hot to the feet; we look down and see grey and red
lines in the cracks below us that are fire; and then a few feet
off, we look into and between some rocks, and see the lava
flowing along, exactly like glass when it is cooling and growing
red from former whiteness, a slow, viscous, sticky dropping
into some hole below. Then we go back quickly and paddle
along toward the other slope of the floor, where steam is ris-
ing; and by and by, as the light is waning after our two hours'
walk, we get within a short distance of the wall edge, and see a
space apparently near higher rocks, some seventy feet high, I
am told, which is Dana Lake. There is now only vapour;
sulphurous fumes that float up and obscure the distance, and
go up into the skies. But as the twilight begins, fires come out
and the space is edged with fire that sometimes colours the
clouds of vapour. At one side a small cone stands up, that
burns with an eye of red fire. From time to time this opening
spits out to one side a little vicious blotch of fire. The clouds
of vapour rise so as to blur the distance, but near by the rocks
are clear enough, and either black, or further off where they
are cliffs, are greenish yellow with sulphur. Sizes become un-
certain. I could swear that this lake was a thousand feet
long and the cliffs were five hundred feet; but Awoki and the
guide, walking along, reduce the lake to real proportions.
Then it is only a small lake of some hundred and fifty to two

hundred feet, perhaps. But the impression still remains —
all is so thrown out of reference. The hole is so uncanny; the
sky above, purple with the yellow of the afterglow, and partly
covered by the yellowish tone of the hellish vapour, looks
high up above us. I sit (and sketch) on the absurd rocks, and
then we wait for something to happen. It has become night;
we determine to give up hope of the breaking up of the lake,
and we start. We have lanterns, but gradually these go out,
and we have only one that has to be cherished, and we scram-
ble along. By and by we halt, and looking back see greater
lights, and our guide says that the lake has broken out. Still
we are disinclined to return on the chance, for the vapours ex-
aggerate everything; and after much scrambling we get back
to the edge of the crater, after a seven hours' tramp. As we
go up the ascent the fires seem larger, and our host and the
guides say that there is some breaking out. Still we are in
doubt; we are disappointed and tired. And still I should not
go back unless the most extraordinary conflagration occurred.
Besides the undefined terror and spookiness of the thing, there
is great boredom. There is nothing to take hold of, as it
were — no centre of fire and terror — only inconvenience and
a faint fear of one thing — but what?

But even without fire, the remainder of those dread hollows
is something to affect the mind. Judge Dole was telling us

CRATER OF KILAUEA AND THE LAVA BED. HAWAII

that he could not get out of his memory his having looked down the hollow of the pit of Halemaumau, then just extinct, and having seen an inverted hollow cone all in motion, with rock and débris rolling down to some indefinite centre far below.

I still have (as I write at Hilo) the scent of sulphur in my memory. From time to time, in our ride to Hilo next morning, this smell would come up, perhaps in reality. That was a bad ride, all over a sort of lava bed like a mountain torrent. Then it ended in the beginning of a road of red earth, soft and spongy, and up to the bellies of the horses. There we met, after fifteen miles of it, a carriage and horses that took us to Hilo, over a pretty road through a pretty tropical forest, to this little old place, the abode of quiet and cocoanut trees, where are very pleasant people; among them M. Furneaux, the artist, who shows us sketches, and talks to me of what I sympathize with — the being driven to means unusual to us, when we try to give an impression of the tone of colour here.

Ride from Hilo around the east of Island of Hawaii, September 19th to 22d.

It will be difficult to give you an account of our ride. As to the places, the names are indifferent, I think, and if I occasionally mention them, it is more for my own help than for yours.

Our ride was to be certainly for three days and more, over what is known as a very bad road; up and down through the gulches that edge the shore, breaking the line of our travel, and making little harbours where the surf ran in to meet the little torrents or runs that hurried to them in cascades or waterfalls. It was, for the first day or so, beautiful; not so very grand, except that the simplicity of the scene, consisting of the sea, high rocks, and some little river running down, had always that importance that belongs to the typical. Time and time again we had the high rocky banks of the little bays covered with trees; then in the centre of the shore, a little half island, with tall cocoanuts, and on one or both sides of it, the torrent and cascade rushing down, and the surf running in in a great lacelike spread over the black sand.

Once when I stopped to sketch for an hour or so, I enjoyed the essence of a type of scene that is with difficulty described, though every one knows it, and with difficulty painted, though any one might attempt it. From the hillside hidden in trees came over some very low rocks a cascade of two rills, and at its feet lay a little sheet of water, of perhaps some fifty yards in length and very narrow. On either side high rocks crowned with great ferns and much moss, and behind the few *lauhala* (pandanus) trees upon them, and great banana leaves in some hollow. The rocks were black, spotted with green and white,

and at their feet ran a little rim of sand. This for the land end of the basin. At the open sea end high rocks running far out into headlands, with many trees and bushes, so as to make walls, along which the sea rushed heavily to some little bar, at one end of which, on a small bluff with huts, grew a few cocoanut trees tossing in the wind: one would wish there were

more. And the sea running far up over this sand melted with a cross current into the run of the little stream, so gently that each looked like a separate tide. Here the road crossed the ford, coming on either side from high-up banks. Near the rocks were the marked edges of the road, and up the stream, canoes, with white ends like the cusp of the moon, and white outriggers protected with thatch, lay on the grass.

As I sat on some wet rocks near the sea, to sketch, I could see what happened during the day. Some wayfarer came down the slope, pushed across the stream his horse that put down its head to taste the brackish water; children and older natives crossed barefooted the less deep water; high up, some practised native in best dress, crossed at some well-known ford by adding a few stones. Later, loud cries, and the

noise of a sail coming down. I could see them without looking, for I had to paint hard with my face turned the other way, and hurried by occasional showers. For our sky was all cloudy and wet, though faint drops of sunshine fell also here and there. But the horizon, as I sat so low, was all clear of that unearthly blue of the islands, against which danced the grey sea, and the triple line of grey surf, white perhaps otherwise, but dull against such a clearness of green aquamarine air.

Then the fishermen landed on the rocks and showed their fish, and all rushed that way, all but the girl who had come to sit behind me, and followed my work, perhaps to see what I was trying to make out. But she too succumbed when a half naked man held up a silvery fish of some mackerel shape right before me and her, and she ran off to the house near the cocoa-nut trees. Then the fishermen took off their ragged clothes, and washed them in the stream, within a foot or so of the tide-water; great strapping fellows when out of their clothes, with heavy muscles, splendid and brown like nuts, and sometimes with red *breech-clouts*, that brought out the olive of the wet skin. Then they bathed, plunging in the deeper channel, where the waves of their movement married the tide of the sea with the current of the stream. And later an old man with peaked grey beard sat down and washed his clothes, then walked in and lay down, he too as handsome in his naked-

ness, as he had looked broken down in his shabby clothes.
Then he rose and slowly put on the wet clothes, to reappear
later in a cleaner dress.

And a Chinaman charged across the stream on his mule,
splashing the water about him. Then as the fishermen were
gone, and all the boys and the women, probably to their meal
just caught, all noise ceased, except the rush of the surf and
the ripple of the tide, and in some interval the trickling of the
little cascade. Above, the wind rustled at times the palms.
Noonday and rest had come. And I left my work, and again
on horseback trudged along the impossible road.

Sunday 21st.

As I went up the bank, a small furtive animal like a weasel
ran up the perpendicular face of the big rock by the waterfall.
It was a mongoose, an animal of a race imported to destroy
the pest of rats, and now a plague in itself, and an example of
the eternal story.

The lower part of the sky was clear, with small pearly
clouds, the upper yet covered with heavy mist, so that the
ocean was framed as above, and occasionally the view con-
fined on the sides by the projecting rocks of the gulches, into
which ran the sea and surf. Once, at Onomea, the cliff was
hollowed into a great arch, beyond which the rock, all green

with foliage, rose further out. Whether framed in by such
cliffs, or stretched out beyond a single gaze, the ocean accom-
panied us most of the time—the *ocean*, distinctly, not recalling
the seas of our shores, but the *great sea*, hiding the secret of
its blue dyes in depths of full three thousand fathoms. And
over its blue ran a perpetual story. Rarely during our few
days was the whole surface under one influence. We saw faint
mists and rain-clouds brushed over the water, often sepa-
rated by intervals of sunny sapphire; the sky above still lit
up and peaceful. Sometimes a part of the ocean was wiped
out and became sky; sometimes great bars of grey broke
across it; and again, as these rolled over the stilled edge of the
waves, rainbows shone either where they joined the sea, or
through their entire height, up into the upper air. For this
great deceptive space seemed at our distance so peaceful, even
when we could see the surf dashing in folds on the rocks and
black beaches. Sometimes a solitary whitecap dotted it, or
when the wind blew more, many spots of broken light threw a
rosy bloom over the enchanted surface. Islands of reflected
light, islands of purple shadow repeated the clouds above, and
often the parent cloud, along with its reflected lights and its
shadows, touched and melted into the waves, making enclos-
ures, within which the eye could see vaguely, a trembling repe-
tition of light and dark; and sometimes, perhaps most when

MEN BATHING IN THE RIVER NEAR THE SEA. ONOMEA, ISLAND OF HAWAII

seen as a background to some trees or rocks, or grey native hut, with a figure in waving red or white framed in the blue opening through it, the distance and the sky melted into mere spaces of slightly different colour.

The eye never tired of this surface of blue below a greener sky, that repeated in the air that colour of greenness (blue-tint shade) that rests the sight. On land, meanwhile, our roads were good or bad, mostly bad, but not the terrors that we had heard of. Our poor nags struggled through deep mud at times, or slipped up and down in the rocks and loose stones of the gulches, or floundered in the river-beds, dropping up and down as they found footing on hidden boulders, or cantered in a tired way over some little piece of road near plantations. But their attention was mostly engaged in stepping along over the half-dried road, looking and feeling like our old "corduroy" roads, the logs being represented by bars of higher and drier mud. Over these we rose and sank, and I had plenty of time to meditate upon the idiocy of that sentimental animal, the horse, and his relative want of judgment. Never did our beasts step in any reasoned way upon these alternations of ground, though the little mule of our guide, as he trotted ahead, never going very fast, never very slow, showed his romantic relatives what pure intellect, devoid of emotions, can do in the practical line. With such nonsense I perforce diverted my

mind, when confined within the limits of the road. But our horses had plenty of rest; we took four whole days for those ninety miles, stopping to sketch, and going to ask for lunch or dinner, and bed, at the plantations on our road. The only difficulty seemed to be our own hesitation at the impudence of our requests. But this is the custom. Our visit had been telephoned ahead by acquaintances; for the telephone, that most citylike of our contrivances, goes around the island, joining together places that are difficult to reach and out of the way.

And so we met pleasant people by chance, and heard about things accidentally by way of conversation, and were most kindly treated. Indeed, when on one occasion our amiable hostess asked us to remain over night, and we had listened to German music, and had talked with the doctor in charge of the plantations, and our host himself arrived from the fields, it seemed hard to go and break our feeling of content. Perhaps I ought to tell you something about the plantations, but that is too much like information — and what do you need it for? All that we saw was sugar, which occupies the east coast; on the other side of the island, as different as the other side of the continent, there are cattle ranches, and we were told that most of the sugar land that is available has been taken already. Most of the low land, I suppose; for the upper

land further from the sea is often reclaimed and used, but it is less favourable. The yield by the acre below, at the highest, has been about eight tons, while the upper is not more than five; all this upon land which a few years ago was forest — wide downs now — covered either with sugar-cane or grass, and dotted with trees, were all covered to the sea edge, which, where I write now is a cliff fully eight hundred feet high.

The sugar plantations employ many Chinese and Japanese labourers, of whom there are a good many thousand, and we saw on two occasions "camps" of Japanese, as they are called. In the shops or stores attached to one plantation (as in others), I saw the Japanese costume again, for men and women — the *kimono* and the *obi* and the *geta* or wooden clogs; of course they are mostly peasants or of low class, as I could easily surmise without inquiring, by Awoki's manner. "They are great children," says our good lady to me, and the doctor at one residence has much to say about the anomalous position he stands in with regard to them and others. He is employed by the government to inspect them, as well as other hands, to see that they are not made to work in illness, and he also examines the flock, in the interest of the employers, to see that they do not shirk. The result is that he is a physician who cannot trust the word of his patient about his ailings, after his patient has made up his mind to be ill, who if one ailing is

dismissed, will call up as many as may seem available — and inscrutable. I am told that the Japanese illness, *kakke*, or as they call it here, *biri biri*, persists among them. It is a form of slow·paralysis, having its premonitory symptoms; sometimes to be cured, but not often. The patients, not white, have the better chance if they be under competent care, for the government gives free medical attention, and I understood that many avail themselves of it who could as well pay.

I need not say that the great tariff question is that of the moment; free sugar with us will shake the Hawaiian tree, and weaker planters will go to the wall. I always feel regret when I see all put into one chance, so liable to fluctuation, and it is to be hoped that coffee, which here is excellent, may succeed and grow more available. I take it that the difficulty is always in the picking, and that there may be chance for some improvement in the facility.

September 22d.

Our last sugar plantation took us to the edge of the great valley of Waipio, from one to two thousand feet deep, at the further and higher inland end of which drops a great waterfall; from its outside sea-cliffs trickle down others from the lesser height of eight hundred. But all was wrapped in mist,

for at this point of our ride we had almost the only bad weather of the trip. Here we turned toward the other side of the island, across great downs and spreads of land like those we had seen on first landing on the island. We were out of the rainy influence. The whole spread of the landscape was that of dryness; of the "Sierras"; we rode at first through vast fields or spreads of green, where the path was marked by the rooting of the pigs, who here run loose and grow wild. A great mountain slope rose to our left — Mauna Kea — and as we dipped to the sea we had Mount Hualalai to continue it. But that was after we had stopped on our last day's ride in a dry country, where distances swam in the pale colours that belong to the volcanoes and the desert, while near us green marked the foreground.

We rested and dreamed in midday, at some hospitable residence, from whose verandah, in the great heat, we saw Hawaiians coursing recklessly about in the way you would like to ride; and cattle on many hills; while the young ladies in the shade made garlands (*leis*) for us to wear around our necks and hats on our last ride to the shore. Adams and I rode slowly down, a mile behind the others, in the blazing afternoon, a most delicious air breaking the heat; with that same sense of space that had accompanied our first day ashore. And as the sun set like a clear ball of fire over the blue sea, and sent rosy

flickerings to the shore, we came down to the edges of the bay.

Above us to the left rose a hill crowned with the remains of some one building that trailed down its side, still red in the sunlight. To our right were palms and black sand and enclosures, apparently deserted, and with an afterglow like that of Egypt, a look of desolate Africa. In the dark we passed over the black sand, and behind the trees through which the moon moved restlessly in the water, and came up to an absurd little hotel kept by a Chinaman, where we dismounted among black pigs charging about, and bade good-bye to amiable Mr. Much, our guide, who had preceded us.

Then we met, at tea, the manager of the last place (Waimea) we had dined at. He told me of what I had missed by not getting in in the morning—the shipping of the steers, which are parked out on the shore, then singled out and lassoed by the "boys," whom they rush after into the sea, where it is the horse and rider's business to get them to the boats. To these their heads are secured, and they are rowed off swimming, willy-nilly, to the steamers, into which some contrivance hoists them.

These cattle came, I understand, from the great ranch of Mr. Sam Parker up in the mountains, a wealthy Hawaiian of partly white blood, whose name is well known besides as giving hospitality in a lordly way in his lonely domain.

And in the evening we waited for the steamer, not in the house of refuge and food, where water was scarce, and where poor Mr. Much could get nothing to eat, as being too late; but near by, under a verandah or wide canopy of palm branches lit up by the moonlight. There we listened to Hawaiian music — while our older hosts sat on the mats — melancholy chants adapted to European airs, and among them one apparently original, a sad, romantic sort of cakewalk, to which one could fancy dusky savage warriors keeping time, with many foliage-adorned feet, and hands tossed up and pointing out. It was called the March of Kamehameha (the old conqueror of these islands), and I let myself understand that it was a reproduction of the veritable sounds that once celebrated his triumphs and mastery over these islands; from which dates the royalty now existing, though his royal race itself is extinct.

And we, too, stretched on the mats brought out, and listened to lazy talk in the language, until the steamer came, when all walked down in time to the wharf, after the sheep and the freight had been put on board, and we rowed out on the water smooth as that of a lake, to the little steamer, and later went to bed and waited until morning, when we steamed for the next port and thence to Honolulu, and our own house in the valley.

We met on board many pleasant people, and among others a former neighbour, though unknown, who is now one of the few American missionaries in the Islands. These, I think he told me, are all that remain who are salaried from America. He spoke to us about Mr. Hyde, whom Mr. Stevenson had been attacking, as if he belonged to him by his name; and explained how exaggerated was the notion of this gentleman's affluence. All, I understand, that he gets, besides what his wealthy family allow him (and for that he could not be held responsible), is some two thousand five hundred a year and his residence — surely not a large amount. I have not myself read all that Mr. Stevenson has written, so that I have but a vague idea of the question, but my informant tells me that Father Damien, as is well understood, was no saint, and that two pastors had told him of things that looked wrong. These are themselves rather vague to the outsider, but much weight seemed to attach to them with our informant — a gentlemanly person, who looked little like the usual clergyman, and had a brave air of the church militant about him. But it was more pleasant to talk to him about St. Gaudens, whom he knew, and about what he had done of late years; for everywhere we find that there are others who know friends; and the desert of Gobi alone would be without home associations.

At Sea, Oct. 2, 1890.

Yesterday we crossed the equator; it was cool and pleasant, as lovely as one could wish. In the evening I found an overcoat comfortable. To-day it is more salty and cloudy, wind behind us more from the north; indefinable blue sea that looks grey against the delicate blue and silver of the sky, but near by, under the guards, it is like a greener lapis lazuli.

Yesterday, as I wrote, we crossed the equator, and left it with disrespect behind us, almost unnoticed — the Line, as they used to call it. And soon we shall have dropped the sun also, which would, were there no clouds, no abundant awnings, leave us with diminished shadows, insufficient to cover our feet. And at the thought of dropping him, the old Taoist wish of getting outside the points of the compass comes over me, the feeling that leads me to travel. Can we never get to see things as they are, and is there always a geographical perspective? Should I reach Typee shall I find it invaded by others? Shall I find everywhere the company of our steamers?

On Sunday morning we shall be dropped into a boat off Tutuila, some sixty miles away from the Samoa to which we go. How long we stay as I told you, I do not know, but we think of Tahiti later, and even other places, that I dare not think of, for I must return some day. But before that day, I wish to have seen a Fayaway sail her boat in some other Typee.

PASSAGES FROM A DIARY IN THE PACIFIC

SAMOA

Off the island of Tutuila, on Board the Cutter Carrying Mail,
Tuesday, Oct. 7, 1890 (Samoan Time).

The morning looked rainy with the contrary northwest
wind that we had carried with us below the equator, when the
shape of the little cutter that was to take us showed between
the outstanding rocks of the coast of Tutuila. As the big
steamer slowed up, a few native boats came out to meet it,
manned with men paddling and singing in concert, some of
them crowned with leaves, and wearing garlands about their
necks, their naked bodies and arms making an indescribable
red colour against the blue of the sea, which was as deep under
this cloudy sky, but not so brilliant as under yesterday's sun.
They came on board, some plunging right into the sea on their
way to the companion ladder, bringing fruit and curiosities
for sale. But our time had come; and we could only give a
glance at the splendid nakedness of the savages adorned by
fine tattooing that looked like silk, and with waist drapery of
brilliant patterns. We dropped into the dancing boat that
waited for us and scrambled into the little cutter or schooner
some thirty feet long, not very skilfully managed, that was to

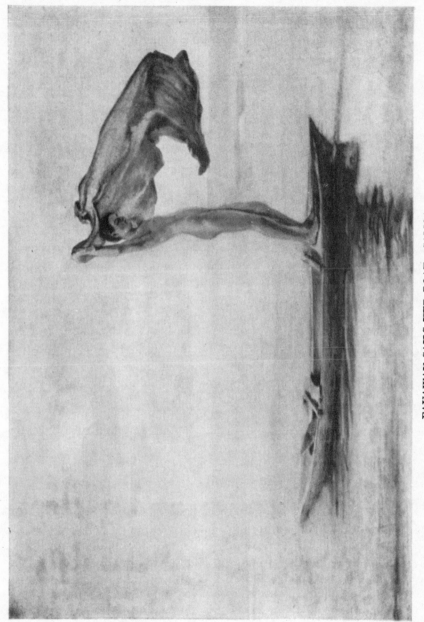

FAYAWAY SAILS HER BOAT. SAMOA

take us sixty miles against the wind to Apia. A few minutes, and
the steamer was far away; and we saw the boats of the savages
make a red fringe of men on the waves that outlined the horizon
—a new and strange sensation, a realizing of the old pictures in
books of travel and the child traditions of Robinson Crusoe.

Our crew was made up of the captain, a brown man from
other and far-away islands, and two blacks, former cannibals
from Solomon Islands, with gentle faces and manners, and
rings of ivory in their noses. Our captain spoke of hurry, and
used strange words not clear to understand in his curious
lingo; but after an hour or so of heavy rain he announced his
intention to beat in again and wait for some change of wind.
And so we ran into a little harbour high with mountains, all
wooded as if with green plumage, cornered by a high rock
standing far out, on which stood out, like great feathers, a few
cocoa-palms. Palms fringed the shore with shade. A blue-
green sea ran into a thin line of breakers — like one of the
places we have always read of in "Robinson Crusoe" and
similar travellers: "A little cove with the surf running in,
and a great swell on the shore." Our cutter was anchored;
then, as we declined to remain on board, either in the rain or
in the impossible little cabin about eight feet long, we were
taken into the boat, which was skilfully piloted through an
opening in the inside reef; and, the surf being high, we were

carried to shore on the backs of two handsome fellows whose
canoe had come alongside. We walked up to the church, a
curious long, low building behind the cocoa-palms; all empty,
with thatched roofs and walls of coral cement; the doorway
open, with two stones to block out casual straying pigs, I sup-
pose. Inside I saw a long wooden trough, blocked out of a
tree. I did not know that this was the old war-drum of pagan
times, now used for the Christian bell.

Behind the church, a few yards off, was our destination —
a Samoan "grass-house," the guest-house of the village, as I
know now. It was thatched with sugar-cane leaves, was
elliptical, with a turtle-backed roof, supported by pillars all
around, and by three central pillars that were connected by
curved beams, from which hung cocoanut cups and water-
bottles, or which supported rolls of painted bark cloth. The
pebble floor showed at places not covered with the mats, as
well as near the centre pillars, where a fire still smoked. Most
of the screens of matting, which make the only wall between
the pillars, were down, making a gentle shade, in which one
woman was sleeping; another, on the opposite side to us, her
back turned and naked to the waist, was working at large
folds of bark cloth. The women rose from this occupation,
and offered their hands, saying, "*alofa!*"* A younger woman

* "Alofa" means everything — hail, welcome, love, respect, etc.

was lying sick, her wrapped-up head on the Samoan pillow of a long bamboo, supported at either end, so as to free it from the ground.

With the same "*alofa*" came an elegant young creature, perhaps some sixteen years old, wearing a gay waist drapery of flowered pattern, red, yellow, and purple — with a loose upper garment or chemise of red and violet — open at the sides. Then another, short and strong, with heavy but handsome arms and legs, and with bleared eyes. And we sat down on the mats, the girls cross-legged, and looked at each other while the captain talked, I know not what of.

As I changed my seat and sat near the entrance with my back against the pillars, which is the Samoan fashion, though I did not know it, another tall creature entered, and giving us her hand with the "*alofa*" sat down against another pillar — also the proper dignified Samoan way. We did not notice her much; she was quieter, less pretty than the pretty one, with a longer face, a nose more curved at the end, a longer upper lip, and more quietly dressed in the same way. Then entered another with a disk-shaped face, her hair all plastered white with the coral lime they use to redden the hair, and dressed as the others, with the same bare arms and legs. She was heavy and strong below, and less developed above, with the

same splendid walk and swing, the same beauty of the setting
of the head on the neck.

And we drank cocoanut milk, while *kava* was being pre-
pared for us in an enchantment of movement and gesture, that
I had just begun to feel, as if these people had cultivated art in
movement and personal gesture, because they had no other
plastic expression.

The movements of the two girls preparing the stuff would
have made Carmencita's swaying appear conventional; so,
perhaps, angels and divinities, when they helped mortals in
the kitchen and household. As the uglier girl scraped the
root into the four-legged wooden bowl set between the two,
in front of us, and before the central pillars, she moved her
hand and body to a rhythm distinctly timed; and when her
exquisite companion took it up, and, wetting the scraped root
from double cocoanut shells, that hung behind her, moved her
arms around in the bowl and wiped its rim, and frothed the
mass with a long wisp of leafy filaments, she tossed the wet
bunch to her companion, as if finishing some long cadence of a
music that we could not hear, too slow to be played or sung,
too long for anything but the muscles of the body to render.
And she who received it, squeezed it out with a gesture fine
enough for Mrs. Siddons or Mademoiselle Georges. I use
these names of the stage, of which I have no fixed idea; those

that I have seen could never have given, even in inspired moments of passion, such a sinuous long line to arm and hand. Then in a similar repetition of conventional attitudes the cups were presented to us, one after the other, with a great under-sweep of the full-stretched arm, and we drank the curious drink, which leaves the taste filled with an aroma not unlike the general aromatic odour of all around us, of flowers and of shrubs. For all was clean and dry about us, house and sur-roundings and crowded people, at least to the senses that smell.

In the slow hypnotism produced by mutual curiosity, by gazing with attention all centred on movement, while pre-tending to notice all the social matters as they went on about us, I could not disentangle myself from the girl who had bewitched us; and as she sat clasping her elbows, with her legs crossed in her lap, like the images of Japanese Kwannon and of Indian goddesses, I tried to copy a few lines. But the original ones flowed out again like water, before I could fix them. My model was conscious of the attention she called up, and from that moment her eyes always met ours, with a flirting smile, half of encouragement, half of shyness.

And now the tall girl that sat beside me, with the quiet face and unquiet eyebrows, put out her hand languidly to reach

for my sketch-book. She was the "virgin of the village" —
doubly important by being the old chief's daughter, and
elected to this representative position, which entails, at least,
the inconvenience of her being always watched, guided, and
intimately investigated by the matrons appointed thereto.
The lines of my sketch, that would have puzzled the ordi-
nary amateur, were clear to her: "See," she said, "here is Sifá,
clasping her elbows, but her face is not made. Draw me,"
and she moved away the hanging mats that obscured the
light. The sketch I made was bad, representing to my mind
a European with strange features. I don't know what she
thought of it, but she recognized the chemise with ruffles on
edges, that covered her shoulders, and made the motion of
lifting it away, which I was slow to understand. Her eyebrows
moved with some question for which I had no English in my
mind. At last the word *misonari?* as she looked toward
Adams, explained what was meant; I said "no," and looked
approval. She rose, passed into the shade, and sat again be-
fore me, her upper garment replaced by a long, heavy garland
of leaves and the aromatic square-sided fruit of the pandanus,
that partly covered her firm young breast, and lay in her lap
against the folds of the bent waist. But my drawing was
scarcely better for all this, and I gave it to her, with the feeling
that what made it bad for me, its resemblance to a European,

might give it value for her. All the time the temptation was strong to treat this child of another civilization as a little princess. She had the slow manner, the slightly disdainful look, the appearance of knowing the value of her sayings and doings that make our necessary ideal of responsibility. What though the Princess puffed at my pipe, meanwhile having secured a cigar, less cared for, behind her pretty ear; what though she pressed two long, slender fingers against her lips, and spat through them, according to some native elegance, she knew that she was a personage and never was familiar, even when she pressed my arm and shoulder, and said, "*alofa oi*," "I like you." Her forehead was high and gently sloping, her eyebrows thin and movable, the eye looked gently and firmly and directly; the nose was a little curved at the heavy end, the upper lip a little long (and pulling on the pipe, if she used it, would lengthen it later yet more), the neck and back of the head had the same beauty of line and setting that I had seen in Hawaii, and her shoulders, and breast, and strong, lithe arms would have delighted a sculptor. She wore her hair gathered up by a European comb, and in front a forelock reddened to the tone of her face, with the coral lime they used. Her legs were strong and fine and her feet only as large as one could expect, with the soles hardened by use over stones and coral.

But she was not the pretty one; her sister, Sifá, was that. The charm of the older one, "the virgin of the village," was in this incomparable savage dignity, that gave a formality to our visit. What to us was an amusement was to her evidently one of the necessities of hospitality, while Sifá could not move about or look without a ripple of laughter that undulated through her entire person. Occasionally, however, our "chiefess" looked at me with a gentle smile, and said "*alofa!*" and by and by, after showing me that she could write, and doing so in my album, (where she dated her inscription *Oketopa*, our October), she gave me a ring with her name Uatea — or Watea as she wrote it. She partook of lunch, eating after us (along with the captain who appeared again on time), and she refused to taste of some apples we had until we had some of her own fruit, all I suppose according to some proprieties well defined. Then Sifá, her sister, met with a little adventure in unpacking our food for us. The captain of the steamer had given us a block of ice on our leaving, telling us that it was the last we should see in this part of the world, and that it might comfort us during our long, hot sail under the tropical sun. In unrolling it, and taking it up, Sifá dropped it with a cry of "*afi!*" — "fire!" and for a few moments we struggled in an unknown tongue to explain what it might be. But I took it for granted that she must have had some Bible expla-

nation of the places where the Bible comes from — that is to say, England and Scotland; hence about winter and bad weather, and perhaps snow and ice.

While the family arranged for their meal we took a walk, "now and again," as our captain expressed it — almost all the words he knew. We walked across what appeared to be the village green — a space of grass neatly cared for — edged by huts and trees, the palms thickening in the distance and hiding the sudden and close slope of the mountain right above us. Bread-fruit trees were planted here and there near the houses, the large leaves making a heavy green pattern against the innumerable shades of green, the spotted trunks were dark; even the cocoanut trees were only white by the sea. We passed a tomb, of a moundlike shape, one lengthened cube placed upon another, and the upper surfaces sloping to an edge like some of the early sarcophagi or Italian tombs — a shape as simple and elegant as one could wish in such an ideal landscape. I shall have to find out if this most typical shape has originated with them, or has come from some foreign influence. However that may be, it made another classical note. Had Ulysses in his wanderings left some companion here, some such monument might have well marked the tomb of a Greek. There it was, all covered with lichen; and another newer one, made also of coral mortar, still white, near trees,

and by former homes, in this little shady "*agora.*" As we
passed into the path that seemed to run up the hill, young
men went by with wreaths on their heads, draped to the waist,
like the statues of the gods of the family of Jove; their wide
shoulders and strong, smooth arms, and long back-muscles
or great pectorals shining like red bronze. All this strength
was smooth; the muscles of the younger men softened and
passed into one another as in the modelling of a Greek statue.
As with the girls we had just left, no rudeness of hair marred
the ruddy surfaces, recalling all the more the ideal statues.
Occasionally the hair reddened or whitened, and the drapery
of the native bark cloth, of a brown ochre colour, not unlike
the flesh, recalled still more the look of a Greek clay image
with its colour and gilding broken by time. Never in any
case was there a bit of colour that might rightly be called bar-
baric; the patterns might be European, but no one could have
chosen them better, for use with great surfaces of flesh. If
all this does not tell you that there was no nakedness — that
we only had the *nude* before us — I shall not have given you
these details properly. Evidently all was according to order
and custom; the proportion of covering, the manner of catch-
ing the drapery, and the arrangement of folds according to
some meaning well defined by ancient usage.

Children played about in the open space; they were then at

a game of marbles; when we returned, this had turned to some
kind of blind-man's-buff; there was no roughness, only a good
deal of soft laughter; one youngster, draped to the chest like a
Greek orator, too big for the children, too young for the men,
leaned upon a long staff and looked on gravely, exactly like
the figures on the Greek vases, or the frieze of the Parthenon.

We walked along into the forest, in the silence of noon-
day, but the abruptness and slipperiness of the path as it rose
rapidly to walls of wet rock, stopped our feet. From the in-
tricate tangle of green, we saw the amethyst sea, and the white
line of sounding surf cutting through the sloping pillars of the
cocoanuts, that made a mall along the shore; and over on the
other side of the narrow harbour, the great high green wall of
the mountain, warm in the sun, and its fringe of cocoanut
grove, and the few huts hidden within it, all softened below
by the haze blown up from the breakers. All made a picture,
not too large to be taken in at a glance; the reality of the pic-
tures of savage lands, in our school books, filled in with infinite
details. From dark interiors of huts, as we returned, came
gentle greetings of "*alofa.*" Awoki, our Japanese servant,
had remained with our hosts, had been fed with bread-fruit
and cocoanut milk, and was busy writing out, under the direc-
tion of the black mate, certain names and words of the lan-
guage; for the mate could be understood, while the captain

had only one certain phrase, "now and again" with which he punctuated everything loudly, so that I could barely understand him. The mate had his own punctuation of frightful oaths and damnatory epithets, evidently mere adornments of speech, for he was most gentle, a kindly and good-natured cannibal, contrariwise to the surly captain; so that I was glad

that he had ventured up from the cutter. The girls had taken kindly to the other brown skin, my servant, and were busy helping him make up his list of words, whose sounds he wrote in Japanese, to my later confusion, when he passed his dictionary to me. (Yet curiously enough, in this first half day, we learned full a hundred words — almost all that I have retained.) So we sat down and rested; the flies, attracted by the bread-fruit, and occasional mosquitoes hovered about the openings; ants crawled about on us — my princess had occasionally on her feet a black bunch of flies, which she brushed away slowly — evidently she did not feel them much — their skins are hard — "now and again," as the captain might say, a woman passed the openings of the hut, bare to the waist, holding a

child against her hip. Soon one of the girls, tired of cross-leggedness, stretched her feet politely under a mat, pulled up for the purpose (for it is not polite to sit otherwise than cross-legged).

The older women slept on the Samoan pillows at the further side, closed in by palm curtains. All but one—who had worked all the time, her great brown back turned toward us — engaged in smoothing and finishing a piece of what we white men call *tappa*. "*Siapu*" I think they call it — the inner bark of the paper mulberry, hammered out with a mallet, which in so many of the islands has been long their cloth. She never stirred from her work; as long as the light held, I saw before me this upright form, strong as a man's, smooth and round, and the quiet motion of the arms in the shadow, made deeper by the sunlight on our side. Later, another shower made us shut down more curtains, but we were safe and comfortable, protected from sun and rain alike, in this most comfortable and airy housing. Then Sifá began beating her thighs and moving her shoulders coquettishly to her humming of a tune, and I thought that I recognized the *siva*, the seated dance of the Samoans, about which I had been told in Hawaii. Such a graceful creature could do nothing that was not a picture, but there was a promise of something more, so that we applauded and said *lelei*, "beautiful," with the hope of a full performance.

But the Princess said nothing; she smoked more and more, as every one joined her, so that I foresaw that our small supply of cigars and tobacco was doomed, especially as other damsels entered, and made more ravages; girls more or less good looking, mostly heavier, one of them called "Tuvale," who knew bits and parcels of English such as *pilisi du na iti mi*, *pilisi esikusi mi*, "Please do not eat me," "Please excuse me." And one of the largest, leaning affectionately against my shoulder, absorbed my silk handkerchief, and tied it around her neck — saying to me, in her language, "Look how pretty it is!" Our matches and match-boxes had long ago disappeared — most little things had left my pockets, but had been replaced. In every way my fair and strong companions seemed inclined to dispute an apparent preference for Uatea and Sifá. Good-natured girls all (but one — the thief of handerchiefs — who seemed to me jealous) — and we were certainly beamed upon, as I never expect to be again. More rain outside brought on the evening, as we took our last meal; the "chiefess" and the captain, who again appeared sullenly out of the dark, eating after us; the captain now, with an apology to us, appeared naked to the waist, a big heavy mass of bronze, covered below with a gorgeous drapery of purple, and yellow, and red. We lay more and more at ease, stretched out, the girls prone, and occasionally giving one of us an af-

fectionate pat; all but Uatea who still preserved her usual reserve, and even tried hard to substitute another ring for the one she had given me — as if her name on it was too much for a first acquaintance. And occasionally in following her face, the only one that seemed capable of complicated ideas, I asked myself whether she was asking herself what equivalents her hospitality would receive: for instinct told me that through her our gifts or our payments should be made; even if it were all to go to others according to barbaric custom. So seeing her rather laden with things, and having had one experience of the excellence of a white silk handkerchief, I offered her another, and wrote her name in the corner, to see her thank me in her usual condescending way, and then toss it over to the old woman who appeared occasionally — to my mind, her adviser and guardian, for from time to time, "now and again," she crept up, between us, like a chaperon or duenna, to see that all was proper.

Then many of our girls disappeared with Sifá, whom we missed at the moment and asked for over and over again. A light was brought and set down upon the matting. Uatea slipped out between the hanging screens and the pillar behind me, and slipped back again, rid of her upper garment with a sort of *poncho* or strip of cloth with opening for head, patterned in lozenges of black, white, and red, that hung down

her back and chest, leaving arms and shoulders bare, and the sides of her body, so that as she bent, the soft line that joins the breast to the underarm, showed under the heavy folds. Then, in came our missing pet, Sifá, with Tuvále and two others, into the penumbra of the lamp. They were naked to the waist; over their tucked-up drapery hung brilliant leaf-strips of light green, streaked with red; a few leaves girdled the ankle; around Sifá's neck, over her beautiful bosom, hung a long, narrow garland of leaves, and on the others garlands of red fruit or long rows of beads interlaced: every head was wreathed with green and red leaves, and all and everything, leaves, brown flesh, glistened with perfumed oil. From the small focus of the lamp, the light struck on the surface of the leaves as upon some delicate fairy tinsel, and upon the forms of the girls as if upon red bronze waxed. But no bronze has ever been movable, and the perpetual ripple of light over every fold, muscle, and dimple was the most complete theatrical lighting I have ever seen. Even in the dark, streaks of light lit up the forms and revealed every delicacy of motion.

So those lovers of form, the Greeks, must have looked, anointed and crowned with garlands, and the so-called dance that we saw might not have been misplaced far back in some classical antiquity. The girls sat in a row before us, grave and collected, their beautiful legs curled upon the lap as in East

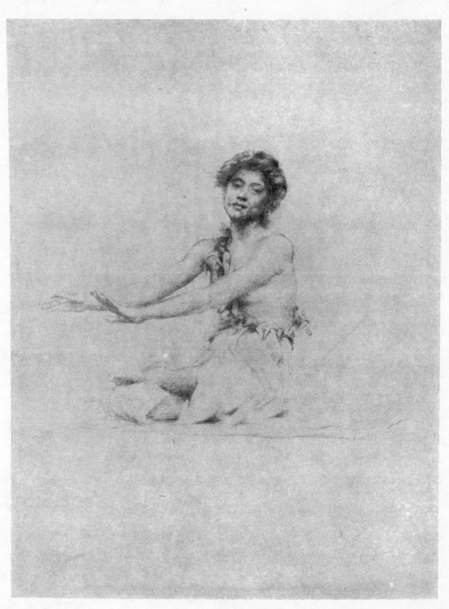

SIFÁ DANCING THE SITTING SIVA

Indian sculptures; and Sifá began a curious chant. As all
sang with her together, they moved their arms in various ways
to the cadence and in explanation of the song; and with the
arms, now the waist and shoulders, now the entire body, even
to the feet, rising apparently upon the thighs to the time of
the music. Indeed, Sifá spoke with her whole tremulous body
undulating to the fingers — all in a rhythm, as the sea runs
up and down on the beach, and is never at rest, but seems to
obey one general line of curve. So she, and the others, turned
to one side and stretched out their arms, or crossed them, and
passed them under the armpit and pressed each other's shoul-
ders, and lifted fingers in some sort of tale, and made gestures
evident of meaning, or obscure, and swayed and turned; and,
most beautiful of all, stretched out long arms upon the mats,
as if swimming upon their sides, while all the time the slender
waist swayed, and the legs and thighs followed the rhythm
through their muscles, without being displaced.

I cannot describe it any better; of what use is it to say that
it was beautiful, and extraordinary, and that no motion of a
western dancer but would seem stiff beside such an ownership
of the body? Merely as motion, it must have been beautiful,
for the fourth woman was old and not beautiful, but she melted
into the others, so that one only saw, as it were, the lovely form
of Sifá repeated by poorer reflections of her motion in lesser light.

Meanwhile Uatea sat to one side of them, near me, and in front, one leg stretched out, the other tucked under, beating time with a stick, disdainful of it all, as poorly done, perhaps incorrectly. "*lelei*," "beautiful," I said — "*leanga*," she replied, with a curl of her lip, hardly looking at the girls. Perhaps she should have led in person, as the official maiden — and I still felt that something was not right. The girls rose and came to sit beside us, while Uatea disappeared in the darkness, behind the three masts crossed with curved beams, that supported the centre of the roof. These, with the shining, polished cocoanut bottles, filled with water, that hung from the beams, and the rolls of mats and bark cloth which were placed upon them as upon shelves, had served as a background or scenery to our theatre. Along all the edges of the big house, in the darkness, were other visitors, and guests, small children, boys and girls, neighbours, and even the two gentle blackies, from Cannibal and Head Hunting isles, with white rings in their noses, that made our crew. But I saw none of the splendid young men, who, crowned with garlands, girdled with leaves like the Fauns and Sylvans of the Greek play, had startled me over and over again, during the day, with a great wonder that no one had told me of a rustic Greece still alive somewhere, and still to be looked at. So that the old statues and frescoes were no conventionality — and the

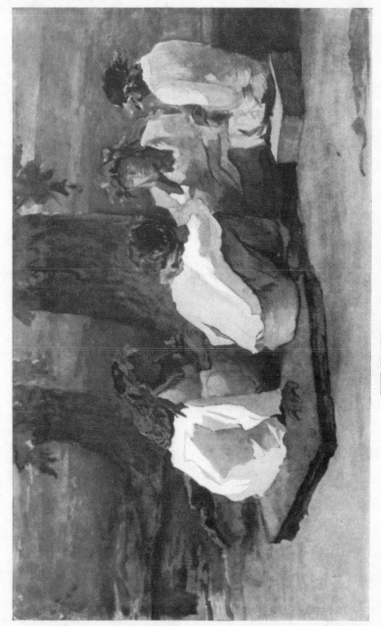

THE FLUTE PLAYER. SAMOA

sailor, the missionary, and the beachcomber, were witnesses
of things that they did not see, because they had not read.
And if one reads, does he care to-day? Had I only known,
years ago. Even now, when it is too late, the memory of
all that beauty which we call Greece, the one beauty which is
to outlast all that is alive, comes over me like a wave of mist,
softening and putting far away into fairyland all that I have
been looking at. From out of the darkness, as if from out of
the shade of antiquity, Uatea stepped out before us, naked to
the waist, crowned with leafage, garlands around her hips, a
long staff like a sceptre in her hand, and danced some heroic
dance, against another girl, smaller than she, as her adversary;
it looked a mimicry of combat; the tall form, the commanding
gestures, the disdainful virginity of the village Diana, chal-
lenging her companion to battle; something as beautiful and
more heroic than the Bacchanals that are enrolled on the
Greek vases. The girl was in her true element and meaning,
more than she could have been in the previous *sivá* dance;
only an occasional touching of the knees together detracted
from the beauty of the movements. I could scarcely notice
the other dancer, nor the third one, an old woman (who rep-
resented, apparently, a suppliant), for fear of losing a parcel
of a picture that I shall never see again, certainly never with
such freshness of impression.

And when Uatea reappeared, clad again, and puffed at my pipe before passing it to me, she much less disdainfully assured me that all her dancing was *leanga* (bad). And she softened a little, and seemed distressed about our quarrel about her ring, taking off all her rings and throwing them away to her guardian matron, perhaps for fear of being reproved for giving too much for too little, for we had given as yet but little — only cigars, tobacco, and trifles; and I asked myself whether the dramatic artist was counting up her possible gains, as others do. Meanwhile, the other girls lay close to us, in the confidence of good-nature; all anxious to make the best impression, a curious example of the wilful charming of woman — and Sifá talked and smiled, and moved, or rather floated, in her place like a maiden siren flirting. Many confidences were exchanged without either side understanding one word said. Each girl wrote something in Awoki's note-book, or helped our making a dictionary. Sifá even summing up figures to prove her possession of the three R's, a confusing addition of accomplishments to the dancing and conventionalities we had seen. But I am told that all read and write, with no book but the Bible. Then between the curtains of mats Uatea disappeared contrary to what I supposed etiquette, but, of course, I knew nothing. The others bade us good-night, not without begging one of us to share their hut,

and we slipped out into the dark, while the mats were arranged for our rest. The storm clouds still covered the sky
— only a few stems of the cocoanut glistened, and the white
bar of the surf made a hard line in the shadow. Some vague,
light forms were those of sitters beneath the trees whispering,
or talking low, for all through our day there had been no
voices raised except our own, or the surly growl of the captain — or the chant that had accompanied the dances; all
other talk had been soft and flowing, with low voices, almost
inaudible to us when distant, adding again to the peace and
softening charm.

We lay down on the mats with our heads toward the centre-
post; a large mosquito bar of thin bark cloth, big enough for
a small room, was let down upon us, the light of the lamp shining through it, and draped in my Japanese kimono, I fell
asleep, in spite of the few mosquitoes imprisoned with us.
No noise from the rest of the house had arisen, all was still;
we were as much isolated as if we had been in a built-up room.
Late or early, I think I heard the snore of the captain, but all
is empty in my mind until I recollect feeling the morning light
and saw some shadows pass. As I stepped out, I saw Sifá
move out, stretching her arms, as she moved toward a little
path. Then issued the captain, with a formidable yawn, and
looked at the sky for presages of weather, and took the same

little path, I suppose toward the bathing pool, or spring, or rivulet of fresh water, that might be in the hollow.

And there came up to the house Uatea, the "Chiefess," looking just the same, and appeared to understand that we were for a bath, as she made the motions of washing her chest. We went to the sea, finding no good place for a bath — it was evidently far off — and I take it that they bathe in fresh water — the luxury of hot climates. For they all seemed to be extremely clean and neat, from the men whom I had first seen at sea, to the girls with limbs rubbed with cocoanut-oil and smelling of the aromatic fruit (the pandanus) that their garlands were made of. Our bath was not a full success — we dared not go out into the surf that rolled turbid waves upon the deep, black volcanic sand of the beach; but the water was warm and soothing, and as I began putting on my clothes, a tall girl of the preceding night came up and sat down beside me on the rock, with an evident seeking for an interview. Notwithstanding my unaccustomed embarrassment, I managed to make out that she was uncertain and perplexed as to the legality of her capture of my handkerchief the night before, and though I told her to keep it, she was still doubtful. Uatea had had one; was she to have the same as Uatea? At last she left me, reassured — I had no more interest — and I saw her go along the shore passing far off the better bathing

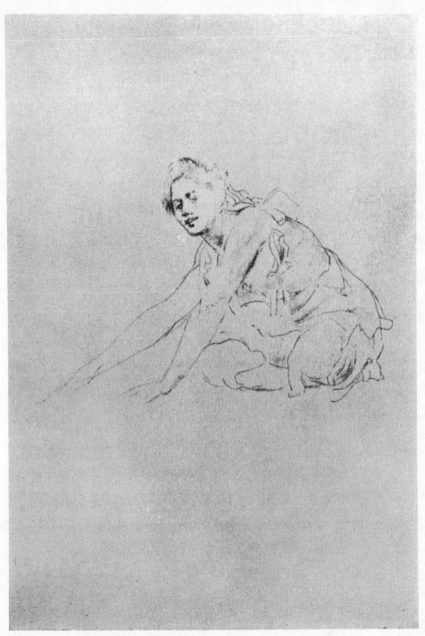

UATEA DANCING THE SITTING SIVA

spot of fresh water, and then disappearing behind distant palms. Breakfast was ready when we reappeared; after us Uatea ate and drank our tea, and wondered at our use of "tea-balls." The captain explained that there might be wind enough "now and again," and that any moment ought to see us off. Sifá and Tuvále gathered about Adams; I smoked my last cigar, for all with our other tobacco were gone — while Uatea asked coldly what I had done with the ring she gave me, as it was no longer on my finger. More and more she withdrew into herself, more and more the "Chiefess" looked as if expecting or anxious or troubled, as to whether an equivalent would be serious enough. But we gave the largest sum that the captain dared to hint at — anything would have seemed cheap. The night before I could understand the *throwing of jewels;* of money, of any reward to express thankful admiration. The "Chiefess" extended a languid hand — her eyebrows rose, a short *"f'tai"* dropped, as if obligatory from her lips — (the proper form I knew already was *"faafe'tai"*) — she gave us her hand with a frigid "*alofa,*" and with Sifá and Tuvále lingering, we walked to our boat. Long after we had set sail we could see them wave their drapery as good-bye. Far off, along the beach, from the hut of the tall girl-thief, my own handkerchief was waved — but even with the glass I saw no more of Uatea.

Peace to thee, O soul of the "virgin of the village," if I have made thee but a thrifty prima donna, or like the King Solomon of Djami, the Persian poet, caring only for realities that pay — it is the part of those born to be rulers.

And now we had pulled out of the breakers, through the narrowest of openings, and were on board the little schooner; the great blue sapphire waves lifted us and sank us, and came up against the blue horizon, or against the tall green cliffs; and once more we saw, in the hollow of the sea, or lifted against the sky, the native boat pushed on by rhythmic paddles, making a red line of naked men against the blue of the sea or the blue of the sky. We have been four hours and a half beating out of this little cove, and have just rounded the isolated rock of the cape, of which I send you a sketch. If I could only send you the colour! — blue and green — a little red and black in the rocks — the white and violet haze of the surf; all as if elementary, but in a tone that no painter has yet attempted, and that no painter that I know of would be sure of; the blue and green that belongs to the classics; that is painted in lines of Homer; that Titian guessed at, once, under a darker sky; and far off the long sway and cadence of the surf like the movement of ancient verse — the music of the Odyssey. We are off some little village on the shore; the boat has gone to get

other passengers, while I try to finish this account of our first
day on land in the South Seas, and to make it live for you by
long accumulation of detail. If, through it all, you can gather
my impression, can see something of an old beauty, always
known, in these new pictures, you will understand why the
Greek Homer is in my mind; all Greece, the poetry of form
and colour that comes from her, as well as her habits; just
as the Samoan youngster who rose shining from the sea to
meet us, all brown and red, with a red hibiscus fastened in his
hair by a grass knot as beautiful as any carved ornament, was
the Bacchus of Tintoretto's picture, making offering to Ari-
adne. The good people of the steamer may not have seen it,
nor the big white English girl who bought some trifle from
him — but it is all here for me — and there will soon come a
day when even for those who care, it will be no more; when
nowhere on earth or at sea will there be any living proof that
Greek art is not all the invention of the poet — the mere refuge
of the artist in his disdain of the ugly in life. What I have
just seen is already to me almost a dream. So I turn to my
Japanese, Awoki, and ask him — "It was like the studio,
Awoki, was it not? but all fine; no need of posing?" And
Awoki says "Yes," whether he understands me or not, and I
think of you and of the enclosed studio life that tries to make
a little momentary visitation of this reality.

The fitness and close relation of all I have seen makes a something like what we strive to get through art, and my mind turns toward the old question, "How does what we call art begin?" These people *make* little; the house, the elementary patches upon their bark cloth, the choice of a fine form for tombs, is all the art that is exterior of themselves and of their movements, into which last they have put the feeling for completeness and relation, that makes the love of art.

Is it necessary for going further that some one should be born, to whom, gradually, an unwillingness to assume the responsibility of action, which the ruler and the priest take willingly, should grow into a dislike of the injustice of power, and a distrust of the truthfulness of creeds, so that he must make a world for himself, unstained and free from guilt or guile? I have begun to imagine for myself some such soul, born in early communities, who might have lived long ago anywhere and have been the hero of some such primitive obscure conflict; but I can see tossing on blue waves, the boat that brings from the shore our new companions, Lieutenant Parker and Consul-General Sewall, who have been on a visit to the harbour of Pango Pango — and in a few minutes they and their white coats will be aboard.

You will by this time wish to know how we are living. We

are settled definitely, for headquarters, at Vaiala, a little way from Apia, from which a little river separates our part of the land. Further on, another small river closes out the territory, and separates us from Apia.

The small river that separates us from the beginnings of the village capital, Apia, is spanned by a little bridge — little because consisting of a few planks, and a handrail to one side, but otherwise a very long gangway. This I believe is kept in repair by the municipality of Apia, and is probably the cause of much discussion in the way of spending money. Occasionally it is washed away, and then we swim our horses across, to the discomfort of my best yellow boots, which I feel are a distinctive mark in my visits to people in Apia. At times the municipality provides a ferry-boat. This so far has been manned by one of those convicts who are puzzles in South Sea economics. He had been taken away from some other chores of supposed hard work. After the first day of ferrying, which was productive of various small trips, this criminal had fallen back on the customs of his country, and on that essential communism which is the basis of their actions and of much of their thinking. He had a hut erected for him, so as to rest in the shade, and there he spent most of his time consuming bananas or accidental gifts of food, and courted and caressed by village maidens, who adorned him with flowers and

anointed him with cocoanut oil. Meanwhile the smaller and less important members of his family did the work of ferrying in the sun. It was all the same, he was vicariously being punished. This is the keynote of all I shall ever tell you here. There is the tendency to let not only property remain undivided, but also injury or gain. A little anecdote told me by a clergyman, who had it from a friend in Fiji, where things are still more so, gives this intellectual position. The Fiji clergyman had been shocked at a horror perpetrated by some of his parishioners. The dog of some person in a neighbouring village had been killed; some of the aggrieved had sallied forth, and meeting some person who belonged to the village guilty of holding the dog murderer, had thereupon incontinently killed him. An "old hand," that is to say, a white man conversant with South Sea habits, explained to the clergyman the naturalness of the deed. He said — forgive the vernacular — "See here; if Jim and me gets into a fight, and Jim plunks me in the head, I don't wait till I can get in a blow at Jim's head: I hit him where I can." One community had lost a dog and the other had lost a man. This is a dreadful example of the idea, and I almost regret introducing it into my description of this idyllic passage of my life. But we are on the road to Apia, which, like all white men's places in such countries, has a taint of brutality remaining from the day of the beachcomber.

It is an orderly little place strung along what might be called a street or two, the main one of which is on the beach, and goes by that name. There are stores, a few hotels and drinking places, warehouses and residences of the consuls, and further on native residences, etc. There are churches too, and a Catholic cathedral of somewhat imposing dimensions; but the churches are those of an ugly village, and no longer have that natural look of the church by our own village of Vaiala, for instance, which has really a character not contradictory to its surroundings.

Further back and right and left all is Samoan and native. We are just by the shore, here fringed with trees and palms, and only some six feet above the inland sea of the reef that spreads right and left before us. In the few great storms that have come upon us in the night, it was not difficult to imagine the beating of the rain against the door of our sleeping house to be the first splashing of some great waves passing over with the roar of the surf outside.

From under the shadows of trees, I see canoes pass close to the shore, visible at intervals between the trees that border it; they seem, like all that happens about us, part of a theatre scene: red bodies glisten in white or coloured drapery, adorned by flowers and leafage; and songs are carried along with the

stroke of the paddles, as in an ideal opera. Blue sea outside; green inside.

The little village stretches along a very short distance, apparently not made of more than a couple of dozen of huts or Samoan houses, with a double village green, here and there planted with trees and broken into and backed on the shore side by plantations of bananas.

Further back the mysterious "bush," into which I have not yet wandered. Just outside, near the shore, and with a little garden, the Consul has built a new and commodious southern house, with enormous verandas, dropped like a piece of Europe among the native forms; there we breakfast and dine; while in the village a few yards off we have borrowed a large, comfortable hut,* in which we spend the day, receiving visitors, writing, or painting,† and at night we occupy a little building of our own European kind, with just place for our two rooms and beds. It is next to Tofae, the chief's hut; so that we are both physically and morally under Tofae's protection. This we insist upon; we are no strangers gadding about, we are chiefs on a visit, and we appeal to the care of our fellows responsible for us. So that doors and trunks and boxes are all open; every one is free to inspect and responsible to the

*This is properly the "*guest house*" of the village.

†Of course we are not allowed to pay — this would not be"chiefy" — but we shall make a present some day.

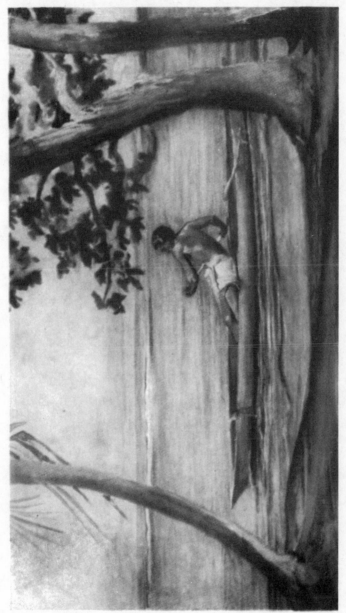

BOY IN CANOE PASSING IN FRONT OF OUR HOUSE. VAIALA, SAMOA

chief. Even very lately, when the criminal — the prisoner condemned for stealing the consular flag halyards — who is imprisoned by being detained within the half mile of the village, and who is under Tofae's wardship — even when this confirmed bad man is found looking through all my property, from sketch-books to night pajamas, I feel quite safe that nothing will be missed through him. Only two silk hander-chiefs have disappeared since I have been on the island, and I can't be sure whether they were lost here or in some of our long trips by sea and land. But Tofae takes the fact to heart, and will, I know, make me some present many times more valuable, to wipe out this possible blot upon the escutcheon.

At the earliest dawn there is motion in the village that I do not hear. The soft grass, cleanly trimmed, which covers all the village space, brings no echo from bare feet. But from the very first morning on the small verandah, no bigger than a large table, I hear a patter of feet that wakens me. If I look out, one or more of the girls of the village, our nearest neigh-bours, is seated there in a corner, ready to bid good morning, and looking occasionally into the open window, to see if I am still abed! Sometimes their shadows, as they pass, break the half light which keeps me in a doze.

When I rise I have to get accustomed to the mild curiosity that inquires after my mode of dressing. Still, as days go on,

I become less the fashion, and can go out to my bath, in my Japanese gown, without stepping over a côterie of gentle maidens. If I get up with the dawn, that slowly lights up the great spaces above the trees, I can see first some figures pushing back the mats that form the only walls of the surrounding huts, stretching their arms, then perhaps, in their simplest wraps, fading away in the uncertain light! They are going to the obligatory bath; not to the salt water in front of us, which they do not look upon as cleansing, but to pools back in the bush, or the little river further off.

With the first half-sleepy motion begins the weeding around the huts, a perpetual task carried on at all odd times. For among these savages, so far as they are not spoiled by the European, the lawn and greenery about the village are tended with extreme care. Many a time, in places that are far away and more strictly barbarous, I have been reminded of the neatest Newport lawns. This is one of the unexpected charms, one of the many things that give everything a look difficult to explain, a look of elegance in the wildness. But we must remember that these good people have always been here, that from immemorial time they have tended what seems to us accidental nature; culture and care and the tropical wild growths are constantly interchanged. That is the South Sea note.

Later on I see some of the men return from their short hour's work at their wet patches of the taro plant, which, with the bread-fruit, represents the staples of bread and cereals both. In this kindly nature, such culture is no more than a gentle exercise. I see even the great Mataafa, the rival of the King Malietoa, and the greatest personage of all islands, returning from his daily task like any commoner, often stripped to the waist, wearing nothing but the wrap along the loins and legs, which they call the *lava-lava*.

After our morning coffee, made of the island bean whenever we are fortunate enough to get it, for we find it better than any brought from Java, we adjourn with the first heat of the early morning to our big Samoan hut. This is next to Mataafa's, in the centre of the village. By this time most of our neighbours have begun to rest, and will keep steadliy quiet for a large part of the day; unless they visit, or unless some special duty calls.

If we are very early, we may still find in our Samoan hut our pretty friend Fangalo, who lives with our neighbours nearer Apia, and whose simple task it is to place flowers about the tables upon which we write or paint, or upon the shelf that connects the great centre posts of the hut, where hang the cocoanut water bottles, and are placed the rolls of native cloth, or extra mats for softer resting.

Taēlē, which means bath, the gentle sister of our landlord, if I can so call him, has already seen that everything is in order, and all the mats that cover the pebble floor are properly disposed. Taēlē wishes good morning, and leaves fruit as presents and hangs the great branches of yellow or green bananas. She stays but little, even when pressed, though she is curious as to why we write so much and what we mean in general. She does not quite approve of us; we ask strange questions: we are not preachers — we are seen writing on Sundays: we are not looking for wives. We may be *aitu* — spirits in disguise.

Taēlē's sweet face is always sad — exceptionally so here where good nature marks most young faces. In that she is not Samoan nor properly Polynesian. But she has gone through much. She was the Samoan wife of the former British consul, Churchward, who left her with her little boy when he was promoted to other appointments. Not that she would have gone with him, I think: the Polynesian rarely understands living anywhere else than in his islands — his own island makes the world. Here Taēlē sits on some rock-edge by the water, and looks out to the far-off sea. I see her so almost every evening.

According to true Polynesian habits, the little child has

been adopted by our chief, Tofae, who is devoted to him and allows him great liberties. So that Taēlē has no practical trouble about little George, who lives Samoan way, and, a son of chiefs by birth and adoption, bullies the less important babies.

The other girls, who come in often to see us, and who are occasionally encouraged by little amenities and presents, are not at all sad. Otaota, the daughter of the preacher, who is himself of sacred descent, if I may so explain it, is not even over-bashful, to the great scandal of Taēlē, who is nothing if not Sunday school. She is willing to pose for her portrait without her upper wraps, though she is no longer the exquisite brown statue that she must have been two years ago. But Otaota is a young woman of the world, and who knows? — perhaps these strangers may be serious in their attentions.

Important people, of course, come in to see us, but more frequently in the afternoon. Of chiefs there are many about us, and Patu, Tofae's brother, is a great chief and has been a great warrior; so that I am not surprised at his curious resemblance to General Sherman.

From all these good people my companion, and I also in a small way, obtain slowly, by driblets, the explanation of what they really are. Slowly they unfold the extraordinary differences which make their ways always misfit ours! Their

social words have really no equivalent in ours; their ideas remain a puzzle to whomsoever insists upon our having a common basis to start from.

I have forgotten to describe what the Samoan hut, called the Samoan house, is like. Ours is a handsome one, not exactly the finest, but still very well built. Its plan is a long oval. Its length is not far from fifty feet; its greatest height something like twenty. It is set upon a foundation of stones, and its flooring of fine pebbles is only raised a few inches above the ground, which slopes in all directions from it. It is made of a series of high posts placed at considerable distances from each other, in the shape of an ellipse. They are connected at the top by a series of double beams, which receive great rafters running from every set of posts to the peaked centre. These rafters are connected by other great rafters and tie beams. At the centre they are supported by two or more great pillars, which at intervals are braced together. Beside these pillars, in the direction of each end of the house, are two holes in the ground; made to receive the cocoanut fire used for lighting, or for the slight warmth that is occasionally needed. Walls there are none in the true Samoan house. Mats of the cocoanut leaf hang from the cross-beams, between the posts, to the floor, or rather to the edge of large stones that make a sort of rim to the building, and serve to steady the

posts and keep off the wash of the rain. In certain very elegant buildings some of these openings, instead of being filled with these movable mats that are pulled up or down for protection from light or rain, are enclosed by a fine wattling. It is a manner of limiting the numbers of entrances, which otherwise, you see, would be a little everywhere.

In such a residence as that of Mataafa, a great man, a sovereign prince and sacred personage, no one would think of entering otherwise than at some defined place.

For the furniture of our residence and that of other people, mats of different degrees of fineness are spread upon the small fine pebbles that make the floor. If we want great elegance and great comfort, we put on more and finer mats. Some of the furniture lies about; some of it consists in the Samoan pillow, a long bamboo, supported at the ends by four little sticks. There are also boxes in which clothes are put away. There are large rolls of native cloth called *tappa*. Some of it is made up into curtains to be used as screens and partitions. Sometimes, but not in our hut, these curtains are made into indoor tents for keeping off the mosquitoes, and, otherwise, increasing privacy. All these things are stowed away among the rafters, or upon the sticks curved like tusks, which project beyond the centre posts and serve to brace them.

For our European habits we have two tables and three

chairs. Most of the day when we are idle we sit on the mats with our guests. But working is better done at the accustomed table.

Toward noontime we hear violent and savage shouts, and see through the square opening of the lifted mats three or four brown savages, with big girdles of green leaves and crowns of verdure, come running and dancing to us from Mataafa's house, which is only a few yards away. They carry a big wooden bowl, partly filled with crushed cocoanut and arrow-root, and some big bread-fruits. They sit down on the edge of our outside stones, and proceed to break the bread-fruit, steaming hot, with great force and violence, holding it by the stem, pounding it and mashing it into the cocoanut milk. This quivering pudding, *palusami,* is then neatly dropped upon banana leaves, made into little packages, and tendered to us with the respects of Mataafa. Sometimes we eat, sometimes we distribute to more Samoan-minded people; but for the first few times it is very nice. I like it better than the raw fish and salt water, which is pleasant also occasionally, though apparently more suited to the habits of that ancestral totem, the shark. But tastes and habits differ, and the Samoan language, extraordinarily rich in words that describe physical sensations, has a special word for that state of weakness and languor wherein such a dish as raw fish is all that the invalid can tolerate.

Mataafa sometimes calls at this hour, sometimes a little earlier, on his return from church, if it be a holy day: for Mataafa is very strict in religious duty. But usually he has chosen the afternoon. He speaks no English, and we have varying interpreters; but still, owing in part to his kindness and courtesy, we have learned a great deal from him. He is not so easily questioned as an inferior might be. When Tofae's tall daughter is called in hurriedly to help out, because we have not had sufficient warning (Tofae's daughter, who fears no man, whose neck carries her head as a column does a capital), she interprets with extreme respect and reticence, as it were, "by your leave," bending her head, looking only sidewise at the great chief, holding her breath when she speaks to him, and almost whispering. Every phrase is prefaced with "The King says," all of which gives us the measure of proper respect, but does not hasten the conversation.

Mataafa is not interested in facts as mere curiosities. I doubt if he would approve of my interest in most things, if he could guess it. Information with regard to the world abroad he cares for only as it affects Samoa — that is to say, in conversation with us. He would like to know that we have some messages of advantage to his country. It has taken a long time to make him sympathize with our questionings about

Samoan ways and manners and their origins, which involve, of course, history and social law. And yet if he could appreciate it, in that way we get at an understanding of what he is, and of the difficulties that beset him!

With such talk, much desultoriness, sketching, writing, smoking, and eating of bananas, a length of which hangs from a beam above, the heat of the afternoon passes away. The shadows begin to fall across the *malae* or village green. The villagers come out and wander about socially, attend to little matters, or sit here and there in favourite corners. Weeding goes on with the more orderly housewives, who keep an eye meanwhile upon the children wandering about. A good many domestic interests receive attention. Sometimes, under the bananas and orange trees behind my house, I see hair-dressing, a serious and difficult operation. The pleasure of the Samoans in turning their beautiful black hair to brown or yellow or auburn, necessitates a peculiar process which is also extremely curious to the eye. For this they use coral lime, plastered upon the hair and remaining there a couple of days or more; so that they go about with white hair, like people of the last century.

Tofae's daughter is charming, with her hair all of this silver-grey and big crimson flowers in it. It sets out a certain nobility of feature, and is, like powder, aristocratic in its

very nature. The rather heavy faces become either stronger or more refined. Each young man has some female who especially understands just how to fashion his hair into certain curls and twists, which are retained during a week or so; for the operation answers all the purposes of curling besides, and of cleaning absolutely. When this application is brushed away the curls will remain; but meanwhile, as he sits with his head bent way down and the lady lathering it, he has that woebegone, submissive look that we see in the barber shop.

Our good people are passionately fond of adorning their persons with flowers and leafage: flowers about the waist, flowers about the neck, flowers and leaves in the hair. Every little while I see rearrangements which make, as it were, a form of conversation. The steps of my house offer a convenient seat for just the proper number of persons. So that as soon as the shade comes down, some girl is seated there with some youngster, and they rearrange each other's flowers. A flower behind the ear means a "going of courting" or readiness that way.

In little separate houses the cooking for the evening meal begins. This separation of the household work from the residence or living apartments is a little elegance and refinement which does a great deal to keep up the charm and holiday look of life about us. When, however, great meals are to be pre-

pared, I hear considerable noise on the outskirts of the village, the chasing of hens, whose eggs, by the by, are, as you may imagine, difficult to obtain, as the hens have the surrounding tropical scenery of the bush to lay in. Owing to the scurry after the hens, the only place that seemed safe to them was my apartment; and my open trunks were very good places to look into for possible eggs.

The cooking of any importance, as you probably know, is a method of baking in the earth: stones heated by fire, in a trench upon which leaves are placed, and then the food, wrapped in more leaves, is placed upon them and covered up with twigs, branches and earth. After a skilfully prolonged residence in the earth, the mound is opened, and the food is found cooked. With fish the results are certainly excellent; but vegetables and meats are often a little raw.

It seems marvellous that the brown Polynesian, apparently a member of the great "Aryan" race, intelligent, often adventurous, has never been willing, when his race was pure, to invent such a thing as a pot to hold hot water, even when clay was all about him. He knew that in far-off islands, from which occasionally came invaders or returning adventurers, there was such a thing as pottery; yet he preferred, as he does to-day, to import a few specimens, rather than spend a few moments in starting this, to us, necessary beginning of what

MATAAFA'S COOK HOUSE. FROM OUR HUT AT VAIALA, SAMOA

scientific men call the passage from savagery to barbaric life. You will remember that with us one of the present definitions of the savage is that he does not make pottery, nor know the bow and arrow. Well: the higher Polynesian never used pottery, and used the bow and arrow, one of the most deadly of weapons, only to shoot for amusement at the forest rat. This violation of certain rules of the game of science is one of the most amusing fragments of contradiction that one meets. When we came to other islands, where there is a mixture of what we deem a lower race — the Papuan, negro or black, we find pottery, the use of the bow, intelligent fortification in war. And the beginnings of decorative art are shown by a keener sense of colour and contrast of form. The high Polynesian, who invariably invaded and defeated the mixed race superior to him in these important details, and brought back the "stuff" has lived with a sort of classic severity. Precedent is everything; new patterns of ornament come in most slowly, and there is an apparent indifference to the picturesque. But owing to this conservation such a Bœotian set of islands as Samoa gives to the artist — the man who remembers the beauty of classical representations, the only fit recall of what he has seen in the Greek sculpture, the Pompeiian fresco and the vases of antiquity.

The rather countrified good taste of these people leads them

to simple methods of dress and adornment, and to keeping the same unchangeable except by small variations. There is nothing nearer to the drapery of the Greek statue than the Samoan wrap of cloth or of *tappa*, which is merely a long rectangle wrapped about the body, either as high as the chest, like the cloak of the Greek orator, or merely around the waist and thighs, always carefully arranged in special sets of folds which designate both the sex and the social position of the wearer; with this the wreaths and flower and leaf girdles and the anointed body, which belong to our vague conception of the Greek and Roman past. There is little more for war time; a great barbarous head-dress of hair, and occasionally some neck ornament of wild beasts' teeth.

In draperies such as I have described, in the shady afternoon, the chiefs sit about the lawn of the village the *malae* or green in places which I suppose are reserved to them by habit. They sit far apart; one of the Samoan characteristics being the habit and the skill of conversing distinctly without raising the voice, and of so speaking as to be heard far off. The hereditary orators, the *tulafales*, who made speeches to us in our wanderings, at the receptions given to us by the villagers, invariably chose to speak at great distances. A couple of hundred feet in the open air seemed to them a fair average. Their voices were never raised above a certain

modulation. In fact one imagined that the next word would
not be heard. But a peculiar inflection for each sentence
wherein the most important points are placed at the end,
seemed to force the sound upwards as the phrase dragged on.
Seumanu our Apia chief who acted as our *tulafale*, when we
travelled, liked to repeat "sotto voce" what the other *tulafale*
was sure to say.

Our chiefs often drank their *kava* in these afternoon con-
versations. Sometimes, but very rarely, it was made by the
girls. Usually any young men of the village, of refined dress
and manners, were called upon to serve. I have a vague recol-
lection — though I may have heard it of some other island, and
may be confusing facts — that the ancient custom allowed any
man who wished his *kava* made to call upon the first young
woman who passed, no matter how high her rank might be;
this of course to be at his peril, like all society privileges. But
however it may be, almost invariably our own *kava*, that is
to say the *kava* to which we were treated, was made by the
women.

You will remember that this was one of the very first of
South Sea habits that we came across on our very first day,
in that other island of Tutuila.

Kava, more properly *ava*, is the universal drink of all
Polynesia. Abolished by the missionary in many places, it

still persists here. *Kava* is a drink made by adding water to the crushed and pressed root of a plant of the pepper family, the Piper Methysticum, which has a narcotic power. Here in this nest of civilization the root is grated upon an ordinary tin grater, before being put in the large, four-legged wooden bowl, from which it is to be ladled in cocoanut cups, after water has been properly added, and with a strainer of bark fibres, the filaments and splinters have been removed.

But in certain far-away places, we have had the pleasure of drinking it in the ancient and orthodox way preferred by all epicures. According to this more aboriginal method, the *kava* root was chewed to a mass of woody pulp, instead of being grated. Young ladies of great personal delicacy were chosen for this purpose; but, there must have been many occasions when one had not time to be fastidious. I cannot say that I have noticed any advantage in the older form, and I am glad that all about us it seems to be forgotten.

The entire preparation and serving of the drink makes a ceremonial form; most absolute in detail and of hereditary and ancestral accuracy.* It belongs to all receptions, and is the manner of showing the distinctions of rank and precedence.

* Mariner, whose book all should read, was kept a prisoner in Tonga about 1806, being one of the first white men there. His companions were killed — he contrariwise, like my father in Saint Domingo, was adopted by the great chief, and learned the language and all habits. On his escape and return he was carefully examined and investigated by the intelligent physician who wrote his book for him. He repeated every gesture of the *kava* just as it is to-day, the scientific man taking it down in an accurate way.

The gestures of the girls when they move their hands around in the water of the bowl, so as to extract the essence of the root, are regulated by long established custom, and are beautiful as the movements of a dance. The handing of the strainer to another attendant, and her swinging it out to cleanse it, make another series of most ravishing pictures. Finally the third attendant sweeps an arm down with an empty bowl, and, curving the wrist inward, brings it full to the most honoured guest, and to the others in turn. With each handing the name of the guest is announced.

Mataafa sometimes gives us *kava*, and occasionally has done us the honour to come and drink it in our own hut. In that case he has his own bowl, a most intimate and personal property, from which no one else must drink; and with all courtesy he apologizes to us for this necessity of position. For as he explains guardedly he is in some sense sacred — having been a form of the divine. And he is the most religious of men in our meanings.

In one princely place that we visited, in Savii, we found a lady who occupied by ancestry the position of "*kava divider*"; that is to say that it was her duty and privilege to determine the sequence in presenting the cup according to dignity. And she appeared without warning and claimed the right.

From this circle of the chiefs drinking *kava* on the green,

even the children know enough to keep away. Even the
young man who hands the cups is careful in his walk not to
appear to turn his back to any one of the chiefs. Respect for
the chief is the basis of everything. It is probably the foun-
dation of their extreme courtesy, only broken by natural
exuberance, impatience, or simplicity. The chief was sacred,
even in war. It was a terrible thing for a commoner of the
enemy to kill him. In legends of Tahiti there are tales of
how men deliberated whether they were of high enough birth
to take the life of a vanquished chieftain. The very language
indicates this division between class of the chief and every-
thing else outside. For the chief and everything relating to
him there is a special language. The chief's head, the chief's
body and all its parts, the chief's food, all that he does, his
feelings, his possessions, his dog, his wife and her actions, even
when she breaks the Seventh Commandment, have special
names. In many instances the common name of a thing is
changed for another when that thing is spoken of in his
presence. In some cases the particular grade of his rank is
indicated by the word used; so that you speak of a *tulafale's*
eating as *tausami;* of a chief's eating as *taumafa;* of such a chief
as Mataafa's eating as *taute*. But it would not be polite of a
chief to use these words with reference to himself.

When passers-by draw toward the end of our village and

reach the highway in front of Mataafa's hut, they keep to the further side of the path, leaving as large a space as it is possible to make, out of respect for the privileges of the chief of chiefs.

On all the fringes of the village, however, the children play quiet games. Our spaces are too restricted for the young men to have their games; but further down they collect at times to play, by throwing a stick so as to make it touch the ground and skim along to the goal. So with us there is very little. Occasionally some of the boys gallop wildly up and down the beach; but there are very few horses in this immediate neighbourhood at which we are not displeased, however beautiful the sight may be, because they ride the horses too young, and push them beyond their strength.

As the evening comes on the sun goes down rapidly, and the afterglow, the most beautiful moment of the South Sea day, begins its long continuance. The girls gather together or sit with the young men, either on the grass or on little raised benches under trees, or very late again on still smaller benches, holding at the most two people, which they ingeniously fit between the divergent stems of the cocoanuts. This half siesta, half conversazione, is carried on as long as there is light, and if there be moonlight, through any number of hours that may escape the darkness disliked by the Polynesian.

Our little friend Taēlē leaves her hut and sits far apart in her accustomed place, all alone, immovable, looking toward the sea, thinking perhaps; but how do I know?

Some of the little children, the little girls especially, repeat in a small way the native songs and the native dance the *siva*. Sometimes a bigger girl sketches out some steps for them; but we are extremely proper in our village, and the *siva*, of which the Samoan is passionately fond, is not looked upon with favour by the missionary or the brown members of the church. However, we succeed now and then in getting girls and young men from the neighbourhood, or passing villagers and travellers, to favour us with this entertainment. The *siva* dances about which I wrote you at length, upon the day of my arrival, are yet to us always novel. By and by I suppose that they will be, like everything else, accepted by us as an ordinary form of social dissipation. But it is certainly worth coming all this way, even to see one of them. The beautiful rhythm of song and movement, the accuracy of time kept, the evidently absorbing delight of the performers, who become more and more insatiate, until one wonders that they are not exhausted by such gymnastics, the pictorial disposition of the scene, usually at night or in dark places, the dancers dressed in flowers and leaves in contrasts and harmonies of colour that are nature's own, with bodies and limbs

glistening with oil, the spectators all absorbed, and as Robinson Crusoeish as the spectacle itself — all these things are the *siva*. If I do not refrain and cut short at once, I shall become entangled in trying to give you word pictures that are utterly inadequate. I feel, too, that the drawings and paintings I have made are so stupid from their freezing into attitudes the beauties that are made of sequence. These beauties do not touch the missionary. The invariable objection to amusement, to dissipation, to that weakening of purpose which our indulgences bring, make this natural of course, and we can understand it. But these kindly natives need, I think, every possible excuse for innocent occupation. There is so little for them to do to-day, and we feel that by lending our countenance to the *siva* we are rescuing both the native and the missionary from a false position. The condemnation of the dance had gone from the white missionary to his brown brother, the local Polynesian clergyman or deacon; and when we arrived we learned that even our excellent Sunday-school, church-keeping friend, Faatulia, the wife of the chief Seumanu, himself also a most excellent and worthy member of the church, had been excommunicated for having danced a European cotillion at the Fourth of July ball given by our American Consul. The revulsion is beginning, and we are glad to help in forwarding it.

We could scarcely have *sivas* of our own — that is to say that our village could not give them properly. They should be under the direction of the right social leader, and we have no *taupo*. The *taupo* is a young woman elected by the village for the purpose of directing all social amenities in which women can take part. It is for her to receive the guests, to know who they are and what courtesies should be extended to them; to provide for their food and lodging. If they are great people like ourselves, for their being attended, for their having all small comforts of bath and soft mats and tappa, for their being talked to and sung to and danced to. She is invariably chosen of good descent, and she is beautiful if fate allows it, but she must be a lady above all. She must also be a virgin, and be continually protected, escorted, watched, investigated, by one or many duennas, who never for a single instant lose sight of her. Her position in that way is a trying one. Contrary to all feminine instincts, she is rarely allowed to have her own way in the adornment of her person. Her expert attendants insist upon having a voice in dressing her on all show occasions; notwithstanding, it seemed to me that I recognized in each individual *taupo* a something that had escaped the levelling influence of so much interest taken in her attire. Remember that she dances in front of the warriors in battle.

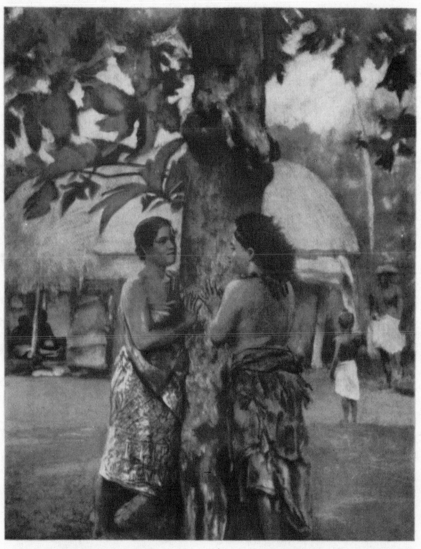

SAMOAN COURTSHIP. FAASE, THE TAUPO OR OFFICIAL VIRGIN
AND HER DUENNA WAIT MODESTLY FOR THE
APPROACH OF A YOUNG CHIEF

When the time comes, the village that has chosen her, also chooses her husband, and makes her gifts, as a dowry. Sometimes, and this is one of the terrors of the situation, the village is very hard to please, and rejects offers which the *taupo* might perhaps have accepted if a less important and freer agent. She can always escape by bolting, and marry as she pleases, thereby forfeiting her position and the respect of well-thinking people. A match not well thought of by society is as much deplored here as in our very best circles. Marriage, apparently lightly entered into, is a very serious matter. Rank, position, is only transmitted by blood; and a mésalliance in Samoa entails consequences still more disastrous than in the court life of Germany. Perhaps my South Sea Islander is not sentimental. He is simple and natural, but he looks at everything in a practical way, and his ideas, having always been the same, enable him to keep this natural simplicity without any protest in favour of that freedom that brings on love tragedies.

As the day draws to its last close in the fairy colouring of the long afterglow, people come back to their evening meal — a regular hour and moment, here where divisions of time seem so uncared for that no older man or woman could accurately know their age; unless they date from some well-known event recorded by the foreigner.

(In other places people have told me, it was so many bread-fruit seasons ago; it was when such a ship was here.)

Magongi, the owner of our hut, returning from his fishing, drops a fish or two at our posts, according to Samoan etiquette and in honour to guests and chiefs like ourselves. Faces are turned from gazing at the sea, toward the houses where meals are getting ready. The young people give up their seats on the little platforms, or "lookouts" by the sea, and the lover confides his courtship, in Polynesian way, to others to continue for him.

This evening, as every evening, with the last afterglow, in each hut of the village, with the lighting of fire or lamp, comes the sound of the evening prayer before meal. In pagan days, with the lighting of the evening fire (meant for light), in the hollow basin scooped out in the centre of the hut, after a libation to the gods *outside*, thrown out between the posts, the Samoan prayed a prayer like this:

> "Sail by, O Gods! and let us be:
> Ye unknown Gods, who haunt the sea."

When I hear the sound of the evening hymn, fixed and certain like all their habits, I recall this prayer, so full of the future that has come upon these dwellers in islands, and has brought with our faith and our ideas — the latter certainly

misunderstood — a slow extinction of their past and of their very existence. For in all Polynesia, though arrested now for a time, there has been within the hundred years from discovery a fading away. As the Tahitian song says:

"The coral will grow and man must perish."

I have been telling of the influence of missionaries upon old customs, such as dances. Let me say something further.

I want to note that it was easier to get the Samoans to accept any form of Christian worship because their religion was simpler than that of the other islands. They were free from a great many horrors — the belief in the necessity of human sacrifice. They hated cannibalism. Their heavier nature had never led them to such immorality as tempted other South Sea Islanders, who thereby resemble us more.

Then the missionaries came to them so late — at the end of the thirties — that the Samoans had already been able to learn about this religion that fixed everything — this desirable law called Lotu, which was to settle everything for them, and make everything straight. (Lotu* also means church, Lotu Tonga, the Tongan Church, etc.) So that within the very shortest possible time the missionaries succeeded in converting them, in fact, were waited for and expected, one

* Religion is a better word, as in Tongan before Christianity.

might say, by the next chance ship. The terrible repu-
tation of savageness of these islanders, owing to their having
murdered La Peyrouse's men in Tutuila, on first acquaintance,
so guarded them that even so far back as 1836, and later,
very little was known of them — they were carefully avoided.
But certain outcasts, escaped convicts, terrors of the sea,
had come among them, and had even begun to instruct them
to expect this law of Good. It is one of the most touching,
as well as one of the most atrocious, of small facts. Old Sam-
asone was telling us the stories of these old times: how some
stranded ruffian, unable to return to white lands, had felt
obliged, upon being questioned, to assert his value and knowl-
edge by some imitation that might not later conflict with the
outside facts. Some brutal, drunken, murderous wretch
would choose, some day, to simulate a Sunday, and sing
obscene or brutal forecastle songs, all the same to those who
did not understand a word, as representing the church service
of song which he described.

Samasone, whose American name is Hamilton, and who has
been here for the third of a century, tells us lengthily and in
detail such stories, and gives us long accounts of Samoan
manners, in the same way that might be his if he were still in
native New England. And when I shut my eyes, I can fancy
myself sitting on the edge of some Newport wharf, and

listening to Captain Jim or Captain Sam, discoursing wisely, with infinite detail.

Fifty years have passed since those things, paralleled more or less elsewhere in the South Seas; and now from the hut of Mataafa, the great chief, which is next to mine, with the sunset, comes the Angelus, sung by the people yet nearer to nature than Millet's peasants. I hear also the Ave Maria Stella; the cry of the exiled sons of Eve for help in this vale of tears, for whether Catholic like Mataafa, or Protestant like my good neighbour Tofae, they are all very Christian. Indeed, my other neighbour is a preacher, an eloquent one, like a true Samoan, a race where eloquence is hereditary in families. I hear him thundering on Sundays against the Babylonians, and all the bad people of Scripture.

They are all steeped in a knowledge of the words of the Bible. In any serious conversation, in political discussion, we hear the well-known types of character referred to, and all the analogies pushed to the furthest extreme.* The rather light-minded girls whom we have about us amuse themselves on Sunday with capping verses from the Bible. The young men of our boat crew, whose moral views on many subjects would bring a blush to the cheek of the most hardened club-

*The traitor is Judas; the hesitating judge is Pilate. When Mataafa's men defeated the Germans, they cut off the heads of some of the Germans killed. When reproached by him for the act as barbarous, they indignantly appealed to David's having cut off the head of Goliath, after having slain him.

man, are fond of leading in prayer, are learned in hymnology, and are apt to be fairly strict sabbatarians. Here and elsewhere, in many other islands, it is often very difficult on Sunday to obtain the use of a boat, the only vehicle possible. Remember that I am, and shall be for a long time, writing from islands, where all life is along the shore, where only occasionally are there roads, or what we would call roads; where there are few horses, somtimes none at all; where the natural road is over the beach, when it is uninterrupted by rock and cliffs, and where the boat can take you quietly along inside of the reef. But as I shall make it out clearly later, the Polynesian likes to have things settled one way or the other, as all sensible people do.

And then the Bible — I am not speaking of the New Testament — is so near them; they read so often their own story in the life of Israel of many centuries back. They are not separated from a civilization of that form by such and so many changes as our ancestors' minds have passed through. Their habit of life must even be said to antedate the biblical. They do not have to make excuses for the conduct of God's chosen people. They can take all as it is written. They need not suppose some error in the account of the witch of Endor. In such a valley, buried under trees, or behind that headland where the palms toss in the roar of the trades,

dwells some woman, wiser and more powerful in the solitude
and in the night than we judge her by day. She can tell what
things are happening elsewhere; what things are likely to come.
She brings in the dead by the hand. She tells of what the
dead are now doing, of their wars and their struggles in the
empty outside world. What she revealed some nights ago,
to a chosen few who say they were present, is murmured about
the villages, and makes a feature of conversation not unlike
society news. I have listened at night, in out-of-the-way
places, among preachers and people of confirmed Bible piety,
to the last reports from the spirit world: to the news of war
there; to the tale of great fights which had occurred on such a
day of the moon, when the battleground of the reef was
strewn with the corpses of the dead already dead to us. And
I remember once hearing how some spirit ruling over a part of
our island had declined to enter into war because he had not
been attacked, and his religious principles, which were Chris-
tian, confined him to the defensive. Perhaps all these things
meant more to my good friends than they did to me, curious
as I was to find in these reports some traits of their character,
some manner of theirs of looking at the things of this world.
I believe that to them these agitations of the outside world
were presages of coming danger, of trouble to their earthly
lives; that they saw omens of victory because the spirits of such

and such possible ancestors had triumphed. But no doubt, in some way not understood by me, all these vague stories confirmed them in certain directions, or made them hesitate. At any rate, it kept the land peopled with fears. It makes the terror of the forest more vivid and more reasonable. The *po* — the dark, the night — is impressive to the Polynesian; the brave man may have all the fear of the little boy. And I own that I have never seen a nature which at night assumed more mystery, a more threatening quiet. The vegetation never rests. The plants are always growing. The sighing of the palms so deceptively like rain; the glitter of the great leaves of the banana, striking one against the other, with a half metallic clink; the fall of dead branches; the sudden drop of the cocoanut or the bread-fruit; the perpetual draught, carrying indefinite sounds from the untrodden interior; the echo of the surf from the reef, against the high mountains; the splash of the water on the shore; the flight of the "flying fox" in the branches; the ghostlike step of the barefooted passerby; the impossibility of the eye carrying far throught angles of tropical foliage — all these things make the night — the *po*, not a cessation of impressions, but a new mystery.

With such a landscape about me, I was ready to believe that handsome young men belated in the passages of the mountains had been met by the female spirit, whether her

name be Sau Mai Afi or not, whose sudden love is death; and that the same being could be a man when the night traveller was a woman and beautiful. Had not the brother of one of our virgin friends been assailed by devils, in some adventurous night voyage, and had he not returned half crazed, and beaten in such a way that he had never recovered? All this had happened while we were there; we might have found him alive had we come a few weeks earlier.

And in the night-fishing how often do the dead, continuing their habits, fish on the reefs alongside of the living. They are silent, and their canoes keep apart, but they may silently step from one canoe to another, only to be known by the chill and anxiety that goes with them. I have seen with my own eyes, far out on the reef, the solitary torch pointed out to me as that of the dead. Often, when suspected, the spirit occupant of a canoe has made for shore and disappeared, *incessu patuit dea*, and has been assuredly recognized by the track of her torch through the mountains, where no living man goes. That certainly must have been our spirit disastrous to young men.

All these sides of common belief, or what perhaps we might call superstition, were shown to us little by little. On the outside our good friends believe roughly as we do, and all this that I am talking about is what remains attached to Chris-

tianity, or more properly, never disentangled from it. And I should suppose that it must have been difficult for the missionaries to expel these survivals of the past, in the same way that the old Church found it impossible, in certain corners of Europe, to wipe out the belief in fairies — the "little men," the "good folk," the "wee folk," the "good neighbours"; the sacredness and influence of places. And here the practical mind of the savage, in its first reaction, after having received a set form of worship and faith as a great relief, would argue that the written Law, the Book, countenances most of the things they *cared* for in their older worship. A very few years after the first christianization which began in the Society Islands, sects were formed, based upon the Bible, or using it as an excuse, with all the security of any theological difference. I have a vague feeling that many of my brown friends think that the Christian, even the missionary, does not carry out properly his belief, and that they themselves are nearer to the letter as well as to the spirit. If the missionaries have let loose among them the famous question of the lost tribes, I have no doubt that many of them must be imbued with the certainty of that descent. Many of their practices are so much like those of the early Jews, that, according to old-fashioned ways of historical criticism, an uninterrupted tradition might be argued. In fact, I am quite sure that many

of the missionaries have so reasoned, and implanted among them a great feeling of confidence. And the Polynesian, having a perfectly healthy mind, likes to have everything settled. Anything more like the typical respectable Englishman I have never met. With the brown man one sees the natural healthy desire of having the questions of religion, of politics, of society, all settled on the same basis; there is such a thing as good form, and that settles it. After the first start, the islanders were much troubled at finding that there were many ways of looking at things, and that religion might be right and manners bad: that the wife of the missionary, who insisted on poke bonnets, was not dressing according to the most aristocratic forms of her own land. And when they find that their written religion does not provide for all their little wants, it must be very natural to supply the smaller ones, which are the everyday ones, with some of the older forms more fitted for individual and temporal advantages. It must be a comfort to many of them to know that the flight of certain birds indicates what they had better do to-morrow; that the coming of certain fish may mean, nay does mean — some change in family history; and they may still prefer to treat respectfully the animals and plants that were associated with their origins — what we might roughly call, their totem. The shark has been respected or the bread-fruit, or the owl;

and in certain cases certain mysterious powers and sanctities might follow the line of descent, though concealed from the public, more especially the white men. Of this, I ought perhaps to say that I am confident; and that the powers would be recognized in certain people even when, as I have seen it, they belong to opposing Christian sects.

The missionaries were Wesleyans, or, rather, men of the London Missionary Society. The form seems to have suited the Samoans. It was a service in which every one took part. There was preaching and eloquence and oratory, and to a certain extent the community was invited into the church — not allowed to enter into the church as a favour. So that notwithstanding their fondness for externals, the Catholic service gives them less of their old, natural, ancestral habits by centring everything in the ministrations of the priest, and by cutting off all chance of any members of the congregation becoming themselves orators, deacons or preachers, and leading in turn themselves. The chiefs also would hesitate in a choice of humiliations; the missionary, white at first and now a native obtaining a position of equal and sometimes superior influence, and that without any civil preparation for the same — indeed with less fitness from the relative isolation of his days of study. Later on I may explain to you more fully how absolutely the chief is the pivot of all social good. He has been for indefinite

ages the cause of all action; he has been personally superior both in body and mind. The entire aristocracy is a real one, the only one I know of. It is impossible to enter into it, though one may be born into it. With our ideas of more or less Germanic origin we suppose a ruler gifted with the power of bestowing part of his value upon certain men lower than himself, and actually making such people essentially different. A Polynesian knows no such metaphysical subtlety. The actual blood of physical descent is essential to supremacy, except in a most vicarious and momentary manner, or as by marriage so that the children may become entitled to whatever the sum of the blood of parents represents. With them an heir to aristocratic privileges or power or influence or prestige represents nothing more than the arithmetical sum of his father's and mother's blood. I have had lately a Sunday afternoon visit all to myself, from a charming little girl who is the daughter and sole child of the king; a nice little girl with pretty little royal ways, who explains to me that she does not like things here so well as she did where she was taught English, where she had been at school, in the British colony of Fiji. There she was a king's daughter, and any English ideas around her would be more flattering to her consequence than even the kindly feeling of the subjects of her father. For her mother is not of equal blood, besides being a foreigner.

The great chief Malietoa Laupepa, whom we have made a king, cannot make his wife, according to Polynesian ideas, any more than what she was before he married her; and the little daughter has only in her veins the royal blood on one side, and a certain respectability on the other. To the true Polynesian mind, such a one of her cousins, of less high descent on the father's side, may be of higher descent on the mother's, and the sum of those descents may be very much greater than the sum of the descents of the daughter of Malietoa Laupepa. Hence it requires a great stretch of loyalty to look at such a little person with the veneration that the Polynesian feels for "chiefy" origin; and you can understand what a disastrous and bloody muddle we have made it for them when we have told them that the word *king* represented anything that they had themselves or could have. With them *Rex nascitur non fit.*

All this has been explained by the supposition of two different races, one of which, that of the chiefs, had subdued the other. There is no such tradition, however, and no apparent reasons to explain the enormous superiority of the aristocratic lines except the simple physical ones of choice in breeding and of better food and less suffering, continued for centuries and centuries. Even at a distance a chief can be distinguished by his size and his gait, and a successful collec-

tion at some political entertainment brings back the dream of lines in the Homeric catalogues of heroes. Great size of limb, great height, consequent strength and weight, a haughty bearing, a manner of standing, a manner of throwing his legs out in walking, like the step of a splendid animal, a habit of sitting upright — all these points tell the chief.*

Upon these superior beings, then, brought up to command, considered as sacred by themselves and by all below them, devolved perpetually the duty of deciding everything that was to be done. Even in a detail so minute to our minds as that of a day for fishing, the chief decided, and does yet, what the community should do. The good fortune of all was dependent upon his wise choice. As the chief has often explained to us, when the women began to talk too much, and fix their minds upon harmful gossip, a healthy diversion was that of ordering them to make the native cloth — an absorbing process. With all the refinement of political leaders, excuses would be found for such an enforcement of industry: the occasion of some visit to be made or received, when every one entitled to it should appear with many changes of dress; when the visitor or the visited should receive presents of beautiful cloth. Let me say how elsewhere, in another group of islands,

*My adopted sister, the Queen of Tahiti, an island enormously changed by European influence and residence, complained to me of some young man — that his walk was insolent, out of keeping, like that of a person of importance by blood.

the earlier missionary interfered and broke up the industry
of women, without evil intention, making them idle, and open-
ing thereby the gate to ruin. In Polynesian life, as I am try-
ing to explain, things were intimately connected. There were
religious forms or words — or shall I rather say, forms and
words of good omen? — accompanying all ordinary human
action. Had the missionaries realized this perfectly, they
might almost have interfered with the savages' breathing; but
they fastened on the pagan forms connected with the making
of cloth, and the women gave it up, and bought cotton from
the white man, and paid for it the Lord knows how.

The chief, then, sent the young men to fish and the women
to work, when it was needed both for physical and moral
good. War, of course, they always had, as a last resource,
just like the great politicians of Europe. The constant inter-
ference, involuntary very often, very often most kindly meant,
of the missionary or the clergyman, diminished this influence
of the chief — an unwritten, uncodified power, properly an in-
fluence, something that when once gone has to be born again.*

*Père Gavet complained to me of what he called the unreasonableness of Sir John
Thurston, the high commissioner and English governor of Fiji, when the Catholic bishop,
upon his canoe's touching the shore of some Christian village, was carried up, canoe and all,
into the public place or village green, Sir John interfered, and forbade its ever happening
again. And I myself could not say that it was not a small discourtesy.

But this was the point, as Sir John told me: in the old Fijian habits such things were
done for a sovereign chief, and for a political ruler; and since the Church had preached the
division of the two authorities, such special homage should have been reserved for the civil
and not the religious power.

And the brown clergyman, continuing the authority of the white one, has something further, less pure, a feeling of ambition, a desire to assert himself against former superiors; and he is perhaps still more a dissolvent of the body politic into which he was born.

I see no picture about me more interesting than the moral one of my next neighbour, the great Mataafa. To see the devout Christian, the man who has tried to put aside the small things that tie us down, struggle with the antique prejudices — necessary ones — of a Polynesian nobleman, is a touching spectacle. When a young missionary rides up to his door, while all others gently come up to it, and those who pass move far away, out of respect; and then when the confident youth, full of his station as a religious teacher, speaks to the great chief from his saddle, Mataafa's face is a study. Over the sensitive countenance, which looks partly like that of a warrior, partly like that of a bishop or church guardian, comes a wave of surprise and disgust, promptly repelled, as the higher view of forgiveness and respect for holy office comes to his relief.

But Mataafa is not only a chief of chiefs, he is a gentleman among gentlemen. My companion, difficult to please, says, "La Farge, at last we have met a gentleman."

His is a sad fate: to have done all for Samoa; to have beaten

the Germans and wearied them out; to have been elected king
by almost unanimous consent, including that of the present
King, who wished him to reign; then to be abandoned by us;
and to feel his great intellectual superiority and yet to be idle
and useless when things are going wrong. And more than all,
however supported by the general feeling to-day, if he moves
to establish his claims, the three foreign nations who de-
cide Samoa's future, not for her good, but for their com-
fort or advantage, will certainly have to combine and crush
him.

He is a hero of tragedy — a reminder of the Middle Ages,
when a man could live a religious life and a political one.

And his adversaries among the natives are among our
friends; and we like them also, though there is none to
admire like Mataafa standing out for an idea for the legiti-
macy of right.

For all the soft Communism of which I spoke, the chiefs
were the stiffening, and are so still in as far as the new ideas,
or rather want of ideas, do not affect their real authority.

As I tried to explain, these are chiefs, lesser or greater,
hereditary, essential; nothing can replace them, no commoner
come into their position or a similar one. Alongside of them
an European monarch is a half-caste or a parvenu. When,
as you will see, we, that is to say the English and Americans,

made one of them a king, we made a thing unknown before, unthinkable in reality among their social machinery.

For however true it is that the chief is so by birth, by authority of nature, you know that in Samoa he is also elective. A council of chiefs of his own race determine whether or no he shall "bear the name." For smaller chiefs, their own names; for certain great ones, such a name as Aana or Malietoa.

With these names goes the power over certain places large or small, but each having a traditional value. Should a chief of sufficient blood have all these five names (and he cannot get them without such natural inheritance and the name may remain empty), should he have all five names, then he is of necessity king, that is to say, chief of chiefs. But if he have only three, then imagine the confusion made in the true Samoan mind by our making him king.

Mataafa has held more names than any other, and would no doubt be to-day elected king by the majority of the Samoans; and absolute agreement would probably always be impossible. But though the treaty between Germany, England, and the United States, as promulgated in the Island, decided that the Samoans should elect their king, and thereby Mataafa would be the man; yet a secret arrangement, or what is prettily called a *protocol*, not published to the Samoans, decided that

Mataafa especially and alone should not be allowed. He was the only man who had successfully defended Samoan independence as far as it could be, by word and by action; he had fought the Germans and defeated them, and that was the reason.

According to American ideas Mataafa would be the only proper person, but Germany and England have arranged for some time back all matters of influence and policy; and whatever we have wished, or might have wished, we have always been obliged to vote over against them, and must continue to do so.

But the German cause is such a bad one, so foul at the origin, and so brutally helped on, that it has been impossible for Great Britain to ignore justice absolutely, and we have done something in the cause of humanity and so far served God.

Money can have no feeling; political ambition only what may help; and the cause of all this trouble which has made this little island known to the entire world is the hope of saving some money badly invested.

A great Hamburg firm with a French name, the Godeffroys, had some years ago established itself in most islands of the Pacific; it was the great firm — the German firm. But as often happens, speculations in other matters, or Russian-Westphalian securities broke the great man, the former friend

of Bismarck, and when a German company, known as "The German Company," succeeded to his assets in the South Seas, they found the greater part of them sunk in the Hares-plantations of the firm in the Islands of Samoa.

Everywhere else there was no hope, but here if sales could be proved valid, if by any means the present labour system of black imported savages from other islands could be replaced by a system of "peonage," for the natives, if taxes could be placed upon the community which can only be taxed by making the industrious support the idle, if in fact, the firm could control the islands, money might again be made and perhaps the millions sunk be made to pay or fully recovered. Elsewhere in islands where French or English ruled, it was so much the worse for the adventurous if things went wrong, and there are cotton plantations and sugar plantations, which have gone to pieces as it became impossible to keep them up, industries and speculations which first started into life with our war.

From early days political or state reasons were carefully kept together with business ones; the political representative of Germany would be also the manager of the firm, so that if one kind of reasoning did not work, then another might. Anything became constructive insult or opposition to the Empire of Germany — even a sort of lèse majesté or sus-

picion of treason. Business and the navy supported each other, and on a small scale the story of the "John Company of India" was repeated, with the same cruelties and atrocities more easily noticed because of foreigners being there, because of our modern institutions of the press and the telegram.

AN ACCOUNT OF RESIDENCE AT VAIALA

Our friends Seumanu and Faatulia tell us, with much emotion, how Malietoa, now the king, wept with them when he went off a half voluntary prisoner of the Germans, hoping that by his sufferings his country would be spared bloodshed; and that in some way or other the Europeans would desist from their grasping demands. Then Mataafa headed the resistance which two years ago saved his race from the extermination threatened by the Germans; made him among his own people the equal of his hereditary claims; and entitled him to the name given him by Admiral Kimberly, that of the Washington of Samoa. To fight German discipline, and German ironclads, with naked followers bound together with the loosest ideas of allegiance, seems a story out of a dream, and certainly would have come to a disastrous end had we not interfered. The Berlin Conference in which we acted restored Malietoa to his home and his power practically, but in theory made him dependent on the choice of the Samoans,

which choice the conference guaranteed. That is to say, those
were the words of the treaty on which Mataafa stood. But
both English and Germans agreed that a man who had de-
feated the Germans should not be elected, whether he was
chosen by the country or not.

This secret protocol is a disgraceful result of the indifference
of our representatives to the good name of the United States,
and to what is more atrocious yet in my mind — a want of
comprehension of the value of the United States and of its
enormous power. One must go abroad and far away to realize
that whenever we wish we are one of the main powers of the
world. It is on our sleeping that grasping nations like Eng-
land and Germany depend.

Mataafa has probably been aware of the secret protocol
which excluded him from competition as king, a protocol, as I
have said, made exclusively to please the Germans, by the very
weak person whom we detailed to the Berlin Conference. To
repeat, we made a treaty which would give the Samoans the
right to elect their so-called king or head chief, and now we
break its lawful meaning by providing that the one man who
would have most suffrages, and who represented the highest
claims of legitimacy, should be exempted if elected.

When Malietoa, brought back by the Germans, worn out in
body through his sufferings in a cruel detention, landed again

in Samoa, he was received by Mataafa. Remember that they are blood relations, and that when one failed, the other had taken up his cause and won. They embraced each other, and were left alone by their attendants. It is said that Malietoa urged upon Mataafa to retain the power, Mataafa declining. Some compromise was effected, the terms of which are not known, but which meant that Malietoa should go on reigning without Mataafa's abandoning any claims. Now Mataafa is in a sort of retirement, living in a manner extremely difficult for us to understand, were it not that he resumes in his person all the ideas that a South Sea man can have regarding the proper chief of chiefs. Remember that he is *tui*, which is nearly what we call a king, of the great districts of Atua and Aana, which have prescriptive rights of election; and he has himself the name of Malietoa — what we would call the title given him by the very district of Malie from which the Malietoa derives his name: and that this was given to him when there was no one to bear this historic burden. Here he is, living in the further end of the village, only a few feet from our own hut, which as you know is loaned to us, we suppose by Magogi the chief, though this is not very distinct. Of course in Samoan way we shall present to him, or to somebody, gifts equivalent to the use of the house, to the dignity of Magogi, and to our own essential dignity of American chiefs.

To my western mind the situation is very curious. Mataafa is already in a mild opposition which at any moment may become extremely serious. He must know the intentions of the three powers, and cannot, as I understand, forego his claims. Here he resides under the apparent protection of the chiefs of the village, our friend Tofae, and his brother Patu, the great warrior, who are I think necessarily partisans of Malietoa; and who would make war upon him in case of a break. But outwardly the greatest reverence attends him. One feels it in the air. At this end of the village, separated from the other by many trees, there is always quiet. The children never make any noise; even the very animals seem to understand that they must not come near. The few disturbances are those of Mataafa's own men when they do any chores in the outside huts reserved for practical purposes, so as to keep all housekeeping away from the residence. The giggling girls are quieter; every one's voice is lowered: on the road that passes at a little distance from the great chief people edge away toward the further bushes in the quietest and most homely manner. There is the perpetual recognition of a king's presence. Mataafa goes out very little. He trudges out to early mass, along the same exact path; has services at home, and every evening the hymns are sung within his hut. He goes out early in the morning to do work, like every-

body else, in his little patch of taro planting, and returns
after this gentle exercise, naked to the waist, like any other
common mortal. His goings out are apparently few; though I
seem to see certain special visitors drop in of an evening.
Sometimes, as you know, he calls upon us, and this was his
first — shall I say command or visiting-card?

(Envelope)

<div align="center">

Ia Lasusuuga Alii
Amelika
Nasei maliu
mai nei

</div>

Oi le fale o Tofae

(Autograph letter)
Vaiala
 Oketopa, 11 1890
 iala susuuga Alii Amelika
Aliie ale nei lau tusi ia te ou lua ia ou lua faamolemole oute
manao e fia fesi la fai ma oulua susuuga fe oute alu atu ilou
lua maoto fe lua te maliu mai i lau Fale alou taofi lea efaasi-
lasila atu is ou lua susuuga.
Ona pau lea ia Saifua.

<div align="center">

O au M J Mataafa

</div>

[Translation]

<div align="right">

Vaiala, Oct. 11, 1890.

</div>

To the Distinguished Chiefs of America
 O Chiefs
 This my letter to you both. Will you please my wish to
meet your Honours? Shall I go to your residence, or will you
come to my house? This it is my wish to let your Honours
know. This is all. May you live.

<div align="center">

I am
M. J. Mataafa
(Malietoa Josefo Mataafa)

</div>

In return for our call the great chief has called many times upon us. He apologizes almost for his position of something sacred, for his being obliged to drink out of his own cup, for instance, and, as I told you, has yielded very slowly to the investigations of Atamo* concerning the rights of law, of property, of kinship, which must at first have appeared to him irrelevant and indiscreet. Even Seumanu, with whom we are so familiar that we threaten to take away his name occasionally (Samoan legal deposition from office), even Seumanu was obliged to say once, "Years ago I would have killed a man who asked me that question!" I believe it was some inquiry as to his exact descent and consequent claims from his grandmother. But one of these visits of Mataafa brought about a meeting with Stevenson which I had thought might not take place for some time. It is always difficult for those of us who have the cosmopolitan instinct to realize how fundamental are the views of the Britisher. Mr. Stevenson had been explaining to us a difficulty I could hardly appreciate, and that was the question of whether he should call on Mataafa or wait until Mataafa called on him. I know how that would be settled in England. No one would expect the Queen or the Prince of Wales to call first, even though they cannot have for themselves the sense of dignity and sacredness which must envelop Mataafa. The

*My South Sea companion, Mr. Henry Adams.

Queen is the head of the church and defender of the faith; but she is not so by blood, whether there be a church or not. It is this peculiar element of something sacred, as it were of the son of a demigod, the natural intermediary between this world and the next, which is gently latent in the original idea of the aristocracy of these people. Even to Roman Paula, the spiritual daughter of St. Jerome, it must have been something beyond our ken to be a descendant of, let us say, Agamemnon or Achilles or other sons of demigods. In this state of mind Mr. Stevenson came in upon us during one of Mataafa's visits, and succumbed at once to the delicate courtesy of the great chief. He managed so prettily to express his knowledge of Stevenson's distinction, of his being a writer of stories, and a wish to know him limited by the difficulties of his position.

Meanwhile, I say, Mataafa bides his time. He waits patiently, en évidence, but doing nothing. This will irritate his enemies, but I seem to see that for him there can be no more legal course. As long as he does nothing, and makes only a mute appeal to justice, he is entirely in the right. He is not supposed to accede to the protocol which excluded him. I think I understand somewhat of the absurdly complicated position which his friends or his enemies hold — position based on hereditary rights; long internecine wars; ancient privileges of small places which have rights of election, but

which are too weak to enforce them; and, above all, on both sides questions of complicated descent. Even if I were correct, and made no mistakes, which could hardly be, I would not dare to go into a lengthy explanation of the claims on both sides.

One great enmity Mataafa has: more intense than that of the Germans, because partly unconscious and founded on the worst passion of humanity — theological hatred. That enmity is the dislike of the foreign Protestant missionary, who moreover is absolutely English in his ideas, his wishes, his intentions, and has a perpetual political bias. Mataafa is a Catholic, like many of the chiefs. Naturally he has Catholic advisers, and some of them may be — though I don't know it for sure — tainted by the same politico-religious ideas as their opponents. They probably supply the great chief with information of what the great outside world would do in his favour; opinions based on their wishes, and not on the meanness of mankind, which is the only logical basis of politics.

As a proof of the atrocities to which the religious mind can consent, listen to this charming detail. It belongs to a time when I was no longer in Samoa. I have mentioned in my other journals and letters the names of the Rev. Mr. Claxton of the London Missionary Society; and I can add to what I said that was *pleasant* that he seemed to be the usual gentle clergyman, with side-whiskers, and sufficiently modern, and

that he spoke very nicely, as I thought, of the religious state
of the Samoans, and evinced a sense of a certain steadfastness
of theirs, which distinguishes them from many of the other
varieties of South Sea people. Mr. Claxton also pleased us by
recognizing the Samoan dances as not being sinful, by being
present at one of them, with Mrs. Claxton. You know that
poor Faatulia was excommunicated for attending the Fourth
of July dance, which was of course attended by the wives or
daughters or aunts of the English or American consuls. The
action of our reverend friend was all the more graceful be-
cause the dance was in honour of Faatulia's niece, if I re-
member. Mrs. Claxton also we hear all sorts of nice things
about. She is "Misi Talatoni," and Meli Hamilton gets a great
deal of fun out of her, pretending that we admire her dress
much more than Meli's. Never would you suspect these
gentle associations connected with the ideas of mediæval
assassination. But in August, our Consul, coming down to
Australia, and meeting us on the way to Java, told me the
following story because he wished me to take a hand myself.
Mataafa's habits were, as might be expected from his charac-
ter, particularly steady as belonging to a war chief, a king, and
a devout churchman. He went to mass every day, by the
same path, and did not flinch or change his track when the
Germans fired at him. Somehow or other, as happens to

generals and to people who make a good mark, he was never hit. On this peculiarity of Mataafa's was based a proposition made by the Rev. Mr. Claxton to the Consul. There was now absolute peace; and Mataafa and myself, or you would have a perfect right to walk along the road to church without being fired at. But German discipline has characteristics quite as distinct as Mataafa's. Might it not be possible, if any German marines were landed by chance, to place some sentries on Mataafa's road, presumably if he went to evening service? He would suspect no harm, and even if he did, would not move from his path. The German sentinel would by duty be obliged to fire, and consequently no one would be to blame, and Mataafa would be out of the way. This the reverend clergyman thought could be managed. What Consul Sewall wished of me was that I should warn a friend of Mataafa's, Father Gavet, who lived somewhere along the coast, but whose long acquaintance with Samoan manners would find some way of avoiding the possibility of this little incident. I wrote to Father Gavet, who answered me, at some distance of time, of course, that the plot was understood; for, as Mataafa said to me, "There are no secrets in Samoa," and the friends of Mataafa had taken necessary precautions. I never heard anything more about it, but I believe that the Reverend Claxton has been withdrawn.

Of course as long as the waters are so disturbed, each party may hope to fish for their advantage; that is to say, the German for politico-commercial reasons, and the English for the same; and this all the more that the English government recognizes what is called spheres of influence, and that it is inclined to concede to Germany such an influence here, even if its representatives be not officially ordered to do so. We, who do not recognize these spheres of influence, are, however, prone to assist all Protestant missionary tendencies, right or wrong. Votes are votes. Besides, not only do we not recognize spheres of influence, but we are uncertain of any political tradition, and we are easily handled by England, to whom we are still intellectually subject. We are also more or less out of the game. We have no Heligoland or Hinterland in Africa, to trade off against influence in Samoa or New Guinea. We are still in the dark as to our fortune; we don't know the importance of the Pacific Ocean to us, nor the immensity of future eastern trade. As the Germans here impertinently remark, we would trade an empire against the votes of a town in New Jersey, or the honour of dining with a countess.

Brandés, the German dictator, that is to say the German official who controlled Samoa for a time, representing both Germany and Samoa, said of us: "A nation, which in all decisions of foreign policy must take into its councils the sen-

ate and sixty million of people, can never have a foreign policy worthy of the name." We might easily withdraw, even temporarily; then for the protection of German property, German forces could be landed in Samoa, the imperial flag be hoisted, and whoever would dare to haul it down? Bismarck, acting through his son Herbert, has apparently well arranged our agreements so that events might turn easily that way. On Mataafa these conditions hinge. As he acts, or is kept from acting, the possible possession of this key of the Pacific will be determined.

And yet the Pacific is our natural property. Our great coast borders it for a quarter of the world. We must either give up Hawaii, which will inevitably then go over to England, or take it willingly, if we need to keep the passage open to eastern Asia, the future battleground of commerce.

You can see how reasonable it is then that Mataafa should take an interest in us as Americans, and hold on to a hope that we might, however faintly, help the cause of his people, and keep them, as he says, from slavery. Moreover, as his men it was who rescued our sailors in the great calamity of 1889, even though they also rescued the Germans, with whom they were at war, he feels that kindness of obligation which comes to those who have tried to benefit others.

All this is politics, and you are probably, like the United States, more or less indifferent to anything that has not the

name that you are accustomed to. To me, on the contrary, my real and absorbing delight is the sense of looking at the world in a little nutshell, and of seeing everything reduced to such a small scale, and to so few people, that I can take, as it were, my first lessons in history. I don't know that I should put it all into the form that Mr. Stevenson uses, in which I do not quite agree with him: that here, at length, we were free from the pressure of Roman civilization. I own of course, that all comes to us through Rome, and that the dago has had the making of us. The words which I use of course imply that. I can't talk of politics, of civilization, of culture, of education, of chivalry, of any of the aspirations of the western world, without using the words implanted with the ideas in our barbarous ancestors; but before the culture and development of Rome was a something which had some analogies to what I see here. I am continually thinking how it may have been with my most remote ancestry, whenever I understand any better the ideas and habits of our good people here. As also they have passed from some still earlier or more remote stages, their ideas are easier to understand than those for instance of the Australian or even of the Fijian. A tendency to the commonplace, to a certain evening up of ideas, seems to belong to them, and makes them easier to understand because in so far they are not unlike us. They dislike excesses in

thinking, and too logical extensions of what might be called political ideas. About all this social difference of organization, I have written to you, I should say continually. I must have given you most of the details, even if I have not made a summary of the form of early civilization.

I am troubled also at writing about things and ideas, and using words which have grown out of things and ideas extremely different and often contradictory. As the Christian terminology, the very language of the Gospels, was perforce made up of pagan forms and terms, so to-day, I shall have to describe what might be called pagan forms and ideas in a terminology now influenced by Christianity, and saturated with problems connected with it, so that probably Greek or Latin would be more natural, though even they, you know, are read by us with a bias that their authors never dreamed of.

But as long as I do not write, it is pleasant to see the ideas without words, and perhaps descriptions may not have been the worst way to give them.

A MALAGA IN SEUMANU'S BOAT

25th Oct., 1890.

Malanga, written malaga, is a trip, a voyage where one puts up with friends, etc.; one of the fundamental social institutions of Samoa.

WHAT SEUMANU'S BOAT WAS

"Secretary of the Navy to the Secretary of State. Acknowledging assistance by natives of Samoa.

"Navy Department,
"Washington, D. C., April 27, 1889.

"SIR: In a report dated Apia, Samoa, March 26, 1889, from Rear-Admiral L. H. Kimberly, U. S. Navy, commanding the United States naval force on the Pacific Station, the Navy Department is informed that invaluable assistance was rendered by certain natives of Apia, during the storm of Saturday, the 16th March.

Rear-Admiral Kimberly calls particular attention to Seumanu Tafa, chief of Apia, who was the first to man a boat and go to the *Trenton* after she struck the reef, and who also rendered material aid in directing the natives engaged in taking our people and public property on shore on the 17th and 18th.

"Special recommendation also is given to the men composing the boat's crew, as follows: Muniaga, Anapu, son of Seumanu, Taupau, chief of Manono, Mose, Fuapopo, Tete, Pita, Ionia, Apiti, Auvaa, Alo, Tepa.

"The Department has the honour to request that you will express to the authorities of Samoa, through the proper channels its high sense of the courage and self devotion of Chief Seumanu and his fellow countrymen, in their risking their lives to rescue the shipwrecked officers and crew of the *Trenton* from their position of peril and distress; and that you will, at the same time, inform them of its intention to send to the Chief Seumanu in accordance with the recommendation of Rear-Admiral Kimberly, and as a mark of its appreciation,

a double-banked whaleboat, with its fittings, and to reward suitably the men composing his crew, for their brave and disinterested service. I have the honour to be, sir, very respectfully, your obedient servant,

<div style="text-align:center">"B. F. TRACY,
"Secretary of the Navy.</div>

"The Secretary of State."

The accompanying extract tells you the story of the boat in which we are making a malaga to some of the places near us — to the northwest end of our island of Upolu, to this little Manono, with an old reputation for war; to the ancient sunken volcano crater of Apolima; and to Savaii, the big island important in politics, and important in name, and important in history.*

Seumanu takes us along in his boat, and as it were under his protection, a convenience certainly, but also perhaps not an unencumbered blessing, for there will certainly be a colour of politics in our trip. All the more that our own boat goes along also with our own rowers, and the consular flag, for the Consul is with us, and is in (I fear) for many speeches which he will have to acknowledge, and we shall suffer all the more. For already there has been much speech-making; the *tulafales*,

*Savaii, Hawaiki, Hawaii; apparently all Polynesians come from a place of the name. It is also a name for the Unknown World. Many islanders of the Pacific believe that this Samoan island is the ancestral Savaii. The Samoans themselves assume it to be so. The island holds the home of the Malietoa, for centuries a supreme chief, one of whose representatives is now king by treaty.

the village orators, and occasionally rulers, or balances of power with the chiefs, and who as far as I can make out keep this place by inheritance — the *tulafales* have been in force. Seu has repeated their speeches ahead of them in a grumbling way, evidently not quite pleased. Perhaps the paucity of gifts in this poor little place helps to annoy him, and yet we gave them short notices of our coming and we are many to provide for, over twenty-five in all; or perhaps, nay certainly, their political complexion is not of the right shade and he remembers too well that they were but figure-heads in the last war, not withstanding their military renown. What annoys him as a chief "qui se respecte," gives us infinite pleasure. All comes down to the small scale that befits the place and its rusticity. It is rustic, as I need not assure you, but it has also a look of make-believe that gives it a look of landscape gardening — the look of a fit place wherein to give a small operetta in the open air.

The village is on a small promontory, beyond which juts the outline of some rocks crowned by a chief's tomb that is shadowed by trees. The water within the bay reef is of a marvellous green-blue, whether it rains or whether it shines, and not far off, perhaps only a mile or so, Upolu is blue or violet or black or grey in mist; and the sea outside always makes some colour contrast with the sea inside the reef. The

village is just high enough upon the shore to conceal the actors
on the beach, except where in two or three places the clean
sand sweeps down under the trees or next to heavy rocks, so
as to allow the tenor and the diva of my supposed opera, to
go down and throw out a great song. This is striking enough
in the day but in the evening afterglow or the shine of moon-
light, themselves apparently made on purpose, it is deceptive;
people step down little rocks on coming out of small huts, a
few real canoes are placed under the trees whose outline in the
shade has been arranged by nature in rivalry of art.

Subsidiary pictures painted by a Greater Rembrandt with
centres of light and prismatic gradations of gloom fill the
cottages placed on the little elevations, and only a few people
gracefully move about — just enough in number: and all with
a classic action that comes of not frequenting foreigners.
Snatches of song, and cadences come alternately from dif-
ferent corners or from under trees, and as I said all this is lit
with a mysterious glow.

Besides, in the day there have been few people; some little
girls only in our guest-home and the chief who with his whit-
ened hair, strong jaw, and sloping forehead has a fair look of
the "Father of our Country."

In the presentation of food, a necessary ceremony, only a
dozen men have appeared, nobodies in particular: and before

them has capered a naked being in green leaves, as to his hips and head, who has danced with his back toward us, keeping the line in order, and who looks at a distance like the Faun of the Greek play in the Pompeian pictures. Then they have all rushed forth and cast down their small presents, taro and bread-fruit and cocoanuts, in palm baskets and as suddenly disappeared; while the *tulafale*, an old gentleman of the old school, making, according to old fashion, a great curve of pace that shook out his stiff bark cloth drapery, has slipped out and taken his place, leaning on a staff, his official fly-flapper balanced on his shoulders. These people of importance, and one I think of great dignity, have squatted down on the grass, and another has seated himself on the great war drum under the bread-fruit trees. Then a long speech has been made, with praise of us and of our country that has rescued Samoa, and thanks to God and prayers for our good health, etc., etc., all in a clear voice, not loud at all, just enough to reach us, no more; and with a Samoan accent upon the end of each phrase where some important word is skilfully placed.

All this we listen to and witness from our little house, whose posts are garlanded with great bunches of red hibiscus flowers and white gardenia and many leaves, and the effect is partly that of some living fresco in imitation of the antique,

partly that of an opera in the open air. But if this is real, then the modern painted pictures of open-air life with the nude and with drapery are false. Our French and English and German brethren do not know what it is.

Apart from the light and its peculiar clearness, Delacroix alone, and sometimes Millet, have understood it; and no one of the regular schools of to-day. Back of these, of course, all the classics are recalled from Watteau and Rubens and the Spaniards to the furthest Greek.

So that the little episode that worries Seumanu is full of fun and of charm and of instruction to us. Its scale is so small that we can grasp it. There are but half a dozen actors, and a small set scene. In front of us, sitting so close to our house, on its pebble slope, that his figure is cut partly off, sits one of the crew, who, when all is over, and the speech has been duly acknowledged by Seu as our spokesman, will count over the presents, and in a loud voice will announce their number and their origin: So many cocoanuts from so and so — so many chickens from so and so — etc.

Two mornings ago we left Vaiala, and rowed westward within the reefs, along the north coast of our island of Upolu, off which, within a couple of miles, lies the little Manono from which I write. Twice we stopped in this enemy's country,

that is to say, among adherents of the former king or head chief set up by the Germans. There was all the charm that belongs to the near coasting of land in smooth waters: the rise and fall of the great green reflections in the blue satin of the sea inside of the reef; the sharp blue outside of the white line of reef all iridescent with the breaking of the surf; the patches of coral, white or yellow or purple, wavering below the crystal swell, so transparent as to recall the texture of uncut topaz or amethyst; the shoals of brilliant fish, blue and gold-green, as bright and flickering as tropical hummingbirds; the contrast of great shadows upon the mountain, black with an inkiness that I have never seen elsewhere; the fringes of golden or green palms upon the shores, sometimes inviting, sometimes dreary. And our rowers in their brightest waist cloths, with great backs and arms and legs, red and glistening in the sun that wet them even as much as the cocoanut oil with which they were anointed. And when tired with sitting, they lie stretched out and confidently rest against the giant Seumanu's great thigh and hip, while he occasionally patted his sleepy weaker brother, La Taēlē.

Still, beauty of nature, and plenty of soft air do not prevent fatigue, even if they soothe it, and I was glad when in the afternoon we had reached Leulumoenga — our final halt — a village type of Samoa, spread all over the sandy flat of the

back beach, and half hidden in trees. As we came up the shelving beach, children and women came down to meet us, and watched us curiously. Among them, in their new dignity of fresh tattooing, a few youngsters eyed us from further off, moving little owing to the pain of the continued operations — haggard and fevered looking, and brushing away nervously, with bunches of leaves or fly-flaps, the insects that increased their nervousness. For tattooing is no pleasant matter. The entire surface from hip to knee is punctured with fine needle-work. The patient stands what he can, rests awhile and recovers from his fevered condition; then submits again, until slowly he has received the full share. Nor does he shirk it — it is his usual entry into manhood; without it the girls are doubtful about him, and he is somewhat looked down upon. The present king, brought up by missionaries, and accepting many of their prejudices, had not been tattooed in his youth.

During the few hours of our stopping we returned the call of Father Gavet, one of the French missionaries, and saw his new church that is to replace an older one destroyed by the great hurricane. It is of coral cement, like most South Sea churches, a beautiful material when it blackens with time. I hope they will transfer some of the old

carvings from the earlier church; which, made by early converts, have a faint look of good barbaric art — so good — oh, so good — compared to what the good missionaries get from those centres of civilization called Paris, London and Berlin!

In the latest afternoon, with coolness and rays of heat and light, we rowed further along the coast to Satapuala, where we were to rest in the great guest-house, under the protection of the chief's sister, the *taupo*.* It was all like little Nua on a great scale, and with more elaborate preparations. We had soft mats to lie upon and later more again to be beds. Nor did our hostess abandon us until the last moment, when we were apparently satisfied with our lair, and according to far-off western habits had officially "retired."

Her decoration of the guest-house, for which she duly apologized as poor and unworthy of our visit, was really beautiful. Palm branches all green and fresh and glistening covered the entire roof and its supports, even the great curved posts of the centre being wrapped in the great leaves, which curved with new lines around the simpler circle of the big tree trunks. Here and there great bunches of white gardenia and of the

* *Taupō*, properly *taupou*, but I have written *taupō* because the sound of the final *u* is too difficult to render, and hardly discernible. It lengthens the sound like our *u*, but with a gentle breathing. You get it more or less in our taboo.

red hibiscus were fastened into the folds and interstices of the leaves and stems.

At night when her brother, the young chief, a famous dancer, had arrived, the dream of Robinson Crusoe which had begun enveloping me in the afterglow, as I wandered about in the sandy spaces among the palms and bread-fruit, became more and more complete. The dances were all pictures of savage life. There were dances of the hammer and of gathering the cocoanuts by climbing, and then breaking them; and of the war canoes, with the urging of the steersman and the anxious paddling of the crew; and a dance of the Bath, in which the woman splashed water over her pursuer, as she moved with great stretching of arms as of swimming. The beating of time on the mats gave, in its precision of cadence and the sharpness of its sound, an illusion that seemed to make real the great blows struck by the dancers, whose muscles played in an ebb and tide, under the brilliant light of the cocoanut fire made in the pit near the centre post.

In these and in others our hostess scarcely took part. Most of the time she sat by us — a tall and big chiefess, elegant at a distance, grave and disdainful — but we were in an ememy's country and the slight scorn seemed quite refined. Still more becoming to an evening with Robinson Crusoe's friends were the costumes worn in the wild dances: the great girdles of

purple and green and red leaves, the red fruit of the necklaces, the silver shells of red flower in the hair of the women; the fierce military headdresses of the men; the bark-cloth drapery moving in stiff folds, and more than all the oiled limbs and bodies glancing against that wild background of green leaves (spotted with red and white), whose reflections glittered like molten silver as they turned around posts and central pillars. Outside, the moonlight was of milky whiteness increased by the whiteness of the sandy beach mixed with a firm white clay. Upon this the sea made a faint wash of *no* colour, in which floated our white boats and the reflections of the silvery clouds that deepened all the sky to seaward outside of the white reef.

Late in the evening of our arrival we crossed over the little village green, which is studded with houses and groups of trees, each house, each mass of foliage set apart, either high on some mound to which steps may lead, or upon a slightly swelling rise, as if in some park, some pleasure garden where all had been thought of and gradually arranged. And so, I suppose, it has been here in all the centuries that have been spent in moulding this littlest village into a shape to suit its people, their needs, their comforts or their likings. And that must be partly the cause of the recall of artistic success and perfection in this rustic scene. All has taken as much time

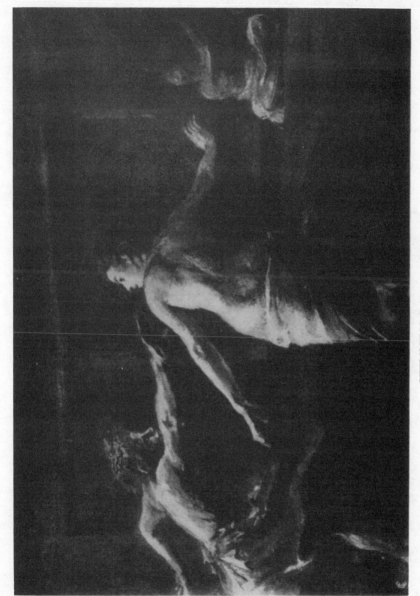

SWIMMING DANCE. SAMOA

and attention as the most complicated European mass of buildings, be they cathedrals or palaces — only the art has little shape but what nature gives it. All the more has nature caressed and embellished and favoured this elemental, unconscious attempt of man.

In the end of the long twilight, with the rose colour still floating in the upper sky, the little place looked more coquettishly refined than ever. Here and there the lights within the huts, often rising and falling in intensity with the blaze of the cocoanut fire, modelled the steps outside or the posts, touched trees and branches far away or near, and made pictures of family groups within, garlanded and flower adorned.

The larger house to which we went was adorned with flowers and all lit up. More people were crowded in it than the little village contained; for the island had sent visitors and performers for the dances which were to entertain us. I shall not describe them. But they were of course interesting, not only for what one liked but for what one did not like, and for our being with others who looked on. The spectators are inevitably part of yourself, as of the show, and in so far, the very way in which I looked on was a new charm.

There was among the dancers a young chief, serious as an Indian prince, who danced gymnastics, and ended with primitive buffoonery that seemed to delight his hearers. At the

other end of the scale was a hunchback dwarf, who played realistic scenes so well as to be repulsive. But all this was a lesson. I shall certainly see all about me, in this form of civilization necessitating health and strength, or their appearance, a great line drawn between those who suffer or are weak, and those who are not — a visible line. As yet there is no place for my hunchback's intelligence, except this buffoonery.

Later we left the dancers and wandered in wide moonlit paths among banana trees. There we came across our young chief looking now as if such a person never could have so demeaned himself, even from political reasons.

We exchanged *alofas* and compliments, and he placed his garlands in sympathy around my neck. He is a beauty, and his father is one of the tallest and biggest, as was his sister, who was once *taupo*.

This morning I have wandered with Seumanu for a few miles, to show ourselves. We pass other villages where we are greeted, and where at one time our yesterday's friend, the old *tulafale*, canters out of his house in a circle, according to ancient fashion.

We see a great war canoe under its shed, and the remains of a high wall that encircles the island and was an old protection in war.

Much should I like to remain, but we shall have to go at

once, for — as I feared — we are not here really for pleasure, but we are entangled in the quasi-necessary political advantages of being seen where there is "influence." But this, I feel, is the kind of place I want to see — out of the way — out of use — where usages linger, and where the landscape is influenced by man so as to become a frame; as it was in little Nua on the island of Tutuila where we first landed upon our first morning in the South Seas.

For a thousand years, probably two thousand, perhaps three — for an indefinite period — these people of this smallest island have lived here and modified nature, while its agencies have as steadily and gently covered again their work. So that everything is natural, and everywhere one is vaguely conscious of man. Hence, of any place that I have seen, this is the nearest to the idyllic pastoral; it is not so beautiful as it is complete.

Iva in Savaii, Oct. 26, '90.

I am writing in early afternoon, a hot afternoon, after a morning at sea. Opposite me in the circular Samoan house are a couple of persons of importance, a local governor, some four or five chiefs, all ranged against the pillars of the building, as I too am leaning against one. Seumanu and some of our acquaintances are to one side; opposite me, a grave young

girl is moving her hands in the great *kava* bowl from which she hands the strainer of bark filaments to a reddened haired young man whose head flames in the sun outside, against the background of green banana leaves. Next her a big fellow keeps grating more *kava;* and another fills the big bowl with water, making big red spaces in the reflection of the sunlight, that streams in on that side. Small parcels of presents of food have been brought in and lie about on their side. Much *kava* has already been drunk and more is being prepared as more and more chiefs come in. Everything except the picture before me is in shade. Conversation, probably politics, is going on slowly, in the usual low tones, with an occasional high-voiced interjection from some less important member. The village orator, with his fly-brush over his shoulder, has long ago made his lengthy speech of welcome, and as we are told to do as we please I write to you, in the interval of watching the faces of the men, or the circular movement of the girl's hands dipping in the big bowl, or running around its wide rim, when she wipes it, before passing the strainer to be squeezed out. The orator watches me suspiciously occasionally, but there is general confidence and peace, that we much need, for the heat is great and our sea trip was rough and hot. As I write, I hear my name *La Faelé* called out, and the *kava* bearer comes to me with the usual swing.

But I fear the *kava*, and merely accept the bowl and return it undrunk according to form. Then many of the circle disappear — to church — the bell is ringing and little children half-naked, small creatures toddling along are already in the doorway; apparently all the neighbourhood are beginning to file toward it gravely, most of the women with hats that do not become them. Even a little girl-child, with nothing but a band around her little fat waist for a drapery, steps along with difficulty, a big hat on her head. This is Sunday conventionality: all the congregation are dressed, even the half-naked chiefs, who had left us, reappear from their huts, with white jackets, and pass on gravely in the procession at a distance. And the Sunday hymns add to the drowsiness of the Sunday afternoon.

This morning when we left the little island of Manono, some five or six miles away, people were going to church but to a different call from that of this absurd little bell. A big war drum, a long cylinder of tree cut lengthwise, was beaten in the oldest, most primitive manner, some way as ancient as man himself. A man bent down over this big wooden trough, that lay like an old log in the grass, and beat it from the inside, with one of the big hard stones that lay in it. The sound was unearthly, I ought to say *uncanny*, and nothing more savage, more a type of the war of the savage could be im-

agined; and it seemed fitting that this war usage, turned now
to the call of Divine Peace, should still remain in the warlike
little island, once the petty tyrant of the little group. Right
alongside, near the great wall built for war, whose remains
surround the island, marks of destruction recalled the exploits
of the German warship *Adler*, that now lies stranded by the
great hurricane, in Apia harbour, and whose crew were saved
in part by the people they were killing, and especially by the
brave giant, in whose boat we have been travelling. Indeed,
there was an element of comedy quite Polynesian, even if
atrocious, in the danger the Samoan rescuers ran of being
fired at from the beach while they saved their enemies in the
sea. But we made the first part of our trip to-day, in a native
boat, for Seumanu's was rather too fine, and too heavy to be
risked in the entering of the curious harbour that we first
made. This was Apolima, "the open hand" — a small, very
small island about a mile out from Manono; the upper part
of a submerged volcano cone, broken down on one side, so
that there is an entrance. We soon reached the great wall of
soft brown rock, which crowned with cocoanut palms and half
covered with vegetation opens suddenly, leaving a small pas-
sage through rocks, just wide enough for our boat, skilfully
paddled in the great blue wave that swung us in. Then jump-
ing out, half of our men caught the side of the boat, to prevent

our being dragged back by the returning swell, and we were pushed and dragged around a corner inside of the rocks. The tide was low and we were carried ashore on the men's backs, through coral rocks that spotted the floor of the small lagoon inside.

The place was just what you might imagine; a little amphitheatre of green, the high reddish rocks standing on each side at the entrance, and between them, a great bank of rock, over which the surf broke so as to hide the little break through which we had come.

As we looked, three great palms stood up against this distance, planted on the higher ground that is all green, and leaning toward the sea as is their (loving) habit. Huts stood about with bread-fruit trees, and further back we were led to a little pool that supplied the place with scant water. Further back yet, the slope was all covered with trees, and after walking a little way, slipping along the greasy banks, and walking up the sloping timber notched with cuts to make stairs, and returning by another that made a level bridge across an empty channel, I sat down to wait for Mr. Sewall, who had walked up to the ridge, and I had time to make a sketch. All this took us a little more than a couple of hours while Seumanu's boat was beating outside, in a fair N. E. wind. At last we were paddled out in the great wave that

washed in and out, and with the swing that belongs to the balancing of a boat in a narrow tide-way. And we kept in the dance until we reached Seumanu's boat, invisible for some minutes behind the blue waves. Then we ran alongside, and we scrambled in, exchanging good-byes — *tofa* — with the chief of the lost hand, who had taken us thus far. Within the next hour Seumanu's boat had come to the outer reef off Savaii, in front of the landing of Iva. But there we had to wait at anchor. The water was too low inside the reef, so that we remained in the thin blue-green tide, that seemed to show everything in it, until a smaller boat came out to us, with Selu, the chief, and we were taken in. We landed among black rocks, within a few feet of a little scanty road, and clambering over a stile of rocks, at some part of the long black fence of stones in front of us, we found a village, which spread higher up and far back behind the trees, with spaces between houses; banana, palm and bread-fruit trees, dispersed as if for ornament or making little patches of plantation. There was a big church of the usual formless kind, not as handsome as the thatched ones with circular ends, that are certainly the types one would prefer. And so we walked up to the house, where we were to listen to speeches and the Consul to make one. Since I have begun to write, all has become more quiet, and I shall merely use my afternoon to make a few notes; we shall

sleep in another house belonging to the Governor and be near, I think, to the chief, whose name is or was Selu, for lately he tells me that he has had the name of Anai given him, and we try to make out together just how near these changes come to the forms of the Western world. This is not a title properly, but as it were a name embodying rights that go to descent; for these men with titles apparently elective are noble-men who form an aristocracy of government and are usually to be distinguished externally by their size or manner as well as by little symbols or expressions of superiority. Anai tells me that of the many chiefs here, whom we have seen or will see, he and another, alone are the "political" superiors, as he ex-presses it; that is to say, he goes on, that they alone talk in public about such matters (I suppose in the way of decision), and that others would be checked if moving. Thus, that to him and to his mate alone the making of war, or as he ex-presses it, the allowing the "shedding of blood" is devolved. This chief is a most interesting and sympathetic person, speaking English very well, though apparently a little wanting in practice, with a pleasant, handsome face, resembling some Japanese types, interested in missionary matters, a strict church member, and showing much interest in foreign matters throughout the world; we talked of the civil war, and of the prospects of the republic in France, and of the universal

"striking" now going on, as we might anywhere; and I am
sure that Anai was "posted" to a later date than we, for the
Consul had handed to him the files of the *Herald* for the
last few months, while we had almost entirely abstained from
that indigestive form of reading. Anai has explained to us
that this being Sunday we shall have no reception, but that
to-morrow there will be a formal reception, called *talolo*, and
giving of presents, and that there will be dances. So that we
shall spend this evening quietly, with a bath in the pool of
fresh water, that is open to the sea, and try to rest.

On Savaii, Oct. 30, 1890.

We are settled here for an uncertain time, perhaps three
days. This is the political capital of Samoa, and we are
occupying the house of the great orator of the islands, im-
portant by his influence, though not so great a chief as several
others by descent or by control, or even by physical superi-
ority, that great proof of eminence in communities like these,
where the chiefs seem to have reserved for themselves a size
and weight that recall the idea of heroic days. Certainly the
first time that I saw a well-chosen dozen together, as I did two
days ago at our last resting place, all sitting spaced out, as if
for a decoration on a frieze, silent and indifferent, or speaking
occasionally without raising their voices, with heavy arms

resting on great thighs, and with the movement of neck and shoulders of men conscious of importance, the recall of Homeric story made me ask myself which one might be Ajax, and which the other, and if such a one might do for Agamemnon. Fine too, as some of the heads were, they were only relatively important, as with the Greek statues that we have, and that we know quite well and intimately, even though their heads be missing. The whole body has had an external meaning, has been used as ours is no longer, to express a feeling or to maintain a reserve which we only look for in a face.

And as I am writing, while the household is enjoying its evening relaxation and preparing for the night, everything about me repeats to me this theme of all being done with the whole body. About an hour ago prayers were said and all sat around while the regular form was repeated, and then our young hostess prayed an extempore prayer commending us all to the care of God. Some words I can catch, but the intonation is sufficient. It is a prayer cadenced as well as the most consummate of clergymen could manage, and repeated without the slightest hesitation. Then she stretched herself out, with her head on the Samoan pillow, and talked with some young male acquaintance outside the hut whose head just appears over the barrier that runs between the pillars, for our house is placed higher than usual. She talked with Adams

who is lying by her, and occasionally she criticises the game
that is going on near her at that end of the house. I have only
followed the little things happening by fits and starts, as I
have made some sketches and have been writing letters, but I
make out that the household is playing some game in which
some motion or gesture has to be duplicated or matched, and
that the beaten side, for there are two rows of players, is to
dance as a forfeit. I say that this is the household, I mean
that I take it for granted, though I see that one of our boat-
men is among them, and that a couple of children have dropped
in. The duenna of our young lady is also there. Sometimes
I see her and sometimes I do not, but I know she is there on
watch. But a *siva* has been organized slowly, a household
unofficial *siva*, begun in little patches — somebody humming
something and several beating hands. Tunes or songs are
taken up and discarded, and sometimes a man, sometimes a
woman, stands up to sketch some motions. At last they ap-
pear to have got under way, and I see them swing and dance,
with little clothing and much clapping of hands, at the other
end of the house, And everybody joins in: even the children
beat time and take up the words — and the two elder women
are the most enthusiastic and full of energy. Occasionally a
burst of laughter salutes what I take to be a mistake or some
wild caper that seems funny to them. Faauli, at last, after

having pretended to sleep or to talk, so as to appear to herself to have done something, sits up and takes more interest. By and by she sketches out some steps in an indolent manner — soon she begins in earnest, and with one of the performers goes through an energetic dance, slipping her upper clothing for greater ease. The clapping and beating time comes fast and furious from every one, and laughter and small shrieks replace the gentle monotone and seriousness of the evening prayer. At last she sits down suddenly, her face rather overcast: (her name means "Black Cloud that Comes up Suddenly"). She has hurt her foot apparently, for turning round to see why all has stopped, I see her bent over and looking at a toe. Note that she does this as easily as a baby with us — her face comes down on her foot raised halfway to meet it. As I come up, she shows me that she has torn off the larger part of a nail, and is paring off the remainder evenly against the exposed surface of flesh. I offer her scissors which she uses with indifference, as we might cut off superfluous hair; and apparently more from politeness and obedience than from necessity, she accepts my court-plaster. Then being properly mended, she sits down to play cards while I resume my writing. Now here has been something that explains some sides of these good people; an absence of nervousness and insensibility to pain— for to most of us such a

small accident would have been very painful and sickening. Before this the dance had been merely an outlet for action, as natural and unpremeditated as any other motion. The entire body has been called into play: from the ends of the fingers to the toes of the feet, all the exterior muscles have been playing gently for some two hours, with almost every person present, whether they sat or stood. This constant gentle exercise must go far toward giving the smooth even fullness that marks them. And meanwhile, too, they have decorated themselves; some one has brought out garlands, and they have been worn: flowers have been put in the hair, as if to mark that this is not work but play.

And now that all is quiet, I shall try to resume my itinerary, and recall small matters that are fading away, and becoming so confused from repetition that it requires an effort for me to distinguish this *siva* from that *siva*, and to remember what *taupo* it was who danced well, and what one it was who danced ill.

I was writing last in Iva, on our first day there, Sunday. It is now Thursday night.

Monday morning at Iva we were up early, before the sunrise, waked by the red glow of the dawn that calls one up easily from the hard bed of double mats laid on the floor of small stones. Every one was up, people were moving about,

probably most had had their early bath, for they were return-
ing with wet clothes, or with their garments spread over them
like a veil. So that we scrambled over the stone wall that
seems so anomalous and unreasonable here. But they not
only divide village from village, but also prevent the straying
of that roaming property, the pig, that wanders about the
village and the forest also, picking up everything of course.
To see a pig picking out the flesh of the cocoanut has been one
of the small amusements of this afternoon, and last night, be-
sides the invariable dog, pigs came into our house and snuffled
at the faces of Charlie and Awoki, who lay outside of the
mosquito netting. The path over the fences brought us to
the bathing pool opening to the sea on one side only, where
among black rocks the fresh water runs up to meet the tide,
filling in the pool. There we went in and swam about,
watched by many of the smaller villagers, girls and boys who
were curious about the manners of the white people. And I
was able to admire the skill, though unable to rival it, with
which the native bathers draped themselves as they rose from
the water, so that man or woman was clothed as he or she
stepped on shore.

By the time we returned, our mosquito nettings had been
put aside, the mats swept out, and Awoki was bringing us the
tea and brown bread, which, with such native food as we liked,

made our meals. Fish there was and yam and taro, and some preparations of cocoanut. And there were cocoanuts for their milk for which I do not care, but there was no water yet, the water in the two pools near the sea, edged with black stones, being blackish until the change of tide should leave the spring to fill up by itself.

Then our host came in and told us that we might rest that morning: that in the afternoon there would be a reception, a sort of review or "fantasia," and presents of food would be given and speeches made, and songs and dances, the whole apparently included under the general title of the *talolo* which was to be given us. So we waited peacefully; I sketched the girls in the neighbouring house, who were at work making the wreaths, the garlands, the complicated flower girdles that should be worn later in the day, and perhaps at night, for there were murmurs of a night *siva*. But I knew that our host was a church member, and that the *siva* is not encouraged, neither the *siva*, "fa Samoa," Samoan way, the Samoan *siva*, nor the *siva* of the Europeans, which we call round dancing; for had not Faatulia, the wife of our leader, Seumanu, been threatened with excommunication for dancing in her innocence in European ways at the Consul's Fourth of July ball. Meanwhile my models across the way in the shadow posed badly: they were always moving, or they came across the way to see what we

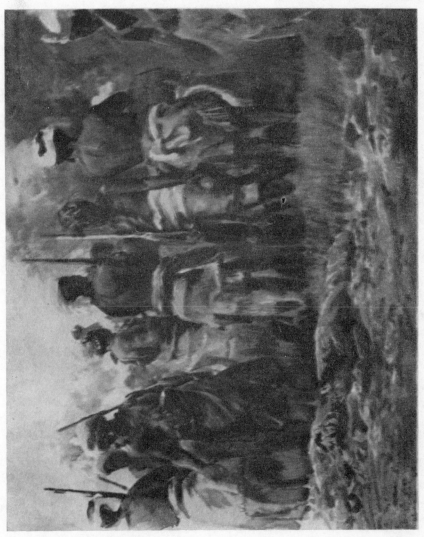

SOLDIERS BRINGING PRESENTS OF FOOD IN MILITARY ORDER. IVA, IN SAVAII, SAMOA

were at. For somebody would stop in and look at us, and go
give the news — a little pile of small boys and girls, three
rows deep, sat respectfully under the bread-fruit trees watch-
ing us. But somehow or other the morning wore away, and
by two o'clock we were told that all was ready, and that we
had better come to the house chosen for us to occupy during
the ceremony. Meanwhile, behind the trees that closed in
the sight (for the village was placed, if I may so describe it,
in an irregular open grove of many kinds of trees), we had seen
for the last hour or so, dressed-up figures moving about; men
with large green garlands, and green cinctures around their
waists stiffened out and made larger by great folds of new
bark-cloth, or by the fine wearing mats which are the most
precious possession of the Samoan: some of them with guns
carried with pride, for these were men who had been victorious
and had beaten off the bullying German.

And now we took our places in the circular house which
looked like a pavilion, and which stood on the east of the large
open space near the church. Opposite us perhaps some two
hundred feet or more was another house, and others spread to
right and left, leaving a large space ending on one side near
the church, whose white façade had written on it its name,
Lupeanoa, Noah's Dove — enclosed by a little clump of trees
to the left, where we could see figures moving with great

swaying of leaf girdles and waist-mats — and the occasional beat of a war-drum came from further back.

We were seated, all facing toward the open space, the next house filled with women and children: Seumanu and our host and other people of importance near us, and the rest of the house packed, but not too closely, behind us. Out on the grass and near trees people sat, mostly women, Others moved slowly to take their places, showing some vestiges of yesterday's Sunday in their hats and long gowns.

Then rushed across them a man all blacked, with a high white turban bound to his head, with green strips of leaves, a few leaves for a girdle, and waving a paddle. This was a friend of Seu's — a funny man and joker, with a hand maimed or deformed — the deformed in such communities take things gayly and are jokers. He shrieked out things that caused shouts of laughter, and repeated "*Alofa* Atamo!" From behind the church came out a mass of warriors, with banana leaves in their hair, and wearing girdles of the long green leaves of the *ti:* their backs were streaked with white lines following the spine and the ribs, and their faces and bodies were blacked. They carried their rifles high and discharged them into the air, then cantered past and away. Again the buffoon and again the warriors.

Meanwhile in the distance, in the opening of trees, we could

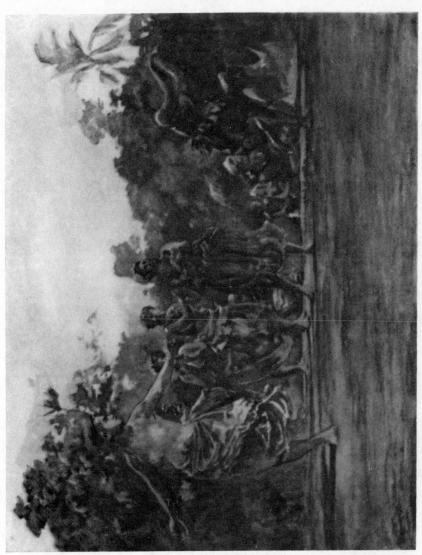

TAUPO AND ATTENDANTS DANCING IN OPEN AIR. IVA, IN SAVAII, SAMOA

see other warriors: behind them the drum and the little fife made a curious war music, and a peculiar shout and call with a short cadence came from the men. Unconcernedly a girl moved across the opening in front, intent on something else, and a hunch-backed dwarf, with enormous wide shoulders and long legs edged with green leaves, came to us and shouted "*alofa!*" Then six warriors again emerged from the grove, swinging their clubs, and marched back leaving the green space before us empty and silent.

Slowly now, moving step by step, the mass of people behind the trees came out, so that they could be seen. In front of the men and of the music a girl, with black, shaggy waist garment, like thin fur, with long red necklaces of beads, and flowers in her hair, danced slowly to the tune, crossing and uncrossing her feet in a hopping step, and swinging with both hands a slight club in front of her, as a drum major might move his stick. Slowly she advanced, escorted by two men clad in mats and garlands, upon whose heads stood out a mass of yellow hair, like the cap of a grenadier, supported by circles of shells around the forehead. They also kept time to the music, but did not repeat the girl's monotonous step that made the central point of interest to which the eye always returned.

This girl was the *taupo*, the virgin of the village, dancing

and marching in her official place at the head of the warriors
— like Taillefer, the Norman minstrel who began the battle
of Hastings. When she had moved slowly a few yards, one
could see that behind in the crowd there were two other girls
representing other villages, who also repeated these move-
ments, while some of the men danced and others stepped
slowly with crossed arms, holding their clubs and muskets.
And the virgin danced forward and passed, and then up the
slope toward us, followed by the other girls, and all saluted us;
when the whole assembly in the field came up suddenly and
threw down before us leaf baskets containing taro and yams,
and cooked things wrapped up in leaves, and fish, and a
number of little sucking pigs, with hind legs tied, that strug-
gled up and down in the heaps of leaves. As each person
threw his load down he stalked away gravely and took a seat
somewhere in the distance. All became silent. I could see
the *taupos* moving off with that peculiar walk of the dancer
who is resting. A warrior with high white turban of bark
cloth sat down against a tree near us, without looking to the
right or left, his gun against his shoulder, and smoked gravely,
while a girl, his daughter perhaps, leaned affectionately against
him. Meanwhile the sucking pigs had been escaping with
hind-legs tied, and every now and then Charlie pulled them
back into place.

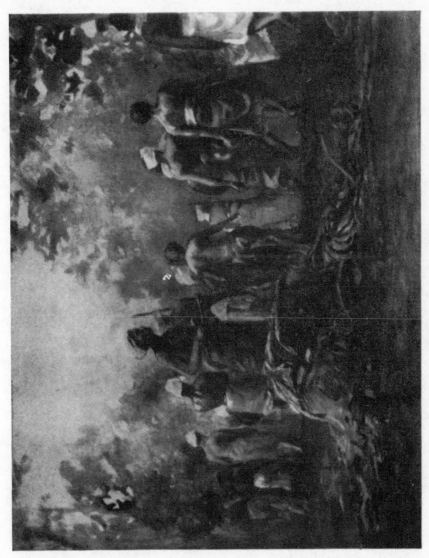

PRESENTATION OF GIFTS OF FOOD AT IVA, IN SAVAII, SAMOA

Then rose the orator, the *tulafale*, from the centre of the three rows of men now seated opposite to us, across the green space, and from two hundred feet away, addressed us slowly as he leaned upon his stick, and seemed not to raise his voice beyond what was absolute necessity. But the cadence always rose in the last words, so that the effect to the ear was of a distinct, emphatic assertion. Then he added, "This is all," and sat down, apparently inattentive and indifferent. Our turn came next. Anai, the chief, translated to us the usual speech of great gratitude to America for having saved them from slavery and from the Germans, and compliments to us all, with prayers to God to have us in his holy keeping. Then a few things were suggested between us, and our political man said what was necessary, and alas, even more: for how can the United States promise anything — that may depend on sugar — or an election, or at any rate is merely a matter of barter? Anai stepped out from the house and repeated all this in Samoan, speaking also quite gently, with little raising of the voice. Nobody seemed to listen, nobody to care, but this was only apparent. All heard and had listened.

Then our own men, who had been hidden somewhere, sprang upon the presents and sorted them: one of them stood up and called them out: so much of this, so much of that, to give full acknowledgment for liberality. Then another spring, and

all was carried away, even to the struggling, sucking pigs that could not be made to understand.

Momentary peace settled over everything, and we had begun to ask questions and to sketch, when we were told that now we should have a *siva*, that several villages would appear in it by their performers, as they had appeared in the military display. Men came up garlanded and cinctured in flowers and leaves, and sat down in double rows before us, some turning toward us, others away. Out of their number first one, then others arose and sat down again in order, fronting us, and the *siva* began; six handsome young men, singing and swaying about upon their hips, to a chant for which time was beaten behind them.

The sun was setting; tired out and amused we walked back in the crowd, stopping to exchange *alofas* with belated warriors who showed us their guns and occasional wounds, which with the Samoan idea of a joke they pretended had been caused by running against wire fences.

We had seen for the first time a pageantry of savage war, in a soft light, in the most peaceful and idyllic of landscapes, so that it was hard to realize again that this was not all a theatre scene, a fête champêtre — a play in the open air. There was nothing to contradict this unreality but the marks of ugly gashes on the arms and chests of the men and the re-

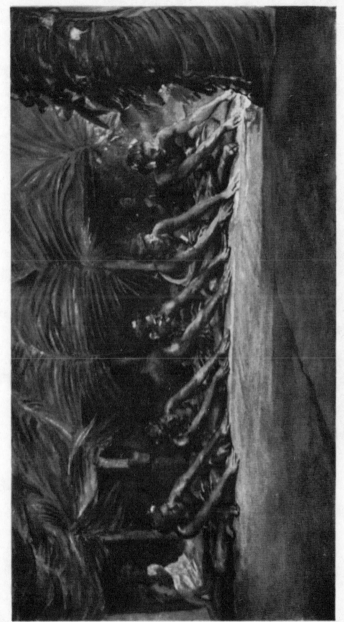

SOUTH SEA SEATED DANCE AT NIGHT SAMOA

call of the savage melody, which was undeniably a war song, requiring no explanation as to its meaning.

In the house we ate our meal spread out on banana leaves, two of the *taupos* coming in to help us by breaking the taro and yams, and tearing the fish and fowls. Then while wishing for nothing but bed and rest, and closed eyes, we were told that there would be a night *siva* in our honour, and that other *taupos* would figure in it. There was nothing to do but yield, and with each a *taupo* to accompany us, we went back to the house that we had occupied in the afternoon. It was already half filled with people, occupying one side of it. I sat down against an outside post, alongside of my *taupo*, next to whom Seumanu reclined at length with another girl, an old acquaintance, near him, and I tried to keep awake while the *siva* went on enthusiastically. At times I would start with some new figure or more picturesque effect, or when fresh fuel was added to the cocoanut fire that lit the scene within. Along the posts of the exterior sat chiefs watching the dance: behind them outside, a crowd of people in the moonlight, and many heads of youngsters. Occasionally a chief would say, "Some one a cigarette or a light," and a boy darted into the house through the dancers, plunged for the light, and returned with it to the great man who had asked.

When the *taupos*, big and good natured, had danced, we

drowsily asked them to sit alongside of us, while the *siva* of the men went on. Between two, as I became more and more sleepy, I was fortunate in finding comfort and support from my first neighbour, against whose big shoulder I reclined, my arm supported upon the weight of her knees — all mine might have been thrown upon her massive form without apparent inconvenience. A gentle tap now and then, and a gentle *alofa* told me that I was all right, and could go to sleep while making believe to look on. But the girls, drowsy as they were, were appreciative of the men's dances, and so was Seu, who called out over and over again, *mālie* (bravo) as if he had not seen thousands of *sivas*, which now, having become "missionary," he does not attend. I knew that I was interested in the intervals of sleep, but all has faded into a sort of disconnected dream. I can only remember getting out into the bright moonlight, and that it made a silver haze outside during the dances. We had been obliged toward midnight to make a speech, with thanks, protesting the fatigue of travel as an excuse for not remaining. The Samoans will sit up all night, especially in their favourite moonlight: they can sleep during the day, and apparently always do so. Around our house, until we had blown out the light, and even for some time after, rows of people sat watching us in the light of the moon: the people sauntered about, or sat in the shade of the trees, with

sharp-edged leaves that made the scene look, as usual, like the stage-setting of a fairy opera.

The next morning we were to leave for the next important place, Sapapali, the home of the Malietoa, the princes who have been for a long time the principal chiefs of these islands, and who are now represented by the present king. This is a rude definition; as I have told you elsewhere, the question of chief-hood and sovereignty here is one not easily represented or defined by our words. At Sapapali, the ancestral home, we should be received by Aigā, the King's niece, and consequently a young person of the highest rank, indeed, I suppose the greatest lady of the land. With us this would be the Queen or the Royal Princess, or the heir to the throne. But here blood and descent are all and in the direct line. This young person was next to Malietoa as being of sufficient blood.

Our arrival was to happen about noon, so that, as in Samoan phrase, it was only about half an hour's walk, we were to leave punctually at ten o'clock. Early rising took us again to the black pool surrounded by high trees, where two of us bathed, watched and escorted by two little damsels with whom the other one of us flirted. I myself was too much occupied with the difficult question of keeping on, while swimming, the fathom of cloth they call lavalava; and afterward of adjusting

it in the water, after swimming for it when it had floated away, and then on coming out, receiving dry cloth with one hand and putting off the wet one. But I found out how one begins in the corner. Later in the morning it had grown hot, as we left pretty Iva, and made our way through broad or narrow roads, to Sapapali. The old difficulty again amused me; we could not walk in proper Samoan order; sometimes one of us, sometimes another was in front, while properly, all of us chiefs should have led, and the attendants followed at respectful distances. So that again Awoki would canter on in front of the chiefs: meanwhile Anai told us things of local information, pointing out where the road narrowed, the place where had stood in older times, a famous tree, a cocoanut. Among its branches the Malietoa, who first became converted later to Christianity, used to conceal himself and lasso or noose such pretty *taupos* or maidens as passing might strike his fancy. One of these had been the grandmother of the young lady whom we were going to visit. While the party talked the scandal over I remained a while by a deep well near the shore, and watched a handsome Samoan ride his horse barebacked to the water, to the sand and distant trees of a little promontory.

When I hurried forward, the party had gone far ahead, and had arrived before me. I crossed the rocky bed of a dry river,

upon whose edge stood houses, and going up the hill before me, came upon a high open space with trees far scattered, and several large black tombs made of stones piled together in regular rectangular form; and in the centre of the green a house high-placed which instinct told me was the guest-house, our destination. Part of the mat curtains were down opposite the central posts: I entered by the open side, and saw Adams and the Consul seated next to a young woman in half European dress (that is to say with a corsage); and on the other side of her Seumanu and Anai. I entered and sat down with some hesitation next to the Consul, and after being presented to her ladyship looked about me. Opposite, the posts of the pretty house all adorned with flowers had each a chief, as a sort of sitting caryatid or buttress. And they were big and splendid; that was the Greek frieze of which I was telling you. Between each massive figure, of Ajax and Nestor and Ulysses and Agamemnon, appeared from time to time some little boy, whose small person made them look more ample, as the boys or angels of Michael Angelo's Sistine Chapel make sibyls and prophets look more colossal by comparison. Then *kava* was brought in and made solemnly, when in stepped a woman and sat herself beside the *kava* attendant who dried the wisp. A moment later, and her presence was explained. She, it appears, had the hereditary right to "divide the *kava*," and

had come to claim it. When the heavy clapping of hands announced that the drink was ready, she called out the name of Aigā, to whom the first bowl was presented as to the greatest personage. Then to one of the guests, then to the next relative of the Malietoa, then to a guest, then to a chief, and so on, contrariwise to what we had seen before, where we as guests were helped first. You see we were at court, in the presence of royalty.

When the ceremonies were over, we chatted with Aigā, who spoke English, and whose amiability pleased me. She was embarrassed and shy, and struggled like some girl, unaccustomed to society, to say some proper things. But the grace of her diffidence was all the greater when one noticed the security of position indicated by her voice when speaking in a low distinct tone to others. At length we rose and adjourned to the neighbouring house, where the feast had been set forth. This we were allowed to dispense with under plea of a late breakfast, but for form's sake we looked at each separate thing, spread out in a long line of Samoan good fare, on green banana leaves that stretched across the house. Then we *papalagi*, (foreigners), returned to a Western soup kindly prepared by Aigā, and our own bread and tea, and sardines, in which fare Aigā joined, and talked to us and we to her, all stretched at full length upon the mats.

Then our lady disappeared with some little show of embarrassment, and had I known how much it cost her, I should have sympathized with her sooner in the annoyance of her having to prepare her toilette for the great official reception (*talolo*), which was to be the next function of the afternoon — the nearest house was the scene of the dressing of herself and her maidens. Through the dropped mats of the openings, girls and women kept plunging in and out, carrying in dress mats, and beads and garlands of flowers, and entangled, complicated cinctures and belts of fruits and flowers, and woven bark — and bringing out the news of how the dresses looked to the loungers sitting at a distance outside. And once I saw carried in a fierce, cruel headgear that our lady was to wear; the great helmet of blond hair, set with sparkling mirrors and tall filaments, to be bound tight with silvery shells around an aching head.

Then we went out to sit and wait on the other side of our guest-house, in the shade toward the sea, while long shadows covered the great space, and the sun itself became veiled and lit the scene with a tempered light more like that of our northern summer. One might almost have imagined an afternoon in some favoured, more poetic point in our coast at home, say Newport on some exceptional evening. The great *mālie* spread out further than the reserved ground of any of

our residences, and its edge dropped suddenly to the sea be-
fore us. Once or twice a thatched house stood on the verge
of this rolling green, all carefully smoothed and weeded like a
lawn. To the left and right were small groves like the wings
of a theatre. Far off to one side curved the bay, with palm
trees stepping gradually into the sunlight. The sea was blue
and green before us, and faintly shining; far off in the haze
of sunlight were Upolu and Apolima — spots of blue. Nothing
broke this space to the furthest dim horizon, except where on
the edge of the cliffs stood one hut through which shone the
colour of the sea and the foliage of the tree overshadowing it.

Then our party came up and sat about us on the slope of the
grass about the house, and from the groves about us came the
sounds of the drum-beat and the call of war music. From
behind the house, in a great circle, ran out in a sort of dance,
our hostess in full gala costume: naked to the waist, kilted
with costly mats held on by flower girdles — on her head the
great military cap. She held a little toy club in her hand; on
either side, with heavier strides, two of the giants, her attend-
ant chiefs, dressed and undressed in the same way, repeated
her movements Some thirty paces behind her, two of her
maidens followed these leaders, turning round in a great circle
of dance, spreading out their arms, and the wide folds of their
waist-cloths, and the lines of their garlands were flung out by

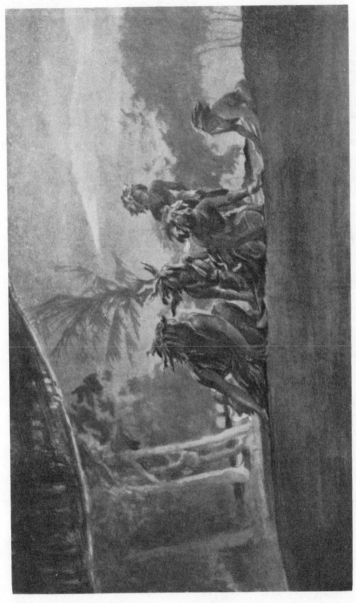

AITUTAGATA. THE HEREDITARY ASSASSINS OF KING MALIETOA SAPAPALI, SAVAII, SAMOA

their motion. In and out of the little grove danced back and forth a crowd of armed men, who threw up their clubs and caught them again.

Right in the middle of the green before us, threading their path between the princess and her girls, crouching to the ground, crawled or ran, bending low, three men, all blackened, with green cinctures of leaves wound round their heads, and short tails of white bark hanging down out of their girdles. These were the king's "murderers," relics of a bygone time when savage chiefs, like European sovereigns, used licensed crime to rid themselves of enemies — or friends — against whom they could not wage open war.

These whom we saw were only on parade. All this served but to recall a former power and its historical descent. But the ancestors of these official murderers of hereditary ancestry had been actively employed. At the whispered word of the chief they tracked the destined victim, risking their lives in the attack, and plunged into him their peculiar weapon, the *foto*, the barb of the Sting Ray, which breaking in the wound and poisonous withal, meant inevitable death.

They were called, as I make out, Aitutagata (Devil people). The display lasted but a short time; hardly more than a few circlings by Aigā and her people, then on a sudden all seemed to come up about us, and the assemblage broke up into groups.

Aigā bore with apparent confusion our compliments. She was anxious to get away.

There was something inextricably touching in the case of this bashful young person — indoctrinated with our ideas to some extent — apparently realizing how we looked upon the scene, how different her dress and actions from those of her white friends and sisters, and yet carrying it all out to suit her position of princess and hostess; what was due to us, and to the traditions of her race.

With evening came the need of change, and I wandered down to the unfinished church begun by the Malietoa, of whom I told you. The massive foundations of coral rock, against which the tide was washing, are finished, as well as part of the walls of the church. In front is a little island, planted with trees: to the left, at once rocks and high trees; on the right, the surf broke again in a little cove with houses and palm trees, standing high against the setting sun. Far off the point, the outline of Apolima, more than ever like a submerged volcano cone, and the long white line of the surf; and near me, almost under me, a dark moving space in the water, where the tide washed more uneasily, the submerged tomb of a woman called Siga (white), a former wife of Seumanu. There was something that made one dream, in this grave, now remembered, now forgotten, a reminder that all memory can

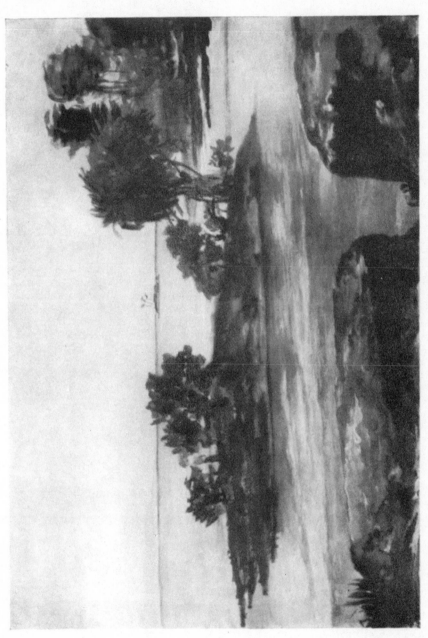

BUTTRESSES OF THE FIRST CHRISTIAN CHURCH AND TOMB OF SIGA IN THE REEF. SAPAPALI, SAMOA

be but temporary, and that the real end is where all ends and is forgotten, and where, as the Spaniard says, "Dios empiezo." I sat and sketched a little, seated on the great foundation. Children and women crowded around, and climbed up the space in front, where the great steps should have been, and filed all around the projecting edge that runs about the church. When I had done I rose, and turning the corner of the narrow ledge, found that I had made a group of frightened prisoners. Then I went to the deep pool near by, where the sea runs into the little fresh water, and was smiled at by the good-natured face, just being washed, of one of the murderers by inheritance, who had figured all blackened that afternoon, with green leaves and a white hanging tail. His wickedness was being washed off with his blacking: or rather, his wickedness was all archæological, kept up as a proof of the former dignity and power of the chief, and of the obedience of his men. For these people seem never to have been grossly wicked or cruel; as I told you, they were not cannibals or whatever they had that way, ages ago, was condemned as bad. They have even been unwilling to exterminate their enemies in their many wars: and when they could put an end to the German, in this last war, they stopped their killing the moment the enemy was beaten, as they imagined. An element of strong good nature seems to persist at the bottom of their character.

That evening we had a *siva*, like other *sivas*, which I am unable to describe, because I was so sleepy that my memory has not held over. I lurked in the dark, behind our hostess, who did not dance. Her missionary training and her position were against it, I suppose, but also, perhaps, she did not dance well, or as well as others. Afterward she lingered with us, in the late evening, as did the *taupo* who had danced. With them were her two girls, attendants, and one or two of the elder women, along with some of our men who acted as chorus. Then "quelque diable le poussant," nothing would do for one of our own party but that he should tease and beg for a dance with more undressing. The older women seemed to enjoy the notion, which reminded them, perhaps, of old days when they were able to be naughty, and had performed all sorts of antics late at night, when the elders and the great people were gone to bed. So gradually, from one dance to another, we came to one in which the performers disrobe entirely for a moment, using some words that represent and lay claim to the same beauty which the Venus of Naples, she whom we call Venus Callipyge, attempts to look at, and certainly shows. But it was all innocent and childish — the *taupo* danced it, and the young girls accompanied her with one older woman — and Aigā laughed and was amused, but hid away behind us, ashamed. Then we made her dance for

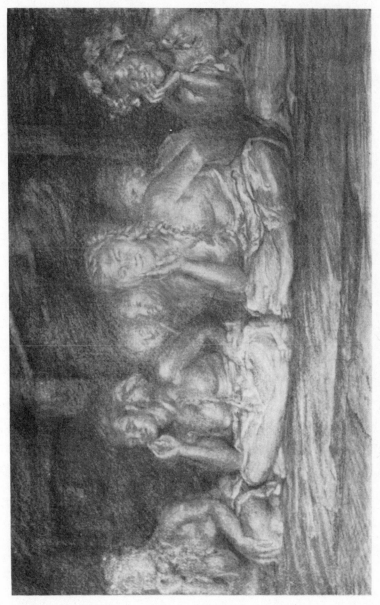

PRACTISING THE SEATED DANCE AT NIGHT. SAMOA

a moment the usual dance, I say we, but it was not I — and as she seemed to think that even that was dreadful enough — we parted with some discomfort. I foresaw trouble, but whether our fair friend was not as much annoyed by the relentless compliments paid to the beauty of others, is more than I can make out, being a man.

In the morning we trotted off a few miles, to this present place Sapotulafai, the headquarters of the great orator, and which is the great political centre. We had a great dinner, at which I sat next to the *taupo* of the adjacent village, a giantess, whose name is not insignificant, though people here are not apparently named, any more than are people anywhere else, by name to suit them. Charlie interpreted her name for me saying, "When you are on top of a cocoanut, and the wind blows hard, and you are afraid of falling off, that is *Lilia*." You have seen a palm tree in a gale, and you can imagine the picturesqueness of this definition of fear, in the wild swinging of the waves of the branches.

We had a *siva* in the afternoon, when a young chief danced with the *taupo* of his village, to whom he is engaged: She gave him some occasional affectionate whacks of reproof at some remarks that distance did not make clear; and we had a great "*talolo*" with the speech of the great *tulafale* of Samoa, and then a return speech, which was listened to with

some curiosity. Some devil inspired me to urge our representative speech-maker to discuss the severe and mistaken view of dancing taken up by the missionaries — I mean the brown clergy. They had done all sorts of good, but they were crowding too much out in their zeal, and the white missionaries were not so excessive—and so forth. And Adams had made a remark that seems to me a deep one. Something more is needed for these people of few occupations. If they are to live to-day they are destined to a putting aside of the excitement of their little wars, and they need some outlet in games that exercise them, and keep up their appreciation of physical life and excellence. Anyhow, these views were launched out at a risk, and in a few days, without a doubt, will have gone all around Samoa.

My own reason was a nearer one. It grieved me to think that Aigā should risk her church position, because she was polite according to Samoan etiquette, and that the other girls, who did the same, to wit, gave us dances, at the request of their fathers and superiors, should be placed between divided duties. This had been an oppression to the mind ever since we came; and perhaps after all, we may have done well.

In the evening, our own *taupo*, Faauli the daughter of the orator, gave us a *siva*; she danced, and danced well, and so did Lilia, the daughter of a great chief, a Catholic, and then we had

the other *taupo*, who danced again with the young chief to whom she was engaged. His dance was certainly amusing to the imagination. The chorus was singing about himself, in his honour, and he performed the steps, if I may so express it. He and another with red girdles and black, furry loin-cloths, and red leaves in the hair, and red bead necklaces, danced with the *taupo* herself, dressed all in red and purple leaves. The dances were a dance of the hammer, and the dance of the cocoanut, and in the glitter of the palm-fire, the ballet of our fairy opera. And satiated with dances I have tried to be quiet and to sketch until now.

Oct. 30th.

We shall leave to-morrow. I feel tired, a little saddened; I suspect that sleeping on the floors at night, in draughts from the back-country, and wandering occasionally, in the midday, among the hot thickets, may have given me some little fever. The German manager of one of the plantations was telling me a little while ago that there was danger in this, though nothing like what he had seen in other countries. On that account, he had lifted the flooring of the houses, built for his men, Solomon or Marshall islanders, whose health was of course of importance to him, during their contract time. After all this care, they will be taken back, perhaps, to the

wrong place, and I suppose, eaten by their fellows, if they happen to land on the wrong spot, or at some neighbouring village.

This afternoon we went to Sapapali, to take leave of Aigā who had been so kind to us, and who seemed almost hurt at our not remaining. We found her apparently sad and troubled, and I regretted that we had been accompanied by the other Taupos of our locality. Not that they were not kept in their places by the greater lady, for this rather timid and amiable person knows perfectly well how to speak to people who are socially below her, and nothing has interested me more than her various shades of inflection in addressing others. But something has evidently annoyed her, whether the break with the church on account of the *siva*, or her girls having been indiscreet, or her having made some mistake that I do not exactly understand. She was much teased by one of us about some "tendresse de cœur," and that may have annoyed her. And the praise given to her little girls, and an attempt to get them away from her control may not have been pleasant. When I had seen the rest of the company pass by my sketching place, and I knew that the visit was over, I went back alone to her house and found her among her girls prostrate and in tears. But she came out to me, so as

to be alone, and she spoke as if we should misjudge her from Sunday-school views and not understand that her parade at the head of her warriors, all undressed, was an official duty to us. And then bade me sweetly good-bye — and but a moment ago my curtain mats have been pushed aside by a messenger who has come all this way at night to bring me flowers from her.

So that I am not in cause: I leave it to you to read. I feel almost as if what I were writing to you were indiscreet enough. Remember that there is little privacy here, and that the houses are half open, so that one may almost rush in. In fact, were it not for the complication of human nature, I cannot see how there could be any privacy. There is privacy somehow or other, but not in our way. Outside the house there may be ways of saying things, inside and out there are dictionaries of signs, but they all have the most wonderful way of hearing, and there are always eyes everywhere. I have remarked that since I have cultivated the habit of sitting on the ground, I see more of everything, and I seem to be able to watch more easily. But, as I said, privacy is relative: nothing has struck me as more Samoan than an elopement which I almost witnessed. The young woman ran away with some young man, along the beach, in the presence of hundreds of people who, it is true, were not exactly watching her. She was just as

publicly caught and brought back, cuffed sufficiently and scolded by her older sister, and I see her occasionally, in a neighbour's house, looking not so repentant as on the first afternoon of her punishment. As I said, I am tired and sad — and I wish you good-night across the ocean and land.

At Home in Vaiala,

　Nov. 4th.

The end of our malaga was not so pleasant. When we left Sapotulafai last week, I was ill and fevered, and suffered quite a little during our long trip of fourteen hours at sea. We had to row it. There was no wind, and our men, never over-energetic, had been up all night in the last enjoyment of social delights. Once indeed, Seu scornfully took an oar, but even with that, twelve good hours' rowing is not bad work, and we got back in the evening at eight, having left Savaii at six o'clock in the morning. The light and colour were as usual: even with fever I could occasionally see how beautiful all was, but I managed to sleep, and do not remember anything in particular, unless it be the long-continued song of the men rowing ——

> "Lelei. Apoli-ma!
> O-le-e — O-le-e!"

Vaiala in Upolu, Nov. 13th.

Yesterday, on Faatulia's invitation, we rode over to the Papa-seea, the Sliding Rock: only a little distance, some hour and a half from where we are, so that by eight o'clock or so we were out in the rain, mounted on the horses seared up with difficulty for the early start. Mine was a horse owned by the boy Poki, who is an owner of horses — he has now three, and his food for them is given by the village common. His still more youthful friend, Sopo, hired his horse to Atamo and somebody else fitted out Awoki and Charley who went with us. Samau, the *tulafale*, and another of our crew were to go ahead and carry some European food and our painting and photographing kit. As we passed along the beach, which is, as you know, the street of Apia, we met Meli Hamilton and Faatulia and Fanua, and little Meli Meredith, all mounted. Gathering them together, under rather a gentle rain, we turned toward the woods behind the town and cantered over a dyke, through a mangrove swamp, where formerly must have been some coral inlet; then past some villages, a few huts, and then into the forest. This is no description to you, but perhaps I can interest you by letting you understand that the delicate form of the great novelist, Mr. Stevenson, passes up or down this road, of necessity, on his way to his Spanish Castle in the mountains. So that when he begins to write South Sea

stories, and is obliged to use local colour, you shall probably admire some beautiful description of all or part of the road.

In the woods we overtook our men, and dear Fagalo and Sué, whose bare legs were paddling in the rain. A little path led through woods all overgrown, in a narrow zigzag, over fallen trunks and under branches beneath which we bent. The light fell through green high up, upon green all around us; innumerable small trees and bushes, and occasionally great trees whose trunks ended in high buttresses of rooting sharp and thin, as if the trunk had been ravined. These are the trees which in the old story-books of travel were supposed to furnish a ready-made planking. Over all grew lianas and vines whose great long stems hung in the air above us, or low enough to be pushed aside as we rode. Notwithstanding the several varieties of growth — the Samoan wild orange with double leaf and prickly stem, whose fruit was used in old times as a soap to wash with, or the Fuafua, with broad leaves — the effect was not unlike the appearance of our own forests, had it not been for the lianas, and the occasional sheafs of wild banana that swung against our horses' heads. For an hour we went along in a scattered file, the sunlight occasionally dropping in upon the great stillness around us. Rarely a bird sung. Once we heard the running of a river. Then we came to a stopping place; all got off; the girls skil-

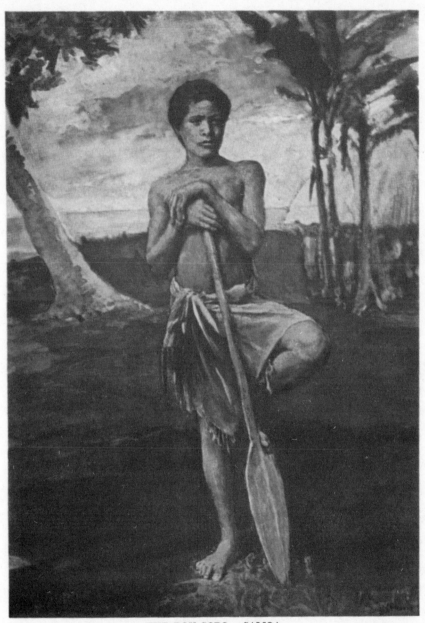

THE BOY SOPO. SAMOA

fully ungirthing and unsaddling their horses, and tying them up to the branches with long ropes. Over the trees that sloped down below us, we could now see the harbour of Apia, from one end to the other, and we kindled a fire of dead wood, to show the anxious friends at our end of the bay that we had arrived. There are three waterfalls in this little opening to which our narrow path had led us, and it leads no further and nowhere else. Of the three falls, each divided from the others by wide platforms of rock, the upper one is low and does not count. It is the second and the third that are "slipping rocks." The water rushes over them in one or many falls, according to the season, and in some of the channels the surface has become so slippery with moss that all one has to do is to sit and be whirled into the pool below. We had just begun to look down into the little hollow, edged on one side by a high rock upon which ferns and vines and green bananas find a scanty foothold, when Fagalo, throwing off her upper covering, seated herself on the edge of the current, and in an instant had slipped off. And a laugh from below echoed above as she rose from the pool and swam to the shore. By the time that we had clambered down to meet her, she had come up and rushed down again followed by Sué. The sight was charming: the pretty girls, with arms thrown out and bodies straight for balance, their wet clothes driven tightly to the

hips in the rush of the water, had a look of gold against the gray that brought up Clarence King's phrase about Hawaii and the "old-gold girls that tumbled down waterfalls." In the plunge and the white foam, the yellow limbs did indeed look like goldfish in a blue-green pool. Further down there is a small rush of water into a little hollow in the rock; the two girls in their play filled it easily, like mermaids in too small a tank. Then we had lunch on banana leaves, to which our wet friends contributed the shrimps that they had caught, accidently as it were, and without thinking, in these moments of "abandon." We had also a mess of *palolo* looking like very dark green spinach, darker than the green leaves in which it was wrapped. Adams insisted that this dish tasted quite like "foie gras," which he also said was quite as nasty a preparation.

To explain what *palolo* is I should have told you of a little expedition we made one morning last week, just on the return from our malaga. But I was ill and had suffered too much from native food to write any more upon similar subjects. Even all my liking for Meli Hamilton and my admiration for the fullness and redness of her lips, and for the gleam of her teeth, could scarcely reconcile me to the wriggling of the great tree worms through which she crunched so gayly and healthily at our last great Samoan dinner.

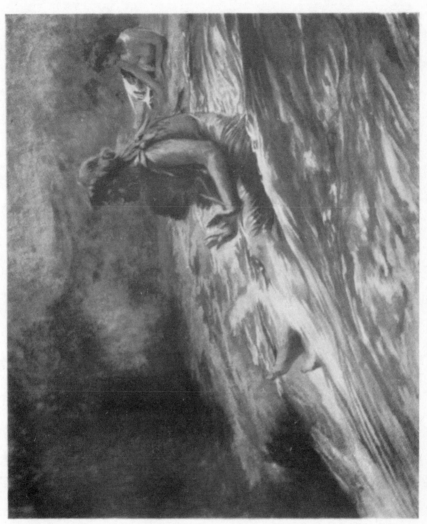

THE PAPA-SEEA, OR SLIDING ROCK. FAGALO SLIDING WATERFALL. VAIALA, SAMOA

At the waterfall, after our lunch, our men had theirs, and they sat with heads all wrapped about with leaves, while the rain came down upon them; for if there is anything that a Samoan detests it is getting his hair wet. The rest of him does not matter. Meanwhile we smoked under our umbrellas, pretty Meli Meredith half under mine, and Meli Hamilton under a big banana leaf. For most of the others rain did not matter. They had either gone into the water or were preparing to do so by sitting quietly in the current. Otaota had prepared for the slide, and was stretched out in the run of the waterfall that now swept over, now left uncovered her extended limbs; for she leaned out upon one elbow, and dipped a hand in the water, scattering it upon the other girls in a lazy way. Otaota was "missionary" that day, and would not uncover the lovely torso about which I have told you so much. Then the sun came out in a lingering, gentle way, as if it dripped down from the sky, and with it all the girls went over; Fanua and Meli Meredith and Otaota. And as we looked down upon them, they swam over and hid behind the branchings of the vines like so many nymphs of streams, their faces and arms glancing like gold out of the green. Near them one of our men made a deep red in the water by contrast. And now Awoki, with much hesitation, prepared, put on the native lavalava, and tried his luck. Yellow he is to us,

but he looked white and pallid among all those browns and reds.

The whole thing was catching, and had we stayed longer we too should have been over, though Adams said that just then our dignity forbade it. But our feeling of dignity had been helped by Meli Hamilton's telling us that the last time she had gone over the fall, she had struck badly against a rock, and so had her companion, the navy officer; so that with the rain beginning again, horses were bridled and saddled, and we all started for a wet ride in the wet woods, down the slippery path which we had to take in single file. Fagalo rode with Charley, on Sopo's little nag, and the last thing I saw of Otaota was her bare legs over the back of Awoki's horse; he sat behind, his arms around her, gallantly protecting all that remained of her with his little waterproof. And we came home tired and wet, but having spent a pleasant childlike day with grown-up children.

PALOLO

Vaiala in Upolu, Nov. 14th.

I broke off yesterday telling you about *palolo*. I think my words ended by telling you that even all my liking and admiration for Meli Hamilton would scarcely reconcile me to the wriggling of the great tree worms which she crunched at our

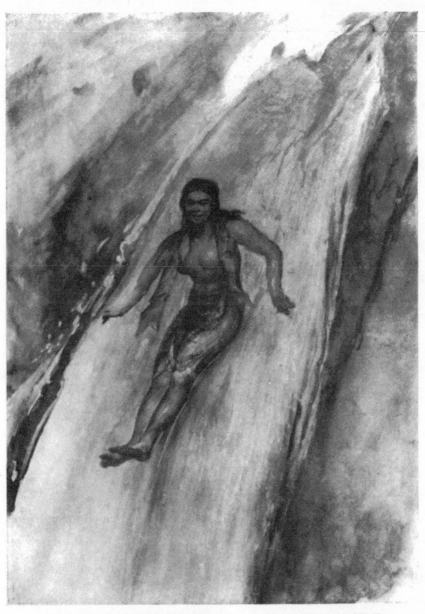

GIRL SLIDING DOWN WATERFALL. BANANA LEAF AROUND
HER BODY. SAMOA

last Samoan dinner. Mrs. Lieutenant Parker became very white as she saw her and I handed her rapidly something or other, brandy or whiskey, to help the occasion.

Palolo has no such horrors. For it we have not had far to go. Only just out into the reefs before us, when, in the early morning before the dawn, we rowed out a few yards to find a concourse of people, in boats and canoes, scooping up with eager hands thin hairlike worms that swarmed in the water within the special hollows of the coral reef.

We were more or less ready for the appearance of these little creatures who, on a certain day of the year and the moon, appear suddenly with the dawn and disappear with the sunrise until another year. We were expecting this arrival, which never fails. As I said, it is looked for ahead; it has its own laws; the scientific ones fail because we have calculated by our dates, instituted for other reasons than the life of the *palolo*. Our Samoan friends are in the secret. We white people compute that the *palolo* is due at dead low water in the night of the third quarter of the moon nearest the first of November, but that reckoning involves Solar and Lunar months, as I intimated.

Our good friends here have been whispering to us and telling us that this was to happen and they know how to be prepared for it. Certain plants, certain shrubs blossom; and then you

know that the time of the *palolo's* month is drawing near. There are signs in the heavens, and the moon helps. It is, I think, in its third quarter that the event takes place. Somebody with us, perhaps several people (because our village contains important and learned people) mark time during the year by counting pebbles, and green feathers, and leaves, up to such and such a day, so that, at a certain moment, our friends can tell us that the *palolo* is due next morning.

The third year one has to count a different number of days, but the creatures down below in the coral know exactly to the minute. The night is watched through, our people are all ready, are warned at the proper moment. People from far away are also ready. Our friends have found each one some proper hole which may be more or less lucky later. We watched the dawn coming upon us, lighting the breakers on the edge of the reef. When the breakers withdraw it is slack tide and we watch, and our friends watch, more intently than we can, the absolute calm of the water. Then, of a sudden, somebody calls out, "the *palolo* is there!" or something like it, and then this empty water is full of long lines of what seems to be worms, which you scoop up, not so anxiously as those who care.

A short time, an hour they say but it seemed to me shorter, the sun is up over the edge and the worm is gone until next year.

It is nothing but something like the thinnest of little sea-weed a few inches long, and you have to accept as a fact that this wriggling mass is made up of worms.

I wish I could fairly describe the place and scene but you can make it up for yourself. The scene is one of busy struggle. It is a matter of food, it is true, also a festival of amusement apart from the picnic side. Very interesting was the eagerness shown in the catching, by the few white girls born here, whom I watched. They paddled about, jumped out with bare feet on to the jagged coral like any Polynesian, but with that seriousness and ferocity of our race, so different from the easy good-natured suppleness of the brown skins who seem to be part of the nature around them.

The dark transparent water inside the reefs, the rosy colouring of the dawn, the splendour of the sunrise which is at length over land and water, would have been beautiful enough even without this animation of human element. But I have not dared taste the *palolo* even as made up yesterday with cocoa-nut milk. I have come to the point of a revolt against almost all of the food, from cocoanut milk to live fish and slugs.

Vaiala in Upolu, Sunday, Nov. 23, 1890.

The end of the last week has been filled with festivity. Seu has been giving a great feast, and this has been a very

serious matter. We have seen other feasts before, but none
so successful and so great. The presents given to Seu and
Faatulia, or rather to Vao, their little daughter, in whose
name the feast was given, were larger in number than we had
yet heard of. Among vast quantities of other things were
hecatombs of pigs — in prose fact, three hundred and twenty-
five — over two thousand rolls of *tappa*, and several dozen of
"fine mats." All the neighbouring houses were in requisition
for the guests, who kept coming from various quarters during
the whole week, and especially from Savaii, where is the
stronghold of Faatulia's family. Faatulia wore the anxious
look of the hostess on her kindly face, and Seu looked worried,
a thing I should have thought impossible. But as I go on you
will see how serious it all is, however gratifying it may be to
pride of position. The house of Seu was charmingly deco-
rated with *tappa*, even to the floor, so as to remind me, but
I own, more pleasantly, of our most æsthetic studios. In
others, there were few European visitors, and more packing
of Samoans. In one other especially, I think loaned by the
King, a collection of *taupos* from various localities filled the
space by the posts, so as to make the hut look like a basket of
flowers. Far in the central penumbra, two female giants sat
all decorated, and around them the backs and waists of the
others looked like a garden of dahlias and brown skin. For

some were "faa Samoa" — others were more or less "*papa-lagi*" foreigners. In that case, however, their waist coverings were amusing. Some had corselets of leaves lapping over like Etruscan or Greek plate armour. Others had coloured netting, others had *tappa* cut out with various openings, like some heathen dream of "insertions" (I think women call it so). One girl had a corselet of cut paper of many colours, making her look like a flower-bed, her oiling giving to the paper a look of leafage. There were dresses of the usual variety and in one case a large number of flower petals caught up one by one in the locks of the hair. In another the whole hair had been filled with little light blue bits of paper cut like petals. Mind you, all this was beautiful, funny as it was, and upon the green grass background, made, as I said, a basket of flowers. The brown skins that were not covered glowed like fruit. In perfect taste, for even garlands are gawky compared to the ineffable logic that the human frame carries with it, one good girl had no covering to her body, and this savage from the farther back country had a face that looked like the Italians'. In the shadow, playing with a bambino, she made a madonna. The reason of it came to me suddenly — her hair was down upon the forehead in the two large folds that we associate with the Italian way, and a great look of seriousness was added to the disdainful kindness of the face. Behind her

head the hair was full, in a mass whose colour was blond with liming, and made a great capital for the column of her torso seen with arms hidden in front. Of her I have made some studies, and posed her for photographs, and later, on the next night, she gave us a *siva* in our own house; Adams and I having duly called upon her, as if we were young men, with five loaves of bread, and two tins of salmon, as is the proper thing for youthful admirers like ourselves.

Around this beehive of yellow and black were assembled matrons and children and boys, waiting for the later food, of which they as relatives would have the larger part.

Far off, in another part of the grounds, Lima, known as John Adams, presided over the food; and in front of him a vast mass of pigs and bananas and taro, etc., etc., littered the ground. John told us about it in a high-pitched voice, with an accent that brought back indefinable associations. Whom did I know of the old school with such perfect intonation in English, and a diction that implied the gentleman by accepted tradition? Could it have been some old officer of the navy — could it have been some far-back Englishman or antique Southerner? But John, even in his exterior manner, brought back all the feeling that we do not speak English as well to-day as once was done, and that our refinement of manner and accent has disappeared.

The feast had begun; under long stretches of *tappa* supported by poles, guests were assembled around the tables of banana leaf, while we wandered about, made prudent by former disasters in diet. It was pleasant to see the triumphant carrying of great pigs by the young men, garlanded and cinctured: the platforms of sugar-cane and taro disposed in a show, as if growing in some impossible yet graceful way — the taro like grapes on a vine.

Then we wandered back to our *taupos* in their home. They were feasting in a circle around the banana trays. Two men were hewing the pigs into segments, with the *swish* so well described by my Chinese philosopher, Chuang Tseu, in his chapter of the "Rising Clouds" — if that be the one. Two older women stalked about amid the food, who caught these chunks of meat and tossed them to the *taupos*. Occasionally they varied this by assorted lots of taro or cooked food. Do not suppose by this that these vigorous maidens were bolting their food. No, all this was Samoan and communistic; no one lives for himself here, but for the lot. These good girls were hard at work, passing all this to old women with baskets, and two young people who sat on the edge of the hut with feet outside, impatiently urged them. "Wait," they said, "wait; our turn in a moment," and amid laughter and chattering and long reproofs of the old women, the food came to them in

turn. I suppose the *taupos* managed to get something, but if they did, they deserved it for the work they had in passing the food away. This is Samoa — where a gift is shared or given away. When we called later on one of the *taupos*, as I told you, and carried our little gifts, half of them were at once given to the owners of the house, and the other half to some chief who happened to be present. All this as a matter of course, with fair counting, as in a commercial firm. Even the cigar accepted by the fair one, passed in a few seconds to her nearest neighbour. Some one was telling me yesterday, of having given a cigar a few days ago to a Samoan, who had just bitten it, when another passing asked for it. Thereupon it was handed away, as a matter of course. "Why did you give that?" the white man said.

"Because he asked," said the Samoan.

"But is there no further reason?"

"Yes; I might some day want a cigar, and if he had one, I should ask." The community of friends and relatives is a sort of bank where you deposit and draw as you may need. So for Seu's food: almost all is given to him. It is given out, sent away if people are not there; a procession of people carrying things from the feast, filed along all the afternoon.

After the feast, a *siva* in the open air, where Fanua danced. The crowd was full all about her and her assistants, girls and

men. The occasion was a notable one. Two white mission-
aries with their wives were present, and the *siva* was danced
before them. Henceforward the excommunication will be
difficult, unless the native preachers insist upon having their
own way. But we shall have been present at this great
event. I spoke to one of the missionaries for a moment, a
rather interesting man, who talked a little about his hopes for
the Samoans, their conservatism, and their not being emo-
tional, however excitable they might appear to be, so that
things once impressed upon them had a fair chance of thriving.

And thereupon we proceeded (those of us who were tired)
to get away — not without, however, looking once more at
another *siva* getting under way, with some of the many *tau-
pos* and their male assistant dancers, to see them oil. Some
one ran around offering the liquid, which was poured full upon
everything, dress and person. And being introduced, I shook
the oily palms of some of the girls and of one splendid chief —
who might have been drier. Then, later, Adams and I called
on our *taupo* friend, whose home we proposed to drop into
next week in our travels, and who is visiting near us. We
arranged with Meli Hamilton as our *tulafale* for a *siva* in our
own house. There at night the *taupo* came, in the pouring
rain, and I sat in my own comfortable chair, with Mrs. Parker
next to me, and felt at home; for in the shadow I could close

my eyes or look on while the figures danced in shadow or in light.

The next day we were summoned again to Seu's feast. A *siva* would be danced for us *papalagi* who had been too crowded the day before. So that we went to see the comedy, which began seriously enough. We sat a while in Seumanu's house, filled with friends and relatives, while a woman, an ex-*taupo*, carefully unfolded the presents of "fine mats," saying what they were for, and from whom, and occasionally something of their history. For the "fine mat" is the great possession — the heirloom, the old silver, the jewels of the Samoan. And one tattered piece that was held up for show, sewed together, its trimming of feathers all gone, and full of holes, was looked at with respect; it had been *royal*. Around these mats cluster romance and story — war and quarrels — and the idea of the palladium, the insignia of power. The mat has been given at marriage and at birth, and has been worn on great occasions — it has witnessed those scenes, and besides carries money value. Its very stains tell stories of those events in life. So that Seu's thirty odd mats were quite an affair, exclusive of the pile of two thousand pieces of *tappa*. As soon as the mats had been counted over, and admired, and a polite discussion arose, our hostess insisting that it must be a bore for us to look over all

this, the polite guests insisting that nothing could be more entertaining.

Then John Adams (Lima), in his fine old-fashioned voice and way, cried out that if we wished, a *siva* was getting ready in the next house, and as our adviser whispered to us that we had better be away, for that now the real work had begun. It was for Seu and Faatulia and the family group to decide as to who should be the people to whom all these gifts were to be made over. A few they might keep, but the mass must go. Every giver had a right to something, if possible finer than his gift: and here was a ploy, as Sir Walter says. Everything must be according to dignity and family and precedence, and everything that society means everywhere. Think of the heartburnings, jealousies, affronts, etc., that hung in the balance. Many a time in Samoa, war has begun by some error in such adjustments. No wonder that we were better out of the way. Even to-day, we are told that several days more, a whole week, will be consumed in these weighty questions, and Seu is to wear his look of worry for days.

Adams and I sat on branches: I, on the right, Adams, on the left of her Majesty the Queen, while a *siva* of two pretty children, little *taupos*, daughters of a chief of Savaii, and of two young men, went on before us in the sweet light, half sunlight and half rain. These two little girls, Selu's daughter

and her little friend, the daughter of a chief of Iva, gave us an infantile imitation, while another chief played buffoon, to give them courage and protect them from serious attention. And this time Fanua sat behind us, and looked on, alongside of many young girls and women whom we have learned to know a little.

Up to this time, the terrible ordeal of decision of presents must have gone on, and will not be through until late next week, when we hope to get Seumanu on another malaga; but this time at our own pleasure, and with the hope of making sketches and studies with more leisure, and with a better knowledge, for as you know, he who runs finds it difficult to read, and there is nothing that I abhor more than the carrying of the studio sight into other visions.

Only the poet is free, whether he be painter or writer, for with him subjects are only excuses, and as Fromentin has put it so perfectly, Delacroix's three months of Morocco contain all that has been said and will be said of the east and south of the Mediterranean. But we cannot all be great people like Delacroix, nor great painters like him, nor perhaps was he at all aware in early life of his always having achieved. But he tried probably, to be exact and faithful, as any one of us might do.

The weather is again beautiful; to-day is all blue and tri-

umphant; indeed, the sky is bluer than it was, although the grass is yellower, and in the afternoon late, the clouds of the horizon are radiant in violet and rose. Fanua has come up to see me, with the Queen's little daughter all clad in pink, who has been living in Fiji, and talks English quite well, and says like a child, that she likes Fiji better than Samoa. Service at the little church opposite is just over, where Fanua has been, and where I have heard the voice of Otaota's father preaching. He has called upon me, apparently interested in questioning about the Mormons, who have sent missionaries here, and whose wives often canter past, against the blue background of the sea. Otaota's father is not a little proud of his preaching, which indeed sounds well out of the church windows, and he asks me why I don't come in to listen more closely. His parishioners sit on mats, and I sometimes lend some of mine to stray visitors, especially to members of our crew. The men sit on one side, the women on the other: and files of women, especially, walk along with mats under their arms or over their heads, or held in front of them; and occasionally a child is carried outside on the hip.

There is a small post near by, upon which is a small bell, and a ladder to get to it, all under a tree, and some young girl or boy rings the clapper with great zeal. I have made a sketch

of one of them who accidently set about a missionary work, without putting on her *tiputa*, to cover her bosom, and who was worried as I sketched her, between the propriety of carrying out her "missionary work" and her want of missionary propriety.

Fanua has left, after sending for the child of a neighbour and caressing it during part of our supposed conversation. They say that she is thinking of marrying, and certainly she will make a nice wife and mother if one can judge by looking at her. Is there anything sweeter than a woman caressing a child? and how fond these Samoans are of children. They swarm about as free as birds, rarely checked; the owner of our house, the chief Magogi, looks more good-natured and smiling than ever, when after his fishing, and leaving a fish with us, he parades about with his child in his arms. Like a woman, he even carries him when he is attending to something else. And Tofae is as gentle to little George (the son of the late English Consul, and of Tāelē) whom he has adopted, as if he were a mother. When he and other chiefs, in the afternoon, sit about on the grass, far interspersed, some ten or twenty feet from each other, in Samoan fashion, little George creeps up and nestles against him, making with him the only group in the big circle.

Fanua has gone, and from Mataafa's house begins a hymn.

I recognize the ancient sound of the Ave Maria Stella (for Mataafa is a Catholic) — another version of the Vallis Lachrymarum that Otaota's father was urging on his people an hour ago: "It is morning and you dance — but night is coming and then ——" The Samoan smile is proof against anything — but Mataafa is grave and somewhat sad, and must take things on a scale far different. The mournful dignity of his position — a king is always a king, and he has been a real one — of highest birth and greatest capacity — must always oppress him. And he has no future, I fear, for his holding power might be against the interests of Germany, to which England will always accede as a bargain, and to which we will yield, for we don't care, and we are not yet aware of our enormous strength, to be used for ill or for good, and we sell it willingly for anything.

The former German ruler here knew all about it, for the Germans have every power of measuring us, and he said to our representative:

"You are really weak — like all Republicans — always at the mercy of little home events, and any one of you will trade for some personal advantage. You can have no policy, that any one of you in politics would not break through, to play a trick on the political adversary; and then you have no fleet nor army, to show to others what you could do. Before

you can make up your mind to anything we shall have taken
Samoa for ourselves."

God willed it otherwise, but the German had measured us,
at least as we are to-day.

The moon is almost full, and comes up in the night, while
the sun is still lighting the sky with pink. Around her a
single cloud is greenish white, while the entire sky is suffused
with rose. The breakers are rosy white; the sea is of a day-
light blue, the furthest distance is lit up, and a rose-coloured
cloud hangs on the horizon far below the moon, while her
wake cuts in silver across the sunlit sea and surf.

The western sky is all afire, and against it, when the eye is
protected, the shadows of the moonlight fall with extreme
clearness and precision. The beauty is ineffable; a little
sarcasm comes up into my mind — a reminiscence of the
theatre, of a too perfect arrangement, in which the machinist
has combined too much together, the sun and the moon both
equally splendid — night together with day. I am sure that
no one would believe it if painted, and most would *know* it
was incorrect. This disturbs my peace — but only a little.
The good that comes from seeing through our teachers, is that
at length we have no more use for them, and the remainder of
life is more economical. And indeed, the world about me
here seems to say, "See with how little we can be rich!"

Another Samoan Malaga, Nov. 30th.

Fagaloa Bay, on the N. E. side of Upolu.

We are on another malaga. I have not quite recovered from illness, so that the trip is not all enjoyment, and I write to you in some dejection and with an effort. We are going around the island, some hundred miles, in our two boats; our own managed by Samau, the *tulafale*, as coxswain, with four men to carry provisions, etc., and plenty of luggage and food for all of us; and Seumanu's boat with ten rowers. We left the day before yesterday, in the early dove-coloured morning, all grey with partial rain, the mountains covered at top, and low down in the gorges, the mist and smoke from villages rising up in straight lines that looked like enormous waterfalls. Our first landing was at Falefä, where a river falls over wide rocks in its way to the sea, not so differently from other pretty waterfalls, except that it makes a broad spread of water that joins the sea, so that from some points one might imagine that the ocean runs in to meet it.

And then behind the frame of the wide fall and its bordering trees, one sees the mountains of the dim interior. There we rested at midday, and I lay on the mats, ill and tired, while Charley explained to the young woman of the house, wife of the native teacher, the meaning of a large sheet of the spring fashions of this year, which she had pinned up, with many

other pictures from newspapers, upon the screen that divided the house. Her husband was away, attending the great meeting or Fono at Malua, the missionary school, where the toleration or rejection of the *siva* has been, or is being discussed. I am told now that the native clergy have held their own; and that though not reproving their white brethren, they have not quite concurred in a full freedom of toleration, but have arranged some middle term by which the question will be always limited to individual cases.

Later in the afternoon I sketched at the waterfall, in that curious silence filled with the sustained sound of rushing water, that belongs to such places, within which a faint, sharper thrill was the gliding of the surf upon the beach behind it. The place was shaded in its own shade, thrown over it by the hills that enclose and make it. Here and there, the sun caught the roll of the water, and the distant valley and mountains behind it were all floating in hot light and moisture that came down in great gusts with wafts of heat.

In the evening we came into this beautiful bay with high mountains on either side, and fringes of lower land. The bay, as its name indicates, is a very long one, running far inland. The site we are in is charming, the great mountains right behind us, and from their lower sides, long waterfalls creep down the cliffs and glisten through the top branches of the palms.

Around us all is covered with trees. I have lounged and slept as much as possible. Atamo has begun to paddle a canoe, taking out the *taupo* with him. She has been very nice to us, doing her best with food, and seeing us to bed, and being in early to see us get up, and doing her duty generally and pleasantly. And she has given us *sivas*. We had met her before at Seu's feast; we felt mutual good will, so that she was prepared. Her devotion to Atamo is great, and as I said, she has done her best by our food, which we managed this time with Awoki's help. Through her eyes we saw one evening the resemblance of the light carried on the reef by the phantom of the lady who appears when night fishing goes on. You may remember, how she (as do others of the dead, or certain spirits perhaps — they are all confused in the Polynesian mind) fishes silently in the crowd of the canoes, or alongside of some single occupant — and then suddenly, when detected or suspected, disappears with the dawn that clears all our doubts away. Of this apparition some here say that she has her own canoe apart, just out of reach — some say that she walks on the water — but when she is followed, she makes for the shore, then is lost in the trees, and soon her lantern is seen going far up into the trackless mountain. There no one likes to follow at night. The dark for the Polynesian has terrors uncertain, natural enough, for the dark here is uncanny, and when

plunged in its terrors the brown man does not like to add a definite influence or a name of ill omen. The belief in what might be called a lower supernatural is still strong: Christianity does well enough for the great needs, but something else is wanted for the smaller fears and dangers — the things about us at every moment; and it has interested us to draw out the small beliefs of this unimaginative and very practical race, who on one side are so much christianized. I wish that I could recall for you the scene in which we heard this story. The hollow silence between the mountain in the night — the water dark before us between darker trees. The dark shadows of the mountains, across the bay — the long glistening line of reflected starlight rolled up with a splash upon the beach that broke the quiet shiver of the palms. And then the one light, far out on the reef which caught the look of our maiden and drew the legend from her. I regret so much that my constant fatigue prevents my noting some of all this for you, and that I give you, too, no better description of what I see. The place is well worth some talk — even if it were nothing but a memorandum of the pretty *talolo,* or presentation of food, in which two or three dozen girls brought up the presents of taro and fruit, and threw them before us, filing out of the green trees, and disappearing again within them.

Ulutogia (part of Aliipata) Dec. 2d.

We are at a charming place in the town of Aliipata, which seems to stretch indefinitely for miles along the shore. We have had two invitations to stop; one from Mataafa, and one from Tofae, who both have their connections here, but we have pushed further on, and are now at the house of a chief, whose name is Sagapolu, as I make it out.

Before us, to sea, over a great spread of blue, are two blue cones, little spots that belong to Tutuila. Near us are rocky islands — two of them outside of our reef. We came in on the blue swell that hid everything, and then pulled hard over the boiling of the surf, in the charm that covers danger. The morning was lovely on the water, and we raced with our other boats. We had said good-bye to our friends in Fagaloa, who the night before had given us a *siva*, not a prolonged one, well done by the girls, and accompanied curiously by the two-year-old daughter of the chief, who followed seriously the performance, and beat time or caught up with the gestures of the older people. Nothing could be stranger, and a more complete proof of the *siva's* being a natural expression. No one noticed the child as anything extraordinary, except by an occasional smile. Our crew was asked to perform, and the villagers and the *taupo* gave the preference, and she was right, to our men. The girls always seem anxious to see the

men's dances; a compliment not always returned by the men. The rising of the moon saw us to bed, and we tried to sleep late, fearing the hard day that has just passed over us.

Here, so far, all has been as usual. The house is far from others, all in the open, with palm trees some way off. At one end of the room is a reading desk, and the ruined walls of the church near by, explain that this house is used as a temporary chapel. At the other end, is a table covered with costly mats, upon which are flowers in glass bottles, and there are two big settles and two big chairs, covered with shaggy white mats made from the fibres of the *fao* tree; all this furniture upon beautiful sleeping mats.

We have had a complimentary speech from the *tulafale*, the old chief, who is thin and emaciated and extremely dignified, and has given us *kava;* and I have learned that Seumanu has a *kava* name of Tauamamanu Vao (fighting with beasts of the field), when *kava* is called out for him; the *taupo* has come in to make it, and Samau of our boat, and Tamaseu of Seumanu's, both *tulafales*, have come in to share it. There has been a spread of Samoan fare, apparently good, but I feel prudent and have taken little *kava*, and have been only a beholder of the feast.

The *taupo*, who is very young, is very silent, even when Atamo says that he is writing home about her.

They are sitting together, he absolutely immersed in his writing, a feat of which he is always capable apparently, and she is wiping her face on a new silk scarf of blue and red which he has given her, so that it has already caught the shine of the cocoanut oil.

Another little girl has singled me out, and has come to make friends, but I can only give her lollipops, that are handed away almost immediately, like my biscuit, to the smaller children. I have invited my fate, for I smiled at this beginning of *taupodom*, when she came in, almost closing her eyes from anxiety, to put a Samoan pillow for me on the pile of sleeping mats that had been spread for us to take a nap. Seu is having his back punched by an elderly lady, and peace and the flies reign over all. Here is a curious fact; one would think that with their habits of sitting and lying about, these people would remain in position, but it is only when they are sleeping very soundly that one can find them steady, unless it be a Tulafale officiating, or a chief sitting for dignity. The foot that does not press the ground is simply waggled interminably. Try it for part of a minute and see how difficult it is; and then you will realize that people who can move the foot for ten or twelve hours a day, may be able to dance when sitting, with an ease that only a juggler knows about his fingers.

Meanwhile, the sky is blue, with innumerable white clouds; — the sun smiles down on the banana grove behind us, and in front of it a little veil of light drops shows that it is raining overhead. The smoke from the house near us bends down lazily over the roofs, and Seu's *tulafale* and one of our men, are beating a tune on the two great war drums. *Lali* is the name of the beating of a tune. One two, two — two, and so on, weird enough and rather tiresome. Such are the intervals of their naps, for they have had three hours of solid rowing this morning, and they need rest. At this moment the old chief comes in and talks about the music — praising the accentuation. These drums are near his house, say some twenty feet off, and are very large; gigantic troughs of old wood.

Then he calls across space for his daughter to make *kava* again; this is the third time within just three hours, but this time the *kava* will be chewed and not grated, as Atamo has asked for it.

Meanwhile a discussion on the name of the daughter: it is Mo Niu Fataia, if I get it right; it does not matter. Her name represents the fact that a place called Fataia, which we passed yesterday, has wild cocoanuts growing upon it that roll useless into the sea: hence her name. "The plenty of cocoanuts, of Fataia, that you don't get." It is this little word Mo that means "plenty that you don't get." Niu is

cocoanut. You will notice all through, so far, how often names for people are arbitrary and accidental. Otaota, the beautiful daughter of the missionary person, is called Rubbish. Fagalo, who slipped the waterfall, is Forgetful, and so on. We have Smell Smoke Namuasua (or Cook-house, as Samasoni translated it) in our boat's crew. In the early traditions, such and such an early divine heroine names her children by things that occur at their birth. One, I remember of "Carpenter's Tools Rattling in a Basket." The Bible is dipped into at random for names, and yesterday I talked to young Miss Kisa, which sounds like Kiss Her, but is Kish "who killed Saul." (My *taupo's* statement, the usual Bible may run otherwise.) I cannot make out whether good luck follows these *sortes biblical*.

At this very moment I see coming to me a young lady who wears a black mat and a mop of yellow hair and nothing else, not even a collar. She is late, having been at church. She is the official *taupo*, the other one only taking a momentary place, and she is the daughter of the chief, and has brought presents of rings and of *tappa*; and her name is Faatoe, which means all agree, "Leave something in the basket" (when all are helping themselves), and I think this is a very fair addition to our stock of names.

All this time the others to whom she is added are getting the

kava ready carefully, gravely, chewing the root to extract its juice. There is a big row of *kava* people or attendants — all pensive; one man, two *taupos*, another man of *ours*, a little girl, and another of our men — no — there are a few others who are around the corner so that I can't see them.

Then I went for a long walk on the seashore. The sun was setting; only toward Apolima was the sky at all clear. Over one of the islands to the north, cloud and mist threatening immediate rain, made a large veil that hung far up and melted its violet lace over the island. The sea was of the fairy green that the inside of the reef takes in rain, spotted with violet where the coral lay. With me walked on one side my little girl, her upper garment fluttering, her young, long brown arms and legs glistening in the sun. She smiled at me for all talk, for English she knew not. On the other side, a hunch-backed dwarf, Japhet by name, with yellowed crispy hair, naked to the waist, a garland of red fruit hanging down on him, to meet the blue drapery about his loins — his bare legs and tattooed thighs glistening also in the light. Their company meant kindness and the *habit of accompanying a chief* — and they were kindly certainly, and meant to please and serve. Neither you nor I could have invented a more curious combination, and one of which I should like to have either a

drawing or a photograph, that it may serve for the ends of my life. If instead of me and my linen helmet, and trousers kept up by a sash we had had one of the Spaniards, who ages ago, perhaps, landed in the unknown neighbouring island of the Gente Hermosa, the "Beautiful People" — some bearded man with butgonett, and velvet hose and jerkin, the picture might have been that of a knight-errant in fairyland. Such a far-away image it made to me, as I looked down either way to the earnest face of the dwarf framed in the fruits of his garland, or the politely anxious eyes and moving bosom of the young virgin of the village, as we stalked on almost abreast, in the silence, making threefold tracks of very different shapes in the smooth wet beach; until the rain broke down, and then I ran back, supported and clung to by my improbable companions.

As the day closes it is still raining. A sort of glow is in the grey of the rain, so that it reddens all the shadows among the trees. Far off toward Tutuila there is high up a great opening where the sky is as of an apple-green that has been washed with the lavender of the rain clouds: big cumulous clouds round out, made gold by the sunset.

The light fades away, and all becomes blurred except always the cumulus in the distant green sky. The lamps are lit and we turn to dinner.

In the evening afterward we got to talking about the legends and superstitions, and we were for a long time merely getting about it. There had been a promise to have something written out for us of old verses, and then songs were sung, ordered from a number of girls.

These were mostly poems concerning the son of the old chief, who died in the last war, and about whom, says Maua, he is always thinking. I watched his face and sketched it while he sat and listened. He is as striking as an Arab chief, with the orbital bones projecting like a camel's from out of his face, so as to make a great line of light or dark around the looking part of the visage. His head recedes far up, and his long beard drops on his thin chest. This death of his son has affected him more and more, so as to make him slightly insane.

Maua says that he was once "the baddest man in all Samoa," and that he was the greatest dancer, and that he had invented many dances, and that he might be tempted to-day to dance, if only we could find some person to accompany him with songs to suit. I think that Maua is wrong, for the chief has become missionary, and is quite absorbed in that sort of thing. As I was saying, he has a splendid, fanatic, Arab head; and so the evening has closed with the old chief's listening to these memories of his son. I am frightfully tired with listening to the legends struggled for. Perhaps a verse or so of

some of the songs might be worth saving out of this wreck of dreaminess. It was a pure, complimentary, Samoan idea, poetic only perhaps because we cannot help translating the feeling as well as the words; it was about a chief the singer sang — a young and handsome chief — and she said how natural it was for the girls to wish for the hero's notice, "for the very winds that blew belonged to him, coming as they did from his ancestral island that lies to windward." But our friends are not poetic, I feel sure. They are intensely practical and full of common sense; they make poetry for *me*. And they are restful — and I — am sleepy, as I said before.

Wednesday Afternoon.

This morning, while it was raining, the old chief talked of the spirits that once ruled. We are told that the chief believes yet in these ideas, but I cannot make it out distinctly, neither one way nor the other. He is missionary now, and as we take his portrait, wishes to hold the prayer-book in his hand. But he tells me there are people who control the spirits (devils, our interpreter and we have called them — *aitu*) and that they predict things and recover property, bringing evil upon him who has erred until he acknowledges. And this power is not given to any man by inheritance, it cannot fall upon a plebeian, neither the son nor nephew of chief or priest, if indeed

there were priests, for this he denies. He says that his people prayed, making oblations to the deities of the village and of the household, and that when these were collected together, they were eaten by *them*, which, he says, means by those who collected — not the priests, but the family or those attached to the chief, who thought it time for such offerings. And these were given to the bush, if it were for the bird divinity; to the sea, if the divinity was the cuttlefish. His was the cuttlefish, and his family did not eat it. All this, of course, you know more or less of; what I say is of no value except insomuch that I heard it myself. To know all here would require to be master of the language, not to be confined by missionary ideas, nor to be connected with such — and after all that, to have a very receptive, a very acute, and a very truthful mind. There are such people in the world, but you or I do not find them usually writing books, and judging questions for others. These soundings of the savage mind are Atamo's properly; he is patient beyond belief; he asks over and over again the same questions in different shapes and ways of different and many people, and keeps all wired on some string of previous study in similar lines. But everywhere one comes right against some secret apparently, something that cannot be well disentangled from annoyance to the questioned one. For instance, in the question of genealogy, Seumanu told us that

had he been interrogated some years ago in such a direction he should have struck the questioner down on the spot. Still we have hope, and if any one can manage it, Atamo will. Web after web I have seen him weave around interpreter and explainer, to get to some point looked for, which may connect with something we have already acquired. As many time as the spider is brushed away, so many times he returns.

This morning talk of the world of bad spirits that do harm to man suggested to me an opening toward a side I had never read of or heard of. Were there spirits that did good as well as spirits that did harm? There I had a door for home history. Yes, there were such, and no further than here: his son had had such a spirit, who went about with him and looked after him, protected him from harm (apparently from woman a good deal; and took, in such cases — as even with us — the shape of some other woman). Sometimes this protection would be sudden; when he was in the way of harm, a good spirit would appear and drive away those that might harm him, and would sometimes lead him personally away — *prevent* him — as the old word goes. And all knew that he was so protected; the spirit had been seen and would only disappear when suspected. Otherwise, any one might take the same for mortal man or woman — as in Homeric story,

where Nestor speaks and acts, but it is Athens all the same. And had this spirit, or such a spirit, invariably an action only for good? Certainly — and nothing had ever contradicted such a view. And yet — only once, the good spirit had killed a man, but it was for protection always, as a guardian. Then, of course, I could ask no further. As you see, analogies keep coming up, our ideas easily dropping into theirs, and *informing* them — probably.

And had these spirits and others been apparently existing out of the world of humanity?

The dead became spirits and fought anew the old battles, with a knowledge of the present; as when a chief *aitu*, known by name, some weeks ago refused to participate in a spirit war urged on by a feminine spirit. "No," he said, "I have been missionary, but if I am attacked I can defend myself. Go on with your war; if you are successful you do not need me; if you are pursued too far, and into my territory, I shall be here."

Nene is the name of this male *aitu* who has "joined the church." . . . And the dead killed at sea turn into fish, into turtles, into sea-life. Now how to clear these from the original spirits existing of themselves? There was one, Tangaloa, who, our friend said, might be supposed to be a distorted vision of the true God. But that you know as well as I.

Here the talk drifted away to a question that, as you see, naturally connects. Were offerings made to spirits as being ancestors? Were offerings made to ancestors? No; of that they were sure — not even if Hawaii was different. And they did not care if the black pig meant anything in Oahu — to them (and the white teeth shone) it was only good to eat. If it crossed them in war excursions, it was only good to kill, but the bird and the cuttlefish, they were not to be hurt; and the bird might mean a good deal to them as it gave them omens by its flight — according to its favourable direction or the reverse, or by its cry. But they had, above all, a great divine omen, the rainbow — which presided over all. When for the people here it was bent over Tutuila, then things were against them; if it stood against them they were not to go into the war, but wait. If, however, it went with them, its end turned toward the enemy, then they were protected by it, and had victory promised them.

We passed the morning in such talk. Then we sailed out to the little island of Nuu Tele opposite, an old crater, and waited a while, while Atamo explored it, thinking to find out matters which might affect present theories. He found raised beaches, stratified, and shells and pebbles in the rock, so that it was mud once, and forced up and not submerged, all to the greater confusion and defeat of Mr. Darwin. But as these

triumphs are out of my line of momentary record, I have only to say that I found in the little savage girl-wife of our momentary host the type of little Sifa of Tutuila, which had almost been lost to us. The usual Samoan face is heavy and not wild, suggests good nature and practical views; poetry is not in them but from them. It is we who put it there, because their bodies mean to us possibilities of expression which we associate with intentions that have not yet been developed in them. Nerves they have not; it is only occasionally that one recognizes any permanent tendency to emotion, often by some trifle that is not always pleasant, as in the sadder face of some dwarf or joker, or as in our host's face, over which great sorrow has passed — or perhaps again in such a "chevalier" as Mataafa, whose character is rare the world over.

Our day passed pleasantly, and as I write, the other end of the room is filled with all these good people lying in a jumble together; Maua and the *taupo* who is pulling at him and lying on him in part; another girl's head under hers, while all their feet run up on the posts. Others yet, lying flat, continue the circle, singing together, and sometimes, without rising, beating a *siva* movement on their own breasts or on each other's. Four of our men, of the biggest, sit far away in the dark, with crossed legs, upright, immovable, like Egyptian statues: or, as

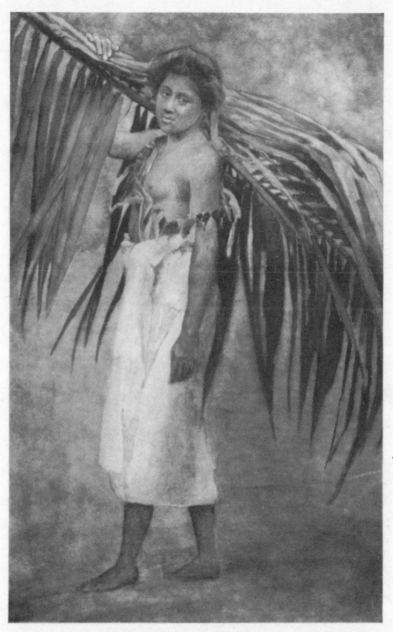

SAMOAN GIRL CARRYING PALM BRANCH

I close my letter, like sphinxes, have bent down to the ground from their hips, all lost in the dark, with large heads and shoulders and outstretched arms.

Lepa, Thursday, Dec. 4th.

We were out to sea, in the sun and rain, between nine and eleven o'clock, and passed the two islands, large blocks of green and brown on the green and blue water. We came here first, pulling through the reef, straight to the enormous beach, where our eyes were at once charmed by the theatrical, or should I say geological absurdity which divided it, cutting it right down from the steep hills behind, to the water's edge. This was a little waterfall of three cascades tumbling over some small rocks projecting far across the beach, so that the water had, as it were, a stone conduit upon which it was carried from the mountain to the sea. It was an absolute set piece, quite practicable, and if ever I have to design for scenery, here is a little natural object all ready to hand. The copy could be supplied with real water, just as this one is, and the palm trees growing upon it would conceal the machinery as they do here, only — if ever I do it, I shall be told that it is unnatural — just as it looks here. Why does the water run on knife edges, instead of taking the easier lines of depth, and tearing up the sand for a bed? I might explain how, for Atamo is

full of geology, and it is not as mysterious, of course, as it looks. But I give it up, and content myself with sketching the little girl between the posts opposite me.

We are in the *faletele* (guest-house) quite near the water. Some thirty feet off from us cocoanuts hang over the beach and the sea. Right behind us are rocks upon which is perched a new and handsome Samoan house, half-hidden in the green of trees. A promontory, finished by a little island with palms, cuts off the further end of that long beach which is divided by the cascade with its rocks and palms. Toward us, on one side, falls the column of water, which ploughs a little canal into the sea. There our men are bathing, standing up under the falling water, and later I shall be there too. The other end of our bay, near us, rounds away behind trees, and a mound, upon which is a fishing hut under palms. In our house the central beams that support the roof, come together like a V. All the posts and beams are decorated with flowers and leaves, and in the centre, near the great branching post, stands a table covered with *siapu* (bark cloth) and with flowers in pots, as on an altar, say a Buddhist table altar. Some of our men are dragging up the boats, but I am too lazy to turn to see them place them under the shelter of the cocoanuts. The *taupo*, is looking at me while I am writing, or at Atamo similarly occupied. She is bored, but I can't help it. I could

not entertain her if anything depended upon it. It ought to be cool, but the beach sends up hot waves of air, and my *taupo's* cocoanut oil melts into it languidly. The name of the place is "A Break Between Waves," and the name of the *taupo's* brother, that heavy youngster, who is talking to Seu at the boats, is Break Love. There is a connection that I feel, but you had better make it out yourself. If the chief is heavy, the *taupo* is clever, and makes herself agreeable. Her sister helps her in every attempt. They are not as dignified as one can remember, and perhaps had we kept to another line of travel, and visited higher types of aristocracy, it might have been different. But they are easily amused and talk much, and are great beggars — and gently, are willing in the same way to marry us, one of them proposing to marry us both herself, and even asking at the last moment, "Are you going away? I thought you would have married me this morning." All this is joke, with perhaps a look to possibilities: for do I not remember how two little *taupos* very missionary, far back in Savaii, changed their little easy manners to seriousness, and almost aggressiveness, when some madcap hinted that we were on a wife-hunt, and had come all this way for it. Those two little pieces would not allow the liberties of five minutes before, nor would they let me go without having catechised me seriously as to these chances —

to which they were willing to submit; but they wished before-hand to know whether there was anything in it.

We had a *siva* at night, in which our young lady figured with the great grenadier's cap that looks so savage and soldierly, and which is really becoming, the heavy faces growing gentle and refined under this heavy contrast. But it is painful to wear, being bound on tight, and how our *taupo* could stand it for three hours, as she did, I know not. She danced and sat down alongside of us alternately for nearly four mortal hours. Through all the dances there was a great display of pantomime, mostly comic, made none the less by the gravity of some of the performers who acted in reality as a dancing chorus; so that right through the crowd of delir-ious young men and women passed in and out a fine old Ro-man senator — I cannot better define him, who never smiled and who wore his drapery as do the antique statues, and whose mind evidently saw other meanings in the steps than did the other dancers. I could almost have wished that there had been some meaning in this accident, some deep, deep thought in this tragedy woven into the cloth of the fun, but I believe that it was merely the pleasure taken by the old man in feeling that his limbs were as vigorous and as supple as long ago. And we went to bed, the entire company remaining alive and interested for several hours after our succumbing to sleep. I

could hear late in the night Charley and the *taupo* crunching
sugar-cane and whispering while Charley, during the whole
evening, had lain sound asleep. But sitting up late in the
moonlight is Samoan. Before I fell asleep, my mind went
over some of the historical developments of the theatre. I
have certainly been instructed that at the beginning complete
realistic performance is impossible. And yet I had been lis-
tening to a play in which every possible combination of a
fin de siècle manner of looking at things had been slowly and
elaborately combined. Was it then that this society in which
I am now living, savage as it seems to us, is really a very
modified form of an ancient structure of life? Or did these
good people, when they sailed from the dim Havaiki, bring
already, in their habits of mind, modified trainings of earlier
civilization? Any similar views would please me, but I should
be better pleased to consider that the rules have not been
accurately defined and that we don't yet really know enough
about it.

This story of nothing I conclude to-day at Falealili, as we
get further on. We were overwhelmed with gifts at parting,
so much so as to make us feel as if perhaps the only fair thing
would be to marry one of the girls, as an adequate return.
Then with the return gifts we might have run away.

A wife brings mats usually, and gives much support, as is well known by one young gentleman I hear of, a captain of some schooner, who has wives in different places. Each of them in turn supports him when he appears, and as long as his visits are regular, and there is no preponderance or excess or skimping in his remainings, everything goes well, and there seem to be no jealousies. In fact, I think that the having to provide would be a great reducer of those sentiments that flourish most where there is idleness and pampering. Let us say that the subject is too complicated, for I feel already as if I had carried over too much of this letter into the next one. I am concluding now twenty-four hours later, at Falealili, while waiting for letters, and appearing to listen to the complimentary speeches of a *tulafale* who rejoices in the name of "Tuiloma, King of Rome." He has a good deal of style, but not enough for such a name, while the chief of Lepa, who drops in to explain his reasons for being absent during our visit, has a fine head and makes a pretty good picture. He has fought against Seu, and they talk over old times. I am told that he fought well, and he looks martial, as I have tried to hint above. Otherwise there is nothing to speak of, at least for me, for I am miserable. It is very hot, and I feel the want of air. I have tried to sketch two little girls making wreaths near by, and they have been driven away to let some *tulafale*

come in and make the ordinary speeches, to which Seu listens with his usual impassive manner. If he is bored no one would know it. Much laughter goes on after the ceremonies. But nothing can restore the little girls. One is a half-breed — very light, her already fair hair bleached with Samoan liming, and she has grey eyes and a very Samoan face. Her father is dead and she lives absolutely like a Samoan. I follow her movements, trying to detect some differences in this little creature, whose fate might have been just as much the other way. All that I can notice is that while I sketch she moves less than the others, and is content with fewer gestures. The fluidity of the pure brown blood is not quite there. I have told you, I suppose, often enough, how difficult it is to catch them in a drawing, unless they are asleep. I have never been able to get a whole minute for any position. Seu sometimes remains quiet for a few minutes, and some of the greater people or men of character are disposed to be steady. But usually it is perpetual movement skilfully disguised under an appearance of quiet. The half-breed was, as I said, more quiet and steady than her darker companions: our little half-breed Charley — sometimes referred to by the old joke of Charley Yow, the Boy Fiend — who serves as interpreter and boy-of-all-work, being a boy, is still more restless than any of our boys. He will lie asleep absolutely as if dead, but if awake he must wriggle. He bends

over in true Samoan way, but as he has neither Samoan grace nor strength, I half expect to see him put his head between his legs, dog-fashion, so as to be able to take a convenient look up his back. He plays with his toes and rubs his fingers meditatively, with the European side of his mind, on the rims of our glasses and saucers. Even the rainwater gets a taste of cocoanut oil when he has been about. Yet he is clearly "Faá Samoa," and lazy as he is and pleased at playing with his fingers on a string tied round his nose, or trying the edge of a knife, he is serviceable as a Samoan. When we put him to the task of interpreting a little Samoan poem a few days ago, he showed an unwilling capacity of mind not unlike what I could remember of schooldays when we had to put Chaucer into modern English, and when we bent all our energy into avoidance. The future of the half-breed is an interesting question here, but too much for my present dreaming.

December 6th.

Later, last evening, during which I was absolutely idle like Charley, and unlike Charley, because I was not well, we had a sort of abbreviated domestic *siva*. We were politely asked if we should like one, and as politely we explained that we were determined to go to bed early, but that we should dislike to interfere, and would look on as long as we were not

too sleepy. The little daughter of the *tulafale*, herself the *tulafale* (spokeswoman) of the chief's daughter, who is the *taupo*, explained to us that being "Misionali," she could not figure in it nor be present, and if she were Misionali I think she did as well. The *siva* was sung sotto voce, and danced softly by three or four women, probably with reference to not disturbing while we looked on — in some curious confusion of meaning. The *taupo*, who is very stolid, with the expression of a judge of the Supreme Court, danced with nothing on but her *tipuka* or upper garment, put about her waist, so that the hole through which the head is put in this variety of "poncho" exposed the least polite parts of her back. And as I referred to her gravity of expression, or want of expression, by an allusion to the expressionless look of a judge on the bench, I might slip in here a pretty anecedote of the bright little daughter of one of our celebrities, from whom you will see that she inherits. Last winter her father gave her a chance to see the cabinet officers together, and on her return she was asked, "Well, were they nice?"

"Not nice, but funny!" she said.

Well, so with the dance; and danced by the virgin of the village and her chaperon it had a curious side. And it was funny enough, with the fun underscored and interlined and underlined, as it were, by verbal comment. Apparently the

true dances that are not played are innocent as well as beautiful, but when the drama comes in, the dance follows the usual history of the drama.

This is a great missionary centre, and to-morrow will be Sunday, a day on which we shall have to rest because the people here are sabbatarians of a very strict kind, and do not approve of travelling on the Sabbath. Our men tell us things of the habits of travelling; they are all, Seu's men and ours, except our two *tulafales*, whose behaviour is all that one could ask for, young gentlemen whose glory consists in the constant and sometimes successful assault of feminine virtue. As they explain it, they would be laughed at at home, if they could boast of no conquests during the trip; but owing to this being an "European malaga," because we are European, they are on relative good behaviour; so that they lead in prayer and sing hymns, and are in other matters quite good boys. I have no doubt also that besides the fact that Saturday night and Sunday will give them plenty of feminine society, they also do not think that it's quite the proper thing to travel on Sunday.

So you see that one can go far and see the same thing, and that, as I told you in Japan, the world is fairly round. Expressions vary, but the meaning is the same.

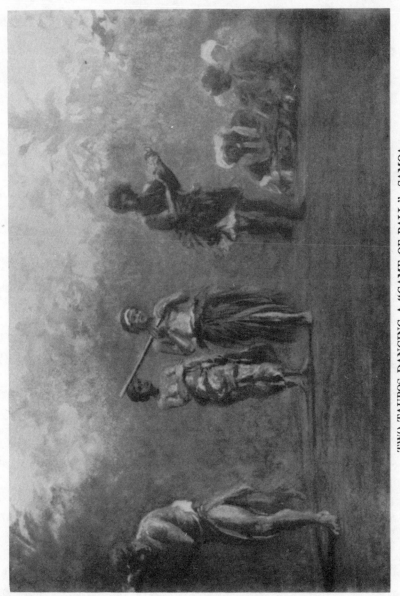

TWO TAUPOS DANCING A "GAME OF BALL." SAMOA

I am writing now from the next station called Vao Vai, "Between Waters," a queer little place looking like some African possibility. Little houses are bunched together near a little river close by us, and in front of us, seen through trees, far out, is a little island full of palms, which the *taupo* tells me, is used as a resort for sick people who go out to get fresher air. She herself explains that we shall have no *siva* because they are sad for the loss of a young man, a half-brother of hers, brother of the *taupo* whose dance and dress I described above, and who was the *taupo* of the preceding village. Our good girl is missionary besides, which will secure us the greater rest from *sivas*. Her brother's death was explained to us last night. He had gone over to Malua, where is the theological school, on a trip, with only one attendant, and fell ill and died here on his return, having, they assured me, been beaten to death by devils. So he said himself before death, and in proof of it, his body was sore. Moreover, just before his death, he ran out into the woods, in the dark. But being caught by the leg, by some *tulafale* or person of importance, and asked who he was, he gave his father's name, thus proving beyond a doubt that he was possessed by his father's ghost, I have not yet been able to get the connection between his father's spirit and those who beat the son to death. But that may turn up yet, for the subject is in everybody's mouth. I

ought, perhaps, to add that the young chief had had a cold before, with inflictions of pneumonia, and had been somewhat relieved by medicine from the Catholic priest at some adjoining station, but the devils were too much for him.

To this little hut, looking out toward the enormous space of the sea, nothing growing in front of us but two half-cut-down bread-fruit trees, on the line of the horizon and the little island just outside of the reef, and the long line of breakers extending right and left and as far as one can see — have just come your letters carried to me across the mountains, in a great rain. I have been in some anxiety for them, for I had had only partial news since September 5th, which was three months ago. Newspapers have also come from San Francisco and from Auckland, giving telegraphic news as far as November 17th, from San Francisco to November 6th; so that our evening is full of incident. There has been a political change through the elections at home that alters the positions of persons, and gives one a sort of feeling that all is not Samoan peace. And the financial news affects us with doubt as to long delays, for drafts on the Barings, or on any one, indeed, will not be quite as easy to use in these little communities. So that this event is a turning point to me out of the world, as well as to the great people in it. To increase the resemblance to home, where

FROM OUR HUT AT VAO-VAI, SAMOA

little habitual matters accompany great ones, we find in this little far out-of-the-way place fresh butter for the first time in many months, and milk. So that with Awoki's cooking, we interrupt for this evening and to-morrow morning, the course of our Samoan food. It is amusing to notice what importance this event has assumed, and to realize that to-morrow, Sunday, will be so much more pleasant for this little change.

Sunday.

This morning I watched from behind my mosquito-bar, where I was pretending to sleep, the procession of people going to church for the second time. I had been waked at dawn by the little bell, which sounded like a steamboat call for all aboard. Against the background of the sea filed continuously the parishoners, grown people and children, most of the women with the hats that belong to their idea of church. But among them were some women with "fine mats" around their waists, that contrasted with the queer European headdress apparently made only for this and similar markets. These contrasting individuals were, I was told, the watchers upon the dead man of whom I spoke, he who was killed by devils in the woods. These fine mats were their guerdon — for he was a chief's son. Had he been the chief, my informant said, mourning would have been general; the people would

have had half their hair cut, and this would be done perforce to such as neglected it. With this information I woke up officially, just as I saw our men filing away to church. Later they came back to ask for canned salmon for their girls. Nothing has occurred. I have sketched most of the time. Atamo has been over to see the little islands, for the pleasure of paddling in a canoe. The *taupo* did not go, whether from missionary sabbatical feeling, or whether she was afraid, or whether the men would not let her, for they said that a woman did not know how to take care of a boat over a surf; rather an ungallant way of looking at it, for the women we have known, pretty generally paddled about well enough inside the reef. Our little *taupo*, who was very nice and quiet, spent most of the evening playing with the men. I have spent the day in intellectual idleness, as I told you, as the place is very small, being half surrounded by a little river, and crowded with small houses. I have moralized in a depressed way, and in this direction: would we at home, if things were clean enough about us to deceive us, find it amusing to sit in an Irish shanty, as we do now in this one? We should have pigs about and occasional dogs, and kind, ugly old women and some politics. And the resemblance grows more and more as I look at it from the dirty point of view. Things are thrown out of doors to the pigs, who are so convenient to put

things into you wish to get rid of, as Mrs. Bell used to say. And the ducks wander about everywhere, and I watch the way the pigs eat cocoanuts, etc.

The chief and the others, the *tulafales*, have made speeches and drunk *kava* over and over again, all day, in an unofficial manner. And I am so sleepy, so sleepy that I almost fell off my chair, for I have a chair or camp stool — during evening prayers.

December 8th. Saagapu.

Anagapu is the name of the chief.

We are a little further along the coast, having passed through a dangerous reef, and waiting for a better tide, which we shall have to-morrow. The village is large, laid out handsomely in length, a little tedious in its regularity, well planted with trees, and with swamps behind and on the two sides that confine it. We have had the longest *tulafale* talk that I have ever suffered from, and I am prostrated with weariness and with sultriness of the air. We had feared heavy rain and looked with anxiety at two great water-spouts circling in the hills as we sailed along. There is an arrangement of mountains just behind us, probably some ancient crater, that looked as if it must be always in a boil of rain. There is nothing to do, fatigued as I am, but to go to sleep, and try to

brighten up for a *siva* that I foresee. The people are many.
There are lots of children, and girls who strut about careless of
their lava-lavas, for this is a place unfrequented by foreigners
and by the elegant people of Apia. I see two blacks, or
Solomon islanders, dressed in lava-lavas in the Samoan way,
who have taken refuge here, having escaped from the German
plantation further on, which we hope to reach to-morrow
evening. The chief tells me that they are quiet and well-
behaved, and that they go to school like the others about them.
All these blacks work harder than the Polynesians, and even
their anxiety of look, as they come with hesitation toward us
has a sort of possibility of action that I do not find in the
browns of a similar class. I need not have suffered so much
from the conventional speeches. Our host, on my waking
from an attempt at sleep, stretches himself against the post
nearest to me, and breaks out in most vernacular English,
stating that he has been a little everywhere, and has been
away from home for some twenty years. He has been as far
as New York, which he says is not a good place for a sailor;
in China many times, in Japan, in India, in France, in Eng-
land, etc. He has conversed with the American Indians and
states that he can understand their "lingo," as he names it,
from its similarity to the Pacific tongues spoken by the
Polynesian. He has theories on these subjects, and believes

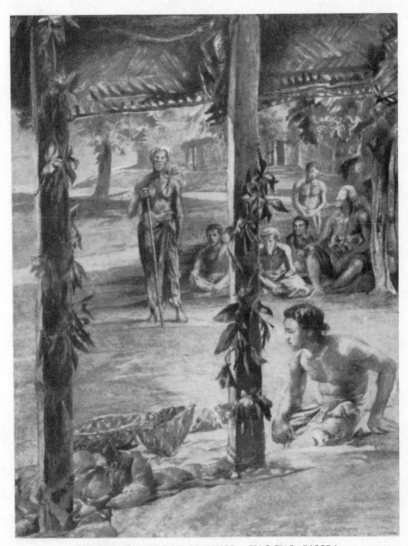

TULAFALES SPEECH MAKING. VAO-VAI, SAMOA

that there is a connection of race between the Hawaiians and the Samoans and Tahitians, and he extends it to the Malays in the west, and the American Indians in the east. And as I listen to him, I keep thinking that the story of the entire Pacific is probably the only explanation of the Polynesian. I should like to hear more, but personages of importance again come in and more talk of the society kind recurs. Later we are asked if we wish a *siva*. We hesitate for every reason. First, we hear rumours of a *siva* being prepared for us further back in some place already passed, owing to some letters of Tofae that announced us. Secondly, we are not impressed by our *taupo*, who besides want of beauty has also a discontented look which in some grotesque way reminds me of modern English high-art pictures — something grumpy. Then I have made up my mind to have a good sleep if possible; so that we say yes, if only the *siva* can be in another house; then we add that if we are too tired we propose to leave. We find, as usual, our boat crew extremely interested in the sub-ject and in the performers, and the neat little house where we go in the dark is absolutely filled with spectators. A place has been set apart for us, filled by our two camp stools, and we are in time. The performers are full of anxiety to begin, and suddenly enters our *taupo*. In the dim light her sul-lenness looks like calm, her big headdress covers enough of

her face to make the lines look delicate; and she comes in with
a sort of hop of assurance, and throws herself down an entirely
different person. She has authority and grace, and the "I
don't know what" that belongs to any one completely sure of
a good professional standard. And she smiles with excite-
ment, her smile widening with the cocoanut oil upon her face.
And so the *siva* was full of fire, and danced in splendid time.
Then we were able to leave and managed to get a good night's
rest. The floor when it is well covered with mats makes an
excellent bed, and when one is sure and protected from mos-
quitoes everything else fades easily into sleep. In the morn-
ing we had a short talk with our host, who complained that
he could not get away again to his wanderings. Samoa might
be a good place enough, but he was bored. He had to submit,
however, to the head of the family, who refused to give him
leave. The old man, as he called him, using our phrase, kept
him confined to his chiefdom. Family authority was thus
vested in his uncle, our friend Seu, *who had the name*, and
though the chief's authority was his own for his chiefdom,
outside of that the head of the family was master. This was
the Roman law in its integrity; our chief personally was as a
son, and only free when exercising a function. Even were he
required to leave and come to his uncle in Apia, he should have
to do so, just as he was bound not to go off as a sailor again.

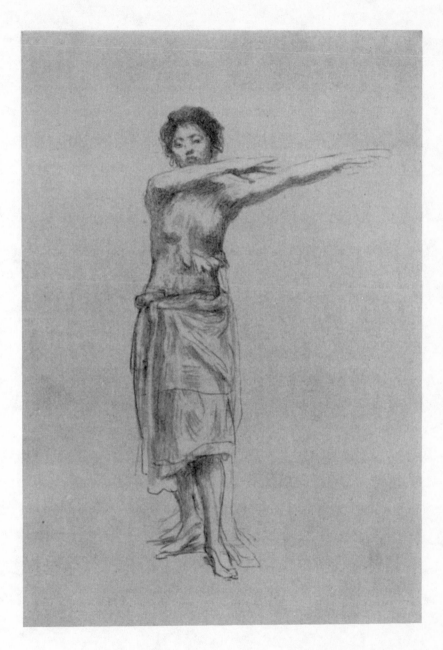

TAUPO DANCING THE STANDING SIVA. SAMOA

Our conversation was interrupted by loud shouts, and the sound of much trampling — and then by shrill cries of women and of children, apparently in derision, for there was much laughter. A girl was running away under the fire of sarcasm, and dodging from one house to another, which she would again leave, probably from finding more trouble inside. And we were connected with it. One of our crew had been too much taken with the charms of one of the *siva* dancers, or she had felt his eloquence too deeply. She had run off with him after the dance, and he had made promises; among others she believed that he would take her with him in our boat, and there she was on time — ready to go — only to find that it could not be — and that he must have known it. In fact, the women kept repeating to her that she must have lost her senses, that she must be an impertinent fool to think of sitting in a boat with such high chiefs. Siamau, our man, was slightly downcast, but not too much so — he was still a conqueror, but the poor girl was — well — she was to be pitied. Her trial and humiliation lasted all the time that we remained, and I was glad when we pulled away. The tide served us, and the wind, and we made a long pull to the place where I am now writing, Satapuala, only some twenty-five miles from home.

Satapuala was as we had seen it before, on our last malaga; but its young chief, whose dancing I had hoped to see again,

was away — to visit Tamasese, the former king set up by the Germans — at the other end of the island — at Lufilufi, which we had passed without calling, in our anxiety to remain outside of the war of politics.

The guest-house was decorated as before, with palm branches on ceilings and posts and central pillars, and flowers everywhere — a most beautiful greenhouse. And the big *taupo*, the sister of the chief, was there, as amiable and dignified as before. In the evening she danced again, this time without the support of her brother. She did not seem as good a dancer. I noticed, however, that more than any one else, she used her hands and fingers to carry out the motion, and that she finished, as it were, the movements begun more rudely and vigorously by the men. She had the same enchanting style and manner, and even at the end, when a standing dance was given more outrageous than ever, she retained, with her smile, a look of not knowing what it was all about, that was as good form as I suppose an official virgin could assume in such a plight.

That was the end. I take it, that as Maua said, this being an European malaga, things were made more formal and mitigated on our account.

We are waiting for the tide with which we shall row straight to Apia, in about five hours — over the well-known sea.

Evening.

We rowed back in true Samoan way, our rowers making a show of pulling and singing a great deal, with an energy that had been better thrown into the oars. In fact, they danced a *siva* of return. The worst and laziest of the lot, an amiable fellow with a persistent smile always on his face, actually rose and fell on his seat with excitement. The other boat, our own, with Samau and our own four men, kept up well with our ten rowers. On boards placed to let them squat Samoan way, under the awning, sat a chief we had taken with us, who wore a great white turban and kept fingering his beard, and a young woman, a cousin of Seu's — so that they looked Oriental enough. In Seu's boat, Tamaseu, the *tulafale*, the stroke-oar, alone rowed vigorously, though the oldest and least strong. He gave out the chant and pulled to it, while Seumanu, standing in the bow, guided us over the shallow water, and Atamo steered. As we turned round the last point, in the light of the sunset, we crossed a large boat manned and paddled by girls, all of them dressed in red, with green garlands around their heads, and for a figurehead a little girl sitting upon the bows, her crossed legs hanging over in front. Two black figures in the stern were the nuns of the convent to which the girls belonged, and they were all returning from a holiday. It was a pretty sight — nothing is more beautiful

than the united movement of paddles and of heads thrown back in chanting, for of course some hymn carried them on, undistinguishable for us from a pagan tune.

December 24th.

Nothing new, except social and political news: the excitement at the Chief Justice's coming, and the innumerable Samoan reports thereupon; and Fanua's engagement to an Australian business man, and her marriage for the last of the year. There are many "cancans" thereupon the question of marriage in due form, or of a Samoan marriage which does not bind the white man who leaves, being much discussed. It was even proposed that she should marry first some Samoan — why exactly would be too complicated to explain.

Meanwhile I am trying to work a little and recover from the dissipation of the malaga. The days have drifted along, and here we are upon Christmas, the weather very hot, and not recalling what you have at home except by contrast.

Yesterday we had a great storm, the wind blowing the tortured branches of the palm in great gestures against the sky. Few were out except the boys, who played cricket all day in the rain, and conveniently dropped their clothes. At night, the rooms were filled near the lamps with small flies that crusted them, and covered the tables in thousands, so that we

could neither work nor read. Through the crevice of doors
and windows a fine dust was blown, the broken fragments of
dead vegetation. We are only six feet above the sea, and
during the night the dash of rain against our wall sounded in
my dreams like the lashing of the surf. In the morning the
flies that had lain in heaps of thousands had disappeared. I
saw the last carried away by the laggards of an army of ants,
which had pounced upon them during the night or early
dawn.

I have been watching some three girls and a boy who have
been sitting or playing about near me. Strictly speaking,
only one, a grown-up girl, has been sitting. The others have
placed themselves occasionally on the high bench to which
the neighbourhood resort at night for a lazy stretch and in-
finite talk. But these children were never quiet, for the two
hours I watched them. Most of the time has been taken up
by wrestling. The boy, who is the smallest, was at first
thrown by the girls, but as they taught him, he managed to
keep his own fairly — until the elder girl was enlisted in the
sport, and kept throwing him and the others, according to
rule, for she carefully showed them the proper grip and some
first movements. All this is a type of the manner by which
constant exercise rounds them out, and I could not but
appreciate how the little girl (of eight perhaps), when she

was not wrestling herself, danced up and down continuously, in an involuntary impatience at having nothing to do in the way of *siva.*

Vaiala, Near Apia.

Upolu, Dec. 25, '90.

This is Christmas Day. I am seventeen hours, I think, ahead of you in that fact; so that at this moment you are only running about for the presents and the Christmas tree, but I cannot wait for you. It is such a Christmas as they have here; they call it *Kilimasi,* and do not quite make the joy and fuss over it that we do, having been christianized by the Wesleyans. And I have not told you the whole truth; when the missionaries came, they miscalculated the time, so that in many islands they run a day ahead, not having dared to acknowledge a mistake that might have imperilled their other teachings, for Christianity was inextricably entangled with cotton goods, gunpowder, etc.

So you see, these people were like ourselves, and could not separate one kind of truth from another, a deficiency which must have troubled you in New York, as it does me both in New York and elsewhere.

But it is legally Christmas to-day, as I began to say, and a holiday, which I can only distinguish from other days,

because there seem to be fewer people idling and lying about. The convict also is not at work, he who labours near us, weeding and cutting down twigs, when he is not sitting and talking to his admirers, who decorate him with flowers and make wreaths for him.

But even this would not be an infallible guide, for the day before yesterday the wife of the very chief who had brought this man before the consuls for punishment (he had stolen the consular flag halyards — why, no one knows), and who had pined in court for thirty lashes and six months' imprisonment — which were not given — the wife of the chief, I say, came to ask us, as great chiefs ourselves, if we thought that the consuls would let the prisoner have a few days off for fishing. And we strongly urged her to ask for it, as a reasonable request — at least, in the comic opera. The other convict, who is a great fraud, has been occupied in ferrying people over the main river (the bridge having gone down in the last storm, and we people who wear trousers and petticoats not liking to wade over). But he also is variable as an index, for he usually employs a small boy of his tribe to do the work, while he lies in a little hut that he has built, and sleeps or eats, crowned with flowers, like a jubilator. I was telling Mr. Stevenson of these details, upon his last call, and he interrupted a description of the tyrannical conduct of the French

in Tahiti and the Marquesas, by the story of a visit he had paid to the prisons there with the inspector. There was no one in the prison for men:

"Monsieur," explained the gendarme, "c'est jour de fête, et j'ai cru bien faire de les envoyer à la campagne." Visit then to the women's prison. "Mais où sont vos bonnes femmes? Monsieur, je ne sais pas au juste, mais, je crois, qu'elles sont en visite."

He tells me that though French rule is of course wrong in principle, therein differing from English or German, the gendarmes are a good lot, whom it is a privilege to know. I have run on into this because I have been thinking while writing of my having told you that I intended to go to the Marquesas and see Typee.

I am slowly drifting that way, but my enthusiasm is dashed somewhat by what I hear. I am told that there are scarcely any more Typeeans — and they are clothed to-day, as indeed, I fear, are most islanders who are handsome, except the good people here, who still preserve the real decencies to some extent.

And that is why I am lingering here, as I see for the first time, and probably for the last, a rustic and Bœotian antiquity, and if I live to paint subjects of the "nude," and "drapery," I shall know how they look in reality. As I write

in our Samoan house, which is only raised a few inches from the ground, I see passing against the background of sea, figures which at a little distance and in shifting light are nearer to the little terra cottas that you like than anything one could find elsewhere. Young men naked to the waist, with large draperies folded like the Greek orator's mantle, garlanded, with flowers in their hair, pass and repass, or lie upon the grass. Young women — and alas! old women — more covered, though occasionally draped like the men, or with girdles of leaves, walk about, carrying leaf-made baskets or cocoanut water-bottles — or they sit and lounge with the young men. An old man, with his drapery partly over one shoulder has just stalked past, holding a long staff that he puts out to full arm's length — for they use their limbs with a great spread and roundness of action. Four girls of different ages (from eighteen to eight) have been wrestling under the trees, practising some grip — and have been teaching a boy how it is done. A friendly hunch-backed dwarf has called to pay a Christmas visit, and to get a friendly nap. Like the girls, he wears nothing but a dark-blue drapery around his waist, and a great garland of fruit and flowers that hangs about his neck. His hair has been dressed and curled in Samoan fashion — that is to say, it has been stiffened into shape with coral lime (which, when washed off, has

reddened it) so that he has the hair of a blonde on his dark head. Japeta, as he is called (Japhet), who by the by is rather "missionary," but believes in witches and devils, and has lived in the woods — and is really very intelligent — is certainly more handsome in this way of costume than if he were to dress in the fashion of Sixth Avenue — or even of Fifth Avenue — for he is of a chief's family. It is true that he has powerful arms and legs that would look well anywhere else than here, where their dancing and jumping and their mode of sitting seems to have influenced the size of the lower limbs, and to have given a roundness to the entire body, that reminds one again of the Greek statues and terra cottas. For the girl form passes into the young man's and his to the older without break. Their dances do a great deal for this result. They all dance a little from the very earliest age. Last night, as I walked home, I found a crowd of little mites practising the figures of the *sitting* dance, in which the entire body is moved, from the ends of the fingers to the tips of the toes. And beautiful they are, these dances. If only I could paint them — but that is almost impossible; some of the gestures could be given, but not the *rhythm*. And they "sit" badly to a painter, and, notwithstanding their idleness, are rarely quiet. Sketching is formidable. They will jump up to see what you have been doing and everybody troops all

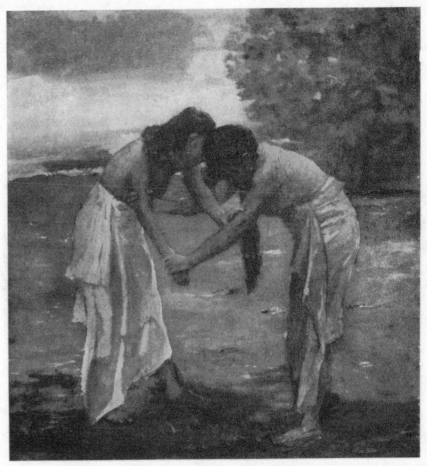

FAGALO AND SUE, WRESTLING. VAIALA, SAMOA

around. Still, I have sent and shall send some sketches home.

One of their dancers has just passed — an official dancer — the official "virgin" of the next "village," but one whose duty it is to entertain guests, and see to their comfort, and dance for them, as also in war to go out dancing with the combatants, as you will see in some of my sketches. She was crowned with flowers, and had a garland around her waist, one around her neck, and her waist was stiffened out triumphantly by the folds of fine thin *mats*, worn as drapery. Behind her (for she is of rank), at a far, respectful distance, has passed, also her attendant, an old woman, who is responsible for her, and a tall, big fellow, also an attendant, with a great drapery, also of yellow mats, fastened by a narrow girdle of white bark cloth. We know her very well, and did she not abuse her prerogative of anointment with cocoanut oil, I should see more of her.

I have wandered away from my intention of wishing you a Merry Christmas and a Happy New Year; *our* Christmas is a hot one (86 to-day), but yesterday was cold and stormy, and the thermometer went down to 78 degrees for a time. The wind blew the palms into all sorts of distressed shapes, and sent amid a deluge of rain so much fine dust of broken foliage through the crevices of our doors

as to remind me of Tenth Street in sultry summer, when they are building.

I wrote to you from the steamer in the first days of October. Since that I have learned that my letter was long delayed. The letters are given to the small cutter or schooner, manned by natives, that meets the steamer, so as to bring letters here. Then she has to beat out for the upgoing steamer to San Francisco to give letters to her. It so happened (and, alas, I know all about it, for I was there), that the schooner was three days at sea, owing to calms, so that she could not return in time, and my letter which was aboard with me was delayed a whole month. It was a queer, an uncomfortable, but a startling experience, this being dropped into the boat — for we landed once and saw things in an, informal way, tasted the sensations of all this faraway rustic classicality with minds unprepared. We spent our first day and night with native hospitality in a little out-of-the-way village, and saw, abbreviated, all the innumerable pictures that I have had leisure to watch since then: The dances and the *kava*-drinking and the village life, and the boats; all preceded by our putting into "the little cove with a queer swell running on the beach," just as in the old story books; and twenty-four hours of calm in a small sailboat under the tropical heat was also a new experience.

So this is why my last letter was so delayed. I did not know of it until long after. Should I get as far as the Marquesas, I shall write to you again, and tell you if anything be left of Typee, but I fear that that is all over. Still, I hear reports of some private cannibalism to which the benighted French object, so that there may still be hopes. But I am told also, as I said before, that they wear European clothing and that is worse than any immoral diet.

There are no Gérômes here and little French in the figures. Of the moderns, Millet and Delacroix *alone* give the look of the nude alive and out of the studio. Also the Venetians and the older men are not out of the facts. And, praise be to the Maker of all (art included), I have not seen any *black* except at night — and even then, "si peu, si peu." Rembrandt would be happy here, especially in the evenings, when the cocoanut fire — that is so bright as to look bright in the day — makes a centre of light strong enough to turn the brown skins to silver and to gold, and then passes by every gradation of the prism into nameless depths that black paint will never give. My dear old painters, even to Van Eyck and Memling, how well they "carry" over the globe!

I should write to you about Stevenson, but I suppose that you can hear more directly through his letters to his friend. We have seen something of him and have been pleased. He

is hard at work, so that visiting him is not a favour to him, even though he may like it, as reminding him of that real world of civilization which he thinks he has left for good.

Nor have I written to you about politics, that are really impressive here, for we have saved these people from a hell of slavery under the Germans. A little gentleness on their part, and they would have had the islands — for these people are gentle enough, and desire rule, but, as they said, "death would be better" — and fortunately we interfered.

I am impressed here, as I have been before, by the force that America could have for good, and by the careful calculation on the part of those who know us best, the Germans and English, upon our weakness of action and irresponsibility, and our not knowing our enormous power.

The Pacific should be ours, and it must be.

Vaiala, Jan. 19th.

This afternoon another little incident of everyday life brings up again my wish that I could set all this world about me to the music of a comic opera — a great *siva*. If only I could understand all that they say, and yet see it as people do who do not understand so that for them the ways of other races seem perpetually funny to the eye. What a charming subject I have now for a third act — or perhaps might I bring

it into the first one — or should we perhaps make it an inter-lude, with the *siva* ballet interspersed? Perhaps, after all, it makes a little opera bouffé for itself.

This afternoon, as I was telling you, I noticed some agita-tion on and about the malae, and around Tofae's house, which is next to mine. This annoyed me exceedingly. Siva,* our first pet from Tutuila, had come to Apia on a visit, and the little silly darling had stumbled upon Awoki and claimed him with all the enthusiasm these people have for him, for his small size, his good nature, and his brown skin.

Our servants and dependents are the only ones who get the truest affection and good-will; we are too far up and too white, and cannot play. I have no doubt that notwithstanding the kindly offers we have had, Atamo especially, from maidens who were looking out for an establishment — I have no doubt, I say, that in their gentle minds was some confusion, some wish for rank and position, and that their real hearts went out to those with us like my little Japanese attendant. Indeed did not Faauli, the *taupo* of Sapotulafai, the daughter of the great *tulafale*, intimate that she wished to keep Awoki with her, and did she not say that if he tried to run off she would put him in her father's jail until we were out of sight and out

* Siva, not Sifa, as I said it at first, and yet she certainly pronounces it with more of an *f* sound than our neighbours of this island. Still I give in to theory, as facts always must, for they have no one to back them, no principles, no money invested.

of reach? Well, Siva recognized and claimed Awoki, and so we obtained her again. I made her sit for me, and found, to my great pride and delight, that I had never been mistaken, and that her rustic movements in the dance were finer far than those of the girls of the great places. We had seen the best first, and had known it. Siva was ill at ease here; she knew that she was considered provincial, or as Charley explains, "the Apia girls think that these Tutuila girls are fools." The same little ways, the same condescension, the same disdainful or inquiring look, that we see used elsewhere, were given by the maidens of our place to the little stranger. And this afternoon, when I had got her out of the way to our house, to try to get a photograph of her with my hawk-eye camera, that never works, I was disgusted at seeing the surrounding green covered with people. The younger ones singled out Siva at once, and with the sincerity of purpose that belongs to youth, said to her what they thought; that her dress was this or that, that her hair was quite wrongly cut, like a goat's, they said, literally, with many such amenities. All this Siva bore as maidens with us would bear, with a distant air and an occasional smile of pity. She was a sort of relative of Tofae's, being herself a chief's daughter, and could not, I suppose, be absolutely extinguished.

But the crowd increased very much between us and Tofae's

house, and twice I had been obliged to single out some offender and drive him off with a threatened stick, when something dawned upon me; these people were really coming to Tofae: no vain curiosity had led them to surround us and sit about the grave of Tofae's father, and fill the greensward between it and the posts of his house. Something was about to take place there. Tofae was seriously taking counsel with some others, and suddenly the crowd poured around his house, the privileged ones entering it, and one little bunch of old women slowly, lingeringly stepping in between its posts

So that I asked, relieved from my own trouble, what was it all about. This was the story: set it to music yourself and Atamo shall write the libretto. Within the fold of the chief has lately been dwelling a maiden thought to be frail, or at least of a stuff not so stern as some others. Perhaps she may have been there in exile for some slight misdemeanour, and her people may have deemed it good for her to live for a time under Tofae. For me she had little charm, if I do not mistake the young lady and confuse her with another young person who has also had refuge there, having bolted from her unpleasant husband and spending some weeks in temporary viduity.

One of our young gallants, and I am both proud and ashamed to acknowledge, one of our own crew, is a great

admirer of female beauty, and fixed upon this maiden as one
he should like to win, even if he had to persuade her to run
away with him, for as far as I know he is married, and had
never intended to set up a rival establishment in legal form.
Nothing here in Samoa can be hidden for any length of time,
so that a more moral place in its way it would be hard to find.
To pay court in the evening supposes a certain surrounding of
many young people, and often the presence of many older
ones, and our young man's wishes were understood by others
than this best girl. So that, most meanly, some of the old
women began to prejudice the girl's mind against this passion-
ate and handsome youth, and instead of opposing her, which
might have defeated their object, they began to tell little
tales about his past, probably exaggerated, as they went on
accumulating. And as he found the girl still resisting he
determined upon a straightforward course in his manly bosom,
and complained to the chief, asking that these libellers be
punished. And the chief listened, as was right, and sum-
moned the old ladies before his tribunal to make good what
they said, or forever after hold their peace. And here they
were, come to be judged, while friends and witnesses and
neighbours circumfused them, anxious about the outcome.

"Well," I said to Charley, "and what will happen? You
have heard it all."

"They have been telling bad things of him, and Tofae will punish them. He will fine them and fine them high, perhaps as much as ten dollars," answered righteous Charley, feeling, as we all did, for the virtuous cause. And then I withdrew, not only because I wished to go to Sivá, but I wished also to meditate upon the principles of eternal justice now about to be vindicated by Tofae. When the old women are silenced and put to naught, shall our young man be strengthened in his suit? And will the young lady triumphantly elope with him? All these contingencies of events might appear spoiled if I inquired too far, so that I have left it all alone, and I withdraw. The subject is too pretty as it stands, and, as I said before, only requires to be set to music.

Vaiala, Jan. 27, 1891.

We are nearer to the cannibal here in Samoa than you would believe at first; far away as we are from cannibal or "devil" countries, we have in the hired labourers of the German plantation a wilder set of savages than would seem from their usual behaviour and the steady work urged out of them by their German masters. You must not forget that these little black men, often so gentle and sweetly smiling, whom we see about at work — in that constant exceptions to all around us — are not absolutely converted by being taken from their

cannibal native lands to work for the white man in Samoa. The smile of their white teeth, repeated by the ivory bars or rings in their noses, conceals, like the gentleness of children, depths of useless cruelty.

The timidity of behaviour of such as I had seen and described to you, who had escaped from the plantations and were in hiding among distant Samoan villages, protected by the gentler brown race from recapture and return to what after all is slavery, is not a permanent index of character. When they have escaped, and have lived in the bush a life of bare chance, finding scanty food, continually tracked and hunted by their masters, often denounced by the Samoans, who do not trust them, they turn both to ancient, ferocious habits, and to the superstitions and fears which belonged to their life at home.

They are always suspected of cannibalism; and the event which has made us all more or less miserable is considered as quite a possible thing, and likely to occur again. News came to us suddenly, out at Vaiala, that Faatulia, the wife of our friend Seumanu, the chief of Apia, had learned a dreadful thing. Her brother, some weeks ago, had sailed from the little island of Manono, and had neither returned there nor arrived anywhere. His boat was found upturned, and he was missing. The story told to Faatulia came from some of the

black labourers, or else from some of those who had escaped out of slavery. Or else it came in the Samoan way, so that, though you know there is a story, it does not require to be fathered by any human tongue. "There are no secrets kept in Samoa," says Mataafa; "they are always being told."

This is what she learned: Her brother, in the last storm, had been driven out of his course; his canoe had been overturned, and he had barely saved his life by swimming. On reaching land in great distress, he had found in the bush a hut, occupied by runaway blacks, and had asked for shelter. He had slept, but fever had taken hold of him, and for some while he was unconscious. Thereupon came up the dread temptation to the black man. Here was that menace of superstitious harm coming from the presence of a sick man, who might die and injure them by bringing the spirit which kills, into their forlorn abode.

Here was food too, if they killed him. Perhaps — I say it with doubt, because I have but confused notions of the exact superstitions belonging to any one of the races I have not met — but the man killed and *eaten* is not so dangerous in the other world as the man who dies a natural death.

At any rate, the story went on to say that the blacks killed Faatulia's brother in his sleep, ate him, buried the bones, and knew nothing when inquiries were made. But somehow or

other, suspicion excited by something done or said made the friends of the missing man dig and find remains which, at the time we heard the story, were being brought down to Faatulia, for identification.

And now how shall they know? The German firm will send their physician, and the American ship will send hers, and the question will assume a political meaning.

It was a sad thing to make our last call on Faatulia, and know that while she talked to us she was trying to forget the ugly thing lying behind the hangings of the hut.

Seumanu was undisturbed as usual, and bade us good-bye with all the coolness of a *tulafale*.

That same afternoon, January 27th, we looked for the last time upon the royal face of our neighbour Mataafa, while he told us again to tell Americans that Samoans owed their lives to the United States.

Then I used up my last daylight in painting a study of Maua, one of the boat's crew, who endured it in a fidgety way that he took for patience. He was cold, for every hanging mat had to be opened, to give a little light on the dark afternoon, under the big roof of our hut.

And again in the morning I worked upon the sketch until the boatmen came up to tell me that the last moment was come. Maua flushed pink with joy, over his whole naked

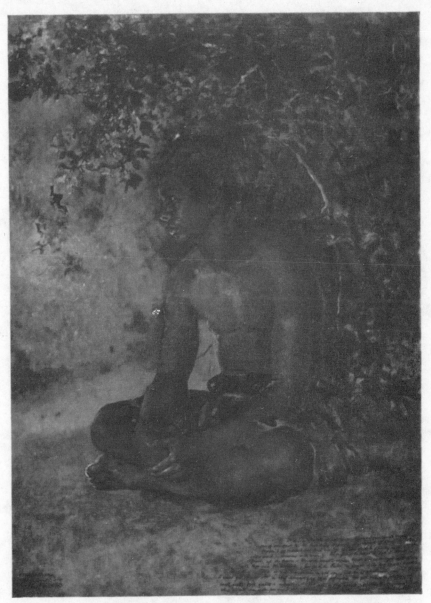

MAUA. STUDY OF ONE OF OUR BOAT CREW. APIA, SAMOA

body, when I told him that I had done. The children on the village green (*malae*) came to say something and to offer little presents of shells and sea beans.

The steamer was whistling for me outside the reef — Atamo was on board —— But I could not be left behind — too valuable a passenger.

I bequeathed my best cocoanut oil to Siakumo and the other girls, said good-bye to Tofae, our chief, and promised, if I returned, to come back under his wing. Samau, our boatswain, carried me on his back, into the boat, and patted my legs, as a respectful and silent good-bye.

The grey water inside the reef was smooth and quiet. For the last time our Samoan crew pulled close to the shore, to exchange *tofas* (farewells) with Meli and her girls; and we went on board, where the sheep from Australia were still huddled on the quarter-deck due to Tahiti later. In the afternoon the island, wreathed in clouds, was already melting away behind us.

AT SEA FROM SAMOA TO TAHITI

We have had days of hard winds and grey weather, and all the more do I make pictures within my mind. For the Otaheite to which we are bound has a meaning, a classical record, a story of adventure, and historical importance, fuller than the Typee of Melville, which we may never see. The name recalls so many associations of ideas, so much romance of reading, so much of the history of thought, that I find it difficult to disentangle the varying strands of the threads. There are many boyish recollections behind the charm of Melville's "Omoo" and of Stoddard's Idylls, or even the mixed pleasure of Loti's "Marriage."

Captain Cook and Bougainville and Wallis first appeared to me with the name of Otaheite or Tahiti; and I remember the far away missionary stories and the pictures of their books — the shores fringed with palm trees, the strange, impossible mountain peaks, the half-classical figures of natives, and the eighteenth-century costumes of the gallant discoverers. I remember gruesome pictures in which figure human sacrifices and deformed idols, and the skirts of the uniform of Captain

Cook. What would be the fairy reality of the engravings which delighted my childhood?

Once again all these pictures had come back to me. *Long ago* there lay, by a Newport wharf, an old hulk, relic of former days. We were told that this had been one of the ships of Captain Cook: the once famous *Endeavour*. Here was the end of its romance; now slowly rotted the keel that had ploughed through new seas and touched the shores of races disconnected from time immemorial. Like the *Argo*, like the little *Pinta* and *Santa Maria*, it had carried brave hearts ready to open the furthest gates of the world. The wild men of the islands had seen it, a floating island manned by gods, carrying its master to great fame and sudden death.

For he was not allowed by fate to try for further Japan, and begin, with the help of Russia, that career of conquest for England which she now dislikes to share with other nations, even with those to whom she first proposed the enterprise and half the spoils.

On that little ship, enormous to her eyes, had been Oberea, the princess, the Queen of Otaheite, whose name comes up in the stories of Wallis or of Cook, and early in the first missionary voyages.

Oberea was the tall woman of commanding presence, who, undismayed, with the freedom of a person accustomed to

rule, visited Wallis on board his ship soon after his first ar-
rival and the attempt at attacking him (July, 1767). She,
you may also remember, carried him, a sick man, in her arms,
as easily as if he had been a child. I remember her in the
engraving, stepping toward Wallis, with a palm branch in
her hand; while he stands with gun in hand, at the head of
the high grenadier-capped marines.

And do you remember the parting — how the Queen could
not speak for tears; how she sank inconsolable in the bow of
her canoe, without noticing the presents made her? "Once
more," writes the gallant Captain, "she bade us farewell,
with such tenderness of affection and grief as filled both my
heart and my eyes."

Surely this is no ordinary story — this sentimental end of
an official record of discovery.

My memory makes the picture for me: the ship moving at
last out of the reef, with the freshened wind, and below her
level the canoe and the savage queen bent over in grief. Then
right on without a break Wallis ends the chapter with these
words: "At noon the harbour from which we sailed bore
S. E. ½ E. distant about twelve miles. It lies in latitude 17°
30's. longitude 150° W. and I gave it the name of *Port Royal
Harbour*." This foreign name has since yielded to the
ancient native one. Besides the charming irrelevancy of

these facts with the words describing the sentiment of eternal parting, Wallis's conclusion gives us the place of Tahiti on the map, and will help you to follow me there.

The name of Wallis, the first discoverer, is so much over-shadowed by the personality of Captain Cook, that I think it better to give you again the story that belongs to each.

Let us go back in mind to the date, the second half of the last century, 1767. The recall to *me* of the ships of Chris-topher Columbus emphasizes the difference between that moment and the end of the fifteenth century. There were still vast spaces of sea unknown; still the object of commerce, of war and of discovery, was the connection with the "eastern-most parts of Asia." What lay between was only guessed at and often avoided. As when Anson, whom I have just been reading, passed through the southern seas in 1742, anxious for an unbroken passage across the great Pacific, in order to strike a blow at the Spaniard in Asiatic islands, he followed the Spanish charts; and in his own, "showing the track of the Centurion round the World," there is nothing marked in the enormous blank space below the equinoctial line, from South America to New Guinea, but the fabulous Treasure Islands — the Isles of Solomon, placed very nearly where Tahiti lies.

When Wallis and Bougainville came upon this island they came as Columbus did — as discoverers; but the times had

changed; and the meeting with a new race in this island of Tahiti — a fifth race, as it was named in my boyhood's schoolbooks — affected European minds very differently from the manner of three centuries before, when the Spaniards went for the first time through a like experience.

It is this new introduction of *modern* and *changed* Europe to another fresh knowledge of the savage world, that makes the solemnity of the discovery.

There is also something in the sudden coming together of the two new nations, England and France, so different from ancient Spain, upon this littlest of lands most lost in the greatest spaces of the sea, four thousand miles from the nearest mainland.

Hence from little Tahiti, whose double island is not more than a hundred and twenty-five miles about, begins the filling up of the map of discovery in the Pacific.

When Wallis arrived in June, 1767, Tahiti and its neighbouring island were under the rule of a chief, Amo or Aamo, as he is called by Wallis and by Cook. He was their great chief — what we have managed to translate as king. It was a moment of general peace, and the "happy islanders" enjoyed in a "terrestrial paradise" pleasures of social life, of free intercourse, whose description, even at this day, reads with a charm of impossible amenity. The wonderful island, striking in its

shape, so beautiful, apparently, that each successive traveller has described it as the most beautiful of places, was prepared to offer to the discoverer expecting harsh and savage sights a race of noble proportion, of great elegance of form, accustomed to most courteous demeanour, and speaking one of the softest languages of man. Even the greatest defects of the Polynesian helped to make the exterior picture of amiability and ease of life still more graceful. If, by the time that I return, you have not read as much about their ancient habits and customs, their festivals, their dances, their human sacrifices, their practice of infanticide, their wild generosity, I shall write you fully about it all, or shall make you read what is necessary. What was visible of the harsher side added to the picture of the interest of mystery and contradiction. The residence of this Chief, Amo, and of his wife, Purea or Oberea, as Cook called her, was at Papara, on the south shore of Tahiti. Both belonged to a family whose ancestors were gods; and they lived a ceremonial life recalling, at this extreme of civilization, the courtesies, the adulation, the flattery, the superstitious veneration of the East. This family and its allies had reigned in these islands and in the others for an indefinite period. The names of their ancestors, the poetry commemorating them were and are still sung, long after the white man had helped to destroy their supremacy.

When Wallis arrived at the north of the island, Amo and Oberea were not far from Papara in the south. They heard of the arrival of the floating island, whose masts were trees, whose pumps were rivers, whose inhabitants were gods in strangeness of complexion and of dress.

The same tragedy had happened there which begins the recitals of savage discovery. The islanders had no notion of the resources of the Europeans, nor had the white men a knowledge of Polynesian customs; so that soon came up the usual quarrel and the use of fire-arms taken by the natives for thunder and lightning. Amo received the news, and notwithstanding the exaggerated accounts, determined to see for himself the supposed island and test the power of its inhabitants. His was the attack described by Wallis, in which a large number of natives surrounded the ship, while Amo and Oberea looked on from a little eminence above the bay. To shorten the contest and thereby lessen the mischief Wallis fired on the canoes and the occupants, and finally on the chiefs themselves. Cannon balls fell at their feet, and tore down the surrounding trees. The unequal contest was over, and the inhabitants came with green branches in their hands, even those whose friends had been killed, to make peace with the English, and offer submission. Wallis relates how one woman, who had lost her husband and children in the fight,

brought her presents weeping to him, and left him in tears, but without wrath, and gave him her hand at parting.

And you remember how, just as Wallis had left one side of the island, Bougainville, the Frenchman, came up to the other, different in its make, different in the first attitude of the natives; but with the same story of gracious kindness and feminine bounty; so that the Frenchman called it the New Cytherea, and carried home stories of pastoral, idyllic life in a savage Eden, where all was beautiful and untainted by the fierceness and greed imposed upon natural man by artificial civilization. So strong was the impression produced by what he had to say, that the keen and critical analysis of his own mistakes in judgment, which he affixed to his Journal, was, passed over, because, as he complained, people wished to have their minds made up.

And immediately upon his leaving, again to another part of the island came the representatives of another race, another, more solemn and less near to modern civilization — the Spaniards; who in their accustomed way, planted the cross next to the sacred grove, which unknown to them was that of the greedy god Oro, and sailed away, leaving two missionaries, helpless and solitary, to wait for their return.

For this other side of the island was separated from the places of landing known to Wallis, by fierce war for which

Oberea had given the signal, by that haughtiest pride which only a woman can show.

The missionaries accomplished nothing; and when a few months afterward the Spaniards called and took them away, their presence had been but a dream — another strange side to the romance of the first discovery.

One year later, 1768, came Captain Cook, whose name has absorbed all others. Twice he visited Tahiti, and helped to fix in European minds the impression of a state *nearer to nature*, which the thought of the day insisted upon.

Nor can one here forget Oberea; and how she seemed to him younger than she had seemed to Wallis, who judged her age by European notions.

And how shall I refer to that "ceremony of nature" to which she invited the captain and his officers, as an exchange for his having let her be present at the service of the Church of England?

The state of nature had just then been the staple reference in the polemic literature of the century about to close. The very refined, dry and philosophic civilization of the few was troubled by the confused sentiments, the dreams, and the obscure desires of the ignorant and suffering many. Their inarticulate voice was suddenly phrased by Rousseau. With that cry came in the literary belief in the natural man, in the

possibility of — analysis of the foundations of government and civilization — in the perfectibility of the human race and its persistent goodness, when freed from the weight of society's blunders and oppressions.

My confused memories of eighteenth century declamation and reasoning bring back to me this one echo. Our little ship is not a library, and I struggle for references. I can only remember fragments of the encyclopædists and of Diderot, and the vague impression that this last romance and analysis of singular writings of Otahite is based upon a direct information outside of that derived from books: that is to say, perhaps from the travellers themselves, or the Tahitian, who, like Cook's Omai, came to Europe with Bougainville.

Later Byron:

"The happy shores without a law,
Where all partake the earth without dispute,
And bread itself is gathered as a fruit;
Where none contest the fields, the woods, the streams:
The goldless age, where gold disturbs no dreams."

These literary images were used as illustrations of the happiness of man living in, what people still persist in calling, the state of nature. There is no doubt, of course, that at the moment of the discovery our islanders had reached a full extreme of their civilization; that numerous, splendid, and untainted in their physical development, they seemed to live

in a facility of existence, in an absence of anxiety emphasized by their love of pleasure and fondness for society — by a simplicity of conscience which found little fault in what we reprobate — in a happiness which is not and could not be our own. The "pursuit of happiness" in which these islanders were engaged, and in which they seemed successful, is the catchword of the eighteenth century.

People were far then from the cruel ideas of Hobbes; and the more amiable views of the nature of man and of his rights echo in the sentimentality of the last century, like the sound of the island surf about Tahiti.

Nor am I allowed to forget the assertion of those "self-evident truths" in which the ancestor of my companion, Atamo, most certainly had a hand. So that the islands to which we are hastening with each beat of the engine, are emblems of our own past in thought, as they have played a part also in the history of which we see the development to-day, the end of the old society, the beginning of the new, the revolutions of Europe and of America, all which lies in my mind obscurely as I recall, every few moments, my vague emotions at the name of *Otaheite*.

I believe too that our feelings are intensified because they are directed toward a far-off island; a word, a thing of all time marked by man as something wherein to place the ideal, the

supernatural; the home of the blest, the abode of the dead, the fountain of eternal youth, Circe and Calypso, the haven of man tired of weary sea, the calm smile of the ocean when the winds have ceased. The word sings itself within my mind, and the dreams I have been recalling give me interior light during these gray days of adverse wind, as in Heine's song of the "Land of Perpetual Youth":

"Little birdling Colibri,
Lead us thou to Tahiti!"

February 12th.

Six days of grey weather and dark nights, and in the last evening, quite late, the sun setting, lit up for a moment an island, Moorea, which is distant from Tahiti only some dozen miles. It made an enchanted vision of peaks and high mountains, as strange as any which you may have seen in the backgrounds of old Italian paintings, far enough to be vague in the twilight haze and yet distinct in places high up, where the singular shapes were modelled in pink and yellow-green. The level rays of the sun pierced through the forest coverings, and came back to my sight, focused from underlying rocks, in a glistening network of rainbow colours. Then all faded in a cloudy twilight, half lit by the struggling moon, and we saw a vague space of island, like a

dream, edged by a white line of reef; this was Tahiti. All night we ran east and west, waiting for the day, which would allow us to pass through the reef that lies in front of the so-called City of Papeete, which is a large village, the "capital" of the island, and the centre of the French possessions in Oceanica.

TAHITI

When we rose in the early morning our ship had already passed the reef, and we were in the harbour of Papeete. There was the usual enchantment of the land, a light blue sky and a light blue sea; an air that felt colder than that of Samoa, whatever the thermometer might say; and when we had landed, a funny little town, stretched along the beach, under many tall and beautiful trees. From under their shade the outside blue was still more wonderful, and at the edge where the blue of sky and sea came together opposite us, the island of Moorea, all mountain, peaked and engrailed like some far distance of Titian's landscapes, seemed swimming in the blue.

Near the quay neatly edged with stone steps, ships lay only a few rods off in the deep water, so that their yards ran into the boughs of the great trees. Further out, on a French man-of-war, the bugle marked the passing duty of the hour. Everything else was lazy, except the little horses driven by the *kanakas*. Natives moved easily about, no longer with the stride of the Samoans, which throws out the knees and feet, as if it were for the stage. People were lighter built,

more *efface;* but there were pretty faces, many evidently those
of half-breeds.

White men were there with the same contrasting look of
fierceness and inquisitiveness marked in their faces; these
now that we see less of them, look beaky and eager in contrast
with the brown types that fill the larger part of our sight and
acquaintance.

We were kindly received by the persons for whom we had
introductions; and set about through various more or less
shady streets marked French-wise on the corners: *Rue des
Beaux-Arts, Rue de la Cathédrale,* etc.; first to a little restaurant,
where I heard in an adjacent room, "Buvons, amis, buvons,"
and the noise of fencing; then to hire furniture and buy house-
hold needs for the housekeeping we proposed to set up that
very day, for there are no hotels. The evening was ended
at the "Cercle," where we played dominoes, to remind our-
selves that we were in some outlying attachment of provincial
France. By the next morning we were settled in a little
cottage on the wonderful beach, that is shaded all along by
worthy trees; we had engaged a cook, and Awoki was putting
all to rights. As we walk back into the town there are French
walls and yellow stuccoed houses for government purposes.
A few officers in white and soldiers pass along.

A few scattered French ladies pass under the trees; so far as

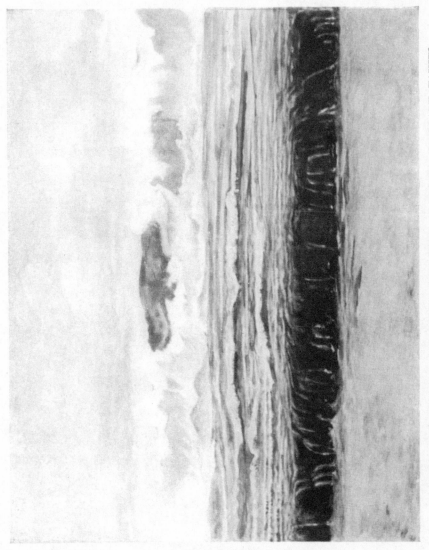

STUDY OF SURF BREAKING ON OUTSIDE REEF. TAUTIRA, TAIARAPU, TAHITI

we can tell (because we have been long away) dressed in some correct French fashion; looking not at all incongruous, because already we feel that this is dreamland — that anybody in any guise is natural here, except a few Europeans, who meet the place halfway, and belong neither to where they came from, nor to the unreality of the place they are in. There is no noise, the street is the beach; the trappings of the artillery horses, and the scabbards of the sabres rattle in a profound silence, so great that I can distinctly count the pulsations of the water running from the fountain near us into the sea. The shapes and finish of the government buildings, their long spaces of enclosure, the moss upon them, remind us of the sleepiest towns of out-of-the-way bits of France.

The natives slip over the dust in bare feet, the waving draperies of the long gowns of the women seeming to add to the stealthy or undulating movement which carries them along. Many draw up under the arm some corner of this long, nightgowny dress that it may not trail, or let their arms swing loosely to the rhythm of their passing by.

Most of the native men wear loose jackets, sometimes shirts above the great loin-cloth which hangs down from the waist, and which is the same as the *lava-lava* of the Samoans, the *sulu* of the Fijians, and is here called the *pareu*.

Many of the women have garlands round their necks and

flowers behind their ears. Occasionally we hear sounds of singing that come back to us from some cross-street; and as I have ventured to look, I see in a little enclosure some women seated, and one standing before them, making some gestures, perhaps of a dance; and I grieve to say, looking as if they had begun their latest evening very early in the day. But this I have noticed from sheer inquisitiveness. I feel that in another hour or so I shall not care to look for anything, but shall sit quietly and let everything pass like the turn of a revolving panorama. In this state of mind, which represents the idleness of arrival, we meet at our Consul's an agreeable young gentleman belonging to a family well known to us by name — the Branders; a family that represents — though mixed with European — the best blood of the islanders. They speak French and English with the various accents and manners that belong to those divisions of European society; they are well-connected over in Scotland. Do you remember the Branders of "Lorna Doone"? At home their ancestry goes back full forty generations. They are young and pleasant, and we forget how old we are in comparison. We call on their mother later, a charming woman, and on an aunt, Mrs.

Atwater, who has a similar charm of manner, accent and expression; and on another aunt, the ex-Queen Marau; but she is away with her younger sister Manihinihi.

In the evening, with some remnant of energy, we walk still further than our house upon the beach, passing over the same roads that Stoddard wearily trod in his "South Sea Idyls." We try to find, by the little river that ends our walk, on this side of the old French fort, the calaboose where Melville was shut up. There is no one to help us in our search; no one remembers anything. Buildings occupy the spaces of woodland that Melville saw about him. Nothing remains but the same charm of light and air which he, like all others, has tried to describe and to bring back home in words. But the beach is still as beautiful as if composed for Claude Lorraine. Great trees stand up within a few feet of the tideless sea. Where the shadows run in at times, canoes with outriggers are pulled up. People sit near the water's edge, on the grass. Outside of all this shade, we see the island of Moorea further out than the far line of the reef, no longer blue, but glowing like a rose in the beginning of the twilight.

At night we hear girls passing before our little garden; we see them swinging together, with arms about the flowers of their necks. They sing—alas! not always soberly, and the wind brings the odour of the gardenias that cover their necks and heads.

In the night the silence becomes still greater around us, though we can hear at a distance the music of the band that plays in the square, which is the last amusement left to this dreary deserted village called a town. In the square, which is surrounded by many trees, through which one passes to hidden official buildings, native musicians play European music, apparently accommodated to their own ideas, but all in excellent time, so that one just realizes that somehow or other these airs must have been certain well-known ones. But nothing matters very much.

A few visitors walk about; native women sit in rows on the ground, apparently to sell flowers, which they have before them. People of distinction make visits to a few carriages drawn up under the trees. Occasionally, in the shadows or before the lights, in an uncertain manner, natives begin to dance to the accompaniment of the band. But it is all listless, apparently, at least to the sight, and just as drowsy as the day.

In the very early morning we drive to the end of the bay at Point Venus, to see the stones placed by Wilkes and subsequent French navigators, in order to test the growth of the coral outside. And we make a call on a retired French naval officer, who has been about here more or less since 1843, the time of Melville. We drive at first through back roads of no

special character. We pass through a great avenue of trees over-arching, the pride of the town; we cross a river torrent, and the end of our road brings us along the sea, but far up, so that we look down over spaces of palm and indentations of small bays fringed with foam, all in the shade below us. On the sea outline, always the island of Moorea, and back on Tahiti, the great mountain, the Aorai, the edge apparently of a great central crater; a fantastic serrated peak called the "Diadem," also an edge of the great chasm; and on either side along slopes that run to the sea, from the central heights, and recall the slopes of Hawaii. But all is green; even the eight thousand feet of the Aorai, which look blue and violet, melt into the green around us, so as to show that the same verdure passes unbroken, wherever there is a foothold, from the sea to the highest tops. This haze of green, so delicate as to be namable only by other colours, gives a look of sweetness to these high spaces, and makes them repeat, in tones of light, against the blue of the sky, chords of colour similar to those of the trees and the grass against the blue and the violet of the sea.

Nearer us the slopes are all broken up into knife edges of green velvet streaked right near us by clay, which in contrast seems almost like vermilion. So far the roads were good, though the slippery clay might be very different when the

great rains came down; and as our driver forced his horses at a gallop near the edges of the cliffs hanging over the lovely pictures of the secluded trees and water, we felt that a more sandy, more prosaic road would better suit the South Sea habits of carriage travel.

All the trees were about us that we knew in Samoa; and many more rounded mango trees, with red fruit hanging on long stems, or lying green by the road. All this was to be seen with cool air full of life, and under a sky more like ours than the Samoan, but exquisitely blue and gay.

Little has been done by us, even of going about; Atamo has written many letters; I have tried to sketch a little from our verandah, in front of which, on the shore, grows a twisted *purau*, called *fau* in Samoa. Through its branches I see the sea and the reef, and the island of Moorea, in every tint of blue that keeps the light, even in the evening or in the after-glow, when the sunset lights up in yellow and purple the sky behind it. And yet there is a reminiscence in my mind of something not foreign to us, even at this moment, when the haze of light seems new, and the pale blue sea is spangled with little silver stars, as far as I can see distinctly.

We have called on the ex-King; and in the evening, at the club, I have seen him — a handsome, elderly man, somewhat broken and far from sober. He was playing with a certain

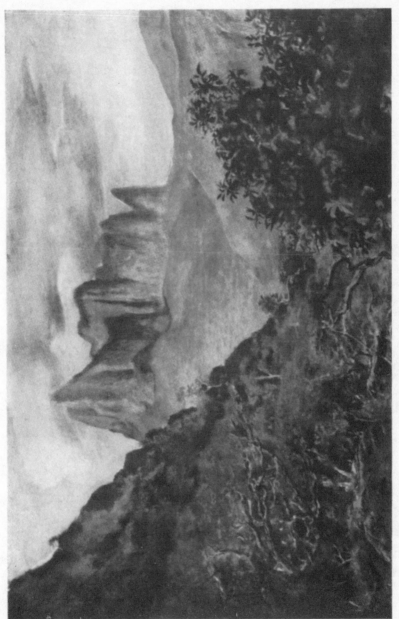

THE DIADEM MOUNTAIN. TAHITI

Keke, a black Senegambian in the French service, a prince of his own negro land, who speaks excellent French, and whom I surprised sitting on the sill of his house one evening (while we were taking a rainy walk). Keke wore in this retirement a pair of marvellous trousers, of a brilliant yellow, with red flamboyant pattern — something too fine for the ordinary out-of-door world. Many of the officials are coloured men from the French colonies, and so is the governor more or less. Of course the idea is infinitely respectable and humanitarian, as so many French things are, but I fear that the Republic is unwise in sending people whom the native here cannot look up to as he does to a white man.

Of course they are all French and have votes, as the natives here can have also; but whether it is for the real good of a population accustomed to dependence I am not so sure. There are many curious anomalies: our American friends of Samoa speak, with our natural way of looking at things correctly, of the preposterous way the French have of backing the Catholic missions and protecting their missionaries, even as we would. But here I find the Catholic mission dependent upon the gifts of the faithful, while the Protestant missions are supported by the French government, as the Protestant clergy would be in France.

The King, upon whom we called and whom we met at the

club in affable mood, surrendered his rights to the French, a few years ago, under long pressure and with some advice from the missionaries. In exchange he received an annual income, and retained his honours and certain privileges. This end I suppose to have been inevitable. His mother, the famous Queen whose name was known to all sea-going people in that half of the globe, whose resistance to French pretensions had come, apparently, for a moment, near bringing France and England into a quarrel, had lived for many years under French authority, a government under the name of protectorate. Such, I suppose, must always be the end, as it has been everywhere that the English have been; as it has been in Fiji; as it will be to-morrow, probably, when King George of Tonga dies; as it will be in Hawaii, whenever the whites there determine to use their power. Nor is the line of the Pomaré, any more than that of the Hawaiian rulers, so connected with all antiquity as to be typical of what a Polynesian great chief might be to the people whom he rules. The Pomarés date only from the time of Cook. They were slowly wresting the power from the great family of the Tevas, by war and by that still more powerful means — marriage, which in the South Seas is the only full and legitimate source of authority.

You know from all that I have told you of Samoa that in

Polynesia descent is the only real absolute aristocracy; there is no ruling except through blood. Hence the absurdity of the kingships that we have fostered or established, which in our own minds seemed quite legitimate, because they embodied the European ideas which belong to our ancestry. Hence the general discomfort and trouble that we have helped to foster. Hence also — and far worse — the breaking down, in reality, of all the bases upon which these old societies rested, the saving of which in part was the only hope remaining for the gradual education of the brown man for his keeping to ideas of order different from our own, it is true, but still involving the same original foundations. Hence the demoralization, the arbitrary "white laws," always misunderstood, always bringing on the vices which they were meant to control; hence the end of the "brown" man by himself.

The missionaries' good-will has never gone so far as to try to understand him as a being with the same rights to methods of thinking as we claim for ourselves. Part of this sad trouble is of course owing to the unfortunate moment which gave birth both to greater missionary enterprise, to a first acquaintance with these races, and to the disruption of authority in the West. Perhaps, indeed, it might then have required more comprehension than could be asked of any but the most exceptional mind to realize that what we call savagery

was a mode of civilization. So must have been the European world when the civilization of antiquity broke down, and things of price went into the night of forgetfulness, along with the mistaken beliefs and superstitions that were joined to them. So here, where, as in all civilizations, religious views, manners, customs, superstitions were woven about every bit of life, the exterminating of anything that might seem pagan involved many habits, and some good ones, which necessarily, from their fundamental antiquity, had been protected by religious rites. Hence we brought on idleness and consequent vice; for idleness is as bad for the savage, whom we innocently suppose to be idle, because we do not understand how he busies himself, as it is for the worker in modern civilization. It is not the actual doing that is important, but such occupation as may determine a habit of useful or harmless attention, which prevents the suggestion of untried moral experiments.

Even tattooing was a matter which like any society duty involved attention, considerable self-abnegation and suffering, so as to suit the supposed requirement of civilization, and a recognition of some manly standard, however childish it might seem to us, even if it seems as absurd as some of our society standards might seem to the so-called savage.

These reflections came from reading a law of missionary

civilization which I find in the records of the year 1822, in the neighbouring island of Huahine; in which a man or woman who shall mark with tattoo, if not clearly proved, shall be tried and punished, and made, for the man, to work on the road, for the woman, to make mats; in a proportion of which the only exact measure that I find is that for the man it is about the same as that for bigamy; for the woman just the same as adultery.

With the coming of the missionaries, with the coming of the white men traders, coincided the first attempts of the ambition of these Pomaré chieftains. They had already done a good deal for themselves before Cook left for the last time. He had seen Oberea, of whom I first spoke, a great person. When he left, her line of family was already on the decline; war and massacre had weakened it. Pomaré — the Pomaré of that day — with the support of the guns of the white men, established his final superiority, and becoming the great chief was solemnly crowned and oiled by the missionaries, like a new king of Scripture. And this man is the last of the line. His first great ancestor, Otu, just appears with the first discoverers' records of the details of the ceremonials and etiquette belonging to high chieftainship, which are recorded in the first missionary accounts.

You may remember the picture painted by Robert Smirke,

Royal Academician, where the high-priest of Tahiti cedes the district in which we now are to Captain Wilson of the missionary ship the *Duff*, for the missionaries. In the centre, with a background of palms and peaks, two young people — Pomaré, the son of Otu, and his queen — are represented on men's shoulders. That was the old fashion of Tahiti, the great chief not being allowed to touch the land with his feet,

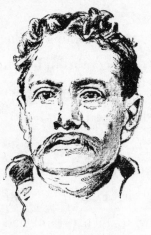

lest it become his by touch. And therein also is shown the peculiar political arrangement by which the young chief took his father's place when a child, and ruled, in appearance at least; for there in the picture alongside of the two young sovereigns, called kings by us, stand father and mother uncovered to the waist, out of respect

POMARE REX

to their child's higher position. Otu and Iddeah, the dear lady whose notions about infanticide troubled the good missionaries to such an extent, but whose courtesy was willing to go so far as to promise that she "never would do it again," when once she had done as she pleased. As I understand it, the Pomarés, then, pass away with the present King, but the great line whose place they took — the Tevas or their representatives — remain. In that line con-

tinues a descent from that Queen Oberea, whose figure, in another picture that I have referred to and which I beg you will look up in the volume containing Wallis's discovery, is so charmingly made a type for an imaginary kingdom, like those of the operas and the tapestries of the eighteenth century, in which nothing is untouched by fancy but the muskets and grenadier caps and uniforms of Wallis and his men.

I have almost been tempted, as you see, to begin a sort of explanation of the history of the island; but I think that I can manage later to give you certain stories which will have the advantage of a more personal knowledge of acquaintance with what might be called the text, than these vague reminiscences of the books that I have read and which are nearer to you than they are to me. Meanwhile, let me tell you that last evening, at the club, His Majesty, who was in extreme good humour, singled us out, told us how he liked us, that he liked Americans, who themselves liked Tahitians, and that the French, who stood all about him, were all d — d — d ——

This he said in English, in a proper reminiscence of nautical terms of reproach, and added blandly, "But I don't understand English."

He has a fine, aristocratic head, and must have been a very handsome man. He has for an adopted son one of the young

gentlemen of the Branders, who will succeed to an empty honour; though there might perhaps yet be a part to fill, for the family that represents all that there has been far back and recently.

Next week we shall go into the country, further along the coast, and make a visit to the old lady who is the head of the house, grandmother of these young men, and who is the chiefess representing that great line of the Teva, alongside of which the Pomaré — the kings through the foreigner — are new people. Then I may write lengthily, or at least with some detail, about matters that I only see confusedly, but which must be curiously full of ancient, archaic history, however lost or eclipsed to-day.

I notice in my habits, now forming, as I write out my journal for you, a tendency to dream away into a manner of philosophizing which evidently has for its first beginning the appreciation of the remote forms of these savage civilizations; so that as I grow to understand them better, it is necessary for my individual happiness of thought to be able to consider the earlier ways of man as not unconnected with the present, and even to be willing to consider all foundations of society as passing methods suitable to the moment, and perhaps in the great future to vary as much from the present as the past is strangely different. The good missionary, who simply looked

upon a good deal of this past as strangely resembling the antiquities of the Bible, consoled himself, and persuaded many of his brown brethren in the belief that they, at last, were the famous lost tribes, who still kept, in many ways and details, that very peculiar manner of life which the Bible sets out in many details.

One evening in Samoa, the great Baker, the former missionary and ruler of Tonga, finding me interested and credulous in regard to many superstitions which he described, and many facts quite as extraordinary that he vouched for, unfolded to me, as a regard of confidence, his firm belief that in these islands of the Pacific, Reuben, Simeon, Levi, Judah, Zebulon, Issachar, Dan, Gad, Asher, Naphtali, Ephraim, Manasseh and Benjamin had found a home. And if a man so worldly wise, such a producer of money, such a controller of weaker minds, dwelt in this view with satisfaction, as a relief from the sordid necessities of power, I think that a mere dreamer like myself can be excused for turning to more scientific and accurate arrangements of men's history.

These words come to me more distinctly suggested by the place in which I am, not because I am thinking of the ancient ways that I touch, but because I remember how Melville passed from those records of exterior life and scenery to a

dwelling within his mind — a following out of metaphysical ideas, and a scheming of possible evolution in the future of man

Papara, April 7th.

This is a land where to live would have made you happy. Outdoors and in the water, and in no compulsory dress, would have been your usual way of passing a great part of the time. I thought of you while I looked this morning at the children playing in the water of the little river, or in the surf that rolls into it or along the shore. The girls, little wee things, swam in the stream near its mouth, where it is safe, and plunged in and out, and swam under water, their feet and backs showing within the light and dark of the currents; for the river has been very full, and the surf and tide have been heavy, so that the children take their turn with the current. The boys were out in the surf, on the border of which occasionally the girls played, edging sideways to it, and running back with swinging arms. The boys and one of the men plunged out with surf boards, ducking under or riding over the waves that did not suit them; then turning just before the wave that suited, they were carried along the shore leaning on their boards. The currents of the sea carried them past us looking on. Of course they knew all about them, and

rough as the surf was, one of them had got past one of the lines of the breakers and tried fishing in some bottom both higher and less vexed. It was a pretty sight, the brown limbs and bodies all red in the sun and wet, coming out of the blue and white water like red flowers. The girls were yellower and more golden than the boys — less tanned I suppose.

They have been running about with less clothing, perhaps because the family is away. They left yesterday, and the daily life is the same. That is to say that only Tati and his family, including one of the boys whose holiday is prolonged, are here with us. The old lady (Hinaarii) the Queen (Marau), Miss Piri (pronounced Pri, short for Piritani, Britain), Miss Manihinihi, and the two young men all went off together; the ladies to spend some time at their house in Faaa, the most rustic, I believe, of their residences.

Pleasant as it is to talk with Tati or do nothing, I miss the ladies. The old chiefess is admirable, and is willing to talk to us of legends and stories with the utmost patience. I wish I had a portrait of her. She has a most characteristic and strong face, upon which at times comes a very sweet smile; as I saw yesterday, when she was asked which she preferred, Moorea, the island she comes from, or Tahiti, where her life has been mostly spent. "Tahiti!" she said decidedly, resuming in the inflection of her voice all the memories of a long

life that has seen so much, and so much that is different and contradictory.

Queen Marau has been very affable and entertaining, telling us legends and stories; Miss Piri has been ailing, Miss Chiki, smiling. The women of the family are all extremely interesting, of various types, but each one with a charm of her own; from Marau's strong face, fit for a queen, to Manihinihi's bright cordial smile. And such beautiful voices as they have, and rich intonation! It is a remarkable family and a princely one. When you read the next few lines you will say that I am prejudiced about my own people, and anxious to have you admire them also; but I don't care, I am glad to have such relations. For, a little before her departure, the old lady sent word that she wished to see us; and when we had come to sit beside her, she told us that she had decided to confer family names upon us, choosing the names which had given the power and which belonged to the ruling chief. Consequently Atamo takes the name of Tauraatua, Chief of Amo, meaning Bird Perch of God, and I of Teraaitua, Captain of that ilk, meaning Prince of the Deep. The old lady said all this with great sweetness and majesty, and we were greatly touched by the compliment.

This afternoon we went to see the little place which is Amo, and from which the Tevas were ruled. It is a small princi-

pality only fifteen fathoms long, and is at present all overrun
with trees, orange and guava mostly. But not so long ago, as
Tati remembers, it was as it had been before the little river
changed its course and tore it up — a large *paipai* or stone
platform, edged with stones carefully set, long ones above,
others with oval ends nicely finished below (turtle heads they
are called). Here lived Tauraatua, sixteen generations back,
simply and frugally, refusing to change his habits with in-
creased power, and contented with cheap fare. Here on the
little platform he drank *kava*, with the river running by; and
once, while lying under its influence (dead drunk, as it were),
came near being surprised by the enemy. Some little while
ago the tall cocoanut tree was still standing, which had served
as a lookout and watch-tower against the enemy; and from
which the watcher had descried the invader just in time to
save the chief, and have him carried away like a precious
parcel.

For Tati informs me that here *kava* was not the mild drink
of the Samoan. It is apparently the same root to the sight,
but whereas whole bowlfuls did not affect us, and whites are
accustomed to it in Samoa, a glassful here, according to Tati,
was and is a serious drink. Its charm lay apparently in the
drowsiness and dreaminess it produced; people spoke of their
having been dead under it, or of having seen things, as with

opium or haschich (hemp), and to-day opium is killing the last
of the Marquesans. It could be nothing more than to carry
out more completely what seems to us fierce whites the mean-
ing of these lands — to exist without effort, in indolence, and
waiting for nothing to happen. The narcotic would condense
it all, would bring a year of dreams into a something that
could be felt like a single act, like an occurence that comes
to you, instead of your making it, little by little, so that the
beginning is forgotten at the very middle of the tale.

Such happiness was broken into by noise, and chiefs de-
manded, for their hours of *kava* influence, absolute silence
about them; not even a cock might crow. One can under-
stand the objection to it made here by the missionaries, which
seen from our Samoan experience seemed useless and cruel.
Another example of a momentary or local matter becoming
built into a principle.

We went to see the new duchy; Adams took off an orange
as a manner of investiture. I made an effort to see if I re-
membered it in a previous existence, but I did not. Tati
remembered it, of course, and the place near by, all overgrown
with great mango trees that have crowded over it, where his
mother lived, and where the stone copings mark the base of
the native house and a platform outside.

Later on Queen Marau told us of the trick by which the

great Chief of Amo won influence, having claimed limits which were contested by powerful opponents. He left the decision to the great god Oro (whose temple, you know, was at Tautira), and where he was when a voice called from some unknown place and "gave him right."

This is the story exactly as Queen Marau told it.

STORY OF THE LIMITS OF THE TEVAS

When Oro was Chief of Papara, Hurimaavehi of Vaieri was ruling over all this side (Mataeia). A woman brought about the overthrow of Vaieri and the headship of Papara.

Oro had a son whose friend, named Panee, was the father of a beautiful daughter, beautiful enough to attract the notice of all, as indeed it was the glory of the place to do. Hurimaavehi, having heard of her beauty, had her carried off at night, by men sent for the purpose. Her father, in his distress, not knowing what had befallen her, but guessing at it, sought her up to every limit. One day, while he was inquiring at the limit near Mataeia, he saw two men coming toward him.

"Where from?" said he.

"From Vaiari."

And how is Hurimaavehi, and all around him, and what new beauty have you in Vaiari?"

The two travellers answered. "If you talk of beauty, there is a wonder has sprung out there, and she belongs to Hurima-avehi."

"She must be well treated?" inquired the old man sus-piciously.

The two said, "No indeed! She has been passed down to the servants (*Teutunarii*), then sent to the dogs and the pigs and to the fish of the sea."

So the father, like a madman, called out all manners of insult against Hurimaavehi; and he rushed away (like a madman) to the limits of the district of Vaiari, and meeting five people — Tite and four others (*iatoais**) under Hurima-avehi, he killed them ("which," says the teller of the story, "was a challenge"), and he gave his insults to be repeated by the travellers to the Chief Hurimaavehi. So that Hurima-avehi was incensed, and came right over to Papara with his people.

Now the girl's father had told his friend, the son of Oro, that Hurimaavehi would be coming to attack, and why. And the son of Oro said, "Come with me"; and they went to his father Oro and told him, how Hurimaavehi was coming to kill them, and why.

Oro said to his son, "Hide under this *marae*" (the *marae*

* Secondary chiefs; pronounce "yatowai."

whose remains or rather whose place we saw at Amo), and to the other, "Do you go up this tree" (the famous cocoanut that served as a watch-tower), "and when he comes back attack and beat him." He came with his men, they beat him, and Hurima-avehi ran off, with Oro and all his men after him, following on and taking possession of every limit, until he came to Teriitua. Then Teriitua said, "No further; this belongs to me." (Hitiaa.)

Then the limit was decided, as the famous story tells.

This is the downfall of Vaiari and the rise of Papara.

And the girl, having served her purpose of introducing the war, steps out of the story.

The daughter of Panee, whose fame for beauty brought on this trouble to herself and subsequent enlargement of her people, was, as the story shows, known as a beauty far from home. Our brown ancestors admire beauty no less than other people; and looked upon it, as we do in many cases, as a good instrument, besides the credit to the family and the favour that goes with the possession of any social power. But you must always remember that our brown forefathers were eminently socialistic, or rather communistic, as their relatives all over the Pacific are still. Never forget this for a moment, whenever you think of them or read about them or any habits of theirs. We have developed from that point to

a degree of individualism that can with difficulty understand what communism means. So that we are easily deluded and over-pleased, or horrified, when like views and systems are proposed in the western world for our descendants.

Now then, the family, in the case of a lovely brown maiden, would not only be her own family (as we call it directly), but spread further and back, in all sorts of relatives, and from that spread out to the village and the tribe; so that her beauty would be a credit to the whole place. Hence she would become a show-piece; and her immediate parents, with the good-will of the community, would guard her beauty, would feed her well and daintily, to make her smooth and fat; would keep her out of the sun that might darken her skin, fairer than that of others, if still brown to our snow-blinded eyes.

She would then occasionally be seen; and it was considered a proper and justifiable extravagance for even a lesser person to have a *paipai*, or stone exterior foundation to his house, upon which his fair child could be seen. And at certain intervals she would take her bath in public with others, and her physical charms be fairly judged. Nor must we think that all this is brutal — no more than with us to-day.

The girl was also judged by her manners, her courtesy and her modesty; for she thought no more of showing her legs than do our young women of showing their necks and bosoms

and backs; and she had the same notion that they have that there are strict limits — even though hers might not be ours. You will remember, perhaps, in early accounts, the pretty description of women playing on the shore or in the water, at games of ball, as did Nausicaa in the days of Ulysses.

Many times have I heard allusions to the habit of keeping in one house a number of the girls together, beauties of the place. And if I remember right, it was to such a residence that the celebrated Turi contrived to pass, notwithstanding the difficulties put in his way — difficulties all the more interesting as mere delays; for the young women had heard of his exploits and expected as much of him. But then, if I remember also, he lived in those days when people, especially the heroes of tales, could be gifted with the power of changing their forms at will. And who could have guessed in the decrepit or leprous old man, pitied for his sorrows by the tender women, the gay Lothario heard of through all islands. Still less could he be discovered in the fish that was caught by the old women who supplied the women's house with food. He it was who dug the great tunnel through the mountain, in order to approach his love without detection — her who was Ahupu Vahine of Taiarapu, of whom Stevenson, in the notes of his Ballads, says that he has not yet been able to find out

who she was. Why! there is a whole "Chronique Scandal-euse" of that period of earliest history.

Oro then belonged to the younger Vaiari, and seized the power of the older branch.

Let us take up the story as he pursues his enemy into the territory of Teriitua, Chief of Hitiaa, who checked his advance, disputing, most naturally, the limits that were being conquered. So that they left the decision to the Gods, as I understand, upon Oro's proposal.*

Upon a day appointed they met for the invocation; but Oro had determined to help himself that he might be helped; as many pious men have done and will do again. A friend of his, whom tradition names Aia, was concealed carefully in a hole or hollow place, near the disputed boundary. Teriitua's call upon his gods, being met only by the silence of the woods, Oro called out, pointing out, I suppose, what he wished, "Is it here?" And his friend answered, "It is here."

The cause of Oro won; a little, perhaps, because according to all tradition, he was a doughty warrior who intended to have his way.

We now belong to both the "Inner" and "Outer" Teva: Te Teva Iuta and Te Teva Itai, the whole eight, whose clans reached all down this side of the island, and into the next;

* Note on Limits: There is a good account in the small edition of the voyage of the *Duff*.

for we have been adopted twice, both at Tautira, and here —
into the two divisions.

The place has now for us an increased charm; a still more
subtle influence envelops me when I think that this is the
home of Amo and Oberea, who first met Wallis and Cook; and
as I look from the violet beds of one of the princesses to the
solemn hills of dark green crowned with cloud, I wonder if
somewhere there may be the hidden tomb of Oberea, now my
ancestress, the quiet familiar surroundings became solemn
with this great reminder of the mountains and the ocean that
faces them.

I listen now, with a curiously new interest, to the expla-
nations of the meanings of landmarks and to their names full
of associations for the Teva line. We have it explained to us
that each chief had a *marae*, a temple associated with the
sacredness of his name; and many rules concerning its foun-
dation; and the places within it reserved to chiefs through
heredity and heredity alone.

Each chief had also a *moua* or mountain; an *Otu* or
cape or point of land; a Tahua or gathering-place, from which
he ruled. Every point, says the island proverb, has a chief.

For the Teva the oldest *marae* was Farepua in Vaiari, from
which, by taking a stone from it, Manutunu, the husband
of the fair Hototu, mother of the first Teva, founded the

marae of Punaauia for his son. (He called it so because of his uncle, who dead was rolled up like a fish — *iia*.)

From these two *maraes*, many *maraes* along the coast, and in Moorea took their origin and proved the family descent. The Moua of Papara was Tamaiti; its Outu was Monomano; its Tahua, Poreho; its *marae*, Tooarai. Our adopted mother's name is Teriitere Itooarai, which you will remember is the name of the son of Oberea and Amo.

Taputuarai in the small district of Amo was the original *marae* of Papara, and from that Amo took the stones to build the *marae* of Tooarai on the point of Mahaiatea.

A poem traditional in the family gives expression to the value of these points — to the attachment to and desire to be near them again, in the mind of an exile, one of the Papara family. The family seems to have been represented by the Aromaiterai and the Teriterai, one of whom ruled in the absence of the other.

How far back this was composed, nor exactly how it happened that one brother, Aromaiterai, was banished, I do not know. One or other branch seems to have been always jealous of the other; but in this case one Aromaiterai was banished and forbidden to make himself known. He was sent into the peninsula to Mataoa, from which place he could see across the water the land of Papara and its hills and cape. The

poem which he composed, and which is dear to the Tevas, revealed his identity:

LAMENT OF AROMAITERAI

From Mataoa I took to my own land Tianina, my mount Tear-atapu, my valley Temaite, my "drove of pigs" on the Nioarahi.*

The dews have fallen on the mountain and they have spread my cloak. †Rains, clear away, that I may look at my home! *Aue! Aue!* the wall of my dear land! The two thrones of Mataoa‡ open their arms to me Temarii (or Amo).

No one will ever know how my heart yearns for my mount of Tamaiti.||

Could anything be finer than the rallying cry of the Tevas:

"Teva the wind and the rain!"

For a line running back to origins confused with the brute forces of the world; originating with divine creatures half animal — with the princes of double bodies, half fish, half man, what more poetic reminder of the intimacy with parental nature.

* Tiaapuaa, "drove of pigs," was the name of certain trees growing along the edge of the mountain Moarahi. The profile against the sky suggested, and the same trees — or others in the same position to-day — as I looked at them, did make a "procession" along the ridge.

† The "cloak" of the family is the rain; the Tevas are the "children of the Mist." Not so many years ago, one of the ladies of the family, perhaps the old Queen of Raiatea, objected to some protection from rain for her son, who was about to land in some ceremony. "Let him wear his cloak!" she said. And of course there are traditions of weather that belong to the family, that accompany it, and that presage or announce coming events.

‡ I understand by this, two of the hills that edge the valley.

|| The inland mountain peak of the central island, which he could not see.

I sometimes think of our chiefess as being able to feel with Phaedra, that the encompassing world is full of her ancestry.*

And here the heroic line brought down through ages to the present day, brings back to my mind the tradition that the lines of the fabulous Homeric heroes were carried into the new Christian world as far as the days of St. Jerome. Nor was the suggestion of the thought of Phaedra, claiming kinship with the universe, so far from the echo of the name of Queen Marau, whose further name is Taaroa, the great first god whose relation to the world is given in the verses:

"He was; Taaroa was his name.
He rested in the void.
No land, no sky,
No sea, no man,
And he alone existing took the shape
 of the universe.

"The pivots are Taaroa:
The rocks,
The smallest sands are Taaroa.
Thus he called himself.

Taarao is the light,
He is the germ.
He is the base,
The strong who created the world:
The great and holy world
The shell of Taaroa.
He moves it, he makes harmony."

* Le ael tout l'ninves est, plein Le mer ayenx."

The records of the past are all in words handed down; and the absence of any outer form to antiquity makes me seek it all the more in the nature which surrounds me, in the imaginary presence of the people who lived within it.

One great disappointment awaited me: I had hoped to find some form in the great *marae* or temple built by Oberea, in her pride of place, which Cook speaks of as the principal building of the island, and describes as an imposing monument. We found it only a vast mass of loose coral stones, treacherous to the foot and retaining but a vague and unimpressive outline. Still it was upon the shore, by the beautiful sea, and the funereal *aito* or ironwood trees sacred to temples still grew upon it. Stewart, the planter who for a term of years was able to keep up a great estate, at the head of a company behind him, planned on a grand scale, and who then failed, was allowed to use the stones of the *marae* as a quarry for his roads and walls. Even before that time neglect and the destruction brought about by the enmities to the old paganism must have changed its shape and destroyed its outline. To-day it is impossible to recognize the form described by Cook. It was made, he says, of a series of steps rising in pyramid way, to a top layer ridged like a roof; and its long sides, which hollowed in slightly, were some two hundred and

thirty feet in length. Now it is a sad ruin, shapeless and barbarous.

As I left it I remembered that Moerenhout, visiting here some sixty years ago, says that few natives except the great Chief Tati saw without superstitious fear the cutting down of the majestic trees which had witnessed for centuries the ceremonies of the forbidden worship, and had survived the decadence of the temples which they adorned. When he adds, the great trees had been cut down which shaded the *marae* further inland, specially sacred to the chiefs of Papara, which had been that of Tati himself and of his children, a rumour spread about the country that the water of the little river, the river that ran through our ancestral domain of Amo, had reddened, and blood had trickled from the trunks of the prostrate trees.

Last month, at Tautira, the absence of all vestiges of the great *marae* of the God Oro, was more impressive than the formless mass of stone associated with the name of Oberea. It is always a disappointment to notice how little this race has turned to the arts of form. I mean this race as I have seen it, in Samoa and in Tahiti. Elsewhere it may have done something, but here the form of music only has been reached — the earliest mode of expression. And though the Polynesian still shows good taste in colour and choice in arrangement, he

seems to have taken but the very first steps in the adornment of surfaces or the arrangement of masses. It is possible that there is something strenuous and needing sustained effort in the plastic arts which these sensuous races, urged by no contrarieties to find some escape out of the present, were too indolent and contented to achieve.

I have made many notes that I shall string together as I best can; but I am ineffably lazy, and this is the place for me in the house of Tati. I sleep in the rooms where his great-uncle Tati, the great Chief, died: he who ruled here at the beginning of the new dispensation, who was a child in the days of the first discoverers, and who lived well into the fifties. He was saved from the massacre of the Papara family when a child, through some recognition of the behaviour of Manea the high priest when he saved the pride of Tetuanui in her contest with the pride of Oberea.

So that the revenge of Tetuanui spared this boy, who became an important man representing the great Teva house. But that was only after the son of Amo and Oberea had died by accident, leaving to the Pomaré Chief no equal rival; and after Tati's brother Opufara had died in battle bravely defending the Pagan side against the Pomaré, helped by the rifles of the Christians.

Tati had apparently refused to avail himself of the offer of Pomaré, before his death, to appoint him regent, nor did he consent to our chiefess being made queen: for he seems in many ways to have asked for the best interests of his nation, and always with higher motives. There are interesting descriptions of his influence and of his dramatic eloquence, which Moerenhout compares to the action of Talma, the greatest of French actors. I read about him in Moerenhout's volumes; I make sketches during the day, and talk to the Tati of this moment, enjoying the sound of his voice and his laugh, and the freedom of the children, and the movement of the servants.

There is one who is always hard at work doing everything, who is really Marau's, a girl of good family, a sort of relation of mine now, and who is called Pupuri (if I catch it right), "Blonde"; and she is blond; her hair is absolutely gold, and when she has her back turned and her hair down you would suppose some foreign visitor from northernmost Europe. She is fair, a little red, like an Irish woman, with whitish lashes, and eyes that do not stand the light well.

Madame sits at one end of the piazza; the ladies flit in and out of their rooms and sometimes talk to us.

Next to our house, where some women have beds and others mats for sleeping, there are other houses for cooking, and for

YOUNG TAHITIAN GIRL

servants who are in reality dependents. Sometimes members of the family eat there, in native fashion, of native cooking, instead of coming to the table at which we sit on one end of the verandah. Near by is a little garden growing on what was once the enclosure of a house; and the little river runs rapidly a few yards off, hidden in part by trees; at which women go down to wash, and which men and boys cross to bathe, and in which splash the horses when they are washed in the morning. It is all delightful and rustic.

We are arranging with Tati about going to Moorea, the island opposite Tahiti, where we can be in the mountains that come right down to the water.

As the island makes a perfect triangle, the clustering together of its mountain peaks, seen from Papeete, used to look like some background of early Venetian pictures, inspired by the Dolomites that Titian knew when a boy. Tati has a plantation and house there to which we shall go; and the family are strong in the island, having antique rights and inheritances in different districts.

We shall stay only a few days here, and then sail or row across to the fantastic island that has made a distance of blue and gold to our days in Papeete, and behind which the sunsets used to sink in every variety of indescribable splendour or delicacy.

Papeete, May 22, 1891.

We did not leave by the steamer; by some curious chance unknown before, it was filled with passengers. It is true that it does not take a large number to fill it. We feared discomfort, and hurrying back from Moorea, we nevertheless lazily let it get away from the point on the coast to which it had gone for its cargo of oranges. Whether or no Tauraatua had already presented to his mind the alternative that opened to us I do not know, but we turned at once to a longer sea trip and a less probable one: to taking a little schooner that had just come from Raiatea, and getting its captain to carry us to Fiji. Thus we should also now be able to call at the leeward islands, Raiatea, Huahine, and Bora Bora, and leave, as it were, our cards. For it seems sad enough to give up the Marquesas; especially as every day we hear something in detail about them. Captain Hart tells us too that there is one *Typee* perhaps still alive; and gives me something of the story of a savage whose photograph is on the bookcase of his office — a gentleman whom Stevenson met, and a lover of human flesh. Indeed, the story goes, that once upon a time he had had thoughts of dining upon the captain — after a previous murder, of course. Now, to know a cannibal and perhaps to become his brother — for that would be a natural result of his acquaintance, as our relationship is just now in

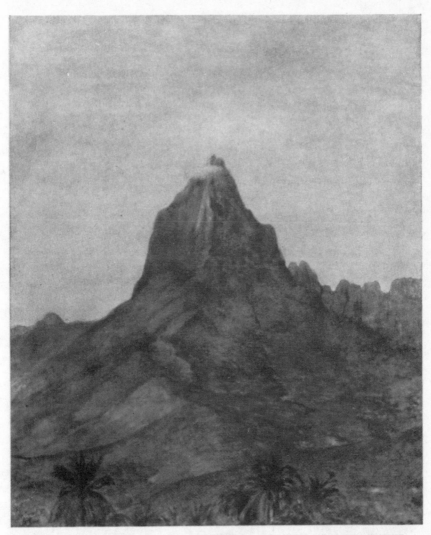

PEAK OF MAUA ROA, ISLAND OF MOOREA, SOCIETY ISLANDS, TAHITI

demand through these latitudes — is an awful temptation. Were there anything more to it — were there anything said that might lead one to believe that he or any other such might really become known and understood—perhaps might one think that the two weeks' sail against the wind would not be too much sea to travel over for a result. But I can make out no such probability from any cross-questioning that I have been able to conduct; and the portrait of the *indigéne* in question suggests a heavy, sullen brutality not at all romantic. I should not care to use him as a model for any picture of *Typee*, where the eating of man was apparently something like a duty or a necessity, not a mere *gourmet* liking for a certain richness of taste. No; we need, after all, more inducement than that one.

The portrait of the Queen is more of an invitation: there is something in her face and the impression we receive from "Prince" Stanislas Moanatini that warrants that we shall be well treated.

Still we are trying to get away in this other direction; that way at least the winds are in our favour, and two weeks' sailing would see us in Fiji or near it; and then in a few weeks more we might be on our return homeward. For all considered, we must make up our minds either to let this thing go on, and drift about the South Seas, taking up the island

groups one by one, as chance will have it, or we must make a stern choice and hold to that. And that choice points more and more to our saying good-bye to these eastern islands, and to determining that we have really seen Brown Polynesia, even if it be only in these three groups, and that the rest is a matter of detail. But it may not be so easy to leave by that little schooner or by any other.

There is a demand for small schooners — that is to say, they have to go around to the groups to pick up cargoes; and the one German firm whose boat runs near enough would like to put the screws on to the uttermost. *More Germanico*, even money is not enough — there must be no equality — and the last alternative so far has been the offer of a passage in a little boat, with other passengers, native women, and a full cargo; which means every available space filled (so that we would merely have our berths to lie in); and that passage to certain places first, and then afterward, when the schooner has discharged its cargo at leisure, to take us from the last point to Fiji. For these discomforts we should have to pay $2,700, within $300 of the value of the schooner. The other passengers would pay $15, which would be the average value. We offered $3,000 for the use of another schooner, having ascertained that she was unprofitable to the same owner; to which he answered by sending her off; and told us that upon

conditions of a like nature we might have her by and by.
The place develops curious sides of what is called business; and
this may be an example. Fancy anywhere else a person
offered the full value of a bit of non-productive property for
a few weeks' rent, and hesitating so as to couple difficult con-
ditions with his leave. But I think our German will come
short of his enormous profit: the steamer that brings cattle
here from Auckland and carries back fruit will probably be
our choice; it is only waiting three weeks more, and economiz-
ing several hundred dollars a week — never a cruel thing to
endure.

And our stay is such an easy thing; it is only because neither
of us has the future before him, but on the contrary, a con-
siderable past filled with the habit of work, that we make the
slightest effort to resist our contentment. The weather is
such as people might travel far to seek: an equable warmth, a
little coolness at night and in the morning, an evenness that
makes a couple of degrees count for a great deal, plenty of
moving air, a beautiful sea, a beautiful sky, and a beautiful
distance at all hours of the day and even of the moonlit
nights.

The Moorea lies in front of us, on half of the horizon; the
little shipping blocks up part of the space; grass-covered
quays are before us, shaded with trees under which pass

groups of natives or straggling French soldiers and sailors, or the few residents that live this way. At times all is silent and solitary; at others carts roll noisily; horses, ridden wildly by native boys, canter past, or some schooner comes in and unloads almost in front of us. Great excitement comes upon us with these arrivals, far greater than with the arrival or departure of the war steamer that serves to carry about the Governor or officials on tours of inspection, and whose presence brings the sunset gun, saluted by the customary refrain of the clarion, and the eight o'clock gun with another blast, as if reporting that the discharge had struck.

Lately too we have been interested in the arrival of Narii Salmon in his boat from the Pomotus, bringing other members of the family. This impending arrival has brought several times to our verandah the two younger ladies of the family, to scan the distance with our glasses. Since the night when Narii ran in, passing the reef in the twilight, our beautiful new sisters have been less frequent. It was a pretty event, the arrival of the little boat, for which others had daily been mistaken; the settling of its identity by its marks; the recognition of its owner by its sailing bravely in through the pass in the dark; then the calls from the shore to know if it were he for sure, and who was on board; and the boats hurrying out and coming back, all in a silence so great that the slightest

rustle of sail or cordage or steps on deck could be distinctly heard.

At times the only sound is the wavering fall of the little column of water that drips from the mouth of a fountain into the sea — to which we go for our supply of pure water. Its threads, thicker or thinner, with the pulsations of the head-stream thousands of feet far back, or with the draught of the wind, make a corded silver fan against the blue sea during the day; in the night a line of tinted light.

These are fine days; but our first stay after our return from Moorea ran over a week of wet weather that kept all asoak, filled the house with damp and mould, and carried into and about it disagreeable things taking refuge in comparative dryness: the centipede that runs away, but bites if interfered with; the scorpion that lurks around dark corners, and scuttles off harmlessly enough, but looking like a child's dream of a devil. The cockroach seems to rule over them, however, and to drive them away; and as the scorpion appears rarely in the house, and only in the verandah or outhouses, we have been lucky. Tauraatua has been bitten, but after a sharp pain like a cut, the matter has faded away. The memory is there, however, and I am glad of the changed weather. Our house, from whose verandah we look upon the sea across the road, and the reef near the horizon and Moorea swimming in light, is

the historic consulate empty of the Consul, whose place we take, his duties only being filled by Captain Hart, the Vice-Consul.

Behind us, across the yard, is our dear old Chiefess's home, where the Queen, Marau, and her sisters Piri and Manihinihi reside; so that we are near our new family, and we call in as often as our fears of intrusion may allow, or need of society, or freedom from so-called occupation. Tauraatua goes over more than I do; he has given up painting, and has returned to congenial and accustomed studies, by working at the genealogy of our new family, and helping to get it into written shape.

For the old lady, Hinaarii, has begun to open the registers of memory, and to correct and make clear things kept obscure, partly from purpose as defences, partly from kindly motives toward others; partly because it is written that memories must perish and the past continually fade and disappear, in part at least. Genealogy, you know, in the South Seas, indicates not only one's standing but one's rights to land. Nothing is ever sold, nothing alienated by any law; so that in one's name and in the names of one's relations are the title deeds of what one has. And now the French Government, in its anxiety to extend all benefits of civilization, and to make all its peoples equals has desired to have everything put into proper shape; and as in Samoa, so everybody here must put

in his claim to the land, which thus will be duly recorded for good and all. For never again will be the time when a family might claim the fruit of a branch of a given tree. These genealogies, kept by hearsay, will be unfolded to the public, so far as needed, and claims settled; there will be no need of concealment, no fear that some side relation, in a little country, where such relationship must exist, will know enough to make out a tree of his own and come in with some claim. Everything conspires for getting some definite record just before the last veil closes over a past already dim enough. And Marau and Moetia are writing out songs and legends, and may be inspired, if their ardour can continue, to help to save something.

Some years ago King Kalakaua of Hawaii had wished to obtain the traditions and genealogies; but the old lady had never been favourable; so that we feel that at least we have done no harm to the family, at least in our western notions, since we may help to save its records.

It is a part of the charm of Tahiti that with it there is a history: that is has been the type of the oceanic island in story; that the names of Cook and Bougainville and Wallis and Bligh belong to it most especially; that from it have radiated other stories: the expeditions of the mutineers of the *Bounty*, and the missionary enterprises that have gone through the Pacific.

With its discovery begins the interest that awoke Europe by the apparent realization of man in his earliest life — a life that recalled at least the silver if not the golden age. Here men and women made a beautiful race, living free from the oppression of nature, and at first sight also free from the cruel and terrible superstitions of many savage tribes. I have known people who could recall the joyous impressions made upon them by these stories of new paradises, only just opened; and both Wallis's and Bougainville's short and official reports are bathed in a feeling of admiration, that takes no definite form, but refers both to the people and the place and the gentleness of the welcome.

That early figure of Purea (Oberea) the Queen, for whom Wallis shed tears in leaving, remains the type of the South Sea woman. With Cook she is also inseparably associated and the anger of the first missionaries with her only serves to complete and certify the character. One will always remember the imposing person who, after the terrors of the first mistaken struggle, approached Wallis with the dignity he describes, welcomed him and took care of him, even, as he says, to carrying him, since he was ill, in her arms, as if he were a child. One would like to go back in mind to the time, if it were possible to realize the thoughts that must have come upon Oberea and Amo her husband on this appearance of the

great ship and the strange men — a floating island as they
first thought it, which they attacked as a portent of ill.
Something like this will be felt by our descendants when
from some distant planet the first discoverers shall drop
on earth. And so Amo and Oberea come in and out of
the stories of the first discoverers, even until forty years
after, when the missionaries of the *Duff* speak of the poor
lady with harsh words and (1799–1800) no pity for her
frailties.

Now Oberea (Purea) was our old Chiefess's great-great-
grand-aunt, as Amo was her great-great-grand-uncle; and
now, with one remove further, she is ours by adoption.*
(You must ever remember that we belong to Amo; that is the
special name of place attached to ours.)

And everything that concerns the family of the Tevas
interests us exceedingly. Does it not interest you also?
This *living connection* with the indefinite archaic past, does
it not bring back the freshness of early days, in which, reading
of the voyages, our minds shaped pictures of what these
places and their people were? Now for me it is a pleasure,
half touching, half absurd, to look upon the queer pictures of
the little place we lived in at the end of Uponohu Bay, as it

*In the other family at home, into which I was born, the distance back seems shorter.
Oberea first saw the European ships while my grandfather was alive, and he must have
read the first accounts carried out to Europe by Bougainville and Cook.

is represented in the prints of Cook's voyages, or the later one of the *Duff;* that place where Melville last lived during his last days on Moorea, as he tells in "Omoo"; and then to think of my own sketches, and the different eyes with which I must have seen it. In the same way, or a similar way, my impressions of to-day become confused and connected with these old printed records of the last century, until I seem to be treading the very turf that the first discoverers walked on, and to be shaded by the very trees.

I have been drawing and painting somewhat lately, so I have been able to take fewer notes than Tauraatua. He is working assiduously, partly because he is engaged in congenial work, partly to urge Marau to go on and write her memoirs, which would then go back to a record of her ancestors. I, on my part, could not do it so well; and I am busy at my drawings, trifling as they are. But I regret it, as I see less of our neighbours, all of whom have their various degrees of charm.

But I like to gather in without strict order these records and memories, even at the risk of Marau's supposing that I am going to put into verse the extremely difficult poems she recites to us. This idea of hers is evidently a devilish suggestion of Tauraatua, who thereby shares the responsibility or throws

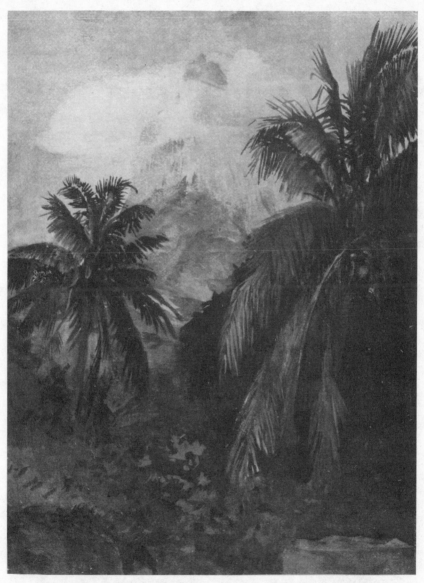

SUN COMING OVER MOUNTAIN. EARLY MORNING, UPONOHU

it off on me at will. Still I shall transcribe into prose some of
the poems at least, to please you. They are woven into the
story of the family and form part of its record, if one may say
so; some of these form parts of methods of address, if one
might so call it—that is to say, of the poems or words in order
recited upon occasions of visiting, or that serve as tribe cries
and slogans. So with the verses connected with the name of
Tauraatua that are handed down. The explanations may
(and do) *embrouiller* or confuse it; they did for me; but they
make it all the more authentic, if I may so say, because all
songs handed down and familiar must receive varying glosses.
Where one sees, for instance, a love song, another sees a song
of war. The Tauraatua of that far back day was enamoured
of a fair maiden (her name was Maraeura) and lived with or
near her. This poem, which is an appeal to him to return to
duty or to home, or to wake him from a dream, is supposed to
be the call of the bird messenger and his answer:

(To) Tauraatua that lives on the "Paepae" Roa (says)
 "euriri" the (bird) that has flown to the Rua roa:
 Papara is a land of heavy leaves that drag down
 the branches:
 Go to Teva, at Teva is thy home:
 to Papara that is attached to thee,
 thy golden land.
 The mount that rises before (thee) that
 is Mount Tamaiti.

("Outu") The point that stands on the shore is
Outo monomono:
It is the (place of) the crowning of a king who
makes sacred
Teriitere of Tooarai.* (Teriitere is the chief's name
as ruling over Papara)
(Answer) Then let me push away the golden leaves
of the Rua roa
That I may see the twin buds of Maraeura
on the shore.†

Of this translation Tati made mincemeat one evening, describing as frivolous the feminine connection, and giving the whole a martial character. The few lines he changes I shall not give here in full; suffice it that he ends with this, which is fine enough:

"He is swifter (Tauraatau who is supposed to rush off) than the one who carries the fort.
"He is gone and he is past before even the morning star was up.
"The grass covering the Pare (Mapui-cliff) is trampled by Tauraatua."

I shall not have time to reconcile the versions, but Moetia seems impressed with the possibility of getting these things translated; and if all will unite, even if two versions are made, the songs will at least be *saved*.

I have received from Marau two poems: one about a girl

* The bird messenger repeats the places and names of things most sacred to the chief (as you will see further), his mount, his cape, his *marae*.

† To which the chief answers that he will look at his mistress's place or person on the shore.

asked to wed an old chief, one in honour of Pomaré; but Adams has become more Teva than the Tevas, and will not note it.

And as a woman has come again into the story, as she has done often with the Tevas, for good and ill, let us go back to Oberea, the Teva princess whom Wallis first met, and met almost by chance, for she and her husband Amo were on a visit to the place where Wallis anchored and landed, and by this accident helped to displace later the centre of power, as has always happened where the white man has made his harbour.

Oberea was on a visit to Haapape, where is the anchorage of Matavai; its chief Tutaharii. Tutaha (in Wallis's book) was connected with the Papara family to which Amo, Oberea's husband, belonged (and stripped, as a sign of respect, in presence of Amo and his little son Teriitere).

The Tevas, whom Amo and Oberea represented, held the political supremacy of Tahiti. Their lands were further down the coast to the south than the districts which the first discoverers first knew, and separated from them by inimical chiefs, momentarily quiescent from fear and doubt. They were especially the Purionu and Teaharo, from whom the first discoverers received a great part of their information; then came, on the west coast, the little district of Faaa (or Tefanai Ahurai), from which came Oberea (Purea; her proper

name, Tevahine Avioroha i Ahurai), the daughter of its chief, Teriivaetua.

Then came a large district known as the Oropaa, consisting of Paea, adjoining Papara, the chief place of the Tevas, and of Punavia, both these connected by family alliances with the Tevas.

The Tevas (and family) held after them, further to the south, the whole south of the main island, and the whole of that half island called Taiarapu, which joins the main island at the narrow Isthmus of Taravao. The east was divided into three districts, but had no common head. Hence the Tevas, usually well combined, with strong clan feelings that last until to-day, controlled all the south and west of the island and Taiarapu, or two thirds of the population, and had only themselves to blame when deprived of their ascendency.

The Tevas were divided, as they still are on the map to-day, into Inner and Outer Tevas; the Outer Tevas on Taiarapu (into which we were adopted by Ori), and the Inner Tevas on the main island (into which we were adopted by our good chiefess of Papara). These made the eight Tevas. Their origin, like that of all clans, is hidden in the night of legend, with the old myths of a semi-divine ancestor and an earthly mother.

And as the women were to play a great part in the history

of the Tevas, it is but fair to begin, then, with that part of the life of Queen Hototu that made them.

THE ORIGIN OF THE TEVAS

This, the earliest of the traditions of the family, was told me at different times by Queen Marau.

At certain hours Tauraatua goes to the low cottage behind our house, that is open toward the King's palace and the government house, but is entirely shut in by trees that fill the little garden, and which has a strange resemblance to many a little American home and is all the more wonderfully unreal. Then the Queen comes from some inner apartment and repeats the legends, poems and genealogies, and one or more of the sisters are often there and add comments or contradiction. During our absence the ladies are supposed to have prepared the material and to have arranged what documents they have, so that in many cases what little I shall quote will be the very words of our royal historian. Sometimes in early evening the Queen has walked down to the shore with her sister Manihinihi, and, sitting on the rocks under the lofty trees, answered my questions about these early ancestors. I can tell you the bald story. I cannot give you with it all that would have made any old story charming — the faces and forms of my instructors, their beautiful voices, the slight wash

of the sea into which Manihinihi sometimes put her bare foot, the wonderful stillness, the slight rush of the surf far out on the reef, the light of the afterglow, the blue ocean far away, the mountains of ancestral Moorea lit up after sundown, the shadows of the big trees moving over the water, and on our side right above us the great heights of the Aorai appearing and disappearing behind the many coloured clouds. At such moments I could forget for the present the little meannesses introduced by us Europeans and feel as if I were back in the time when my name was Teraaitua.

They were my ancestors in fairyland of whom fairy stories were being told, and even the absurdities had the same charm of the stories of our nurseries which they so much resembled.

The great ancestress Hototu, from whom come all the Teva, was the first queen of Vaieri. She married Temanutunu,* the first king of Punaauia. All this is in the furthest of historical records, as you will see by what happened to this king and queen at the time when gods and men and animals were not divided as they are to-day, or when, as in the Greek stories, the gods took the shapes of men or beasts to come and go more easily in this lower world which they had begun to desert.

In the course of time this king left the island and made an

* Temanutunu means bird that lets loose the army.

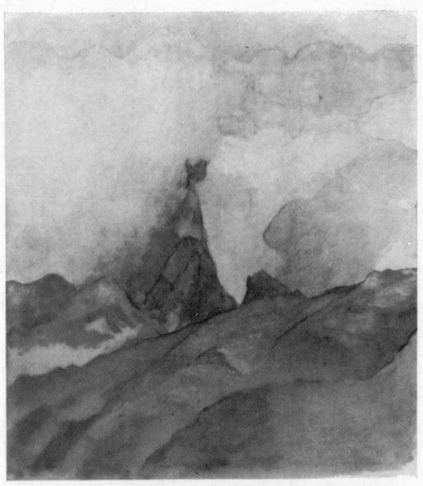

EDGE OF THE AORAI MOUNTAIN COVERED WITH CLOUD,
MIDDAY. PAPEETE, TAHITI

expedition to the far-away Paumotu (pr. Pomotu). It is said that he went to obtain the precious red feathers that have always had a mysterious value to South Sea Islanders, and that he meant them for the *maro ura* or royal red girdle of his son, for he had a son by Hototu who was named Terii te Moanarao. The investiture with the girdle, red or white, according to circumstances, has the same value as our form of crowning, and took place as a solemn occasion in the ancestral temple or *marae* of these islands of the South Sea, but the red girdle seemed even in some Samoan lore to have an ancient meaning of royalty; I remember Mataafa, the great chief, asking me why the English Consul wore the red silk sash which he probably affected in his dress as being of an agreeable colour.

While the king was far away in the pursuit of these red feathers to be gathered, perhaps, one by one, the queen Hototu travelled into the adjoining country of Papara, where we were the past month, and there she met in some way the mysterious personage, Paparuiia.* With this wonderful creature the queen was well pleased so that from them was born a son who later was called Teva, but this is anticipating.

This was the time as we have told you when men and

*Vaeri Matuahoe (mud in my ears), a Tino iia (fish body) the double man, half man, half fish, recalls the god of the Raratonga who himself recalled to the missionaries the god Dagon.

animals and gods were mixed, and this great ancestor of the Tevas was evidently some form of god. The story came to an end in a sudden way. While the king was still away, his dog Pihoro returned, and finding the queen he ran up to her and fawned upon her to the jealous disgust of Tino iia, one half of whom said to the other, "she cares for that dog more than for me. See how he caresses her!"

So then he arose and departed in anger, telling her, however, that she would bear a son whom she should call Teva: that for this son he had built a temple at Mataua, and that there he should wear the *maro tea*, the white or yellow girdle, the chiefs of Punauia or Vaiari, who in this case were the king and queen, being the only ones that had the right to the *maro ura*, the red *maro* or girdle, for which you will remember that the king was hunting. Then he departed and was met by Temanu-tunu, the husband who had landed at Vairoa, and who entreated him to return. He refused just as the two Shark-princes, of whom I told you at Vaima, the little river that ran so clear near Taravao, refused another husband for a similar reason, saying that his wife was a woman too fond of dogs. "Vahine na te uri" (woman to the dogs). When I asked if he never came back, the queen, or was it Moetia, told me that since that day the man-fish had been seen many times.

The dog is however much connected with the Papara family,

and his presence is occasionally felt. Tati the brother of the queen told some stories of him. One of these stories refers to what happened to Narii when a child. His mother had him with her at the occasion of the building of a bridge near Papara. There were many hundred people there. Tati was there with his two nurses according to custom, and Narii had also the two who had charge of him. At evening one of the nurses saw something like a dog run up a tree above them, and into the branches, and at the same time something waved from him like rags. Just then the child was drawn from the arms that held him, his mother's, but something grasped him firmly, while a ball of fire rushed out above him and went on to the sea some quarter of a mile distant. So many people saw part of this, namely, the ball of fire that there was no doubt of it.

Nor must I forget to say that all about Papara there is a good deal in the way of ghosts or queer sights. For instance, just beyond the little enclosure of our hereditary Amo, where the little sluggish river runs in the woods beyond the ancient stone foundation, evergrown with trees, there are spaces where occasionally the figure of a man appears and disappears through the trees, and old rags of clothing flitter behind him. There last Saturday, while two men were at work, what at I don't know, perhaps looking after vanilla, one of them looked

up and saw on the face of the little cliff, a small hole, not noticed before, out of which at once stepped an old man dressed partly in an ancient manner, who dusted his clothing as he got erect and then disappeared. The two men went to the spot and found the hole. There was some talk of enlarging it and digging into it, but the discoverer objected so strongly, and has still kept up his objection so well that nothing more has happened.

The shark is connected with our cousin Ariie's family at Tautira and has still power with them. Not so long ago Ariie's mother came here worn out and dusty, having ridden instead of having been carried in her canoe as usual. She told the following story — she had intended to come but had declined to bring her daughter with her. Now her daughter is a believer in the shark, and she thereupon told her mother that she should not get off. Nothing would induce her to say more but the mother was rowed up inside the reef as we had been on the same course along the coast of Pueu. I don't know exactly where it was, but somewhere in the evening the rowers complained that their path was obstructed by a large shark. The old lady ordered them to row on; as they did so she looked up from the bottom of the boat where she lay with her head wrapped up in the usual loin-cloth or *pareu*. She saw before them, an enormous shark, lying at right angles to

the boat, partly out of the water, and all along his back a row of lights like lamps lit up the water. Unwillingly the men obeyed her orders to row on and struck the fish full on the side without making it move away, the boat running up on his back. Then she determined to return and when she got home, rebuked her daughter angrily, for she knew that it was her daughter who had done this, and rather than yield to her she had come the whole way with horses. Tati says the girl is known to have power that way and that she calls upon this protector when she is angry. Upon such occasions a special odour easily to be recognized as the smell of the shark fills the air. As far as I can see the shark is at least a cousinly god to us, somewhat of a relation and protector, and henceforth, I think as I suggested above, we ought to be safe from him at sea.

As in the story of the ancestress, Queen Hototu, so important and aristocratic, freedom could belong to women where descent and inheritance placed her above others. Daughters transferred to their children rank and title, and consequently property, and in fault of other heirs could become chief. The mother, therefore, of an heiress to a title was another chief even to her husband, and had privileges that he could not have; for instance, a seat in the family temple. All this she transmitted to her child.

The mother of our old chiefess was known by at least thirteen different names, each of which was a title, each of which conveyed land; so she was, for instance, Marama in Moorea and owned almost all the island; so she was Aromaiterai in Papara. This investiture would be received for a child, as child to a chief, would be carried to the family temple to be made sacred, as was done in this case, thirteen different temples having received the child, the mother of our chiefess. As in all Polynesia the Arii or chiefs were more or less sacred as was the ground upon which they rested; but that was only among their own connections. There the inferior chiefs, men or women, out of respect stripped themselves down to the waist. That is why Captain Wallis relates that Tutaha as well as Vairatoa, stripped in the presence of Amo, our ancestor, and his little son. Why exactly the wife of Vairatoa uncovered herself *up to the waist* when she presented cloth to Wallis, I have not been exactly able to find out, but Tati says it was probably from the same notion of very great respect.

So you see the connection of the *marae* with the chieftain's power; a knowledge of *maraes* and of the origin and descent of families is intimately connected. Each family had its stone in the *maraes* where it claimed family worship.

The Teva's original *marae* is said to be that of Opooa in the sacred island of Raiatea; but their own tradition makes it,

as I have said, at Mataua, where the head of the Tevas wore the *maro tea*.

When Temanutunu, the husband of Hototu, mother of Teva, brought back the red feathers from the Pomotus, to be worn in *marae* by his son, he founded the temple or *marae* of Punaauia. Thus the story indicates that Vaiari and Papeari were the original centres, and Punauia and Papara chiefs wore the red or yellow girdle in right of descent from Vaiari. We must understand that power did not reside in the mere wearing of this girdle; it was only a symbol of the power of descent which represented alliances of families in a land where blood was everything, where a chiefess killed her child if not of high enough birth.

Do you remember, or have you read, in the "Voyage of the *Duff*," the terrible time the missionaries had with "Iddeah," the wife of the older Pomaré? It is almost a pity not to quote it in full; and if I had the "Voyage" by me I should do so. Like Oberea, she was more or less separated from her husband, and had, like the great Catherine or the great Elizabeth, a young favourite who went about with her everywhere, as the missionaries saw. He was of low blood; hence the necessity of putting the child to death; and as all this was openly understood, the missionaries undertook to persuade "Iddeah" (as the missionaries called her) to abandon the hereditary

notion. Notwithstanding every exhortation, she declined to do so, and killed her child according to custom; though like a politic person, she promised not to do so again. And I have told you about the late Queen Pomaré and her affairs.

Hence again, everywhere the *marae* comes into the story of the islands; with it, of course, begins the families — no *marae*, no family — and with the building of the greatest *marae* of all, the one that Cook saw and described in its new importance, the power of the Tevas culminated and was broken forever. You know that we saw its ruins on the beach of Atimaono, and walked up the crumbling slopes of coral, with Pri and Winfred Brander, whose ancestors built the family temple.

The pride of the Tevas, the pride of Oberea, brought on the revenge of the offended. But that part of the story I must put off, and tell you some of those that go further back.

The Tevas were proud and domineering, but the family of Papara, of which was Amo, and where flourished Oberea his wife, were still more so; for Papara was the leader politically. Historically the chieftainesses of Vaiari and Punaauia, as we saw by the story of the origin of the Tevas, were older and of greater dignity; but it was the Chief of Papara who called out the Tevas, who presided over them, and who alone had the right to order human sacrifices for the clans.

There were, as you know, eight Tevas, inner and outer, the inner ones Papara, Atimaono, Mataiae, and Papeari; the four outer ones, the four districts of the peninsula of Taiarapu; Paea and Punaauia were tributary. The origin of this limitation, the origin of this power, goes back to some great and uncertain distance which I have not been able to ascertain, but it may be a thousand years back or not more than five or six hundred. That could perhaps be determined more closely by a more extended inquiry. At that time Papara was subject or tributary to Vaiari, and when Mataiea belonged to the Chief of Vaiari.

For this liberation of Papara, and placing it at the head of the Tevas, Oro, not the god, but a chief of that name, is the cause. He was a small chief within Papara. His father's name was Tiaau; you will remember my speaking of him in connection with the little chiefery of Amo, to which Adams and I have succeeded; and you may remember the story of the chief and of his *paepae** there, all grown over now, and of the cocoanut that served as a watch-tower. It all comes into the story, if told in detail.

There were thus battles and wars within the Tevas, and there is another story of Papara and our ancestors into which a woman comes again, and not only one woman but another.

* Stone foundation or base of house and space around it.

I leave it as I first wrote it down, though it suggests in itself much alteration and explanation. I shall call it:

THE STORY OF TAURUA OR THE LOAN OF A WIFE

Tavi ruled in Taiarapu, known for his wild generosity, and for the beauty of his wife, Taurua Paroto. To him Tuiterai of Papara sent messengers, begging the loan of his wife for the space of seven days. There may have been hesitation on the chief's part, but his habits of giving prevailed, and Taurua came to Papara, to spend her seven days with Tuiterai. At the end of that term she was not returned to her lord, who sent messengers for her.

But Tuiterai refused. "I will not give her up," he said, "I, Tuiterai of the six skies, her who has become to me like an *ura* to my eyes, rich *ura* brought from Raratoa — my dear gem! I have treasured her now, and I treasure her yet, as the *uras* of Faaa; and I shall not give her up now. No, I shall not give her — why should I give her up — I, Tuiterai, of the six skies; for she has become precious beyond the *uras* of Raratoa?" Thus the song preserves his refusal; so Tavi made war upon him, and Tuiterai was defeated and made prisoner, and was upon the point of being put to death. But he pleaded with his captors who had bound him, claiming that he should be taken to Tavi, and, if killed, then killed by him a chief. So

that they carried him away in a canoe, all tied up, that he could neither move nor see; and his bonds increased the faintness caused by his wounds. But he pressed his captors to hurry, for fear that he should die by his cords; and he knew how far he had gone, for his fingers, touching the waters, recognized the *"feeling of each river, as every skilful swimmer knows."* At length he was brought before Tavi, and set before him, along with Taurua.

But Tavi said to his men, "Why did you not kill him when you had caught him? It is not meet that I, a chief, should put him, a chief, to death." And addressing Tuiterai he said, "It is you that have bound me with cords that bind my heart and make the skies gloomy, as if you had drawn them down and bound them over me. You have taken one who lay in my arms, and tied a knot between her and me, and you have broken the ropes that tied us together — her and me. Take her!"

So Tuiterai won Taurua.

But dark fate seems to have pursued the generous man, and later Tavi was defeated in war and fled to the Pomotu Islands, where he disappeared.

The war again came from Taurua the beautiful: she had a son by Tavi, a son called Tavi Hauroa, and Teritua also, and names had been given him from other places, as Taurua came

from Hitiaa. For this child Tavi put a taboo (*rahui*) on his
land, and tried to extend it further on, wherever he might
claim. But Taaroa Manahune had married Tetuae-huri, the
daughter of Vehiatua, and was expecting the birth of Teu.*
"Your wife should eat pigs," was said to Taaroa; so they eat
the pigs, resisting the claim of Tavi, who being at Pai crossed
at Tehaupo, and was beaten by Vehiatua. A part of the
defeated returned from the Pomotu, and were granted the
holding of Afaiti, under the boy Tavi Hauroa. But in an evil
moment, he flew his kite over the *marae* of Fareupua, so that
it was caught in the *aito* (ironwood — casuarina) trees; and
at the instigation of Tunau, the high-priest, he was put to
death. How and why? By whom? Was his companion
also killed?

There would seem to be a moral to this tale, which would
run this way: that generosity is a doubtful quality, and that
it is wiser to take another man's wife than to let go your own.

Some explanations I should have woven into this story for
you, but I write almost directly from Marau's recitation, and
it was only afterward that I got from her some more details.

In reality, the right of Tavi to place a general taboo or
rahui on Taiarapu generally was a very questionable one. It
might have been merely a question of pride that made him

* The founder of the Pomaré, who later became great chiefs and then kings, by European
consecration.

insist upon it when his claim was weak. It was also, it would seem, a general desire in the other members of the clan to weaken its power or limit its range.

By making a general *rahui* or taboo, as we call it, the chief had everything that grew, everything that was made, everything that was caught, set aside for a time, for some particular use: to make further feasts or for the food or the property of an heir, for instance. Hence its frequency after the birth of a young prince or princess. Or it might have been that some great feasts or generosities had depleted, if I may so call it, the treasury. Later even, some of the missionaries in Catholic Islands have found it useful to preserve the plants, and allow them to increase so as to prevent the recurrence of a famine.

Tavi had only undisputed claim over Tautira, Afaahiti, Hiri, and in Tai.

Vehiatua ruled over the southern and western parts of Taiarapu, as far as Teahupo and Vairoa.

The little Teu, who was born of Tetuae-huri, the daughter of the Vehiatua that defeated poor Tavi, became the big and important Teu founder and first of the Pomares, called kings by the missionaries, who did much to establish them in that position, unknown to the mind and the customs of the Polynesians of the East Pacific. The son of Tavi, who came back from the Pomotus, and was received in royal style and given

the district now called Afaahiti, was killed at the *marae* of Farepua of Vaiari, as I have just related.

Among the chiefs who helped Teu to his new position was Terii nui o Tahiti, who bears a very interesting name: The Great Chief of Tahiti. In this case the word Tahiti refers to a *marae* of Vaieri, not to the island. Besides Farepua, Vaieri had this *marae* of Tahiti, which very probably gave its name to the island at some remote period; and it must have been a Teva name.

The fortune of the Papara family seems to have come up at various times, and to have culminated at the time of Purea (our Oberea). Her pride and the pride of the Tevas brought about disaster long after she had passed from power. The woman began and the woman ended. She was married to Amo (of Cook), as we know (Teviahitua), and was herself the daughter of Vaetua, Chief of Faaa, the district between the Tevas and the Purionu; whence later were to come the Pomarés, enemies of the Tevas and of the house of Papara. Her real name was, as I have said before, Te Vahine Aviorohe i Ahurai. Her brother Teihohe i Ahurai had a daughter who married Vairatoa, whose daughter Marama was the mother of our old chiefess, and consequently the grandmother of *our* queen and princesses. In this way, then, Pomaré II, who became king, was the second cousin of this last Marama;

and, as in Tahiti cousins are brothers and sisters, Pomaré called her sister.

Hence, again, the tendency between the last Pomarés and the old lady to make matters right again, and to join the families by marriage, as when Marau married the last Pomaré (V), or when Pomaré III wished our old chiefess to be queen, instead of the famous lady whom we know as Queen Pomaré, with whom our adopted chiefess was always most friendly and intimate.

And so at the time of the last century, Purea, or Oberea, had no superior, unless the head of the older Vaiari branch. Teriirere, the son of Amo and Purea, was a child when Wallis came, hence must have been born in the neighbourhood of 1760; and in his honour and for his advantage, a *rahui* or taboo was placed upon all the Tevas for the child. The might of the *rahui* was great; the power to impose it, as it confirmed rights and prestige, gave great umbrage, and there was a way of breaking it without war that could be resorted to. That was to have a chief or person of equal rank, or a relation of the same degree, come as a guest to the place where the *rahui* existed. According to custom the guest was entitled to receive as guest all that could be given, and that meant all the accumulations of the *rahui*. Terii Vaetua, Purea's own mother, determined to break it, and came from their home in

Faaa, in her double canoe, with the tent upon it indicative of royalty (*fare-oa*).

The canoe bearing her mother entered the sacred pass in the reef opposite the *outu* of Mataiatea. This pass was reserved for princes alone. Purea was living at that time opposite the pass, some little way (two miles) from Papara, and called out to the canoe as it entered:

"Who dares venture through our sacred pass? Know they not that the Tevas are under the sacred *rahui* for Teriirere i Tooarai? Not even the cocks may crow or the ocean storm."

Her mother answered, "It is (I am) Terri Vaetua, Queen of Ahurai."

"How many royal heads can there be?" said Purea. "I know no other than Teriirere. Down with your tent!"

In vain Vaetua wept and cut her head, according to custom, with a shark's tooth, until the blood flowed. She was obliged to return without a reception from Purea. Then a granddaughter of Terii Vaetua, a girl under twenty, a niece of Purea's, made an attempt in the same direction. But the same cry came from Purea: "Down with your tent!"

Tetuanui (Reaiteatua) the girl, came ashore, sat down upon the beach, and in the same way cut her head until the blood flowed into the sand, according to the old custom, asking, if

unredeemed, blood for blood. Manea,* the high-priest, her brother-in-law, then came upon the scene. He feared the danger of making enemies of the Auhrai princesses, and he said thus: "Hush, Purea! Whence is the saying, the *pahus* (drums) of Matairea call Tutunai for a *maro ura* for Teriirere i Tooarai. Where will they wear the *maro ura? Maro ura* — the red girdle of royalty and surpreme chiefhood. In Nuura i Ahurai. One end of the *maro* holds the Purionu, the other end the Tevas; the whole holds the Oropoa."

(Words that I do not quite understand, as given by Marau, but which implied the danger of breaking up their union.)

"I recognize no head here but Teriirere," answered Purea.

Then Manea, unable to do more than to clear himself, and make what amends were in his power, for the insult he could not prevent or turn away, wiped with a cloth the blood shed by Tetuanui, and took her to his house. When, forty years after, Tetuanui took her revenge in the massacre of the family of Papara, this action of Manea saved part of them; and through him we descend, in the male line, from the Tuiterai of the preceding generation. From Tetuanui, by her marriage with Varatao, the first Pomaré chief of the unfriendly Puri-

* Manea appears in Cook and in the accounts of the first missionaries. The detail escapes me, as I have no book just at hand, at this moment. I have a vague recollection of some slight scandal again in family matters, but missionaries were fond of tittle-tattle, like most people.

onu, was born Pomaré II, the first king and he who became the chief enemy of the Tevas.

Marau, in relating all this story, on different occasions, felt, I believe, the old pride of Purea beat through her: her voice rose in repeating the words: "Down with your tent!" and "I know no other royal head than Teriirere." I could almost believe that it was she who asserted herself in the person of her great ancestress.

But for all that, now before the final disaster, the house Papara seems to have met a great check again, in a display of the power and pride of Purea. She and Amo built for Teriirere a new *marae* on that same point where the ladies of Ahurai shed their blood in protest — Mahaiatea and Amo took its foundation stone (if I may so call it) from the original *marae* of Taputuoarai. Cook has described it as he saw it in 1764 — the most important building of the kind he had seen. And over its remains I have scrambled, as you know, unawares of all that it had meant. How much better can I understand the resistance made by our old chiefess to letting it be used as a quarry for the buildings of the great plantation af Atimaono, the great sugar estate of the adventurer Stuart; now involved in a ruin like to that of the old temple. The chiefess, for this refusal, was removed from her position for a time; how reinstated I do

not know. You know that I told you before, she is a chiefess, recognized by the French Government, as well as by inheritance, Tati acting for her. It was one of those outrages that the new generations perpetrate on the old; and in this case more disgraceful than usual. But few people sympathize with the "*lachrymae rerum*" that touched the pagan poet.

You must look up Cook's description, which I have not by me. Everything in the way of books here is fragmentary, the public library usually unvisited, and many of its possessions scattered carelessly.

The completion of this monument coincided with the beginning of the war that drove Amo and Oberea away, and ruined Papara for a time; a war which occurred between Cook's first and second voyages; so that he found his former friends reduced in power and dignity. The Vehiatua of that time, with Taiarapu and the Purionu, joined in the attack upon Papara thus breaking the Teva power from within.

There is a poem, difficult to render, which is associated with this completion of the *marae*, and which seems to bring the war from that. There has been much trouble to make a settled translation of it. The one which I add is a revised translation by Moetia, conferring with the others, whose translation

in the rough I have kept separate. I give you Marau's own copy.

"A standard is raised at Tooarai
Like the crash of thunder
And flashes of lightning
And the rays of the midday sun
Surround the standard of the King
The King of the thousand skies.
Honour the standard
Of the King of the thousand skies!

"A standard is raised at Matahihae
In the presence of Vehiatua
The rebels Taisi and Tetumanua
Who broke the King's standard
And Oropaa is troubled.
If your crime had but ended there!
The whole land is laid prostrate.
Thou art guilty O Purahi (Vehiatua)
Of the Reva *ura* of your King.
Broken by the people of Taiarapu
By which we are all destroyed
Thou bringest the greatest of armies
To the laying of stones
Of the *marae* of Mahaitea.

"Poahutea at Punaavia
Tepau at Ahurai
Teriimaroura at Tarahoi
Maraianuanua the land where the
Poor idiot was killed!
Eimeo the land that is decked
By the *ura* and the *pii*.

"The prayers are finished
 And the call has been given
 To Puni at Farerua (Borabora)
 To Raa at Tupai (an island belonging to Borabora)
 To the high priest Teae,
 Go to Tahiti
 There is an *oroa* at Tahiti
 Auraareva for Teriirere of Tooarai.
 Thou hast sinned O Purahi!
 Thou hast broken the
 Reva *ura* of the King.
 Taiarapu has caused
 The destruction of us all
 The approach of the front rank
 Has unloosed the *ura*.
 One murderous hand
 Four in and four out.
 If you had but listened
 To the voice of Amo, Oropaa!
 Let us take our army
 By canoe and by land,
 We have only to fear the
 Mabitaupe and the dry reef of Uaitoata.

"There we will die the death
 Of Pairi Temaharu and Pahupua.
 The coming of the great army of Tairapu
 Has swept Papara away
 And drawn its mountains with it (the King)
 Thou hast sinned Purahi
 Thou and Taiarapu
 Hast broken the Reva *ura* of the King
 And hast caused the
 Destruction of us all."

This is Moetia's and Marau's translation, I do not know whose copy it is — Moetia's or Marau's. I got it from the latter. This song of reproof, cherished by the Teva, as a protest against fate, explains how the dissensions among the different branches of the eight clans allowed them to become a prey to the rising power of the Purionu clans, headed by Pomaré, the son of one of those Ahurai princes whose blood ran into the sand near where the great *marae* of Oberea was built, as I have told you a little further back. The vicissitudes of wars, the changes brought about by the influence of the foreigner, all of which worked in favour of the Pomaré, culminated in a final struggle in December, 1815. The partisans of the old order, both social and religious, were headed by Opufara, the brother of Tati, the Chief of Papara. On the other side were the partisans of Pomaré, the Christians, the white men and their guns. To accentuate still more the character of the contest, the final battle began on a Sunday, the attack being made by the pagans during the service which Pomare attended. As in mediæval times, in our own history, the Christians did not begin the fight until the conclusion of the prayers in which they were engaged. On the other side the inspired prophets who guided the pagans urged them to predicted victory. The cannon of the Christians checked the fierce onslaught of the men of Opufara; though for a short

time their courage had seemed to prevail, and Opufara fell first, at the head of his men. He urged them bravely to continue the fight, and at least to avenge his death, and the struggle continued long enough for him to see their brave resistance to the superior advantages of the guns in their enemies' hands. But the end came, as we can well imagine, and Opufara drew his last breath as he saw the utter rout of his clan and their supporters.

For the first time in Polynesian warfare Pomaré stopped the massacre about to begin, and promised peace and pardon to all who should submit.

His friends, as well as his enemies, realized, in their astonishment, the enormous difference brought in by the new faith. This clemency did as much as actual power to win over those defeated. Most all men submitted to the new great chief, to the new religion; the *maraes* were destroyed, the image of the god Oro, a palladium long fought over, the cause of cruel wars, was burned; the people turned to Christianity, and the old order was completely broken up, carrying with it the power of the chiefs on which, unfortunately, the social system was based; because this power was more intimately connected with religious awe and belief than with military supremacy.

Had I more time, I should have liked to describe more fully the details of what I have only indicated. The whole

story of the years between the decadence of Oberea's control
and Pomare's triumph is full of meaning to the Teva. With
our clan, Opufara is still a representative of its courage and its
pride. With no little feeling does Queen Marau urge me,
when I return to Paris, to seek out the *omare* or club of the
great Chief Opufara, preserved perhaps yet in the Musée
des Souverains. In the Museum at Sydney in Australia,
among the fragments and samples of cloth and dresses
collected by Captain Cook, I shall perhaps find some bits
of the garments of Oberea.

Saturday, June 6th at Sea.

Wednesday was to be our last day. We had decided to
join the steamer chartered by us for Fiji not on its arrival
but later at Hitiaa on the opposite southeastern coast of the
island, partly to see the other side of the island, partly to
say good-bye to Tati who would load our steamer with
oranges.

We were to leave at noon for our drive around the island and
there were to be prayers that day in all the churches against
the illness now afflicting the island. The King was ill; our
chiefess wished her family to be present at church. Before
the breakfast to which we were asked, she bade us good-
bye as she proposed to return to church: they have a way

there of spending the day off and on — the natives — as we remembered at Tautira.

She drank our healths and made us a little speech, having kissed Tauraatua, and holding our hands in her soft palms, she wished us again good-bye. She was very dignified and simple. Nothing could have been simpler or more touching. As I remember, she wished us the usual safe journey home and health and "hoped that we might return, where, if we did not find her, we should at least find her children." After that we had a long and cheerful breakfast with the remaining family, and then we drove away around the coast to Hitiaa which we reached in the early evening.

The drive, though a rough one, was beautiful; of course we could not see inland the high mountains and deep valleys, except when on one occasion we crossed a wide river and valley and could look back. But we skirted the sea everywhere, and our road ran between the cliffs, every few rods making new and exquisite pictures of sea and trees and rocks, and of waters running to the sea. I do not know if this side of the island be finer, all is so lovely in detail, but it is bolder and more rocky. I thought, as we drove along and had passed Point Venus, how well chosen had been Bougainville's name of Nouvelle Cythere, for we were on his side of the island. The feminine beauty of the landscape and its "infinite variety"

completed the ideal of a place where woman was most kind.

The charm of the day closed in our arrival at Hitiaa where we were to pass the night — in a little village of pretty huts set in cleanly order, in a grove of high bread-fruit trees. All was green even to the road, except a few spaces in front of houses, neatly pebbled. In the shade were the figures of Tati and of our hosts, coming to meet us — all in light colours, white, blue, red, and yellow, making a picture that might have done for a Watteau. We dined out on the green right by the shore, where the surf broke a few feet from us. The air was sweet with odours, and cool. It was pleasant to be with Tati again and hear his laugh, something like Richardson's, whom he resembles in size as well as in many little matters. But I know that I said this before

We slept in a cleanly native hut, of the usual style, a long thatched building, lifted on a stone base with a floor, and sides made of rods like a cage, but with European doors. At either semi-circular end, muslin was hung along the walls so as to exclude the light and to protect a little from draught. Each end had a curtain drawn across it, so that one's bed was enclosed, but our host and hostess watched us to the last with unabated kindness. Everything was scrupulously clean. The next morning was like the evening. Blue clouds blown

over a pink sky, all far above us, for all the trees rose high and we moved about from shade to shade. Tati had driven away before daylight to put oranges on board. The village was very silent, as if deserted. We spent the morning in idleness; walked to the great Tamanu trees at the end of the village of which Tati had told us when he tried to find words for the impression of solemnity which European Cathedrals had made upon him. The trees are like great oaks, but rise with a great sweep before branching. Right by the road is a cluster of them with great roots, all grown together in a lifted mass. We sat idly by the sea and looked at Taiarapu all in blue, and at the sea between us and our little Tautira also all blue, which we shall never see again. Men, on the inside reef alongside, were fishing, standing patiently in the water.

Over us, stretching far and touching the water at places, spread the great Tamanu trees. We sat there in their shade. The water came up to my feet and washed out my drawings in the sand, as memories of things are effaced.

It was pleasant to be absolutely idle, listening to the soft noise of the tide rolling minute pebbles on the sand, looking at its edges fringed with bubbles, that folded one over the other like drapery, and watching the wet fade smoothly off the shore.

The trade wind blew strong. The air was very cool. Mrs.

Tati gave us breakfast with a smile of welcome and *iorana*, and little Tita flirted with us.

Then I slept; and waking determined to have some record of this our last day, and sat again on the shore, and made a note of Taiarapu across the water on which the rainbow played. Near me the surf ran in rapidly on the shallows, all in blue shade; the Tamanu's branches above me were reflected in the motion — and underneath the trees, boys paddled in and out, in their little boats without outriggers, using their hands for paddles, so that as they swung their arms they looked as if swimming hand over hand. It was still very cool, and I felt that I had probably exposed myself to what is the danger of this place at this time. It can be so cool after heat, and so damp with such draughts that I do not wonder at the constant colds and troubles of the lungs that I have noticed. I should call it a lovely climate — and an exquisite climate — but not one for a pulmonary patient. Now I am astonished that Piri's doctors sent her back here.

In the evening we had Tati again at dinner and talked with him about his perhaps coming over in '93, Exposition time, and about the correctness of his sister's translations of poetry. We tried in vain to get some love songs, though he promised to send some to me later, but he told us stories of Turi, famous for prowess in love — the Arabian love of the South Seas —

also of the tradition of an isle inhabited by women only, such as is told of on the farther shores of the Pacific, and such as Ariosto wrote of; and some anecdotes, not to their credit, of Pomaré the great or his father Teu, some of the scandalous scenes of which had been enacted not far from there, and had been commemorated in the names of the rivers. "But perhaps after all," Tati said, "they were no worse than other chiefs who lived before them, for as they all had unlimited power that power led them to many excesses."

The next morning we arose to find the little steamer some three miles off. Perhaps there were fewer rocky ledges upon our path nor did we see the olive gray mist of the *aito* trees (iron wood) against the blue sea, or the shining wet rocks. But otherwise it was like a continuation of the ride of the day before, a dragging through grassy, wet roads, and plunging into small streams, where coral rocks whitened the clear grey bottom. A very few people nodded to us as we passed. I suppose that most every one was engaged at the packing of the oranges further away; orange trees filled the roads, the peel of oranges in long, yellow spirals, dotted the grassy edges of the rivers hear the huts. Small black pigs scampered and tore away into the "brush" on either side, where in a hollow of the road undisturbed by our passing so close, old Eumaeus the swine-herd crouched alongside of his black hogs

who ate savagely what he had provided. And again we came to such a place as we had seen on our drive of Wednesday, something never noticed elsewhere by us, where some ledge of rock came up toward the sea, leaving only a narrow passage. There a little wicker fence had been built across the road resting against the rock on one side and the trees on the slope below; and there we opened a gate, as if all this lovely land had been but some domain, and had been set out in its beauty of arrangement by skilful hands, to please owners who lived perhaps inland, behind the vague spaces of forest trees, or up the hazy valleys. All that was wanting to the idyl was what we had seen before, red bunches of wild bananas brought down from the mountains and hung on bamboo poles or left supported by branches and roots, on the wayside, along with heaps of cocoanuts half hidden in grassy hollows, giving the idea that other owners and gatherers had but just placed them there while they went off for a moment; for a plunge into cool water perhaps, after the hard toil of the carrying.

Tati has explained to us how that really the owners were not far away, but that afraid at our coming or at that of others they were concealed. It was what is called their consciences, or rather what the French have subtly called "le respect humain," that drove these good people into concealment behind pandanus or orange trees. That day that we drove

away, leaving our dear chiefess go to church, was all through the country, apparently, a church holiday, and no one having gone to the mountains for such worldly things as banana food wished to be seen at work, when all were apparently moving to and from the churches, clad in brightest garments, and looking like the lilies of the field.

But this morning, like yesterday, was a day of work; and soon we saw along the shore and drove past it, a very long shed, with shining thatch, and with hanging curtains of matted palm, where were many people, men, women and children, who had been packing oranges and now were resting and eating. The place was as joyous and full as the previous land had been solitary; work had stopped, the last boxes of oranges were being taken to the ship in double canoes, that is to say, two canoes joined together by an upper planking or deck of canes. On one of these with our luggage, we also embarked — the ropes that were fastened to the trees on shore to steady the steamer, were loosened, the anchors lifted, and with a good-bye to Tati we were off. That afternoon we saw little of the island lost in cloud until we turned the corner of Point Venus, and looked up the gorges that led toward the Aorai. Then soon we were in Papeete and could go ashore and watch the packet from San Francisco just sailing in behind us, and try to say good-bye again. Again I felt the curious twinge of

parting, again Ori's wife Haapi kissed my hands. The late afternoon flooded the island and the clouds half covering it with a dusty haze of yellow light. The sea tossed fresh and blue as if lit by another sky. We passed the fantastic peaks and crags of Moorea, seen for the first time on its other side and wrapped above in the scud of the trade winds blowing in our favour. So in a gentle sadness the two islands faded into the dark; the end of the charm we have been under — too delicate ever to be repeated.

There I thought, five hundred years ago, I was young, happy and famous, along with Tauraatua.

> "Ils sont passés ces jours de fête
> Ils sont passés, ils, ne reviendront plus."

If only when I received my name and its associations I could have been given the memories of my long youth; the reminiscence of similar days spent in an exquisite climate, in the simplest evolution of society, in great nearness to Nature, that I might find comfort in those recollections against the weariness of that civilized life which is to surround my few remaining years.

<div style="text-align:center">

D. M.
Oberea
S
Posnit
Teraitua

</div>

TAHITI TO FIJI

Sunday, June 14th, at Sea.

Lat. 20–42 S. 839 miles from Rarotonga.

Long. 174–44 W., 431 miles to Fiji.

On Tuesday we were before Rarotonga: on *Tuesday* according to the ways of the place, where, as in Samoa, the missionaries made an error in time, and have never dared to rectify it. But to us outsiders it would have been nearly a Monday, though later, no doubt, the captain would throw off a day for us as we went west, perhaps even drop it here politely.

Rarotonga of the Cook Islands is a little island about twenty miles around, with outlines reminding one of Moorea; the look of a great crater whose sides had been broken out, leaving sharp crags and here and there curious peaks.

I had been suffering very much from my ancient enemy, sciatica, which declared itself almost as soon as we left Tahiti, and has kept me in pain up to this moment. But I managed to get ashore, and to take a long walk along the pretty road that goes around the island. We called on the Resident, Mr. Moss who took us to see the Queen or Chiefess Makea, for

whom we had a letter from Queen Marau. She was the usual
tall, smiling Polynesian chiefess, pleased at the addresses of
her letter, which made her out a *queen*, as she showed to the
Resident. For I gathered in the careless accidents of conver-
sation, she had been lately elected chiefess by a parliament
composed of representatives of the islands who are supposed
to have federated for a general government. But Makea is a
chiefess of great descent, being straight from Rarika, one of
the two chiefs who years ago met here, one of them coming
from Tahiti, the other from Samoa; one driven away, the other
in exploration; and who colonized the islands, and in the
persons of their descendants fought for supremacy down to
this date. So that it is something that this representative of
one descent should have been agreed upon. Many of these
traditions have been recorded by the Rev. W. W. Gill in his
"Myths and Songs from the South Pacific"; though his book
refers particularly to Mangaia which is a neighbouring island
about one hundred miles distant.

"Yes," said the Queen, "Moni Gill." She had seen his
book and proposed to make some corrections. Money Gill,
he was nicknamed because he was so fond of money. Let
me add that I also understood that the gentleman was gener-
ous enough and not mean.

The missionaries have had complete control all this time;

and yet things "laissent à désirer," as the French have it. There has been a system of "government," as Mr. Moss rather ironically sounded the name. There had been one hundred policemen in this little island of Rarotonga. Each policeman was a deacon, and the punishment of everything was a fine; the fines being pooled together and divided afterward.

Many deeds were fined and punished that were innocent or excusable, but all the fining had not in these thirty years increased the chastity of the women. Though the reports of the missions do not carry out this fact, the individual missionaries admit it, and what weakening of real authority has resulted one can only guess.

Some years ago the missionaries objected to smoking. To-day our missionary on board has a cigar or pipe in his mouth most of the time. In those years Makea was fined and excommunicated for smoking a cigarette. Being driven out she became reckless, and I am "credibly informed," drank and "even danced." And so her example stood in the way, and the missionary came back to her and begged her to return and be disexcommunicated, even if she should smoke; so that at least others should not have her precedent for dancing. But she refused. How it all ended I should have liked to remain to inquire, of her or the Resident, but the steamer waits

not, and I only get these queer little bits of information by chance hearing. But you know that I believe that one gets a good deal from such trifles. I find the British Resident cheerfully hopeful of getting these people under some shape of government other than the kind of thing they had which cannot last. He took us to the building which is a school-house and Parliament house, and we heard a little of what he was doing to get them to regulate matters in some shape that can serve as a basis. But you can imagine what little dif-ficulties come up when those of the neighbouring island, whose chiefess Namuru I saw at the Queen's, had sent word in their innocence that they had fined a Chinaman for complaining to her and writing what they called a lying letter. In their Polynesian simplicity (and they are shrewd enough) they had forgotten that in an interview they had admitted all and given the Resident every detail.

But there is no doubt that everywhere, the native church-men, put up to the use of arbitrary authority, will do many queer things — things that everybody knows of through all the South Seas, so that there is no need of detailing them. They suffer, too, from having but one book, the Bible, which (especially the Old Testament) they know by heart, and where they can easily find a precedent for anything they may choose. They might get ideas from other books, but then

they would have to learn English, etc. "What then will happen?" say the missionaries. "Do you see these good people reading Zola?" Their conduct is somewhat Zolaish at times, but then it is carried out in their own language. Hence much objection to teaching them English or anything that might lead to danger. It is the old trouble that missionaries have always found — more especially if they were obliged by principle to suppose that they might have some liberty of choice. The position is a hard one. I saw the expression of the missionary's wife when another hinted under his breath that perhaps the Catholic Sisters might be allowed to come and teach. Such an extremity, however, would blow things sky-high; and if it be necessary that there be education, perhaps the missionaries will consent rather than see the enemy bring it. The English protectorate has only lately been established, and naturally all these questions are fresh.

We took away with us the next day one of the missionaries, his wife and four children, who fill up quite a little corner of our little boat. The scene at their leaving was very pretty — as far as the apparent devotion of the native women who had charge of the children. They kissed their arms and legs, and so humbly the hands of the missionaries, with such an appealing look for answer. They are pretty young people, our clerical friends — the wife Irish, I should say — and are

interesting as types. The poor little lady has been ill all the time, but I can see that even then she has a will of her own. The care of the small baby has devolved on the husband missionary, who has some trouble. The children are wild, good natured and Polynesian and sing hymns with the Polynesian accent and cadence, occasionally bursting out in a cheerful laugh when they have apparently hit it successfully.

We have a French captain of artillery who is leaving Tahiti for Noumea (New Caledonia) and who tells me things of his expedition in the Chinese war and the taking of Formosa; also a Tahitian judge on furlough, who confirms what I have seen of the oral claims to land through genealogies committed to memory, the authenticity of which he has to leave to his native associates on the bench to decide.

This afternoon we pass two little islands, Onga-Onga and Onga Hapai, uninhabited; to which people come at certain seasons to make a little copra. They seem lost and without relation, for we do not understand the ocean bottom that would make all rational. Near them, and some five miles from us, a long line thicker in the middle, is the new island thrown up some five years ago or so, of which Mr. Baker, premier of Tonga, gave us an account. He had visited the place while the eruption of mud was still active, had come quite close to it, even nearer than was safe, for the wind

came near forcing him within range of the explosion. He has related it in a little pamphlet.

"This perhaps," says Adams "was the beginning of an atoll, a mud eruption, spreading out like this one under the sea, a surface upon which the coral started." We had seen in the morning of our second day out, a "low" island, Mauki — a low mass upon which any elevation counted — but it was a mere mass of grey-green upon violet and blue, in the twilight of that day, so that we did not make it out at all. The island besides has no outside lagoon like a true atoll, but a fresh-water lake inside; so that we have not yet seen an atoll.

The little volcanic islands, perhaps both belonging to one crater, are edges of its walls still standing, and a long ledge that runs to meet some projecting wall or dyke, may either belong to the side of the crater, or may it be a raised beach? Adams looks carefully through the glass, but there is too much haze. The little islands grow smaller and smaller as I write — little patches of sharp shape, of a fleshy violet on the clouded blue of sea and sky. It is late evening. The wind, which has been unfavourable, seems to veer a little. We have been *unfortunate:* the trades that should have blown steadily have almost deserted us, but we are fortunate to have a steamer. And all through we have felt cold, though not officially, that is to say, at midday the thermometer marks from 80 to 83.

Monday, June 15th.

Still fine weather, blue sea, blue sky; some little islands — the end of a chain of reefs and islands Onga Fiki appears in the horizon and promises us arrival for to-morrow.

The passengers are more cheerful, the children less feverish. The little missionary lady plays on the piano and sings a hymn, the Judge leaning over her.

The Captain "profite de son dernier jour pour perfectionner" his English, and bewails with me the unreasonableness of English or British pronunciation. "Why," says he, "does the steward say 'am,' for 'ham,' I suppose, for he can't mean anything else, and why does he say there is much 'hair' when the wind blows? French seems more logical." I comfort him as best I can, but he no doubt has a hard time before him.

More islands to the northwest, and later at night we shall make others, and to-morrow be at Suva of Fiji; unless we run on some reef, but the captain has been here before — some ten years ago, it is true.

FIJI

Suva, Wednesday, June 17th.

Yesterday we arrived as expected, and have been since that, reposing in the calm that can never so pleasantly come upon one as after an uncomfortable sea voyage. The steamer, unknown to the island, unawaited, must have appeared to bring some important news: perhaps something in the nature of a disturbance or trouble in some of the places connected with this one politically; perhaps in Rarotonga that we had left, where the new English order is but recent. But if such was the case we knew nothing of it, and waited quietly on board in the beautiful little harbour; looked at the lines of mountains on one side of the amphitheatre, edge upon edge of blue; upon the reef's haze of white light; and on the other side, upon the little town stretched out on low land, but prettily connected with the distance, and high land by little hills picturesquely balanced and arranged, with trees and houses and some native buildings; and then along the beach, the usual shops and trade buildings, more British than anything we had yet seen.

Each of the five spots we have disembarked at has had a

distinct character, more distinct now that we compare them, and nothing could be further, in its small way, from the other small way of Tahiti: ancient, provincial, French, sad and charming as the setting of some opera-comique that I have never seen, but should have liked to invent. Here everything was brisk and clear and promising, as if typical of the promise of something, while Papeete of Tahiti held the remains of some former system of government and business.

Little schooners with sails set were anchored in the harbour; a three-masted ship and H. B. M. S. *Cordelia* gave importance to the scene. Steam launches plied about. On the wharf, East Indian coolies, turbaned and draped, were grouped with their women in great white draperies or in bold colours, all yellow and all green, or in one case with a violet *sari* edged with light blue, and a gown of dark blue edged with the same; all these gracious folds thrown out in great masses when they moved, so that even far as we were one could see the movement of the limbs. There are now, I was told when I asked, some seven thousand of the East Indian people in these islands; for the Fijians are Polynesians and work little. So that as elsewhere, the growth of sugar or cotton, or in fact anything requiring continuous care and some exertion, cannot be carried on without the outsider — East Indians, Chinese, Japanese, or Melanesian from other islands.

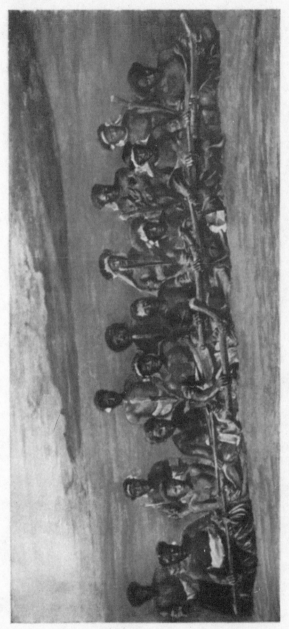

CHIEFS IN WAR DRESS AND PAINT. "DEVIL" COUNTRY. VITI LEVU, FIJI

The first Fijians came up to us almost at once in the boat of the pilot; dark chocolate figures with great shocks of hair standing out, yellowed with lime as in Samoa. They resembled our Samoan friends more than any we have seen yet, notwithstanding great differences. There was a certain likeness — something in the expression and in the make of the face; only so far as these few hours give me, the look is browner.

They seem more military, more masculine; all this impression intensified by our reminiscences of Tahiti just left behind us, where the healthy good humour of Samoa seemed to fade into sadness and into a refinement that appeared feminine. Fine strapping fellows in red *sulus* (*sulu* is the same as the *lava-lava* of Samoa or *pareu* of Tahiti — the loin drapery), and red-edged, white sleeveless shirts, pulled the Governor's gig that came out to fetch us. After landing and being driven up to the Governor's house, we found a sentinel draped with the *sulu*, and naked to the waist, with a straight sword and belt and his musket, pacing in front of the verandah. I believe it was owing to his great shock of yellow hair, like a grenadier's cap, that he looked completely dressed and most decidedly a soldierly figure. He or another is now walking up and down in front of me as I write, and at night, at the relief watch, I know by the deep voices that he is still there,

and that I can sleep safely, as safely as if he were not there —
and all the more that his gun is empty. The servants also
about the house, probably the same men, wait upon us with
this simple splendour; and hand out the dishes with out-
stretched arm, "from the shoulder," and keep up, for me, a
military look.

The Governor, Sir John Thurston, has kindly invited us to
take up quarters with him. Lady Thurston and the family
are away, so that we are but few people in the long, rambling
building. It is beautifully placed on a slight height, at the
edge of the town, and faces the bay and the long line of
mountains of the opposite side. There are large grounds with
grassy roads, and the beginnings of a large garden which the
Governor is setting out with great success. From it already
he has been able to supply plants of the finest Trinidad cocoa,
which I see growing in little tubs of bamboo, which when
again set out will simply rot away and leave the plant accli-
mated. However, I do not purpose to make out a list.
What might interest you is that the garden follows a line of
moats, once belonging to a fortified town which was here, so
that it has quite a look of meaning in its picturesqueness.
This is the first recognizable trace that we have yet seen of the
fortified place protected by ditches. We have seen walls built
up in places for forts, or arrangements of timbers and stones

of a momentary character, such as those in Samoa; but here the laying out of the lines seems to have been determined with some engineering intelligence, and the space covered implies ground convenient enough for residence. However, we shall see later, we hope, something more of such remains, and understand them better. Meanwhile we are at peace: no more war has been noticed than the cricket match and lawn tennis games that we saw yesterday afternoon. We have about us decidedly, protection, and something that I have not had for a little while, some young Britishers. There is something very soothing to me about them, when I like them at all. In fact, if this continues, we shall feel as if we had simply reëntered "civilization" and be completely spoiled. The conversation of Sir John is very interesting and instructive; for he is not an amateur in his line, though by the by, he photographs very prettily.

Suva, Sunday, June 21st.

On Thursday afternoon we accompanied Sir John on a little trip up the big river Rewa which lies to the east from here. This steam launch carried us over the shallow bar, inside the reef into the broad river which has a rapid current, owing to the tide that runs up far enough for the breakwater to reach some twenty-five miles. The river has also a considerable in-

cline, but the statement made us without guarantees, seemed excessive — fifty feet in those twenty-five miles. The land was low on either side, a great delta, and only occasionally could we see the mountains and hills in the distance. The banks were high, cut by the river, and knobby at spots where the harder clay remaining from the washings made little lumps or eminences. At first we met the mangrove swamps, then by and by banana and cocoanut, and visible here and there bread-fruit outlines against the sky. Then there was not water enough, though the launch draws but one foot, and even with that little had touched at the bar; so that we landed and walked a little way to Rewa the village or town that we were bound for. A pretty little clayey road, like a causeway, better than any in Samoa; plantations and houses from place to place; natives under the trees turned out for the great event of the Governor's visit; here and there in shady corners groups of young men, putting on the final touches of the decor-ations in which they were to appear later: red and black paint, great bunches of *tappa* about them and girdles of black *fao*, as in Samoa, and *titis* of white streamers and of many plants. Then we came to a sort of stockade, the compound of the chief, and stepped over his gate, as usual, some stakes planted in the ground, waist high, with a stepping one outside; not in our white ideas a dignified mode of entrance. Inside a pretty

arrangement of trees and buildings, with that usual charm that I have wearied you with, of looking as if arranged for effect, while most probably placed merely for most convenience; like that picturesqueness which accompanies our old farms and which seems opposed to most modern things with us. We turned around the main house, and sat down upon mats spread out in front of the river; passing first through two little groups of natives and led by the chief, to whom we were introduced in turn after the captain of the *Cordelia*. Then a chief or personage of importance addressed the messenger or herald of the Governor, who sat in front of us on the grass, profiled against the river, and with certain forms, presented to him some whale's teeth tied together, upon which, apparently, everything was to depend. They were accepted, both these gentlemen curled up on the ground and the officer sidled up in what I suppose is due form. Then after a very short speech of the briefest kind, we were led to the big house for *kava* and we entered on one side, walking up the long plank — and passed through doors of heavy timber, ornamented with sennit in patterns and found a big room covered with many mats, soft and bed-like to the foot. There we sat at the upper end, a little raised and on more mats. At the other end of the one long room were the notables. The chief sat on one side near us; as guests we had his place. Between the

two groups a long rope with ends of clustered shells was then laid at right angles to us. This was to mark the division, said my informant, and to enable any one who came late to find his due place. At one end of the rope the Governor's herald in jacket and *yappa sulu*, at the other, the young men making the *kava* (here called *yangona*), in an enormous bowl. Meanwhile certain persons chanted something, with much swaying and pointing of hands and various gestures, like a rather solemn *siva*. Among the singers was the next important chief, who led the chant. The singing was the usual Polynesian cadence, stopping abruptly; and after several chants, between which silence reigned, *kava* had become ready and was applauded and then poured out. For the first time since Mataafa's visit I saw the use of the Great Chief's Cup. The Governor's herald handed him his own cup, into which the *kava* bearer poured a part. Then upon the Governor's drinking and throwing down his bowl, a groan of approval came from the crowd before us. The same for the English Captain (Grenville); the same for Tauraatua and myself — who had the honour of drinking out of the "chiefy" bowl. For others the larger, common bowl was filled; an advantage or not, as one might like to have more or less of the stuff — which on the whole I think I like: that is to say, that one gets accustomed to it, and that it has a clean taste and seems to

brace one a little. But evidently the *kava* here and in Samoa is not the *kava* of Tahiti, described by Tati, so powerful that such a drink as our little bowl of yesterday held, would have stupefied us surely. That ceremony over, a short speech was made, very different from the long orations of the Samoan *tulafale*. It was answered by the herald and the meeting was over. Then we walked out of the chief's compound to the open space, where a dance was to be given. We sat under a canopy of mats, comfortably out of the sunlight that filled the open space edged on one side, between trees, by a long building quite high, with many doorways, all high up in the wall windows. This is a guest house, divided by posts into partitions that serve for each party of travellers. As they arrive they take up such a division for their use. Between it and the next is a narrower one occupied by a hearth, serving the parties on both sides with the economical fire that all other people than white people make. There, when they are settled the village sends them the necessary food.

Outside of this big building sat a crowd of many women, while only one woman sat near us, probably some relative of the chiefs who were near us. To the right, in a long half-circle, a mass of children, most of them nude to the waist, beneath and in front of a little bunch of trees. Then when all was quiet, in trooped the chorus, who sat down in front of

us in a confused circle, added to on the edges by occasional late comers. A few were nude and adorned with leaves. Many of them held in their hands bamboo sticks cut to different lengths and of differing sizes. These struck upon the ground gave a series of sounds according to their length and thickness — a most primitive music and a most impressive one. Had we heard this in surroundings untouched by the European, we should no doubt have felt more keenly the extreme archaic rudeness of the method. With this was mingled the chant of the others, the usual Polynesian chant. At length, to our left, having come up behind us, appeared a mass of men, armed with clubs, ten abreast and about fifteen in file; an orderly phalanx, keeping step to the music with that marvellous accuracy that everywhere indicates the Polynesian sensitiveness to time in sound. They scarcely advanced, merely moving in place, first upon one foot, then upon another, until some change in the music started them off briskly toward the other end of the arena. The big yellow masses of their hair stood out like grenadiers' caps, and around their heads. Dragging to the ground almost, were long veils or strips of white *tappa*, looking like bridal veils. White flowers were fastened in the hair; great armlets of leaves about the upper arms; collars of beads and hanging circles of breastplate, with great *titis* (Samoan name for the ornamental

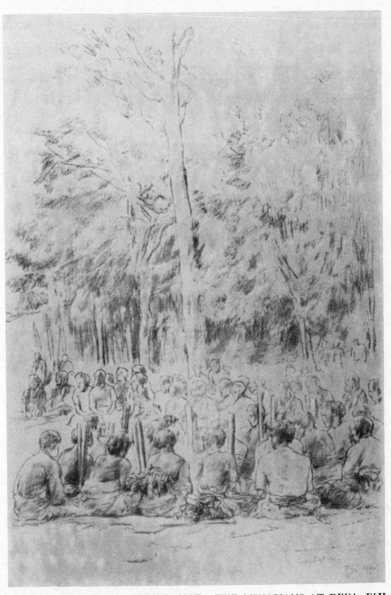

MEKKE—MEKKE. A STORY DANCE. THE MUSICIANS AT REVA, FIJI

girdle) of white and green, stuck out or swung about them. They wore usually dark black waist hangings like the black *fao* mats of Samoa; though here and there black *tappa* served for the drapery, and was gathered about their waists in enormous folds: in general a great "symphony of black and white," with strong accents here and there of faces, necks and hands painted with velvety black of soot. When they had marched to the other end of the open space they began their dances, keeping time with extreme care, but making motions of attack and defence all together. Then breaking their order, the centre took one line of attitudes and movements, and the flanks another, even to crouching low down and waiting while the centre advanced and came back. It was a splendid, warlike, barbarous spectacle, our first sight of a complete military dance; for the Samoan that we had seen was more the representation of a real advance of barbarian warriors. To this succeeded other dances of like kind, as our first dancers belonging to the place, were succeeded by others belonging to adjacent districts.

The leader of the first corps came up to us, threw down his club before the Governor, and sat down beside us panting and perspiring. He was a big handsome man, redolent with cocoanut oil, the son of one of the chiefs, and had once on a time been at school in Sydney, where he had learned other

weaknesses besides those that come from education. Next
to him in front of us, as usual, sat the Governor's "herald"
(native name Matafamea) representative of an office heredi-
tary in certain families; and took charge of the applause,
calling aloud "*Vinaka!*" which means *good;* to which the
Governor sometimes added, "*Vinaka sala*," *very good*. And
it was very good. Not only did we have club dances,
but also dances with spears, extremely long spears, made
to shake and tremble like the "long shadow casting spear"
of the Iliads; while sometimes the warriors stood all
motionless, crouched or poised, or leaning with the other
arm upon their clubs. Finally the last cohort came down
in a mass, the front rank waving great fans and bending
to the right and left, while the main body of the men bran-
dished their spears above them. To add to the confusion of
sight of the looker-on many had their faces painted not only in
black but in vivid red, so that one would feel that a certain
surprise and astonishment might well attend their appearance
and attack. Things of the kind taken by themselves seem
useless, but seen in real use, the motives that have brought
them about unfold, and one can see for instance how the
painting of the face makes a mask behind which the intentions
or purposes lie concealed and in ambush. When all this was
over the crowd melted away, and we walked back to the chief's

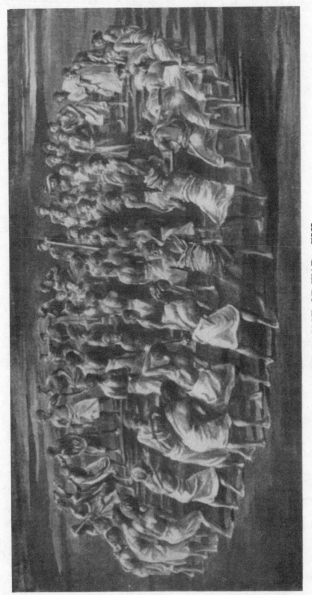

THE DANCE OF WAR. FIJI

house, stopping, some of us, for a moment at a less important one to see what it was like; slipping up and down on the polished wood of the drawbridge, and resting on the raised daïs at one end, filled with grass and covered with soft mats, where the owner slept. Behind us on the wall was a lithograph in colour, framed — the Madonna of Raphael's — the good man probably a Catholic. Otherwise less fine, the house was as the other. Some one of the party wasted some time in asking for a dance of the women, which we did not obtain, and so we were late on our arrival; and as we sat down on the mats outside, near the Governor and the captain, we found that the ceremony of presentation of food had gone on for some time, and that we were only in at the end. But we saw the herald divide it, somewhat as in Samoa. It would as we understood, go back to the village that gave it — the big hog not cooked enough, and the great basket of taro.

We lounged until evening in what we might call the garden, right upon the river. Here and there a few trees growing up against the leafy walls — for their sides were all covered with leaves that melt into the grass thatch above — or standing apart; below one of them was a large smooth slab of stone, brought from before an old heathen temple, to make a pleasant seat. It looked like Japan, just such a little place as would have been arranged with infinite art, with just so many

trees, and with such a stone to appear as if accidental and yet to contradict a little. The river before us was very broad; on the other side a perpendicular bank not high, perhaps like ours, some four or five feet at the most, covered with the appearance of an uninterrupted mass of trees, though perhaps at places there were open spots like ours. Canoes moved across bringing back visitors; as the night came on big fish rose out of the water with a splash. There was a long white sunset, and then we had dinner on the mats, and after talk and lounging there we walked outside a little and then turned in for sleep on the mats, under blankets and mosquito nets; for it was cool, or felt so, and yet the mosquito hummed.

In the morning I wandered out at dawn, and walked up and down the little space with the Governor, who told me humorous stories of wild adventures, mostly with reporters. The Governor's conversation is charming, full of information, and with a great enjoyment of fun. The few stories he had told us were like little comedies, and I regret that his position and duties, as they, increase, will probably prevent such a man from giving any record of his experiences and his views in the South Seas.

As the day came up our party turned out of doors; attempts at photography were made. Some chiefs came up to speak to the Governor; one he presented to me, a cheery old gentle-

JOLI BUTI — TEACHER. FIJI

man of grey beard, strikingly European at first sight, who laughed at the little joke that we were come to take him to America, like so-and-so who went and never came back.

Another steam launch drawing less water had come for us to take us to the Navuini plantation (sugar) only some six miles in a straight line from us, but further with the curving of the rivers. While we were breakfasting cheerfully on the mats it had run aground and would not be off until a change of tide in the afternoon. So that our boats were called, and stepping down a little copper-lined ship's ladder delicately grafted into the bank, we were in the boats and had a long hot row to the plantation. There we rested, going up to a high verandah in one of the residences from which there was a view of the delta of the river, and we could look toward the gradual passage of the land into hills and then into mountains.

I felt too tired to follow through the rows of the plantations interesting as they undoubtedly are, because I have some previous idea of the thing. I should have been more interested if I could have seen some of the native sugar plantations which we passed, the existence of which at all seems to me a remarkable thing: the first sign so far in the South Seas of any work not absolutely easy, undertaken by natives. One of them was near our point of departure, and was across the river from the owners or holders; for as was explained to me, it was a

family, not an individual, as you know, in the idea of society and property that exists here; in the same way that we have seen elsewhere in the South Seas. There is the family, in so far different from our communistic ideas; then the families that are sprung from a common traceable near root, over them, headed by the heads of families, the greater chief representing the ensemble of families of like origin or who have control; and so on to the highest. As connected with this, the Governor was illustrating the interdependence in some such way; putting ourselves back to an indefinite time, an arbitrary moment when things were unchanged; let us suppose that the head of a village is moved by complaints that some one of his own little association of families has misbehaved. There is no trouble in such a case; all authority is given, and proper punishment meted out directly, if such be necessary. But let us suppose that it is some fellow of a neighbouring village who has killed the straying pigs of our village, or who hangs too closely about some girl of ours — why our chief, however disposed to break his head, must wait to see that such a disposal of the outside offender would not displease the chief who had equal authority over both places. So that he takes a present, the famous whale's tooth, such as that we saw offered yesterday to the Governor, at the beginning of all conversation; and presenting it, he makes a story of the case, and

of what he himself would like to do about it. If the present is rejected, the matter is left as it was. But it may be that it is accepted, and the superior chief may approve and not interfere, or he may approve (*annuit*), and yet protect the offenders indirectly, so that they should not be hurt — nay, so that they might come off victorious and the attacker be humbled and diminished. Or he might say: "The case is grave; I understand what you want; let me think a little over it;" then he himself approach the still higher ruler and consult him. So that the responsibility was shifted away as far as convenient.

THE STORY OF THE FISH-HOOK WAR

But this fairly is politics, and we were talking of property, and perhaps it is better to give you an ancient anecdote that was told at breakfast with great vivacity by Sir John. It is the story of the famous "Fish-hook War." Let us suppose three brothers or relatives, each with a district, or village perhaps, under him — people well-to-do, with property and women. Let us label them — (for their names would only trouble us and entangle me) — A., B., C. Now somehow or other a story got out that A. had become possessed, in some way or other, of a wonderful fish-hook, something quite extraordinary in every way and "*hors ligne.*" Exactly how it

was I don't know, but B. felt that if it were so good he should like to have it himself, and most naturally, according to the communistic ideas of the South Seas, he went over to A. and asked him to give him his fish-hook. A. thought awhile, and then answered that he would be most happy (South Sea way), but that unfortunately he had only a little while ago (South Sea way), given it to D. or E. or F. as the case may be. Now B. knew that this was a lie, but I suppose he smiled politely, or in a sickly way, and went off wroth at heart. Some time after, whether taking a whale's tooth or not, I don't know, for I am not yet posted in the use of the implement, A. called on C. and said to him: "I don't like the way followed by our brother B. in his behaviour to us. He has been persecuting me about a fish-hook, that he might have left alone, and he seems to wish to grasp everything. I think that we ought to give him a thrashing."

C. agreed: they notified B. that on such a day, say Thursday next, they would proceed to attack him, kill his pigs, ravish his women, burn his houses, and generally make an end of him; and that he had better put up his war palings at once. Of course, South Sea way, he was to be informed of the hour and place of the duel. B. did so, but he was thrashed, his houses were burned, his pigs killed and eaten, his women ravished; and he himself had to take to the wild bush, where for a

couple of years he remained. Then the others thought that after all he was a brother, and had been punished enough, and they called him back and helped him to rebuild his houses and started him in life again. Again, South Sea way, all the property they had was in common and disaster to one was disaster to all. But B. after a little while went to A. and said to him: "Of course you might take offence at my having asked you for your fish-hook. It is not for me to decide now, and all that is over; but I don't see that C. should have behaved as he did. He had no complaint against me, and I think he behaved meanly. Now he is lording it all along. Why not do to him as you did to me?"

"All right," said A. So again A. and B. notified C. that his pigs should be attacked, his houses burned, his women ravished, etc., etc., and to get his palisade ready for an attack at an appointed time. Sure enough, down they came on him, and chased him out and drove him into the bush. But after a few months they repented and remembered his brotherhood, and recalling him rebuilt his houses and set him up again in business.

And things went smoothly for a time, but C. one day thought it over, and going to B. unbosomed himself thus: "It is all right that you should have walked into me, but what had I done to A.? Nothing whatever. He might have had a

grudge against you who troubled him about the possession of the fish-hook, but what could he have against one who had helped him always. He is grown over-proud and powerful. Why should we not bring him to a reasonable level, and perhaps after all get the fish-hook?" So they agreed and sent him the usual summons to prepare for devastation; but also let him know that if he would merely get out in time after putting up his war fence, and make no resistance, no further harm would be done him than to kill his pigs and burn down his houses; but that he must take absolutely nothing away; all must remain just as it was. So A. consented, and went into the bush, and the other two came down and made devastation. And in a few days they called A. back and said to him: "Well, now things are fairly square, we may allow you to come back; and we will help you to rebuild your houses. We can't give you back your pigs, they are eaten — but, oh, where is your fish-hook?"

Then A. became shamefaced and said to them: "It is too bad, but the fact is *there never was any fish-hook.* I was drunk one day, and in a boasting fit I invented the owning of a wonderful fish-hook. That is all there is to it." So that, made wiser by fate, they remembered their general brotherhood, and put up with the nonexistence of the unfortunate fish-hook.

This is a good story of Polynesian war, such as seemed to

keep all these good people going, gave them excitement, work to do, provided against unnecessary increase, and yet seems rather to have kept up their numbers, now diminishing apparently everywhere ın all islands. It may be that when, as in Tahiti, there may come up the possibility of lawsuits over land claims, the fierce activity of war shall be transferred to the pursuit of rights in courts, as the bloodthirstiness of the Norseman still persists in the "process ifs" Norman-French.

But here they have not yet come to that. No arbitrary professional and scientific ideas, such as aid the French, have yet taken hold. The poor Tahitian, elevated to the dignity of being the equal of a Frenchman, pays for it the penalty of having to record his titles to land by methods new to him. These titles, if not claimed within some European space of time, are to lapse, so that he rushes now into court, with a terrible array of verbal testimony, claiming all he possibly can, and sure to be contradicted or to find his land counterclaimed by some neighbour, jealous of letting any dormant right, however doubtful, pass away forever. Poor Pomaré V, the late king who abdicated in favour of the French, as Thakombau did here, in favour of the English, was claiming (as I may have told you) when we were there, in Tahiti, two months ago, all sorts of land presented officially to his first ancestors and ancestress, as great chief, or as what we now

call king; somewhat as Adams and I were placed in possession of our little district so many fathoms long. Against him the battle may not be difficult; as he has resigned his kingship, the titles go back to the first owners, who gave it to a ruler, not to a person. But meanwhile in the court records and notices of trials his name is scattered upon every page.

Here things have not yet come to that. Old ideas that are inherent in the Polynesian way of thinking are not roughly put aside; and I must say that I personally have a sense of coming to a place where my mind does not go through the rack of seeing misapplied laws and rules break up everything, for the risk of possibly doing some good, with the certainty of much harm. For, after all, what are titles of ownership? There is the excellent story of the New Zealand chief, who pressed with impatience to start his claim and make it short, answered promptly, "I eat the former owner" — a brief summary of many ownerships everywhere. Or of the others who proved their claim to land by showing that from far back they hunted rats there. (You will remember that in Samoa rat-hunting was a dignified and "chiefy" sport.)

The lali, the heathen war drum that at the Governor's house calls us to our meals, has a story about it in this line of thought: Years back Sir John ascended the highest peak in Fiji, some five thousand feet or more high. And having

toiled up and being enveloped in cloud and mist, instead of taking refuge in caves, as did his companions, he sat down upon a little hillock, over which was spread his waterproof, and waited for the sunlight that was to show the land below through the rifts in the clouds. Some time afterward one of the magistrates had come to ask about the ownership of one side of the mountain, and was assured by the men of — such and such a place, that it was theirs, a claim contradicted by those on the other side. But the first party insisted, saying, "Years ago our people buried their war drum on top of the mountain. There it is yet." And true enough, though the spokesman had not been there since childhood, the little mound or hillock was caused by the burial of the drum. So that this piece of evidence was duly recorded by being sent to the Governor; and the evidence is daily produced for us with the beating of it to call to meals.

I have wandered far away from our course upon the river Rewa. There is nothing more to it; we had a pleasant time. There were several officers of the *Cordelia* along with us. They had been in Samoa and knew our good friends of Apia; Seumanu and Faatulia and the girls, and old Tofae, and they agreed with us in liking them. They were in for photography also, at least the captain; and generally I enjoyed the pleasure that I have often had in meeting Britishers. The captain was

full of things he had seen and been amused by. The ship had
just returned from Tonga, where it had taken Sir John, and
I was told about details connected with church life there: the
most important feature in many islands, that makes, for in-
stance, Raiatea and Huahaine and Bora-Bora, our neighbour
islands of Tahiti, curious survivals of an arbitrary code of
behaviour.

There are too many to repeat; and all that I have is dis-
jointed, but you know the fancy I have for believing that a few
anecdotes help to give an explanation — and you would tire
less of them than of my own disquisitions. Whether it be so
now or not I don't know, but formerly the great church in
Tonga at Nukalofa (I suppose) was so ordered as to promote
the cause of European dress and also of European trade. The
different doors gave access to people according to their cos-
tumes. Consequently distinct places were given to those who
owned hats and who wore them over shirts and trousers. By
another door, to other seats, entered the hatless owners of
shirts and trousers. And *lastly*, the lowest place of all and
separate entrance was for those who even with shirts wore
only the *lava-lava*. In contravention of all this, the Governor,
our Sir John, and the English officers accompanying him on
some hot Sunday, turned up coatless, with only shirts and trou-
sers, and I hope restored the native mind to a healthier turn.

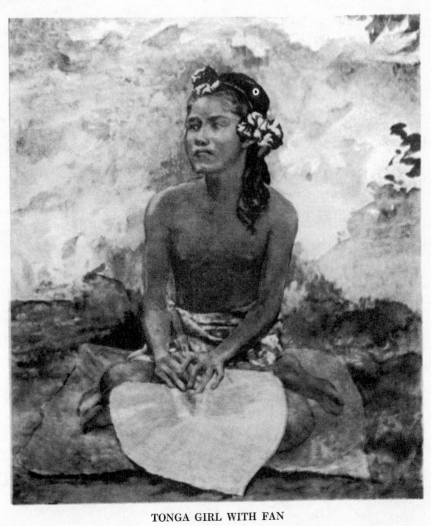

TONGA GIRL WITH FAN

Some way back the natives contributed largely to donations for the missionary society, and I have heard that as much as $30,000 has been sent repeatedly away from this little island and its small population. The Polynesian, in this, like every one else at bottom is on the surface also a vain creature, incited to display and show off; which perhaps explains a great many of his apparent atrocities, perhaps even a good deal of his cannibalism. So that these people have been spurred into giving at church as a special mode of distinction. Again I am reminded by my conscience that I have heard of such things amongst us. But I must go on with them: giving, as a mode of generosity, has been prevalent among them, fostered by everything that we can think of — and especially by the fact that a chief, as head of a *community*, is nothing but a *conduit* for property. Some may stick if the conduit is very rough, but to give and give much and all has seemed to me from my first days a Polynesian brand. Was I not telling you last month, or some way back in those lovely days of laziness in Tahiti, how Tavi, the over-generous, gave his wife to Terriere of Papara, through whom we trace our Polynesian descent. Well, with giving in such ways goes *show;* a silent giver gets no credit and no power thereby; and most do not like the strict Gospel teaching, so what is a man to do who planks out his *dollars* in church? Any man with twenty-five

cents in copper gets more out of it than he does — crash go the copper coins into the plate, while the one silver piece slips in edgeways. To remedy such a state of things, the proper person brings his money in the largest bulk, and if perchance during the week had not had the occasion to get change, he finds in the sacred building itself a corner where his large piece can be exchanged for small; so that in all the pride of justi-fication, he can roll the coppers into the plate, and even per-haps brim it over, and send the pennies whirling along the floor.

With many such comparisons of observations we beguiled the time. The steam launch met us on our return, and we sailed again over the bar, just in time for the tide, for we were bumped in the crossing, though the launch only draws a foot. And now we are resting again, enjoying the delightful cool-ness; for though the thermometer does not quite bear me out at times, it has been cool all the time, except of course when one is in the sun. But the thermometer has gone down to 66 at night, and keeps up pretty steadily to a range between 70 and 76; and though I have suffered from sciatica on board ship, I am getting over it.

In this civilized life we are looking forward to a trip, at the end of this week, into the mountains, accompanying the Governor, who is going to "prospect" for the site of a sani-

tarium high up. Strange to say, no one seems to think of it in the other places we have seen. How easy it would be in Tahiti, for instance, to go for a change up to some of the great heights; and such openings into inland places makes things generally quieter and more orderly.

The thing is vague in my mind, only I fear that we shall be several weeks in carrying it out, and certainly it will be a rough undertaking. Then too, how shall we manage to be just in time for the steamer to Sydney, and then how will the arrival of that steamer dovetail with the departure of the steamer that is to take us to Singapore?

But to quote from a letter of King George of Tonga to Sir John, worth citing because it is a type of the semi-religious phraseology we have seen all through the Pacific, bestowed upon us or upon others:

"When the first man fell from the former state of good he received from God, there came upon our hearts pain and doubtings and strife and divisions among ourselves, in regard to unforseen things that may happen in the future.
But it is with God alone to restore happiness."

George Tubou's words convey everything necessary, and I shall report to you when things have been shaped. Meanwhile "Salaam," as the little Indian boys said to me at the sugar plantation — "Salaam, Sahib," the first sounds that in-

dicate that we are about turning toward home, and that India is the next stage.

AN EXPEDITION INTO THE MOUNTAINS OF VITI LEVU

Vunidawa, Viti Levu.

Sunday, June 27, 1891.

We reached Viria on our first evening out, having made the journey in boats as far as the sugar mill of Namosi, drawn along smoothly, as if on skates, by a little steam launch, upon which was also part of our contingent; for even at the beginning we were many: the Governor and his secretary, Mr. Spence, and Mr. Berry, for surveying and the A. N. C. (armed native constabulary), and the Governor's servants, and Awoki, and the Governor's herald the Mata Ni Fenua (eyes of the land), and certain others, and soon Mr. Carew the magistrate on the Rewa, and so on.

It was the same river scenery, mangrove swamps washed by the river, and by the tide which influences the stream for some forty miles or more — steep banks cut by the water to an edge, and covered with grass, sugar-cane, banana — occasional but rarer — cocoanuts and so on.

Later on as we came nearer to the end of the day's trip, as the banks grew higher and more hillocky, they became more and more cut up by ravinings and small cuttings which were

sometimes wet, with rivulets or bayous, sometimes dry, and often so close and narrow as to make but little clefts in the stone and earth. Across them, over them; rounding their edges or filling them, grew the trees, sometimes small, sometimes of great height. All this repeated everywhere made a continuous set of little pictures of broken lights and forms — through all the course of the river.

In a small way nothing could be more picturesque. At places where the bank had sloped and made some little flats, men and women were collected, bathing or washing clothes: many of them East Indians, women clothed in the flowing garments, of bright or "entire" colours looking in their favourite yellow, like great birds; occasionally running along the shore beach, their drapery swelling behind them, impeding and showing the motion of the limbs, and recalling the correctness of the drawings and paintings of Delacroix, who alone, so far, had made the Oriental that he saw, look like anything else than a geographical or artistic curiosity. When I think that a few weeks sufficed to store his mind with all that he had done or implied in this way, I return to my admiration for his work, which sometimes for a man of the eighties of this century looks too much like the doings of a man of the thirties.

Once along a high bank near some station (government station), a row of constabulary stood up and then sat down in

a row, respectfully on a platform of the bank, to do honour to the *Kovana* — the Governor.

Late in the afternoon we turned at one of the confluents and reached our destination for the night. A high sandy beach all broken over with footsteps, looking like a Nile embankment — many natives sitting about on it — then disembarkment and a little walk through some sugar-cane and banana, on a little raised road, and we came to a native town or village, inside of a deep ditch of circumvallation, filled with trees, and inside of a big waste space, the house we were to occupy, alongside of a few others. The same method of entrance — the trunk of a tree made into a plank with the natural curve, with notches and holes occasionally in the wood, as the tree has grown. This wooden path led quite high up, and some eight feet or so to the base running around the house — the *yavu* or permanent base, which is allowed to remain when the house is dismantled by time or by man.

The house, the usual one with the walls covered with leaves. In one place a *ti* branch in full bloom of yellow-red, projecting from its side as if it grew there (a decoration for our coming). The doorposts of trunk of tree-fern, all dark grey and corrugated, looking like stone; and above the doors a false lintel, engaged in the wall and smaller than the door, looking like a round bulging stone (as if so cut by a pre-Romanseque archi-

tect); the cutting of the chisel admirably indicated, but in reality nothing but a bunch of grey dried leaves, so brushed together that they suggested the grain of stone under the chisel.

In front of the door, or rather at its edges, engaged in the platform, shells disposed in a pattern, and the same disposed in a half circle in front of the stairway plank deeply sunk in the earth, so that only their ridges were visible. All this exquisite good taste in spite of the repeated assertion, which may be true, that these good people are not at all sensitive to æsthetic feelings.

The interior as usual: yellow cane in patterns on the walls, and dark columns of tree-fern, and rafters covered with sennit. Soft mats on the floor were made softer with leaves thickly strewn under them.

Here there was a presentation of whale's teeth, of *kava* and of food; and here the Governor listened to reports of the place, and talked to the *mbulis* (prounounced bulis) (local chiefs of a certain degree), and later listened to some petitioner of a neighbouring place, who in the twilight had come to him while standing out in the open; and had squatted down and mumbled and whispered, and offered some written petition. Then we ate and slept and in the morning, walked along the outside upper base, and looked upon the hazy scene — then

bathed in the river while the mist still floated above the tallest trees.

When the sun was well up our party divided, three of us going by canoe, and the Governor and officials and retinue walking or riding on.

Here then we parted, A. & T. taking the canoe, while the Governor and the magistrates went on foot and horse by land, to Vunidawa. There was a little thatched awning upon the canoe's deck, large enough for three to manage to stretch under. Six men, three at each end, poled or paddled in the canoe as the water was deep or shallow; while one man, in this case I think a sergeant of the "armed native constabulary" (A. N. C.), stood on the outrigger, or sat about and took charge.

The low roof prevented one's seeing much of the shores, for to sit up was to have one's view absolutely excluded. But all the more important became the little details of vision, the beauties of line and colour that one sees everywhere in the movement or the rest of water, its breaks upon shore or upon rocks, the reflections that it carries with it, and the near banks or little distant escapes of vision, all framed within the cane posts of the sun shelter. It was all much the same as the day before, but the shores became bolder, the breaks greater. Rapids rushed around us, and our men poled hard against the

force of the water. We passed or were left behind by the other boats carrying the enormous luggage and accumulation of provisions for such a party. The profiles of the men in the other boats stood up in contradictory curves and lines against the shadows and lights of the distance, or the darkness and glistening of the water. They shouted and called and got all the fun and excitement out of the hard work that could be had. As the slopes increased and the river-bed showed more gravel and boulders in large patches, the talk and chatter of the men reminded me of former days in Japan, up in the high lands and by the rivers that run there on great gravel beds.

At every step this impression of reminiscence increases and must increase, as it occurred to me on the very first morning of arrival, upon seeing the many small hills and mounds fringed with trees, behind which came down great slopes of distance; even an occasional waterfall was there to remind me. The heat was great, the silence also, even though the men shouted; for occasionally we heard nothing but the movement of the poles and the ripple of the water. A hawk would flutter off from some tree. Dragon-flies lighted on the deck or upon one's outstretched legs. A spider, folding up like a pair of scissors, so as to look all long instead of circular, began to build its web, for there were flies; and all little things became

of interest by the time we had reached our first halt. We were helped up some very high banks of red clay, partly covered with green bushes and trees, and found ourselves at the entrance of a pretty little place, with plants and trees neatly set out, for colour spots. We lunched most comfortably in a native house.

With this break we began again our river course, the rapids increasing, and the difference between the shoal water and the pools becoming more evident. Occasionally a large spot of river greened or darkened into what was depth. In such we longed to bathe, when the moment of halting would arrive, or before departure, but in none such of these did we swim. Indeed, little by little, one felt the influence of the assurance that sharks visited these deep holes, and that to some fifty miles or more up these rivers there was a possible danger. The shape of the river banks, the marks on the shore, the thickness of the dry parts of the river, the size of its boulders and pebbles, the manner in which the tongues of conglomerate that ran along with the river-bank were cut down, the sudden cuttings and hollows and ravines of the bank, all showed what a mass of water, in wet seasons and years, must pour down these rivers. Then when the tides are high and the waters give access, great sharks come up and bide their time in the deep pools. No year passes but that some natives are at-

tacked. Here then the smaller ones remain when the river runs lower, and change their colour and become fresh-water sharks, and sometimes when small are harmless; but the impression of danger is there. I am told that they are seen far up, and that even as far as we shall get on Monday night, they are occasional.

We landed in the afternoon at Vunidawa, some thirteen miles by land from our morning's stay; again coming up high red clay banks, of a beautiful slope most charmingly set out and arranged, upon which stands the "station." I was told that the arrangement of cuts and breaks and ditches was all modern or recent, but that at one place there were the remains of the old cut or moat on the upper hillside. But the place had a fortified look — one looked down from high banks (below and around which ran paths) upon a hollow centre in which stood native houses and great trees. In the distance, mountains across the river; toward the west, one great streaked mass, with an outline vaguely like the Aorai of Tahiti, the smaller ridges in front of it showing high precipices that looked violet in the dawn, with occasional shiny white spots; all else with a faint haze of green, except where far off, further to the west, a pointed peak looked blue. Along the bight of the curved river a line of cocoanuts stood near the high banks. Further on one could discern to-morrow's road, that dis-

appeared behind a turn of the river, and up the edges of the intermediate hills in the distance yellow patches and markings modelled the slopes of the first uplands.

Sunday.

All next day we rested. The sitting-room of the pretty native house was decorated with native *tappa* (*masi*) of many patterns. Books and magazines were upon the tables and shelves of cane. The Governor and the resident magistrate, Mr. Joski, whose house this was, received reports from the *mbulis* (chiefs) of the neighbourhood, while sitting out in the evening on the green slope of the garden.

We left again Monday morning for the first beginnings of mountain country and more inland manners. Our party again divided. Atamo and myself and the momentarily ill Awoki took to the water and again went up stream. The weather was exquisite, the draught of the river just cooled the heat. Constant animation and struggle on the part of the boatmen for the rapids became more and more frequent. Half the time, with the strength of the current and the shallowness of the water, four of the six men plunged in and pulled and tugged at the boat, pulling it through the boiling water, lifting their legs high, one after another for stepping over the boulders, every muscle strained with effort, the poles bending

against the rocky bottom. Occasionally the man who stood at bow or stern, upon the little vantage nook of the thickness of the canoe, would be slung off by a swerving of the current, and his own stretching far away to the side, and would retain some place from which he could join us. The other boats passed us or were left behind. We saw them far off on the slopes of the torrents, lifting shining poles against the shadow of the banks. Sometimes the water swept over and our own little planking was wet with it. As the rapids increased so did the spread of the stones and boulders of the remainder of the river. We rested once for midday meal. Then in the afternoon we landed and walked a little way along a causeway road to a little village on a bluff, where the wide river turned. Then passing through many houses and turning around a deep moat, filled with bananas and other greenery, we came upon the edge of the little hill. Here stood a house of a different type, more like the type of the mountains; a very high, dark, thatched roof, more than twice the height of the wall together with the stone base, or mound embedded with stones, called *yavu*, out of it grew bunches of the red *ti*. This mound embedded with stones is kept and has its name; the house on top will be built and rebuilt.

At one corner a great palm tree rose above the high roof. From the little plateau, planted with occasional trees and

rising steep from the river, a sloping and curved path led down between water and village, separated from the latter by the deep moat filled with trees, and coming at length to sharp earthern steps (if one can so call anything as rude) that took us to the river end, to our bath in shallow water, the edge of the deep pool under the cliff. Far back behind us spread the river-bed with the stream between, and in the distance behind the hills a line or shoulder of mountain streaked perpendicularly with great shiny patches of rock. In this house we spent the night. It was inside, like all those we have yet seen, charmingly finished with patterns of fastening on the reeds of the walls, and sennit decorations on beams and lintels and posts. A rude representation of a cow or bull had been worked into the roof.

The next day we began our walk, leaving the canoes for good; and after a few hours over clay ground and some rocky streams, we came to a wide space of the river; across which we were carried in rough litters made of bamboo tied together, then, walking up a clay bank between trees, came upon the little village around which the river curves. This was Navuna.

Here the view was confined to our huts and those of our neighbours. Behind us a plantation of bananas; visible partly around the corner of a neighbouring house, a great tree shading the centre of the *rara*, the village place, where in the morn-

ing the Governor and the two magistrates interviewed the representatives of this place and of others. I could make out fairly well that a certain court of reproof was going on; for all through these places was something which explained itself a little further along.

Nasogo, July 3rd.

The midday saw us off from Navuna, and through similar scenery to a little village on the edge of a river running far below it. The village is Navu (n) (di Waiwaivule) in the district of Boboutho.

Now we began to be helped by being carried in the litters provided us by Mr. Joski; for crossing and recrossing streams, it was perhaps as easy a way as being carried pick-a-back. But where it was both a triumph and an excitement was when we were lifted up the steep sides of the gorges; then the looking back or forward, and seeing below one's feet the toiling carriers of the other litters, swaying to and fro with their burden; and behind them again the long file of what was getting to be an enormous retinue. For a background the distant mountains, or the bottom of the gorge, black shingle and rushing water, or shallow pools reflecting the green above. But prettier than all was some passage along the stream; the men in the water; the mass of the party sometimes in the water

near us, or disappearing around picturesque frames of corner rocks, over shingles and boulders; and reflected all about us the entire picture — the distant mountains and rocks in sun and mist, the near rocks covered with green, or with purple and grey of conglomerate; and the song of the rapids ahead in a black and white streak counting against the trembling green.

But when we walked then much did we regret our litters. To the native our good path was for the most part on the dry river-bed, and lengthily and wearily we picked a precarious footing over innumerable pebbles and stones and boulders; sometimes thinking that the walk was easier on the big ones, because one went from one to another; sometimes on the smaller and more rolling ones, because one got several under one's slipping foot. But my neighbours always helped me: sometimes Lingani, one of the Governor's men, or one of the "Army," as we called them (the armed constabulary), or some *mbuli* who accompanied the escort, or some newly accidental neighbour; so that all went well enough, and we reached our night's destination without the sprained ankle that had discomfited Mr. Spence early in the trip.

All is a little hazy to me up to where we are now. I remember the look down the ravine and up the other river. I remember that huts began to be more peaked or more like

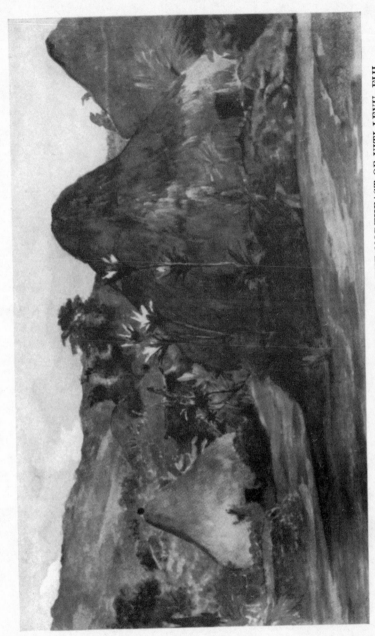

EDGE OF VILLAGE OF NASOGO IN MOUNTAIN OF THE NORTHEAST OF VITI LEVU, FIJI

beehives. I remember one which had been fitted up as a heathen temple or devil house, and from whose roof many strings hung down — as conductors, one may say of influences. There had been a basket attached to one of them, which the Governor cut down. I remember, of course, but one running into the other, presentations of whales' teeth and food, and *tappa*, and dances (*mekke mekke*), with or without the dancers being wrapped in the enormous folds of cloth, that afterward were unwound with more or less difficulty, to be piled up high as a man's height into great masses of presents. (And by the by, though all that is extinct to-day, some thirty or forty years ago a return to this old manner of making gifts of *tappa* came near to bringing on a civil war in Tahiti.) The Tahitian custom referred to came up again some while after Queen Pomaré (Aimata) was on the throne, her brother Pomaré III having died quite young, and leaving her, who had not been trained entirely by missionaries, exposed to the passing influences that come up with new conditions. At some time or other she capriciously desired that upon certain occasions she should be received in Tahiti (on her arrival, I think, from Eimeo — Moorea — but that is unimportant) in the old way. Among other customs would have been that of presenting her with *tappas* offered by a number of young women, who, having danced before her all

swathed in this native cloth, should then gradually be un-
wound, and having nothing upon them, continue the dance
to an end. This was part of the thing, and I only remember
this detail. It was then that Tati of Papara, the grand-
father of our old chiefess, came to the front, and in a most
remarkable manner, both by threatening armed opposition,
and by the use of an eloquence worthy of the greatest examples,
broke down the will of the Queen and the plotting of her then
advisers. It is thus greatly to Tati that peace and the final
quiet prevailing of Christianity was due.

As to Aimata, or Queen Pomaré, that she remained more or
less of a pagan at least for a long time, the fact or report that
she destroyed two of her children (probably base born) is in
the direction of a testimony. Of course the meaning of the
word Christian is variable according to time and place and
especially according to date, so that the geographical and
historical limit of the meaning should never be insisted upon
in too set a manner.

The next day's tramp brought us here, but apart from
certain geological facts in which Adams was enormously inter-
ested — for example, the superposition of the conglomerate
upon everything else, and the finding of shells in the softish
rock at this height — all was pretty much the same.

Our present place is very charming, reminding me of the

last. It is at a corner again, with the river turning round one side of it, and the stream up which we came on the other. Between them a bluff covered with trees, the space of the bed of the river mostly filled with boulders and gravel and rocks, though we roll the rapids, or slide the quiet waters; a great rock just facing the village, as an advance buttress of the mountain behind it, which melts tier upon tier into an entanglement of foliage; and the town or village itself, built on a succession of terraces, all worked over and planted, and edged with walls that seem part of the natural structure; here and there, even right in the village, a boulder black or grey, almost of the colour of the thatch of neighbouring houses, and protected, shaded, encompassed with trees or high decorative plants as they usually are. As always everywhere apparently, the projection of any tongue of land makes itself into a knife edge; so that the idea of a ditch or moat would be suggested to the savage engineer by the very make of the land. Therefore from each side the slopes go down, and below you see tops of trees, banana, palm or what not, and tops of huts staged down.*

Then where the land rises again on the slopes, big boulders stand up, reminding you again of the thatched roofs; and far away on heights are places where villages stood, and where

*The ditches or slopes, natural or otherwise, can be filled with sharp stakes and other cruel devices scattered among the trees so as to make a serious defence to any sudden attack.

some years ago these very savages were attacked and driven off.

For all these parts of the country were once a stronghold of the more savage tribes; if not the more powerful, who sometimes came down and attacked the lower places. And all through here some of the gentlemen who were with us had gone, when the time had come to make an end of it, destroying the towns and reducing the wild people to forced peace. Occasionally I overheard these reminiscences, which do not date so many years ago — fifteen or sixteen, I think. The Governor had headed or accompanied expeditions, and one or more of our companions had been on such attacks, after having suffered the loss of a number of relatives and friends. But all that is over now; only, as in all mountain countries, there is a sort of regrowing of that bad seed, such as we saw in this recurrence of the old devil worship.

Here we saw of course again more ceremonies and presentations of food, the latter becoming a serious necessity with the great number of men accompanying us. The Governor is not only a representative of the Queen, he is as such the chief of chiefs, and most wisely his policy, whether or not it has been the policy of his predecessors, has insisted upon this point. Every ceremonial of observance, everything that would belong to the native ruler, is encouraged and

kept up. Not only such natural observances must exercise an indefinable prestige on the native mind, but they also must allow, in what is a personal government, the use of an apparatus of control exactly suited to the native mind: thus any subordinate chief can be reprimanded, talked to and put in his place in such a way, that he feels it from ancestral habit; he can be removed or set aside. A man serving out a sentence can be kept a prisoner behind the paling of a bamboo house that he could break through as easily as he can see through it.

With time, as the natives change, the laws and ordinances that they have made themselves,for most things, that have seemed good to them and which are not contrary to the absolute essentials of English law, have been left, and will change as they change, and may fit themselves to an unknown future.

This will explain the naturally sensible reason for which the Governor differed with some of the Catholic missionaries, or rather their bishop, about which things I have heard, if not complainingly, at least with suggestion of arbitrariness from one or two good old Samoan priests. For instance, it is a great chief's privilege and marks him that he should be "*tama'd*" to in passing — that is what marks him, and establishes his position in the hierarchy of rule.

But there is no reason why a bishop should claim it; even if in old days the confusion with regard to power of sacredness,

of respect, and worship had always existed here as it has been all through the world. So also the case of the missionaries objecting to the chief receiving the first fruits of the land, often symbolized nowadays by a mere few pieces of some growth, because long ago it bore a religious as well as civil meaning. I fear me that our old friends, the Jesuits of China, were the only very wise men that served as missionaries, so that they alone never went by their personal whims or measured matters by their own fast rule.

But this is far off from my natural path of mere record of what happens or what I see. For some things at least the sketches will help you. I may succeed in making some note of the cheerful clearness of colour and tone all about me, though of course I can only make a choice. If I give you the day, then the veiled charms of morning or of evening, the enveloping of distances in misty colour, must remain unattempted of record. Or if I try the haze of the beginning or end of day, then I shall not have anything for you of the lightness and gayety of the brighter hours. But the sketches will give you the shape of the houses. You will sympathize with the inconvenience of getting in or out, in the dark or wet weather, excellent as it must have been as a device for protection against too sudden intrusion of doubtful friends.

We wait one whole day: then we enter the mountains for

good, and pass over them to make our way to the coast which will be a matter of four days or so. It may be warmer higher up, as there may be more cloud; so far it has been cool at night, the thermometer going down as low as 56.

In Camp in the Bush.

Saturday night, July 4th.

We left Nasogo (pronounced Nasongo) early this morning in the mist; going down into the river-bed, among the boulders, and crossing the stream several times: the same river that rushed down around the little point or promontory of Nasombo — a streak of black or blue or green or white, among the black stones spread out between the rocky bluffs. Then we attacked the mountain and the forest — stumbling and slipping over rocks and moss, and matted tree roots. The path had been somewhat cleared for us here and there, but it was hard travelling through the wildwood; all damp above and below with the continuous moisture. In this desert of leaves and tree trunks, the passages of former torrents served for paths. Over us were quite high tall trees, but between their upper branches and the mossy wet earth spread a broken canopy of tall ferns, and lianas and the branches of smaller trees and plants. Here and there a great fern connected with the tree fern, but unlike it, spread or lifted long fronds like canes some

twenty feet in length. Upon every tree hung innumerable
mosses and parasites. Below, all over, a tangle of ferns;
beautiful as ferns are, though you know that I care little for
them; I am even so unworthy, that the prospects of rare
orchids does not stir my blood; I would give them all for roses,
violets or for apple trees or the cherry. I am essentially and
absolutely European in these things, and retreat behind my
rights as an artist to have preferences and keep to my instincts.
But for you who love such things, I can say that there were
many rare plants; a creeping lily, for instance, and innumerable
ferns.

The fatigue of the ascent became greater: we halted at
noon on a little open space above a high precipice, from which
we could look back at the whole course of the river sunk far
into the mountains and curving in the far distance around the
amphitheatre, stands on its little bluff the village of
Nasogo which we had left in the morning some four hours
before. Beyond it the river ran, a black thread in the dark
grey shingle, below the big bluff, and around the little prom-
ontory by which we had bathed for two days. Then we
had lunch and Sir John on this Fourth of July proposed the
health of the President — and drank to that of Mr. Harrison.
Then the "Armed Native Constabulary" gave a salute of
six guns which echoed far away down the valley and into the

grass country that we hope to reach to-morrow perhaps. No doubt there will be stories afloat that we have been attacked. We were then some 2,300 feet up — the thermometer indicated 62°.

Later, as I was very tired, I was carried in the rough palanquin of boughs down the steep hills — the path so narrow that much ingenuity and noise and discussion was expended by my carriers to pass through the trees: fortunately the conveyance was elastic and could be sloped any way. In fact at times I stood up or sloped back so as to have to catch on, but I fell asleep and the men carefully moved along the hanging branches and lianas so that they should not strike me. Almost everything that came down merely hung in an elastic way. Rarely did a big tree stretch over the path. The last thing that I saw before closing my eyes was the file of our party beneath me: Their heads just visible between my feet; the "Native Constabulary" in their uniform of bushy yellow hair, and blue shirts, and red *sulus* worn like sashes.

The little British flag had been stowed away to prevent it striking, and I missed its flutter or dazzle in the green. One of my big black attendants was hanging upon a small sapling dragging it down from the path and dropping far below afterward. The noise of the axes of the scouts sounded in advance and started the parrots cawing in response; the

sun broke upon us and so I fell asleep in the more grateful warmth.

We reached the place chosen for camping in the early afternoon after another couple of hours' march. Our halt was upon a little bluff right on the line of march — where trees had been cut down, and huts and sheds built for us, and where already many of our people were resting. Here had come the women sent in the morning by the other road, if one can call it so — the bed of the stream. They were to carry food for our people — for we had by this time some two hundred men along — many really of use, carrying boxes and trunks and provisions, all distributed, so that every little while I could notice in the long procession, the man with the frying pan — the man with the governor's chair and so forth. But there were also amateurs who carried a club, or a little packet of food done up in a leaf, or an odd umbrella for one of us — or like the last page in the "Chanson de Malbrouck," "Et l'autre ne portait rien." Some were so called prisoners — viz., men condemned to labour for a time — and I was much amused at the story of three of them who were encamped in a long shed alongside of the magistrate (Mr. Carew) who had brought them as servants. They were all three in it owing to the eternal cause — "la femme" — who in Fiji seems to be *"teterrima causa"* In fact, as there are not women enough to

go around, it was not astonishing to hear that one great influence of the recent heathen revival in this wild region of cannibals was the hope of the young men, that if there were rows and trouble, some stray women might fall to their share. This evening I wandered out along the sheds and saw a good many — not more agreeable to look at than those I had seen before and certainly far uglier than the average ugly men. One youngster, another "prisoner" was preparing to oil himself, surrounded by a little group of female admirers, reversing apparently the fact of their being few women for the men.

We warmed ourselves at the fires, for, though the temperature was about the same, all was wet and damp, the firewood all covered with green moss. Our little hut was a fairly good one, made of wild banana, and the interstices filled up, or rather covered up with the great leaves of the wild ginger.

July 5th.

The night was rainy and all was damp in the morning, when after prayers we started again into the wet woods. The cry of the parrots like a wild *flapping* of voices had been the first sound of early dawn. Then the camp had begun to move with chattering and laughter; people filed along all the morning.

When our time came, I had again the use of the loose palan-

quin in which I was taken for the first two miles down the deep side of the mountain. It was interesting to look up at the trees above, and to notice how much more of the vegetation grew in the air above than in the earth below.

Every tree was covered with plants, mosses, creepers; the vines and lianas that hung about were themselves covered with smaller growths. Perpendiculars of gigantic vines hung, though they looked as if they held themselves up, but the least pushing of our party would send great spaces of green trembling far off. The branches that were in my way were loose and swinging, and rarely did we meet so low down the branches of a solid tree. High up through the great loops and festoons and upright stretches of the creepers, or here and there the great leaves of the wild ginger, the light was delicately stencilled with the pattern of the leaves of the great ferns. But high as everything seemed above head in the trembling wall of green our occasional passing of some mighty trunk of the *da kua* tree, whose branches began far up above everything, made still smaller the caravan passing below. Upon the branches and curves of the great trees, in every nook of protection they could afford, flourished other small forests of air plants, ferns and creepers for whose support the great oak-like limbs of this giant of the pines seemed to spread. Lifted high in relation to the plunge beneath, I spent half the time in

looking at the details of this upper picture, unseizable otherwise in our rapid marching — but after our rest in mid-journey I preferred the tramp, and walked on with the others, slipping and sliding up and down, until we reached camp (after five hours' walk) on a little open space. Just before this we had passed through a little park-like country all different from the sharp edges, ascents and descents of our usual travelling — the grass grew high, trees dotted the swellings here and there, the sun kept all dry so that it was hard to believe that only a few feet behind lay the eternally wet forest. In the tall grass grew orchids like lilies, orchids large and small of the *fagus* variety. Butterflies and moths flitted about. The open country smiled after the sadness of the woods. Our resting place was not quite so open, but yet it had a similar appearance. It had evidently once been inhabited — there had been taro patches at one extremity of the open space. Here again, as throughout what we had seen of Fiji, the inhabitants had been chased away from their holdings in the perpetual wars. Indeed only twelve or fifteen years ago these good people here were cannibals and liable to be eaten if they did not eat others. The advantages of their present lot in this way were referred to in the sermon of the native preacher who had accompanied us, for this was Sunday and we had prayers in the morning and service and sermon in the

afternoon. Of course I get all this at second hand, or even further; but the good man took also occasion to lecture his travelling flock, a flock as I understand, not his natural audience, upon the folly of returning to devil worship, of which there had been cases in this part of the country, as I have mentioned, I think, and pointed out to them that it was only an agitation brought up by people who wished to kindle trouble for their peculiar ends, as, for instance, that in the scarcity of women, some of them might fall to the share of fomenters of trouble, in case of any upsetting of things, however momentary — for there are fewer women than men, as I think I was telling you.

Here the desolateness of this open space (with our pretty and comfortable temporary huts it is true), but still indicating a once large population, brought up this question of the relation of the women in connection with agricultural work. They appear "sat upon" and not joyful and free as in other islands that we have seen. But of course appearances are only for *us;* they are certainly kept away and take a secondary position. But then of course they have to be put away from the mass of our men who are beginning to number heavily. Mr. Joski says that we are as many as four hundred. These women, who look so saddened, did a great deal of the heavy work, if not all — a matter which seems unnecessary at first, as the

men used to idle and fight, but perhaps it might be worth while to look at the matter from inside and see how things must have stood in old times.

In the morning, when, as to-day, the mist hung over all the valley, over every point that could be cultivated or was so — when the little village alone above would be lighted up distinctly, it would have been impossible for the warriors to plunge into these shadows to look to these plantations, offering themselves as an easy prey to any ambuscade or attacking party. No; the right thing, of course, was to wait until the sun rose far enough. Meanwhile skirmishers looked about and travelled through the neighbourhood, armed against any foe. When they were satisfied that there was no immediate danger the women and children could go out and work in the fields or attend to anything necessary, while the men were about, ready to protect them in case of danger; certainly, this was to the woman's advantage; had she, when travelling or going about, shared with the man the carrying of weights, how easily would they both have fallen a prey to the enemy. No, she would naturally have said, "you go before with your lance and club and see that the path is clear; I follow with the food." All this is a picture of what was once, and here no more than elsewhere, except that here things were upon such a scale that there was no chance for anything but this perpetual

war. By such considerations the past of *all* nations comes back.

July 6th.

People of the neighbouring district came here to do homage to the governor and present food and they added still more to the number, filling the neighbouring hollows and moving about in and out of the lovely little brook all shaded by trees, in which we bathed in cold water, for the temperature remained pretty steadily the same, in the neighbourhood of 63° to 68°.

In the morning we left Ngalawana, and made a short and desperate plunge through the woods in the hollow to the N. W. and up the mountainside. It was raining and had rained, and anything more slippery than the road over which all these hundred of people had been travelling I cannot think of. The steepness was bad enough, and one could have rolled down if one had a good start; but some of the paths might have been "tobogganed" over. The bare feet of the natives managed it well enough, though with much slipping. And their ideas of direction of a road are peculiar, the straighter the better and across country; so that recently about the very roads that are in consideration, they say to the governor that of course they will make him *his* roads to travel on as it suits him, following easy paths, but that he must not expect

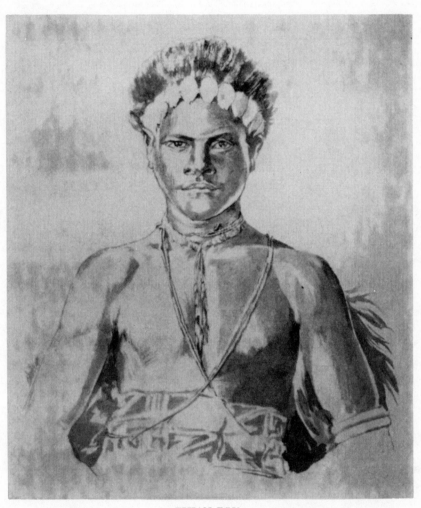

FIJIAN BOY

that *they* will use them. Still easy ways are great persuaders, and notwithstanding this conservatism, the new roads in other parts are travelled over by the now converted heathen.

We arrived at length at a little village on a spur or ridge in a large valley where we are to rest for a few days — the first village, small as it is, since Nasogo. Here the governor was waited on by two deputations who presented whales' teeth and food and who were received in the usual way by the Mata ni Vanua (the herald) and the other attendants with the usual voices of *ah! wui! wui! — wu — u! wooe — wooe!* and so forth, making everything look more and more African as we go along; for all the way through in these mountain tribes, the negro colour and look, and woolly hair on head and shoulders and legs, and I am sorry to add the smell, marks how far we are from our smooth brown Polynesians.

In the evening all was bathed in the afterglow; pigeons called in the trees; through the air that seemed thickened with the light-green, long-tailed parrots sailed slowly, with an occasional flap of wings.

Matakula, July 7th.

We are resting here to-day; while the governor explores the neighbourhood for the purposes of his establishment of a sanitarium. We are not so high on the present ridge as he

would desire: only 2,200 feet while it might be possible to find a plateau or wide ridge as high as 3,000. It is much warmer than before and dry at least. The night was cool — as low as 54°. The day is warm. I rose early, with the cries of the parrots in the wooded hill behind us; looked at the mist in lakes about us, out of which stepped the high trees and the mountains in the distance — even the dark conical huts of the little village built along the ridge at whose extreme end we are, were still wisped with moisture. The sun rose slowly behind the mountains, bathing everything in mildly pale varieties of wet colour — and all was lit long before the sun came over the hill behind us, and poured heat and dry light upon the scene.

We have been doing nothing: sitting out under umbrellas — then under a mock grove which the men suddenly made for us, digging up neighbouring trees and tree ferns and planting them around us in the soft soil.

For this they used the digging sticks they had, merely heavy bits of wood with pointed ends, in some cases turned up at the sides. We are here in primitive country: the boys of the village brought the water in bamboo joints this morning: the huts are of a peculiar hay-mow character — the features of the people, as I said before, are remarkably "African," though often the colour is of a rich brown — but more usually a

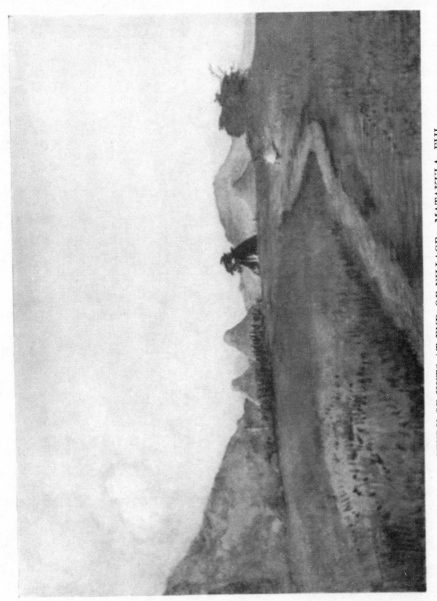

STUDY OF HUTS AT END OF VILLAGE. MATAKULA, FIJI

chocolate, that is negroish, is the type of colour, passing to a blackish grey. Most of the old people here have been cannibals; and fifteen years ago all this part was then still dangerous: on some attacks of theirs, upon the coast people and upon the whites, two of whom were eaten, war was made upon the villagers in this direction; their villages burned, and their people driven out and divided among other places. Some of the gentlemen with us talked at night of those days and of the fighting. If I have more time, I shall try to join together some memoranda or to jot them down as they come up.

At night, when there is no rush for bed, around a fire in the open the talk goes on, always interesting and rich in anecdote, and it is only a pity that we are not more acquainted with the places and people and past story: it is like looking at an embroidery that has no foundation.

But last night a story reminded me of the dream of Pomaré Vahine, told us by the old lady, Hinarii, in Tahiti, which I sent you, I believe. This is not a record of the pagan underworld, as that was, but one of a new Christianity, and as such makes a curious "pendant." It is one of the late things reported about, and a source of comment and of influence. It appears that the wife of one of the principal people of some neighbouring place — perhaps a *mbuli*, but I was very sleepy when I heard it, and details are misty — appeared to

be dead, was duly watched and prayed over — and then suddenly she called out aloud; when naturally enough, the entire assemblage scampered out of the house: at length the husband took courage and came up near the house, and heard his wife call out "Mbuli Mandrae" (I don't remember the right name, let us call him so) "is that you?" "Yes" — "Well then I must tell you what I have seen." So to those who returned, the good woman said that after death she found herself on the path, and crying, to find the road to Heaven. The road forked: at the one fork were a number of men dressed in white — at the other a number in black, and when she expressed a wish to go the road to Heaven, the white men passed her on, tossing her as it were from one to the other, until she reached a great gate which was made of looking-glass or mirror. There she knocked, but was told that she must go to one side, where a scribe asked who she was and what she wanted. She wished to get into Heaven. So her book was consulted, and she was asked if she was free from sin. "Yes" she replied — "I have been faithful to my husband." (Sin with these good people is of *one* kind.) "No indeed," said the judge, "do you not remember one mid-day when so — and so ——" The poor woman admitted her fault and was immediately handed from one white being to another, until she reached the fatal corner, when the black-clad people tossed her along as rapidly, until

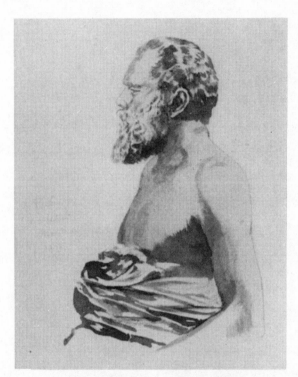

RATU MANDRAE — FIJIAN CHIEF

she saw a large lake of fire in which were swimming, people who were shrieking out of the seething liquid, and then dropped in again with cries of agony — around the pits hung ropes from which many were suspended and dipped into the liquid fire. "See," said some one — "that empty one is yours, but you have until *next Thursday* to return to your home and warn your people of what is in wait for the sinner." So the good woman had returned, and, having warned them true to her appointment, died for good on the Thursday. The impression has been great.

July 8th.

In the morning, after the night-rain and fog, the hills and the dry country below our little narrow level were grey in mist, slowly dispelled by the sun that tossed it irregularly into the air. Before sunrise, in the dawn, the distant mountains, the higher hilltops and the uppermost trees near us rose from out of a lake of white cloud; with the coming of the sun, things became less distinct, until again, just as the sun passed over the little rocky mountain behind us, the fog lay again level in hollows while the last wisps of water blew around us, dimming this or that hut of the village of which we were part. The parrots chattered again. The doves cooed in the forest a few yards off, and in the line of the

hills behind, a curious bark in the distance was the voice of another variety of dove. Two or three times that morning, and again during the day, we heard the gun of our "hunter."

This was to be our last bad day of walking and we made a good show at it. We were to drop some seven hundred feet perhaps a thousand during the day, down the other side to get toward the sea; and this in the wet wood, over clay and roots, or over wet clay and wet stones when we should be on the open mountainside. The forest was as usual; occasionally the trunks of large *da kua* trees stood up like separate columns in the green. In one case this great cylinder was up to some fifty feet all reddish and bright with loss of bark. It had been cut off to this height by the natives, who use climbing sticks to reach far enough, in pursuit of an edible grub in the rotten bark.

The trail left the woods after a time and descended the mountainside covered with reeds that flowed away from us as we passed. This was the toughest of the path; slippery with black mud and red clay, the slippery fallen leaves giving a better hold, and only seen when trodden into; this uncertain way down a steep grade upon which occasionally we slide as easier than slipping, was the most fatiguing pull I have ever made. Once or twice to my amusement, the dog of Mr. Carews, young and inexperienced in such travel, seated him-

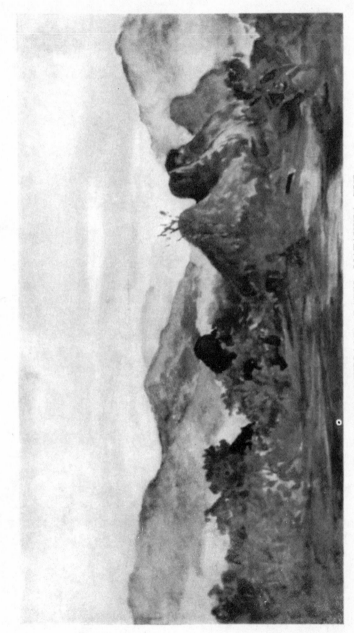

BEGINNING OF VILLAGE—DAWN. MATAKULA, FIJI

self on his hind quarters and pushed himself down on his fore paws. The bare feet of our native companions and their powerful legs carried them along with relative ease, and when they helped me, I was carried along for a little while at a great rate; slipping of course, but balanced and getting on as if on skates.

We were often on the edge of the precipice and at length stopped at a little open spot, where on some black rocks that edge it, we stopped for a time and looked upon the deep valley, whose opposite side was different in character from what we had travelled in. We were now on the dry side of the island (a relative term), and the look of the opposite mountain was like that of the hills of Hawaii, or of Tahiti; a curious golden grey-green, intensified wherever the innumerable hollows gave protection and greater damp to trees and bushes.

We were on the slope of a tongue or ridge between two valleys, but it was only quite late that the clouds lifted enough from the tops of hills to let us catch a view of the valley we were going to, of the course of the brilliant little river and further off, of high points of blue that enclosed the sea.

Meanwhile we halted for lunch at a little level park-like space, and walked to its edge with the hope that the clouds would break, but there was nothing but a mass of white vapour in front of us that filled the valleys, rose above us, and broke

against the crests that we had left, or beat around, leaving blue sky above us in deceiving patches. There, while we rested, the *shikari* brought in, with doves, two long-tailed parrots, the one green with green and yellow breast, the other blue and red and green; the latter feeds on fruits and is not obnoxious to the natives; the green is more predaceous of their gardens. This was my first sight of the killed parrots and with the soft grey of the doves they made a brilliant and gay mat upon the green grass.

I picked out a few feathers to send to you with this, wishing that I could also send the impression of the scene, with all these groups of browns and blacks about us, and the cloudy landscape above.

Later in the afternoon, after having waited for a sight of the great view in vain, we dropped down again through the same terrible woods, and reached in the early evening the little village of Waikumbukumbu, the last of the mountain villages, whence we should find a made road to the coast. The name Waikumbukumbu means seething waters, and describes with exaggeration the look of the little gorge in which its site is chosen.

We crossed over rocks the path of the little torrent, now rolling between rocks, now filling stone pocket in its bed, or sleeping quietly between high wooded banks. The houses of

the village were partly those of the mountain, the beehive; partly those of the coast with long ridge-pole, and built up on high mounds, covered with stones or grass. But the openings were the smallest I had seen — a big man in some cases might just have fitted in. One little one which I have sketched for you, and which was prettily placed by the side of the ditch, and with the adornment of a few trees, was exceedingly small and queerly bulged out in roof at once over its low reed walls. The thatch had been extraordinarily thick, projecting very far, and its edges were cut perpendicularly down so as to make a line with the wall, and you had a proportion of thickness of thatch greater than the wall or the roof. To all those roofings that were old, and which covered almost the entire houses, time had given a most delightful texture and tone, making them look as if covered with a most exquisite grey fur. The thatch of the new buildings was yellow and shaggy, giving the look entire of the reed: as the leaves are weathered off, the fine stem alone remains: the thing is exquisite as thatching, having an appearance of extreme finish.

The little house or *mbure* placed thus at the entrance of the village just gave place to two persons within — and Mr. Carew (magistrate and commissioner, who knows all about things, has been here twenty-three years and is a student of words and languages) says that such would have been a

"devil" house formerly where the priest or prophet or wise man could reside alone and be applied to.

Here, he said, with the love they have for shutting things up, he could close his door easily, and be happy in the sweating heat of the night. The horror of draughts I can sympathize with here in the hills where the change from the 80° or 83° of day to the 52° of night makes the motion of air between narrow walls easily felt, but this night was not cold and with only one door in the house we felt the closeness. Outside the temperature was exquisite (somewhere about 68°), and the picture of our carriers encamped about the village and fires, that lit up themselves, the trees, the houses, and the opposite hills by fits and starts, kept me awake notwithstanding the very fatiguing day. We had been six hours on the walk with the rests included, and such a walk.

We bathed in the hollows on the rocks that night, and the next lovely morning, and then began our last march. The mass of the carriers had been dismissed; and I think that we were not more than fifty men or so: the road, a very wide one, began by running up hill as straight as might be, in Fijian fashion, as if to show that the natives were not afraid of mere steepness.

The walk was a hard one, and we had hesitated as to whether the river-bed would not be easier, as we had been advised; but

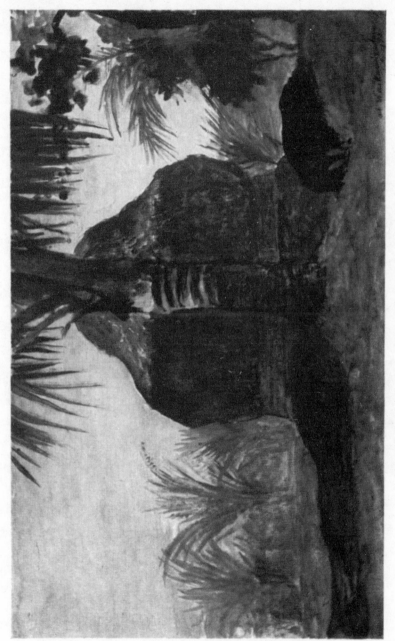

MOUNTAIN HUT OR HOUSE AT WAIKUMBUKUMBU, FIJI

after all a road is a road, even if it leads up the side of a house, and by noon, we had done all the worst of it. A beautiful sight opened before us, like a reminiscence of Hawaii: we had the mountains behind us and on either side, partly green, partly rose or golden. As usual, we were coming down a dividing ridge that ran into the plain; mountain edges framed the sides, far off stretched a fairy sea with points that framed it, and on one side a mountain with high perpendicular cliffs standing up against the distance. Everything swam in light; blue and violet filled the distance; a big plain, in which glittered a little water, spread from the blues to the green near us in gradations such as Turner loved: even the very stippling of the innumerable trees, so many of which were the pandamus (the *lauhala* of Hawaii), reminded me of him, as the scene recalled Hawaiian islands. Along the road thin *lauhala* — the *fao* of Samoa, the *fara* of Tahiti — growing every now and then and marking the distance, and again repeated everywhere in the blazing spread of green and yellow of the plains, grew not thick and full like those of Samoa and Tahiti, but strangely and queerly with outstretched arms and straggling foliage.

We loitered along the road at places where there were big trees and water. Halfway, Mr. Marriott, the magistrate, had sent a horse for me to ride, which convenience allowed me

to look further and freely upon the landscape from this height;
but we were some time on the road, some five hours at least,
though it was but ten miles I suppose.

Vanuakula, July 10th.

We came down in the afternoon to Vanuakula, a neat little
place reached after a long promenade under the hot sun, upon
the road that ran on a dike in mangrove swamps. There we
found news of the little steamer *Clyde*, and saw its Captain,
Mr. Callaghan, and were told that at night we should get
aboard so as to get off early in the morning for Ba, in such
manner as to hit the tide without which we could not possibly
enter the river to-morrow morning. So we waited for the
rise of tide in a little village green square, and a pretty native
house and saw a native dance of armed men (*mekke*) given
as a mark of honour along with the food, and as a manner of
presenting *tappa* of which an enormous quantity was given
to the governor.

Each dancer, as we had seen before, carried upon him in
long folds yards upon yards of the cloth, looped like a dress,
caught around his shoulders perhaps, or only at his waist;
sometimes folded stiffly far over his head, like the floating
folds of drapery upon an archaic bas-relief; and after the
dance he unwinds himself from the enormous entanglement,

and adds it to the pile that our men gather together and fold up. This plunder the governor carries off: in true native fashion, he is but a conduit for gifts: when some chief or persons who have need to fill up gifts or do the proper thing, think it is time they come and beg for things, the whales' teeth, or the *tappa* (native cloth) and receive them. As I think I said before, it is pleasant to see the governor keep up strictly every native custom that secures order and belongs properly to their official life. He is very strict about it, insisting upon every observance that his position requires and carrying all out.

While we waited, looking on at the dance, or afterward when the ladies of the village came in bringing gifts of food, having properly asked permission to do so; two Samoan women sat beside us. They had come from a neighbouring house to call; one was younger than the other, and looked with her hair "à la Chinoise," her slanting eyes, and flattened nose, and wide lips, very much like certain musme of the Japanese inns and tea houses. This one had been Samoan way, married to some more or less white man, who had left, and she was now a grass widow. The other was, "*faa* Samoa," married to some half-breed: and she of the slanting eyes noticed Awoki near us, and somehow or other took him in as a variety of Samoan.

Did he come from Africa or whence? and Japan had to be

explained. But she said she was anxious to get back home, and that things here were *leanga* including the dance which we had been looking at, and the women and girls who were coming up in a long file much bedizened with velvet, cotton, paper cut into strips (of every shade imaginable), leaves around the waist, etc.; from her all dressed all over, to her who only wore long leafage about her hips. They were prettier than any we had seen: that is to say they were some of them not unpleasant; but only a few: and after all it is only the quite young who suggest anything more delicate than the men. Raiwalui, one of the governor's boys is more feminine looking notwithstanding his strength and height than any Fijian woman I have yet seen. All this is so far as we have seen, and as I told you, so far the women and children get out of the way, not only because they always do so more or less, but also because of our men who have numbered at times several hundred, so that the women and children are crowded away in corners to leave houses empty for the visitors. But the Samoans looked like beauties alongside of their sisters of Fiji here, and sailed off with much superiority and conscious ease while the Fijian women had walked off in single file neither looking to right nor left, but keeping a downward look and following their leader.

Dinner we had outside on the mats, and just before the new

moon sank we embarked in the dark upon the little river that was to take us to the sea and the steam launch. We were poled along for some few miles near mangrove trees whose roots hung above us, the wash from our water splashing in among their roots and trunks. Occasionally some more solid ground showed a few houses, or some clump of palms against the sky half clouded. Then a long row out to the ship, all dark, large masses of dark sea and dark sky, with the moon almost set, looking at us like a half-closed eye under the forehead of an enormous band of dark cloud.

The next morning at ten we steamed for Ba, ran out quite far, but in shallows inside the far reef, where at one place the beginnings of things could be seen, as upon the horizon, at sea apparently, a line of mangrove trees, widely spaced, dotted the sharp division of blue sea and blue sky. Still between them there was a little greenish band like water and really partly water, and to one side a little line was the reef on which they had begun to grow.

Inland, the long lines of the mountains look faintly tawny and blue; the swamp belt of mangroves surrounding the shore looked very low: we could discern, at places, the circles or elevations by which we had passed over the serrated edge of the mountains.

Then we ran into a river for some little while, the usual

green bank, the trees, and the sugar-cane, and the mountains in the distance with here and there a strange pillar-like mountain or a perpendicular pile, to remind one of volcanic forms.

A number of figures clothed in white sat upon the green bank and watched the governor's approach. When he landed they made the usual salutation headed by the *roku* or chief.

Nailaga, July 12th.

We walked into the village neatly laid out in squares, our first large place since we had left Suva: all quite uncivilized, but in native shape. We found a handsome native house, handsomely finished, with a fine *tappa* hanging, cutting off one end, and many mats. This was the house of the *roku* who had saluted the governor, a curious person — not a young man — with greyish hair cut short, short grey moustache, and a face looking not at all Polynesian — a very refined face — meaning one that was not in the least heavy — gentlemanly and wary, and with a peculiar indifference as if he went through his formalities without anxiety because they were the thing. He reminded me of some one at home, a little unpleasantly, for the gentleman was evidently not frank unless for his advantage, and he was old enough to have belonged to ancient cannibal days. He had a white shirt on with a turn-down collar, and a small blue scarf all which finished him;

and his skin, not too dark, made still more the impression of a person who knew just how to do it. So it was also when later he gave the *yangona* or *kava* — and led the chant, so delicately and correctly, a little bored, looking to see if it were quite ready, so that he should have no more to wave his arms and hands in a fixed way to the song. Here was an Asiatic type — my simple Polynesian was no longer there.

Later on, when he came to arrange a bamboo rail for our more convenient getting up and down the slippery plank that served for entrance, he asked our permission: the house was no longer his since we were in it. Contrariwise to him, all his companions were rude looking, some, I regret to say, exceedingly hard looking. Most all at the *yangona* ceremony were stripped to the waist, and decorated with garlands, that emphasized more terribly some frightful countenances.

After that, the presentation of food and the great dance, like others we had seen but with many variations added, such as the moving in long files two together, or in files moving in two opposite directions, or in striking in order each other's clubs, or in throwing arms and hands about in various ways resembling the attitudes of the famous *siva*.

All this was in the big square. On one side a great mass of women, girls, and children looked on, seated: along the road

passed Indians coming and going from work: the women in their *saris* and dresses of light red and yellow.

Since that we have been very idle; have called on Mr. Marriott, and at a sugar plantation and lounged all Sunday — the twelfth — at which date I am writing to you. It has been cool at night, but only because of the draughts of the big house, with its three big doors. The temperature inside is just 70°.

Nanuku Coa, "Black Sand."

We left Nailaga (in Ba) on Monday morning in lovely weather. The early hour after our breakfast was spent in some conversation between the governor and chiefs, while Atamo surveyed the scene from the top of the embankment on which the house is built, enjoying the pleasant shade in which we all were, thrown across the lawn by the great house. Then again we walked off to the river bank after the governor had restored to the Roku the great stick of office, which had been received on the governor's arrival. This was about six or more feet long, with ivory top and grip place (made, however, in England).

The *Clyde* took us along for hours out on the Ba river, and along the coast back upon our way. We tried to descry the outlines of the heights which we had reached and descended.

Peak behind peak stretched along, with the buttresses of hills sloping down, all on this side looking white or yellow or pinkish in the sun. The dry side of the island was faintly marked by the dryness of the colour, for which I regretted that I had no pastel or chalk colours to imitate the powdering glare of the sun on the great surfaces, streaked with descending bands of a shade unnamable by our categories of colour. But we knew that all this resemblance to a desert was only for the distance; nearer by, the places we had been in were green or yellow-green. There was of course dry, yellow grass and seeds, and violet of dried bracken — the grey-violet of the ferns such as we had seen even in wettest Hawaii, but wherever any hollow gave a chance, no matter how small, there things grew green. In the nearer hills drier green marked the hollows, and modelled the surfaces; and by the shore the heavy green of mangroves lined the edges.

Thambone, Monday 13th.

Late that afternoon we had turned several points, and came to a halt with want of depth of water opposite the place we were going to stop at. Here we landed in a more inconvenient way than usual. We were pulled out in the gig a little way, then carried on the shoulders of the men to a shifting sandbank on which we walked or sank, as the case might be; then again

embarked on native backs that were rough with curling hair, and again reached a mud flat of considerable length, framed with mangrove trees, along which we walked to the shore; this was drier, not washed over by the tide daily as the former, upon which I saw growing green, as if never covered by salt water, the first shoots of the mangrove. Its seeds are heavy and float point downward until they stick in appropriate soil. The flat near the shore was all covered with an efflorescence of salt, and caked and broken up by exposure to the sun. Ratu Joni (Johnnie) Madraiwiwi, who had come to meet us, showed us the little pits or hollows for collecting salt water and making salt; for we had come to the dividing place of the South Seas. Here people have made salt, unlike the Polynesians of the Eastern Seas; here they have baked earth for pottery — here they have used the bow and arrow — in these ways more civilized than their half fellows, who in other ways seemed so much less savage than they. But here, as you know, the races mix: the black is all through here: and strangely enough with the black are all sorts of arts, and a higher sense of ornament and decoration and construction.

For all this I have my own theories, but this is not the place to ventilate them, even if I liked theories, and you know that I detest them — if taken seriously.

Africa — "nigger" land — was certainly pictured where we